The Animator's Survival Kit

RICHARD WILLIAMS

THE ANIMATOR'S SURVIVAL KIT™

ff

faber and faber

LONDON·NEW YORK

First published in 2001
by Faber and Faber Limited
3 Queen Square London WC1N 3AU

Published in the United States by Faber and Faber Inc.
An affiliate of Farrar, Straus and Giroux LLC, New York

Typeset by Faber and Faber Limited
Printed in Singapore

A CIP record for this book is available from the British Library

ISBN 0–571–20228–4 (pbk)
ISBN 0–571–21268–9 (cased)

10 9 8

To Imogen,

my co-conspirator and wife, without whom this book would certainly
not exist – and the author might not be around to write it.

I want this book to put over what I have found to be the best working methods, so that animating becomes better and easier to do.

There are lots of formulas, principles, clichés and devices here to help, but the main thing I want to pass on is a way of thinking about animation in order to free the mind to do the best work possible.

I learned it from the best in the business and I've boiled it all down into a systematic working order. It transformed my work – I hope it will be useful to you.

A commercial I did based on a Frank Frazetta poster.

CONTENTS

WHY THIS BOOK?

When I was ten years old I bought a paperback book, *How to Make Animated Cartoons*, by Nat Falk, published in 1940. It's now long out of print, but I used it as a handy reference guide for 1940s Hollywood cartoon styles when I designed the characters and directed the animation for *Who Framed Roger Rabbit*.

More importantly for me, however, the book was clear and straightforward; the basic information of how animated films are made registered on my tiny ten-year-old brain and, when I took the medium up seriously at twenty-two, the basic information was still lurking there.

I was living and painting in Spain when the incredible possibilities of what animation could do engulfed my mind. I planned my first film and took the money I had left from portrait painting to London. I starved for a bit, finally found work animating television commercials and managed to self-finance *The Little Island* – a half-hour philosophical argument without words which won several international awards.

The Little Island, 1958

Three years later, when I'd finished the film, the unpleasant realisation slowly crept up on me that I really didn't know very much about animation articulation, that is, how to move the stuff. To train myself I traced off the animation that Ken Harris had done of a witch in a Bugs Bunny cartoon (*Broomstick Bunny* – 1955, directed by Chuck Jones). Doing this only confirmed how little I understood about movement.

While I was making *The Little Island* I had seen a re-release of *Bambi*, but since I'd considered myself a revolutionary in the field of animation, I'd rejected the film as conventional. But when I finished my film, I saw *Bambi* again, and almost crawled out of the theatre on my hands and knees. 'How did they ever *do* that?' I'd learned just enough to realise that I really didn't know anything!

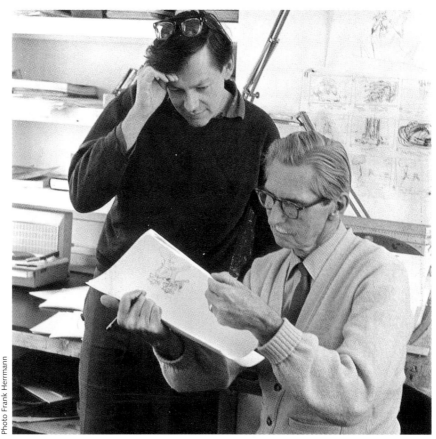

Photo Frank Herrmann

Animation master Ken Harris and wannabe, 1969

So, how and where to get the expert knowledge? I was working in England as an independent and didn't want to go into the Hollywood cartoon mill. I wanted it both ways. I wanted my artistic freedom but I also wanted the knowledge.

Preston Blair's *How to Animate Film Cartoons* was available, but because I was put off by the squashy-stretchy 1940s cartoon style, it was harder for me to grasp the underlying principles I was after – although it's a solid book and Preston was a very good animator from the Golden Age. It's ironic that forty years later I would become best known for my work on *Who Framed Roger Rabbit* – drawing in precisely the same style that had put me off learning from Preston.

Much later, I was able to work with Ken Harris, the first 'real' master animator I met, and whose witch in *Broomstick Bunny* I had traced off. It's generally agreed that Ken Harris was *the* master animator at Warner Bros. Certainly he was director Chuck Jones's lead man.

In 1967, I was able to bring Ken to England and my real education in animation articulation and performance started by working with him. I was pushing forty at the time and, with a large successful studio in London, I had been animating for eighteen years, winning over one hundred international awards.

After seven or eight years of working closely with Ken, he said to me, 'Hey Dick, you're starting to draw those things in the right *place.'*

2

'Yeah, I'm really learning it from you now, aren't I?' I said.

'Yes,' he said thoughtfully, 'you know . . . you could be an *animator*.'

After the initial shock I realised he was right. Ken was the real McCoy whereas I was just doing a lot of fancy drawings in various styles which were functional but didn't have the invisible 'magic' ingredients to make them really live and perform convincingly.

So I redoubled my efforts (mostly in mastering head and hand 'accents') and the next year Ken pronounced, 'OK, you're an animator.'

A couple of years after that, one day he said, 'Hey, Dick, you could be a *good* animator.'

When he was eighty-two, I would go out to Ken's trailer home in Ohai, California and lay out scenes with him that he would later animate. He'd often take a half-hour nap and I'd keep working.

One day he conked out for three hours and by the time he woke up, I had pretty much animated the scene. 'Sorry, Dick,' he said, 'you know . . . I'm just so god-damned *old*.' (long pause) 'Oh . . . I see you've animated the scene . . .'

'Yeah,' I said, 'I didn't know what else to do'.

'Nice drawings . . .' he said, then pointed. 'Hey, that's wrong! You've made a mistake.' And of course he was right.

'Dammit Ken,' I said. 'I've worked with you for thirteen years and I *still* can't get your "thing". I'm afraid it's going to die with you.'

'Ye-e-aaahhhhh . . .' he snickered, then said, 'Well, don't worry, you've your own pretty good thing going.' Then he snickered again.

Ken was a very fast worker and I was always squeezing him for more and more footage and getting him to animate even when the taxi was ticking outside waiting for him to catch a plane home to the States.

When he died in 1982 at eighty-three, my real regret was that when I was a pallbearer I didn't have the guts to tuck a blackwing pencil into his hand in his open coffin. He would have loved that.

When I first started working with Ken, we had just completed the animation sequences which occur throughout Tony Richardson's epic film *The Charge of the Light Brigade* and I thought I was getting pretty proficient. When Ken saw it in the theatre he said, 'God, Dick, how did you guys ever do all that work?' (pause) "Course it doesn't *move* too good . . .'

But I'm still not ashamed of our work on that film.

After that we went to see The Beatles' feature cartoon *The Yellow Submarine*. Though I liked the designer Heinz Edelman's styling, the 'start-stop, stop-start' jerky quality of most of the animation meant that after a half hour much of the audience went to the lobby. No matter how stylish or inventive – jerky or bumpy animation seems only to be able to hold the audience for about twenty-five minutes. While *The Yellow Submarine* had an enthusiastic cult following from the advertising agencies and university crowd, the general public avoided the film. It killed the non-Disney feature market for years.

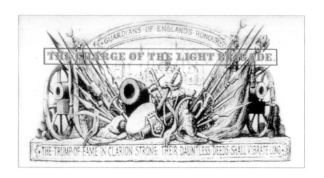

My animated sequences from Tony Richardson's epic film, *The Charge of the Light Brigade*, 1968.

4

A top United Artists executive who distributed *The Yellow Submarine* told me, 'This is the Beatles at the height of their popularity and *still* people stay away from non-Disney animation.' Film executives at that time always said of animation, 'If it doesn't have the Disney name on it, no one will go see it.' But the real point is, it wasn't just the Disney name – it was the Disney *expertise* that captivated the audience and held them for eighty minutes.

Almost the same week Disney's *The Jungle Book* came out and was an instant hit. I went along to see it reluctantly, thinking (as I still considered myself an innovator) that though there might be something interesting, it was probably predictable stuff.

That's how it started – with standard-issue wolves adopting the 'good housekeeping seal of approval' cutesy baby. I remember the boy Mowgli riding a black panther moving and acting in a clichéd way – until he got off. And suddenly everything changed. The drawing changed. The proportions changed. The actions and acting changed. The panther helped the boy up a tree and everything moved to a superb level of entertainment. The action, the drawing, the performance, even the colours were exquisite. Then the snake appeared and tried to hypnotise the boy and the audience was entranced. I was astonished.

The film continued at this high level, and when the tiger entered weighing eight hundred pounds and was both a tiger *and* the actor who did the voice (George Sanders), I realised I didn't even know *how* it was done – let alone ever be able to do it myself. I went back to my studio in shock and, through the night, I wrote a long fan letter.

In those scenes I thought I had recognised the hand of the great Disney genius Milt Kahl, who Ken Harris had raved about. The first name on the directing animator's credits *was* Milt Kahl, so I assumed the work that stunned me had been Milt's. And it turned out that it was – except for one shot that was by Ollie Johnston. Johnston and Frank Thomas had done lots of other marvellous work in the picture.

So I wrote to Milt saying that I thought *The Jungle Book* was the absolute high point of pure animation performance and that I didn't think it would ever be possible for anyone outside the Disney experience to reach that pinnacle.

It turned out Milt said it was the best letter they ever had – and even better, that he knew my work a bit and wanted to meet me.

Irrepressible ambition made me change my opinion that they *alone* could attain such heights; I figured, I think correctly, that given talent, experience, persistence – plus the knowledge of the experts – why should everything not be possible?

I couldn't stand it any more. I had to know *everything* about the medium and master all aspects of it. Cap in hand, I made yearly visits to Milt and Frank Thomas, Ollie Johnston and Ken Anderson at Disney.

One of the most important things Milt said was: 'Our animation differs from anyone else's because it is believable. Things have weight and the characters have muscles and we're giving the illusion of reality.'

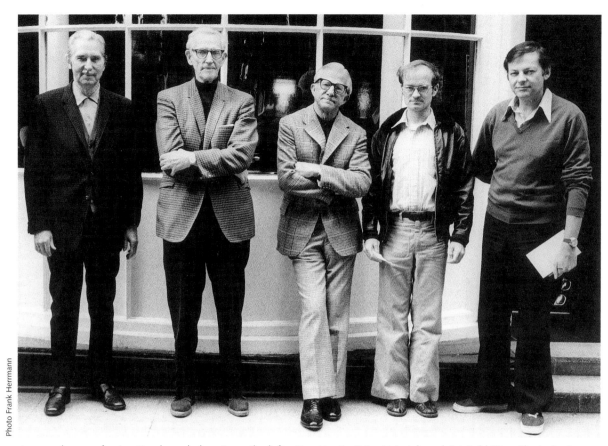

A powerhouse of animation knowledge. From the left – Ken Harris, Grim Natwick and Art Babbitt, with students Richard Purdum and me outside my Soho Square studio in London, 1973.

But how to make it believable? I didn't go there to drink Milt's bathwater or to find out what Frank Thomas had for breakfast. I would fire my carefully prepared list of questions at them and later write down everything they said. These wonderful virtuosos became my friends and were incredibly generous with their help. As Milt said, 'If you ask questions you find out what you want to know. *If* you're lucky enough to ask someone who knows.'

I was also fortunate enough to enlist the marvellous legendary animator Art Babbitt as a collaborator and teacher. Babbitt had developed Goofy and animated the Mushroom Dance in *Fantasia*. He 'dumped his kit' of knowledge by giving several month-long in-house seminars as well as working with me in my London and Hollywood studios for several years.

In 1973, I hired the eighty-three-year-old – but still brilliant – Grim Natwick as a 'live-in' tutor in my London studio. Grim had made his name designing Betty Boop and animating most of Snow White herself in *Snow White and the Seven Dwarfs*. I also worked closely with Emery Hawkins who Ken Harris regarded as the most imaginative animator. Emery was wildly creative and rotated in and out of every studio. I was also able to work for a short time with Abe Levitow, Gerry Chiniquy and Cliff Nordberg. Dick Huemer, one of the first New York pioneer animators, and later a key Disney story director (*Snow White and the Seven Dwarfs*, *Dumbo*, *Fantasia* and all the early Disney features) also gave me a very clear picture of the early days of animation.

Most of them are gone now but this book is full of their accumulated knowledge and craft.

6

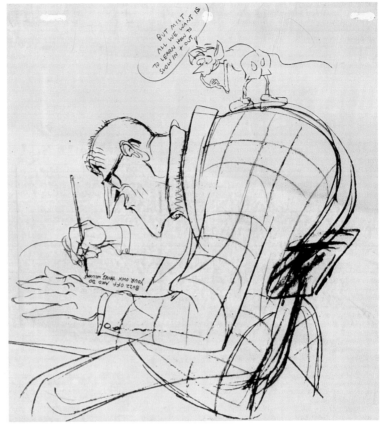

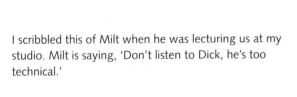

I scribbled this of Milt when he was lecturing us at my studio. Milt is saying, 'Don't listen to Dick, he's too technical.'

Milt was always encouraging me to do my own personal, more unconventional work, which he liked – but I wanted the knowledge first.

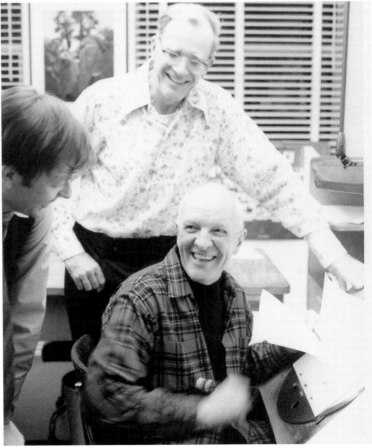

Two geniuses at once tutor the author – Frank Thomas standing and Milt Kahl at the desk, early 1970s.

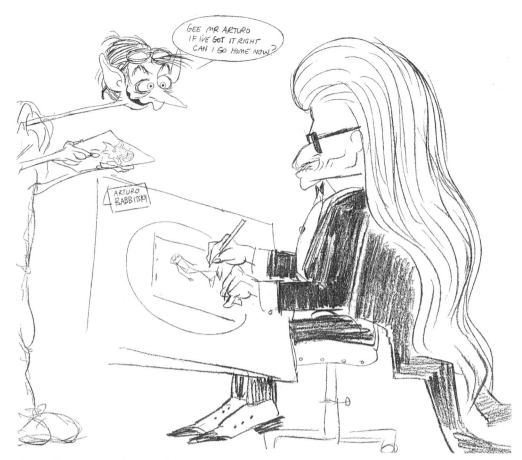

'The Arthurian Legend' was a formidable professor who regarded the professional skills of the animator as being equivalent to those of a concert pianist.

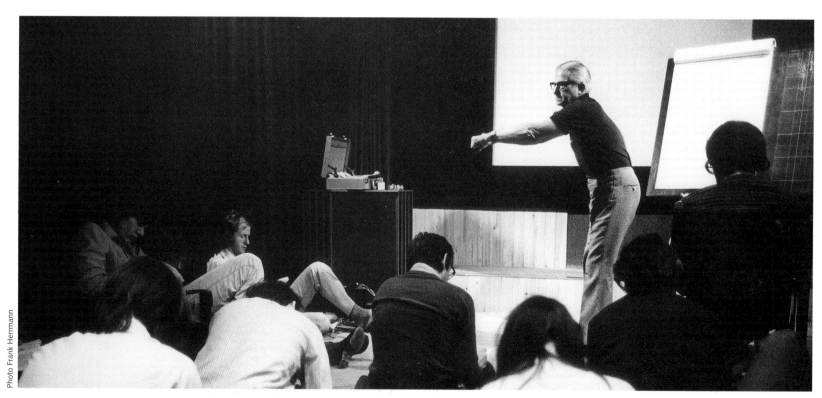

Art in action: his first month long seminar at my London studio was like water in the desert for us.

In the three-day masterclasses I've been giving lately, some experienced professionals initially feel that we're running over material that they're quite familiar with. Then about half way through the seminar things deepen and on the last day it all suddenly knits together. Some even describe it as an epiphany. Well, it sure was for me when I finally 'got it'.

So please read the whole thing.

Animation is just doing a lot of simple things – *one at a time!* A lot of really simple things strung together doing one part at a time in a sensible order.

The movie actor, Scott Wilson sat through my three-day San Francisco masterclass. To my surprise he came up at the end and said, 'Of course you realise, Dick, that *this whole thing* has been about acting.'

I said, 'What?' and Scott said, 'These are the *exact* equivalent methods, exercises and analyses we actors do in our acting workshops.'

So acting is intrinsically part of the whole. And if you can't draw or articulate movement how are you ever going to do the acting?

Someone once asked Milt Kahl: 'How did you plan out the counteraction you used on that character?'

Milt blew up: 'That's the wrong way to look at it! Don't think of it like that! I just concentrate on giving the performance – *that's* what's important! The play's the thing. You'll get all tangled up if you think of it in a technical way!'

Of course he's right. If a musician knows his scales, he can concentrate on giving the performance and bringing out the ideas inherent in the music. But if he constantly has to think of the mechanics of what he's doing – then he can hardly play.

Therefore, if we know and understand all the basics – then we've got the tools to create. Only *then* we can give the performance!

This book is an anatomy course in animation. Just like an anatomy course in life drawing, it shows you how things are put together and how they work. This knowledge frees you to do your own expression.

It takes time. I didn't encounter Ken Harris until I was nearly forty and he was sixty-nine. I had to *hire* most of my teachers in order to learn from them.

I hired Ken in order to get below him and be his assistant, so I was both his director and his assistant. I don't know if this is original, but I finally figured out that to learn or to 'understand' I had to 'stand under' the one who knows in order to catch the drippings of his experience.

There's a tale about a decrepit old Zen master wrestler. A very fit and brilliant young wrestler begs the old master to take him on and show him the master's ninety-nine tricks.

The old man says, 'Look at me, I'm old and decrepit and I'm not interested.'

The young man keeps pestering the old man who says, 'Look, son, I'm fragile now and when I show you the ninety-nine tricks, you'll challenge me, they always do – and look at me, you'll make mincemeat of me.'

The Charge of the Light Brigade, 1968

'Please, oh please, master,' pleads the powerful young man. 'I promise I will never challenge you! Oh please teach me the ninety-nine tricks.'

So reluctantly the old man teaches him until the young man has mastered the ninety-nine tricks. The young man becomes a famous wrestler and one day takes his master into a room, locks the door and challenges him.

The old man says, 'I knew you'd do this – that's why I didn't want to teach you in the first place.'

'Come on, old man, there's just me and you in here,' says the young one, 'Let's see what you're made of.'

They start and right away the old man throws the young fellow out of the window. The crumpled-up young man moans up from the street below, 'You didn't show me that one!'

'That was number one hundred,' says the old man.

This book is the ninety-nine tricks. The hundredth trick is called talent.

I became a repository for various strands of animation lore and I've taken all this stuff and given it my own twist. The goal here is to master the mechanics in order to do new things. Get the mechanics into your bloodstream so they just become second nature and you don't have to think about them and can concentrate on giving the performance.

I remember once saying to Emery Hawkins (a wonderful, unsung animator), 'I'm afraid my brains are in my hand.'

Emery said, 'Where else would they be? It's a language of drawing. It's not a language of tongue.'

So everything I know about animation that I can put into words, scribbles and drawings is here in this book.

DRAWING IN TIME

Why animate? Everyone knows it's a lot of hard work doing all those drawings and positions. So what's the hook? Why do it?

Answer: Our work is taking place in *time*. We've taken our 'stills' and leapt into another dimension.

Drawings that *walk*: seeing a series of images we've made spring to life and start walking around is already fascinating.

Drawings that walk and *talk*: seeing a series of our drawings talking is a very startling experience.

Drawings that walk and talk and *think*: seeing a series of images we've done actually go through a thinking process – and appear to be thinking – is the real aphrodisiac. Plus creating something that is unique, which has never been done before is endlessly fascinating.

We've always been trying to make the pictures move, the idea of animation is aeons older than the movies or television. Here's a quick history:

Over 35,000 years ago, we were painting animals on cave walls, sometimes drawing four pairs of legs to show motion.

In 1600 BC the Egyptian Pharaoh Rameses II built a temple to the goddess Isis which had 110 columns. Ingeniously, each column had a painted figure of the goddess in a progressively changed position. To horsemen or charioteers riding past – Isis appeared to move!

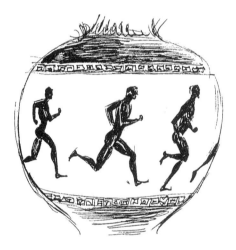

The Ancient Greeks sometimes decorated pots with figures in successive stages of action. Spinning the pot would create a sense of motion.

As far as we know, the first attempt to project drawings onto a wall was made in 1640 by Athonasius Kircher with his 'Magic Lantern'.

Kircher drew each figure on separate pieces of glass which he placed in his apparatus and projected on a wall. Then he moved the glass with strings, from above. One of these showed a sleeping man's head and a mouse. The man opened and closed his mouth and when his mouth was open the mouse ran in.

Although photography was discovered as early as the 1830s, most new devices for creating an illusion of movement were made using drawings, not photos.

In 1824 Peter Mark Roget discovered (or rediscovered, since it was known in classical times) the vital principle, 'the persistence of vision'. This principle rests on the fact that our eyes temporarily retain the image of anything they've just seen. If this wasn't so, we would never get the illusion of an unbroken connection in a series of images, and neither movies nor animation would be possible. Many people don't realise that movies don't actually move, and that they are still images that appear to move when they are projected in a series.

Roget's principle quickly gave birth to various optical contraptions:

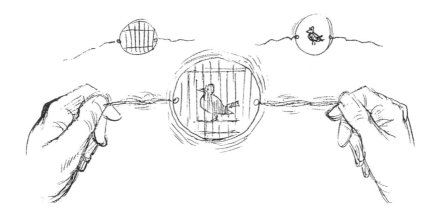

The Thaumatrope: A cardboard disc mounted on a top – or held between two pieces of string. A birdcage drawing is on one side and a bird on the other. When the top is spun or the strings are pulled the disc twirls, the images merge and the bird seems to be in the cage.

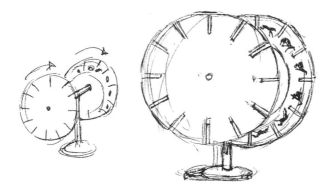

The Phenakistoscope: Two discs mounted on a shaft – the front disc has slits around the edge and the rear disc has a sequence of drawings. Align the drawings with the slits, look through the openings and as the discs revolve we have the illusion of motion.

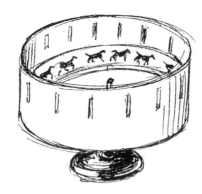

The 'Wheel of Life' (or the Zoetrope): Appeared in the USA in 1867 and was sold as a toy. Long strips of paper with a sequence of drawings on them were inserted into a cylinder with slits in it. Spin the cylinder, look through the slits and the creature appears to move.

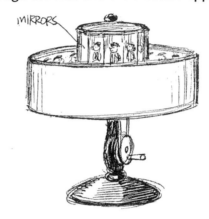

The Praxinoscope: Devised by the Frenchman Emile Reynaud in 1877. He was the first to create short sequences of dramatic action by drawing on a 30 foot strip of transparent substance called 'Crystaloid'. This opened the way for the tremendous advances to come.

The Flipper book: In 1868 a novelty called 'the flipper book' appeared worldwide and it remained the simplest and most popular device. It's just a pad of drawings bound like a book along one edge. Hold the book in one hand along the bound edge and with the other hand flip the pages and 'see 'em move'. The result is animation – the illusion of continuous action. Drawings in time.

This is the same as school kids making drawings in the corners of their math books and flipping the pages.

Today the 'classical' animator still flips his drawings the same way as a flipper book before testing it on the video or film camera. He places the drawings in sequence, with the low numbers on the bottom, then flips through the action from the bottom up. Eventually he should get good enough at it to approximate actual screen time and spot any errors or drawings that need altering. Now that we have the video camera with its instant playback of the drawings at film speed, not everyone learns to flip.

In 1896 a New York newspaper cartoonist James Stuart Blackton interviewed the inventor Thomas Edison who was experimenting with moving pictures. Blackton did some sketches of Edison, who was impressed by Blackton's speed and drawing facility and asked him to do some drawings in a series. Later, Edison photographed these – the first combination of drawings and photography. In 1906 they publicly released *Humorous Phases of Funny Faces*. A man puffed a cigar and blew smoke rings at his girl friend, she rolled her eyes, a dog jumped through a hoop and a juggler performed. Blackton used about 3000 'flickering drawings' to make this first animated picture – the forefather of the animated cartoon. The novelty brought explosions of laughter and was an instant hit.

A year later Emile Cohl made and showed his first animated film at the Follies Bergères in Paris. The figures were childlike – white lines on black – but the story was relatively sophisticated: a tale of a girl, a jealous lover and a policeman. He also gave lampposts and houses intelligence and movement, with emotions and moods of their own. Cohl's work prefigures the later animation dictum, 'Don't do what a camera can do – do what a camera *can't* do!'

Winsor McCay, brilliant creator of the popular comic strip *Little Nemo in Slumberland*, was the first man to try to develop animation as an art form. Inspired by his young son bringing home some flipper books, he made 4000 drawings of 'Little Nemo' move. These were a big hit when flashed on the screen at Hammerstein's theatre in New York in 1911.

As another experiment he drew a bizarre short film, *How a Mosquito Operates*, which was also enthusiastically received.

Then in 1914 McCay drew *Gertie the Dinosaur* and McCay himself performed 'live' in front of the projected animation, holding an apple in front of Gertie and inviting her to eat. Gertie lowered her long neck and swallowed the fruit – astounding the audience. This was the first 'personality' animation – the beginnings of cartoon individuality. It was so lifelike that the audience could identify with Gertie. It was a sensation.

In McCay's words: 'I went into the business and spent thousands of dollars developing this new art. It required considerable time, patience and careful thought – *timing and drawing* the pictures [my italics]. This is the most fascinating work I have ever done – this business of making animated cartoons live on the screen.'

McCay also made the first serious dramatic cartoon, *The Sinking of the Lusitania*, in 1918. A war propaganda film expressing outrage at the catastrophe, it was a huge step forward in realism and drama – the longest animated film so far. It took two years of work and needed 25,000 drawings.

Later, as an older man being celebrated by the younger funny-cartoon animators in the business, McCay lashed out at them saying that he had developed and given them a great new art form which they had cheapened and turned into a crude money-making business done by hack artists.

This well defines the endlessly uncomfortable relationship between the pioneering artist/idealist and the animation industry – working to comfortable and predictable formulas.

Still doth the battle rage . . .

In the twenties Felix the cat became as popular as Charlie Chaplin. These short Felix cartoons were visually inventive, doing what a camera can't do. But more importantly a real personality emerged from this flurry of silent, black and white drawings and Felix 'himself' connected with audiences worldwide.

The Felix cartoons led straight to the arrival of Walt Disney, and in 1928, Mickey Mouse took off with his appearance in *Steamboat Willie* – the first cartoon with synchronised sound.

The brilliant Ward Kimball, who animated Jiminy Cricket in *Pinocchio* and the crows in *Dumbo*, once told me, 'You can have *no idea* of the impact that having these drawings suddenly speak and make noises had on audiences at that time. People went crazy over it.'

Disney followed *Steamboat Willie* with *The Skeleton Dance*. For the first time, action was co-ordinated with a proper musical score. This was the first *Silly Symphony*. Ub Iwerks was chief animator on both films and a lot of the sophisticated action of *The Skeleton Dance* still holds up today.

Disney leapt forward again in 1932 with *Flowers and Trees* – the first full colour cartoon.

18

Then he followed it one year later with *Three Little Pigs*. This had a major impact because of its fully developed 'personality' animation – clearly defined and believable separate personalities acting so convincingly that the audience could identify with and root for them. Another first.

Astonishingly, only four years after that, Disney released *Snow White and the Seven Dwarfs*, the world's first fully-animated feature-length film, raising cartoon drawings to the level of art and holding the audience spellbound for eighty-three minutes. A truly staggering feat accomplished in an incredibly short space of time. (It's said that many of the artists booked themselves in advance into hospital to recover from the effort of completing the film.)

The tremendous financial and critical success of *Snow White and the Seven Dwarfs* became the foundation of Disney's output and gave birth to the 'Golden Age' of animation: *Pinocchio*, *Dumbo*, *Bambi* and *Fantasia*, as well as the *Silly Symphonies* and Donald Duck and Mickey Mouse shorts.

Surrounding the potent Disney centre were the satellite studios: Max Fleischer with two features – *Gulliver's Travels* and *Mr Bug Goes to Town* – and Popeye shorts; Warner Bros' Looney Tunes and Merrie Melodies with Bugs Bunny, Daffy Duck, Porky Pig; MGM with Tom and Jerry, Droopy and the great anarchic Tex Avery shorts, and Walter Lantz with Woody Woodpecker. Fed as they were by the knowledge and expertise emanating from the Disney training centre, their much wilder humour was often in reaction to or in rebellion against Disney 'realism' and 'believability'.

But after the Second World War the situation changed.

The arrival of television and its voracious appetite for rapidly produced product demanded simpler and cruder work. 1950s stylisation gave birth to UPA studios in Hollywood who created Mr. Magoo and Gerald McBoing Boing. UPA's approach was regarded as more graphically sophisticated than Disney and used more 'limited' and much less realistic animation. At the same time there was a worldwide flourishing of personal, experimental and 'art house' animated films made in new ways with many different techniques and with very different content to the Hollywood product. Animators were reinventing the wheel stylistically but were ignorant of the structural knowledge developed in Hollywood's Golden Age.

This knowledge, though residing in the hands of the originators, was generally ignored as being 'old hat' or was forgotten in the following thirty years.

However, in the last few years, the renaissance of animation as a form of mass entertainment is giving rebirth to the old knowledge. The startlingly successful innovations of computer animation are helping to transform animation in all it's multi-faceted forms into a major part of the entertainment mainstream. Alongside this, there is also the explosion in the computer games industry.

If drawn 'classical' animation is an extension of drawing, then computer animation can be seen as an extension of puppetry – high tech marionettes. Both share the same problems of how to give a performance with movement, weight, timing and empathy.

The old knowledge applies to *any* style or approach to the medium no matter what the advances in technology. Most of the work methods and devices in this book were developed and refined in the Hollywood animation studios between 1930–1940.

I've co-ordinated what I've learnt from various approaches and I'm presenting it here in a form based on my own experience in this medium – with its limitless possibilities of imagination.

Emery Hawkins said to me, 'The only limitation in animation is the person doing it. Otherwise there is no limit to what you can do. And why shouldn't you do it?'

I meticulously painted this poster for the 1981 London Film Festival. Everybody said, 'Oh, I didn't know you did collage.'

TIME TO DRAW

This section is really for classical animators. However, I haven't been surprised to find that most of the leading computer animators draw rather well, so it may be interesting to them too. It certainly helps enormously to be able to put down your ideas – even in stick figures. For the classical animator it is crucial.

Drawing should become second nature, so that the animator can concentrate on the actual actions and the timing of them and give the performance life.

When you're doing cartoons all the time, it's very easy to slide into formula drawing. During the making of *Who Framed Roger Rabbit* I found this pinned up on our notice board:

· EPITAPH OF AN UNFORTUNATE ARTIST ·

HE FOUND A FORMULA
 FOR DRAWING
 COMIC RABBITS:
THIS FORMULA FOR
 DRAWING COMIC
 RABBITS PAID,
SO IN THE END HE
 COULD NOT
 CHANGE THE
 TRAGIC HABITS
THIS FORMULA FOR
 DRAWING COMIC
 RABBITS MADE.

— ROBERT GRAVES —

Life drawing is the antidote to this.

When you're doing life drawing, you're all alone. One of the main reasons animators – once they become animators – don't like to spend their evenings and spare time life drawing is because it's not a collaborative operation.

Animation is usually a group effort, and one has the stimulus of constant interaction, both competitive and co-operative, with the cut and thrust, highs and lows, political factions of complaint and inspiration, all the tensions and anxieties, rewards and excitement of group production.

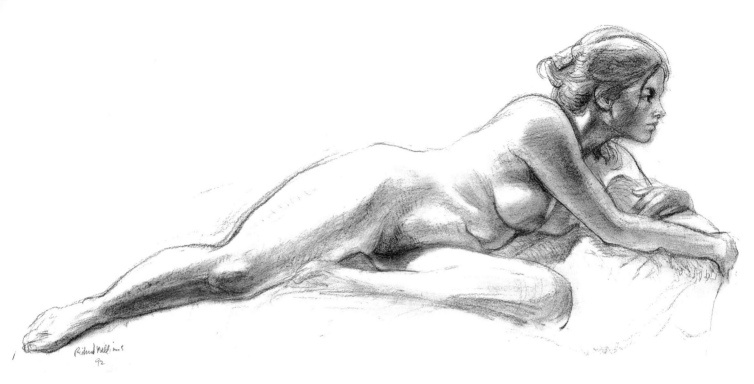

With life drawing there's no one to admire your efforts – rather the reverse. It's always shocking to find you're not as advanced or skilled as you thought you were, and since it's about the hardest thing to do with no rewards other than the thing itself – it's no wonder few do it or stick at it.

Most animators are exhausted at the end of a day's work and have families to go to. Also, one has to do a *lot* of life drawing to get anywhere – not just a bit at a time here and there.

But the fact remains that there is no replacement for the hard work of solid life drawing.

There is one payoff and it is substantial – the gradual and fundamental improvement of all one's work.

Winsor McCay once said: 'If I were starting over again, the first thing I'd do would be to make a thorough study of draftsmanship. I would learn perspective, then the human figure, both nude and clothed, and surround it with proper setting.'

And Milt Kahl said: 'I don't think it's possible to be a top notch animator without being an excellent draftsman. You have to try for the whole thing, you know, got to know the figure. Know the figure well enough so that you can concentrate on the particular person – on the *difference* – why this person is different from somebody else. The ability to draw and be able to turn things and the ability, the *knowledge* that enables you to caricature and to exaggerate in the right direction and emphasise the difference between things is what you're doing all the time. Any time you're doing a strong drawing of anything well, your drawing is strong because you're depicting why this is *different* from something else. You need that figure-drawing background in order to sharpen. Every animator should have this background and unfortunately they don't! You just can't know too much. If you're going to lampoon something, or do a satire – you have to understand the straight way. It gives you a jumping-off point. It gives you a contrast. You just do it and do it . . . and do it!'

24

Art Babbitt is blunter: 'If you can't draw – forget it. You're an actor without arms and legs.'

But we can *learn* to draw. There's the myth that you are either a born draftsman or not. Wrong! Obviously, natural talent is a great help and the *desire* is essential, but drawing can be taught and drawing can be learnt. Its best to have done a ton of it at art school to get the foundation in early. But it can be done at any time. Just do it.

Here are three pieces of drawing advice that were given to me – and which stuck.

When I was fifteen years old and really keen on being an animator, I took a five day-and-night bus trip from Toronto to Los Angeles, and walked up and down outside the Disney Studio fence for days hoping to get inside. Finally an advertising friend of my mother's saw my drawings and rang up the Disney PR department, and they took me into the Studio for two days; they were very kind to me and even did a press story on me.

It was there that I received my first piece of great advice. Richard Kelsey (Disney story artist and designer/illustrator) said, 'First of all, kid, learn to draw. You can always do the animation stuff later.'

I desperately wanted to become an animator and I produced my sketches of Disney characters, which were kind of at the Roger Rabbit level since I was a precocious little bastard. Dick Kelsey looked at them and said, 'Yes, but I mean *really* learn to draw.'

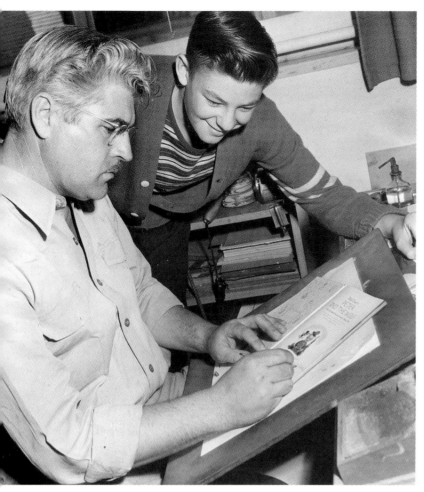

Richard Kelsey with eager beaver. Disney studios, 1948.

My commercial work, age 17.

Weeks later when I was getting on the bus to go home to Toronto, I rang Dick up and asked again, 'What do you think I should do?' – 'Learn to draw!' he said.

One great regret I have in my life is that forty years later, when I was animation director on *Who Framed Roger Rabbit*, I saw Dick in the Disney canteen out of the corner of my eye, but I was so caught up in the production politics I didn't break away to go over and thank him. I never had another chance.

After my trip I went straight to art school and received the second piece of advice, from a great teacher and superb draftsman, Eric Freifield, then teaching at the Ontario College of Art. He looked at my life drawings and said, 'Well, here's a clever little fellow who's never seen anything.' I said, 'What should I do?' He said, 'Go to the library and look at Albrecht Dürer for two years.' I did. And not surprisingly my interest in animation vanished for years.

I paid my way through art school by knocking off Disneyesque dog food ads like the one above – at the same time doing 'realismo social' like this lithograph of a revival meeting 'Where the healing waters flow'.

After that I lived in Spain for a couple of years doing paintings like these until a totally unexpected affliction by the animation bug got me. Forty years later a top executive on *Who Framed Roger Rabbit* kept referring to me as 'artsy craftsy' or 'artsy fartsy'. How did he ever know? He must have smelt it as there was no sign of it in my animation.

'WHERE THE HEALING WATERS FLOW'

Gilbert Williams '52

The third piece of drawing advice came many years later – I was fifty – when I was pretty accomplished, and it came from a much younger man. My talent is primarily 'linear', which makes cartooning easy. However, since animators have to enclose their shapes, there is a tendency to end up just drawing outlines – like colouring-book figures. In other words, animators don't usually draw from the inside-out, like a sculptor does. Sculpture had been my weakest subject – although I'd done a lot of life drawing and had a grounding in basic anatomy.

John Watkiss – then a twenty-three-year-old, self-taught, brilliant draftsman and anatomist – held his own life drawing classes in London. (Recently he was one of the principle designers of Disney's *Tarzan*.) I used to hire John periodically to do presentation artwork and we were friendly. I went to John's evening life classes for a while and one day John, who is ruthlessly honest, pointed to my drawing and said, 'Hey! You missed a stage!' I felt like a butterfly pinned to the wall. He was right. I knew exactly what he meant. I was weak from a sculptural point of view. I was too linear.

Years later, when I had dropped out of the 'industry' part of animation, I re-studied my anatomy and worked on drawing from the inside-out. I advanced backwards and filled in the missing stage.

I showed my ex-illustrator mother several of these life drawings when she was bed-bound just before she died. 'I've been working at reconstituting myself, Mom, doing all these drawings.' She looked at them carefully for some time, then said, 'Very nice, very nice . . . Nothing new.' Advice from the inside – from one's family – somehow doesn't have the same impact as from the outside. However my mother had once said, 'When you go to art school, you'll find everybody sitting around practising how to do their signature,' and sure enough, there they were, some of them doing just that.

She also gave me this great advice: 'Don't try to develop a style. Ignore style. Just concentrate on the drawing and style will just occur.'

Of course there's an opposing view to all of this 'you've got to learn to draw' stuff.

The great Tex Avery, master of animation's ability to do the impossible and make the unreal spring to life – and the first director of Bugs Bunny and Elmer Fudd – said:

'I was never too great an artist. I realised there at Lantz's that most of those fellows could draw rings around me . . . I thought, Brother! Why fight it? I'll never make it! Go the other route. And I'm glad I did. My goodness, I've enjoyed that a lot more than I would have enjoyed just animating scenes all my life.'

Tex stopped animating and became a great, original and innovative director. The biographer John Canemaker said: 'While Disney in the 1930s was trying to convince the audience of the "reality" of his characters in his film world, by creating his "illusion of life", Tex went in the opposite direction, celebrating the cartoon as cartoon, exploring the medium's potential for surrealism.' He never let audiences forget they were watching an animated film.

Tex had a twenty-year run with his wildly funny approach to the medium, but he found it impossible to sustain. 'I'm burned out,' he said. His colleague, animator Mike Lah said, 'He didn't have any more space. He used it up.'

I love Tex Avery's cartoons – his drawings and character designs. His Droopy is my favourite cartoon character. One of the nice things about doing *Who Framed Roger Rabbit* was to emulate Tex Avery's humour – 'But not so brutal!' were my instructions. Though, as Milt said, 'You have to try to have the whole thing.'

I am convinced that if an animator's drawing foundation is strong, he will have the versatility to go in all the different directions possible at his fingertips. He'll be able to draw anything – from the most difficult, realistic characters, to the most wild and wacky. And it's not likely he'll exhaust his resources and suffer burn-out.

Because of his strong drawing ability, Milt Kahl was usually saddled with animating 'the Prince' or Disney's 'straighter' characters – which of course are the hardest ones to do. Whenever anyone criticised his work, he'd say, 'OK, you can do the Prince.' And they'd soon vanish.

Word spread among the more 'cartoony' artists that, 'Milt draws beautifully but he can only do the straight stuff and he can't handle zany stuff at all.' Then, between features, Milt animated most of *Tiger Trouble*, a 'Goofy' short. Everybody shut up, and stayed shut up. His work is a classic of broad and crazy animation.

'If you can draw funny that's enough' is an animation myth that's been around a long time, and still seems to persist. This is because a few of the early animators lacked sophisticated drawing skills – but nevertheless were very inventive and excellent at getting the essence of the drama and performance.

The myth was that all they needed was to have a good draftsman as an assistant to do the final drawings and everything would be fine. But in the mid thirties, when the new wave of young animators with better drawing skills came on the scene and learned from the old guys, the ground was soon littered with out-of work animators who could only handle the cruder cartoons. The new breed of better draftsmen took their jobs away from them. If the present boom in this medium ever contracts it's certain that the more skilled artists will be the survivors.

Bill Tytla – famous for his animation of Stromboli in *Pinocchio*, the Devil in 'Night on Bald Mountain' from *Fantasia*, and *Dumbo* with his mother – once said: 'At times you will have to animate stuff where you can't just be cute and coy. Those are the times when you'll have to know something about drawing. Whether it's called form or force or vitality, you must get it into your work, for that will be what you feel, and drawing is your means of expressing it.'

Obviously all this doesn't apply so much to computer animators since the 'maquette' of the character is already planted inside the machine, ready to be manipulated. But since most of the leading computer animators draw rather well, many work out their positions in small sketches, and, of course, the planning, layout and story artists and designers draw exactly the same as their classical equivalents.

I had an unnerving experience in Canada when a friend asked me to give a one-hour address to a large high school gathering of computer animation students. They had a very impressive set-up of expensive computers but, from what I could see of their work, none of them seemed to have any idea of drawing at all. During my talk I stressed the importance of drawing and the great shortage of good draftsmen.

A laid-back greybeard professor interrupted to inform me, 'What do you mean? All of us here draw very well.'

Words failed me.

At the end of the talk, I showed them how to do a basic walk, and as a result got mobbed at the exit, the kids pleading desperately for me to teach them more. I escaped, but I'm afraid that's what the situation is out there – a lack of any formal training and no one to pass on the 'knowledge'.

You don't know what you don't know.

One of the problems rampant today is that, in the late 1960s, realistic drawing generally became considered unfashionable by the art world, and no one bothered to learn how to do it any more.

The Slade school in London used to be world-famous for turning out fine British draftsmen. A distinguished British painter who taught at the Slade asked me, 'How did you learn how to do animation?' I answered that I was lucky enough to have done a lot of life drawing at art school, so without realizing it I got the feeling for weight which is so vital to animation.

Then I said, 'What am I telling you for? You're teaching at the Slade and it's famous for its life drawing and excellent draftsmen.'

'If the students want to do *that*,' he said, 'then they've got to club together and hire themselves a model and do it in their own home.' At first I thought he was joking – but no! Life drawing as a subject went out years ago. It wasn't even on the curriculum!

I had a boyhood friend who became a bigwig in art education circles. He ran international conferences of the arts. About sixteen years ago he invited me to Amsterdam to a conference of the deans of the leading American art colleges. He knew me well enough to know I was bound to say controversial things, so I was invited as his wild card.

In my talk I found myself lamenting the lack of trained, talented artists and that I was hampered in my own studio's work because I couldn't find trained disciplined artists to hire. The applicants' portfolios were full of textures, abstract collages, scribbles, often nude photos of themselves and friends. No real drawing. I didn't realise how strongly I felt about this and as I talked I found myself nearly in tears.

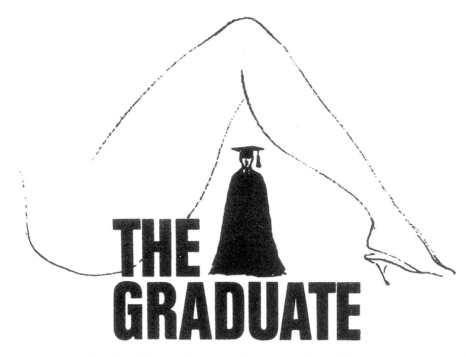

THE GRADUATE

My advertising campaign design for Mike Nichols' *The Graduate*. A foundation of life drawing was invaluable when I had to draw this simple leg for this movie logo.

I JUST CAN'T STRESS the IMPORTANCE OF LIFE DRAWING IN ANIMATION TOO MUCH....

I harangued the deans of the art schools for failing in their duty to provide proper skills to their students. Surprisingly, when I finished, the deans called an emergency meeting to which I was invited. 'Look Mr. Williams,' they said, 'you're right, but we have two problems. Number one: since classical drawing was rejected years ago, we have no trained teachers who can draw or teach conventional drawing as *they* never learned it themselves. And number two: our mostly rich students – on whom we count for our funding – don't *want* to learn to draw. They would rather decorate themselves as living works of art – and that's exactly what they do.'

So I said, 'Look, all I know is that I can't find people to hire or train; but otherwise I don't know what you can do.'
They said, 'Neither do we.'

Lately things have improved somewhat. So-called classical drawing seems to be coming back, but with a hyper-realistic photographic approach because skilled artists are thin on the ground. Shading isn't drawing, and it isn't realism.

Good drawing is not copying the *surface*. It has to do with understanding and expression. We don't want to learn to draw just to end up being imprisoned in showing off our knowledge of joints and muscles. We want to get the kind of reality that a camera *can't* get. We want to accentuate and suppress aspects of the model's character to make it more vivid. And we want to develop the co-ordination to be able to get our brains down into the end of our pencil.

Many cartoonists and animators say that the very reason they do cartoons is to get *away* from realism and the realistic world into the free realms of the imagination. They'll correctly point out that most cartoon animals don't look like animals – they're designs, mental constructs. Mickey ain't no mouse, Sylvester ain't no cat. They look more like circus clowns than animals. Frank Thomas always says: 'If you saw Lady and the Tramp walking down the road, there's no way that you are going to buy that they're real dogs.'

But to make these designs work, the *movements* have to be believable – which leads back to realism and real actions, which leads back to studying the human or animal figure to understand its structure and movement. What we want to achieve isn't realism, it's *believability*.

While Tex Avery released the animator from the more literal approach in order to do the impossible, he was only able to do it so successfully because his animation was mostly done by Disney drop-outs who already had 'the Disney knowledge' of articulation, weight, etc. So, ironically, his rebellion, his 'going the other route', had its basis in an underlying knowledge of realism.

But don't confuse a drawing with a map! We're animating *masses*, not lines .So we have to understand how mass works in reality. In order to depart from reality, our work has to be based *on* reality.

IT'S ALL IN THE TIMING AND THE SPACING

I met Grim Natwick (born Myron Nordveig) in a Hollywood basement when he was in his eighties. Grim was the oldest of the great animators, being already in his forties when he animated eighty-three scenes of Snow White in Disney's *Snow White and the Seven Dwarfs*. Previously, he'd designed Betty Boop for Max Fleischer, for which he received nothing and was furious about it 'til the day he died, aged 100.

I'll never forget the image of this big Norwegian American sitting in the golden twilight, extending his long arms and spatula hands saying . . .

The bouncing ball says it all.

The old bouncing-ball example is often used because it shows so many different aspects of animation.

A ball bounces along,

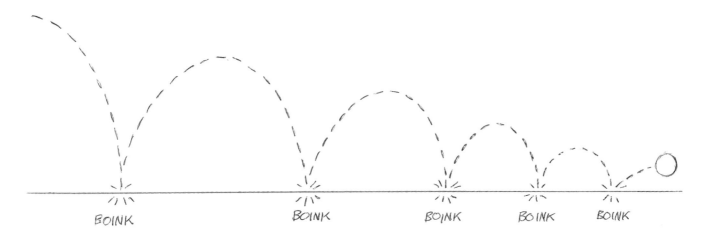

and where it hits – the 'boinks' – that's the *timing*. The impacts – where the ball is hitting the ground – that's the *timing* of the action, the rhythm of where things happen, where the 'accents' or 'beats' or 'hits' happen.

And here's the *spacing.*

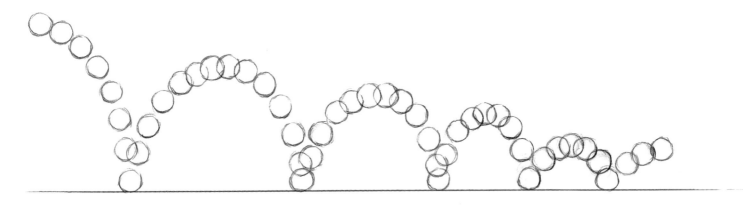

The ball overlaps itself when it's at the slow part of its arc, but when it drops fast, it's spaced further apart. That's the *spacing.* The spacing is how close or far apart those clusters are. That's it. It's simple, but it's important. The spacing is the tricky part. Good animation spacing is a rare commodity.

So we have:

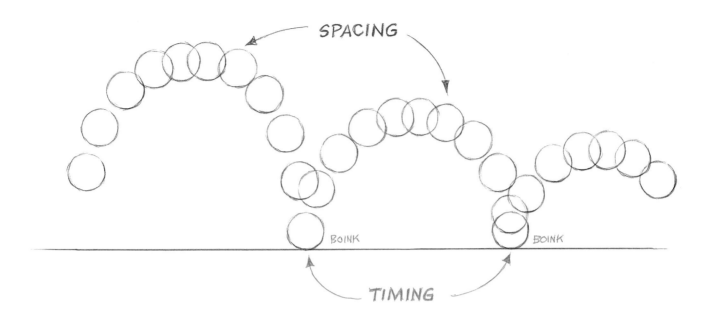

The two basic elements of animation.

To experience this, take a coin and film it in stages under a video camera.

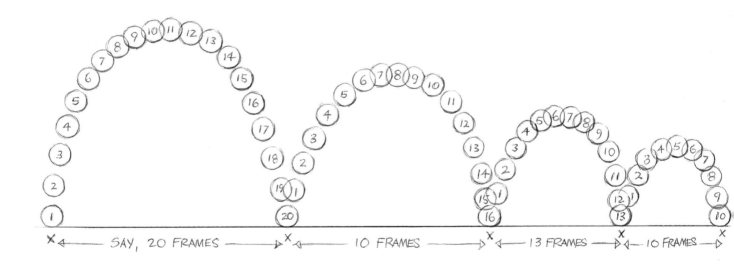

First plot out the *timing* – where you want the ball to hit the ground. Then push the coin around – taking a picture at each frame – and see what looks right or wrong. Try it with different timings and spacing. You're already animating. You're already dealing with the important fundamentals and you haven't even made a single drawing. You're doing pure animation without any drawings.

Hidden in this simple test is the weight of the ball – how it feels, light or heavy; what it's made of. Is it large or small, moving fast or slow? This will all emerge if you do several tests – which only take a few minutes to do. The importance of the timing and the spacing will become obvious.

Because *you* did it, a certain amount of personality will creep into the action – whether the ball is deliberate, slow, jaunty, erratic, cautious, even optimistic or pessimistic.

And all this, before you've made a single drawing. This reveals how important and dominant the timing and the spacing is. Even if the ball positions were drawn in detail by Michelangelo or Leonardo da Vinci, the timing and the spacing of the drawings will still dominate.

Another interesting way to experience the difference between timing and spacing right away is this:

Let's put a coin under the video camera and move it across the page (or screen) in one second – 24 frames of screen time. That's our *timing*.

We'll space it out evenly – and that's our *spacing*.

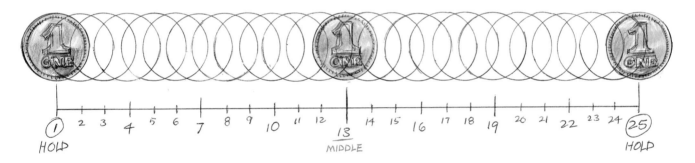

Now we'll keep the same *timing* – again taking one second for the coin to move across the page. But we'll change the *spacing* by slowly easing out of position number 1 and easing gradually into position number 25.

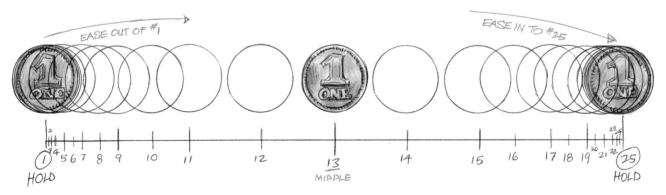

It still takes one second for the coin to get over there. It has the same timing – but there is very different movement because of the different spacing. Both start together – and both hit the middle together – but the spacing is quite different. And so the action is very different.

You could say that animation is the art of timing. But you could say that about all motion pictures.

The most brilliant masters of timing were the silent comedians: Charlie Chaplin, Buster Keaton, Laurel and Hardy.

Certainly for a film director, timing is the most important thing. For an animator, it's only half the battle. We need the spacing as well. We can have a natural feel for timing, but we have to learn the spacing of things.

One other thing: The bouncing ball example is often used to show animation 'squash and stretch' – that is, the ball elongates as it falls, flattens on impact with the ground and then returns to its normal shape in the slower part of its arc.

It *might* squash and stretch this way if it was a very soft ball with not much air in it, but what

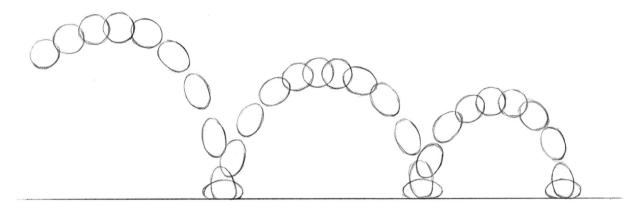

I've found is that you can get a good enough effect with a rigid coin – *provided* the spacing of it was right – so this added technique is not always necessary. Certainly a hard golf ball isn't going to bend all over the place. In other words, if you do this squishy squashy thing too much, everything comes out a bit 'sploopy', like it's made of rubber. Life ain't like that. At least most of it ain't. More about this later.

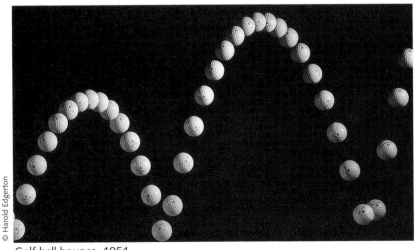

© Harold Edgerton

Golf ball bounce, 1951

Having established all this, let's go to lesson one:

39

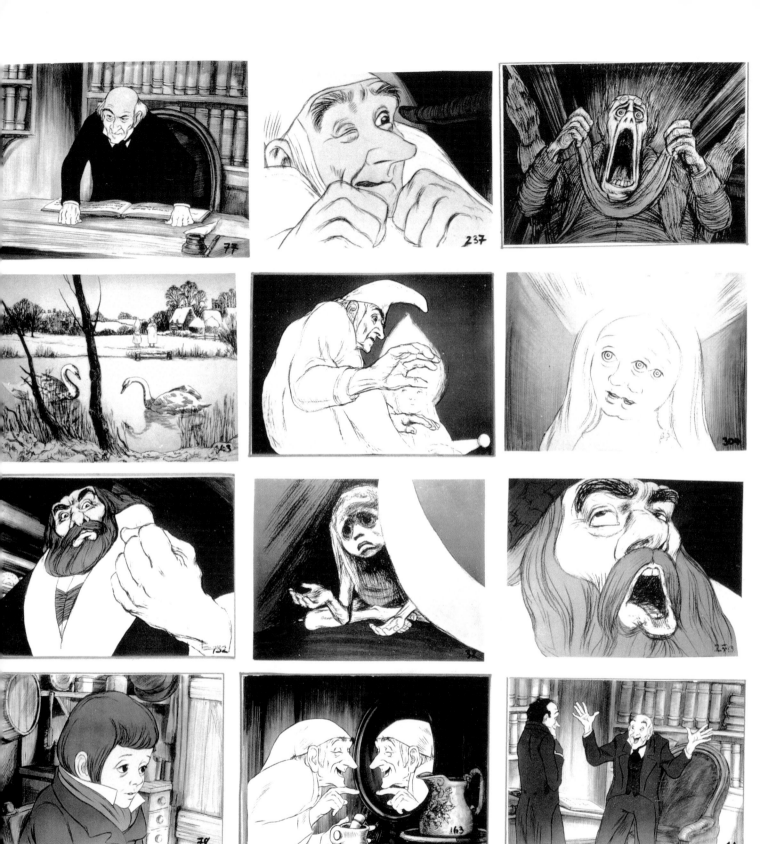

Stills from Charles Dickens' *A Christmas Carol*, 1972. We're starting to get better. I got my first Oscar for this half-hour film made originally for TV. You wouldn't think a lot of this was drawn by Bugs Bunny animators! It couldn't have been done without Ken Harris who carried the load on Scrooge. Towards the end, Chuck Jones (the Executive Producer) lent us Abe Levitow, a great unsung animator with majestic qualities. We also had help from Disney alumni George Nicholas and Hal Ambro. My own stalwarts were Richard Purdum, Sergio Simonetti and Roy Naisbitt.

40

LESSON ONE

UNPLUG!

Unplug! Take off your head phones! Turn off the radio! Switch off the CD! Turn off the tape! Close the door.

Like many artists, I had the habit of listening to classical music or jazz while working. On one of my first visits to Milt Kahl I innocently asked:

Since it came from a genius, this made quite an impression on me. After this I learnt to face the silence and think before swirling my pencil around. My animation improved right away.

This has been the case with many artists when I've passed this wisdom along. Recently, two previously sound-addicted computer animators were shocked to find that their plugged-in colleagues instantly made them objects of ridicule for not having wires coming out of their ears. They were even more surprised at the startling improvement in their work.

. . . end of lesson one.

Portrait of the artist after receiving lesson 1.

ADVANCING BACKWARDS TO 1940

Let's advance backwards to approach where animators were during the 'Golden Age'. And then go forward from there – so we can do new things.

The thing you are going to build on must be basic.

Everyone wants to decorate their house with interesting pieces before putting in the corner-stones and supports. Everyone wants to jump ahead to the sophisticated bit – glossing over the dull, old support work.

But it's the thorough understanding of the basics that produces real sophistication.

As Art Babbitt said:
'The knowledge that went into making little drawings come to life is in the early Disneys. Nobody taught us how to articulate these fanciful characters. We had to discover the mechanics ourselves and pass them around amongst each other. There are many styles but the mechanics of the old Disney animation remain.'

They had it all worked out by 1940, around the time that *Pinocchio* was released.

It was a wonderful system – precise and *simple*.

First we'll take it bit by bit – and then we'll put it all together.

A very interesting thing happened when we worked with Grim Natwick. He was so old that each day he tended to snap back into a different professional period of his life: one day he would come in and do circular 'rubber hose' animation from the 1920s, then the next day he would be in a 1936 'Snow White' phase, making tons of smoothly moving drawings, the next day would be sharp, physical actions with plenty of static holds from his 1950 UPA 'Mr Magoo' period, then he'd be doing as few drawings as possible, as if he were animating a 1960s TV ad, and then the next day back into fulsome *Fantasia* mode.

One day I found him drawing in an old style – something like this:

He wasn't just showing the arc of the action – he was indicating all the different spacings on his drawing.

I suddenly realised that this was probably the origin of the charts that animators put on the edge of their drawings

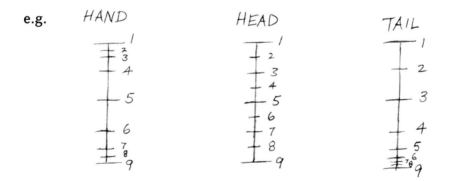

I asked, 'Hey, Grim – did these charts just gradually move across the page away from the drawings?

A far-away look came into his eyes – '. . . Yes . . .'

In the 1920s, animators did most of the work themselves. Dick Huemer was the top New York animator and was working for Max and Dave Fleischer on their *Mutt and Jeff* series. Dick told me they said to him, 'Your work is great, Dick, but we can't get enough of it.' So Dick said to them, 'Give me someone to put in the in-between drawings and I'll do two to three times as much work.' And that was the invention of the 'inbetweener'.

Dick later said in an interview that it had been the Fleischers' idea and that he just went along with it. But Dick actually told *me* that he had invented the inbetween and the inbetweener, the helper or assistant.

The main drawings or extreme positions came to be called *extremes* and the drawings in between the extremes were called the *inbetweens*.

The chart shows the spacing.
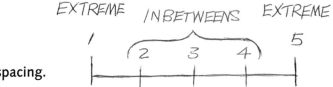

We'll put in three even inbetweens between the two extremes.

Number 3 is smack in the middle between 1 and 5. Then we put number 2 right in the middle between 1 and 3 – and number 4 in the middle between 3 and 5. We've got the inbetweens spaced evenly.

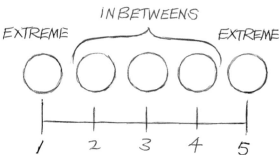

EXTREMES and BREAKDOWNS

Take the example of a swinging pendulum: The extremes are where there is a change in direction – the ends of the action where the direction changes.

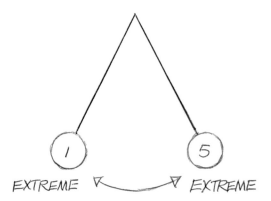

Because the pendulum's arm maintains its length as it swings, the middle position creates an arc in the action. We can see how important that middle position between the two extremes is going to be to us.

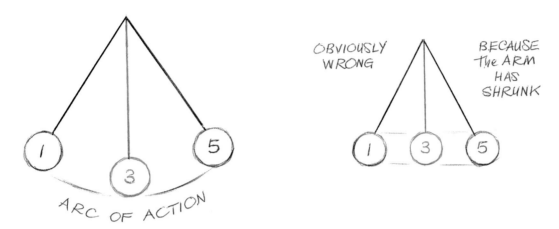

It's obvious how important this middle position is. In the 1930s they called this the 'breakdown' drawing or 'passing position' between two extremes.

We'll add two inbetweens.

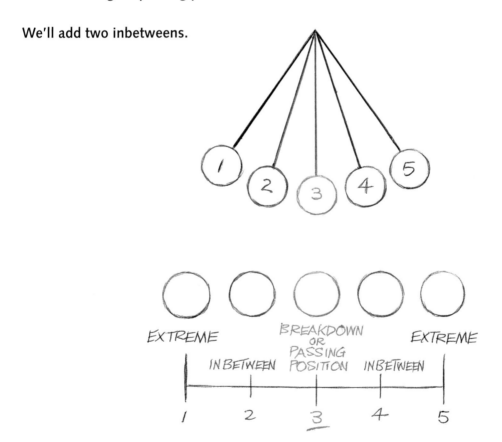

Some animators <u>underline</u> the breakdown or passing position because it's so important to the action. I have the habit of doing this because it's a position which is crucial to helping us invent. We're going to make tremendous use of this middle position later . . .

If we want to make our pendulum ease in and out of the extreme positions, we'll need a couple more inbetweens:

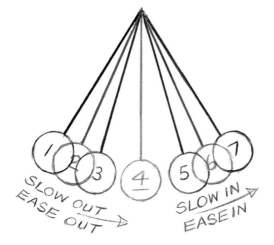

So our chart will look like this.

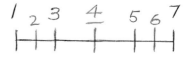

What we're doing is easing in or easing out of the extreme positions. 'Slowing in' or 'slowing out' is the classical terminology for it, but I prefer today's computer animators' term of 'easing in' and 'easing out'.

To make the action even slower at the ends, let's add a couple more inbetweens.

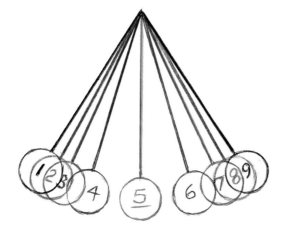

Now our chart will look like this.

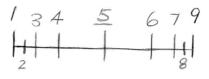

Ken Harris always called it 'cushioning' – which is a nice way to think of it.

Master animator Eric Larson – who became the instructor of the younger Disney animators – says that what animation has to have is a change of shape.

So, let's change from a closed hand to a pointing finger.

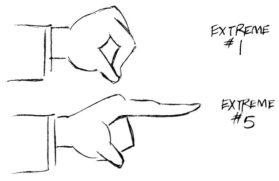

EXTREME #1

EXTREME #5

If we 'ease out' of number 1 in order to point – number 5 – the chart will be:

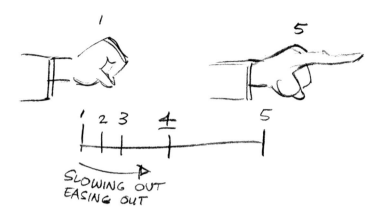

Alternatively, if we 'snap out' or 'speed out' of the closed hand and 'ease in' or 'cushion in' to the pointing finger the chart will be:

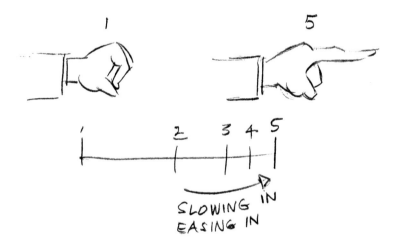

For a more relaxed, slower action we could add more inbetweens and ease out of the closed hand, and speed through the middle, and then ease in to the pointing finger.

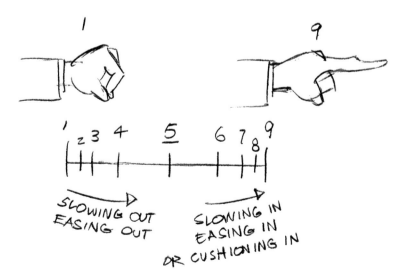

The animator can get away with just drawing the two extreme positions and making a chart for the assistant to put in all the inbetween positions.

I was spoilt by being taught by marvellous, hardworking, top Hollywood animators and I had a few shocks when I worked with some of the lesser mortals.

Here's how a Hollywood hack animator might duck the work:

A character enters screen left . . . and goes out screen right.

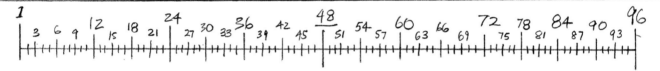

To walk across the screen it's going to take 4 seconds – 96 frames. So the animator does drawing number 1 and drawing number 96 and gives this chart to the assistant and goes off to play tennis. He wanders back in next day and blames the assistant for the terrible result.

This may seem far-fetched, but it does happen.

Moving on – we know the extremes and the breakdowns are crucial to the result, but the inbetweens are also very important.

The genie in the computer creates perfect inbetweens, but for 'drawing' people – getting good inbetweens can be a real problem.

Grim Natwick constantly intoned, 'Bad inbetweens will kill the finest animation.'

In 1934, when the novice Milt Kahl – having just started work at Disney – first met the great Bill Tytla, he told Tytla that he was working in the inbetweening department. Tytla barked, 'Oh yeah? And how many scenes have you screwed up lately?'

Like most people starting out, I did all my own inbetweens. Then I got my first 'official' job animating for UPA in London. They gave me an inexperienced assistant who drew well, but this is what happened:

We had a simple character of the period, a little girl called Aurora who was advertising Kia Ora orange drink. 'Where's the Kia Ora, Aurora?'

She looked like this.
I drew drawings 1 and 3 and 5, my assistant put in inbetweens 2 and 4.

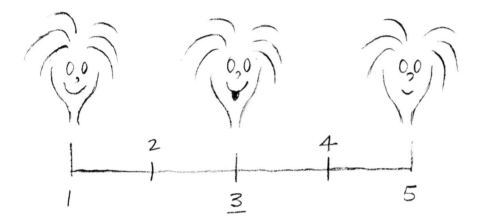

He had ambitions as a designer and he didn't like egg-shaped eyes like this:

He liked circular eyes like *this*:

So the inbetweens all went in like this:

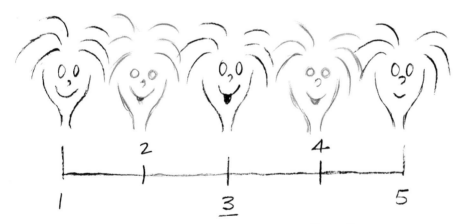

The result on the screen, of course, is this:

Wobble, wobble, wobble.

As is common in production when racing to meet the deadline, we end up hiring anybody off the street who can hold a pencil. And this is what happens:

Say a live actor is holding an animated coffee cup –

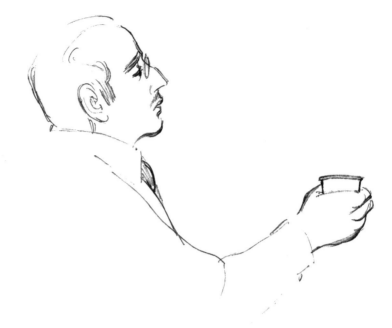

The inbetweener from the streets doesn't understand simple perspective – so the curved top of the cup gets put in *straight* on the inbetweens.

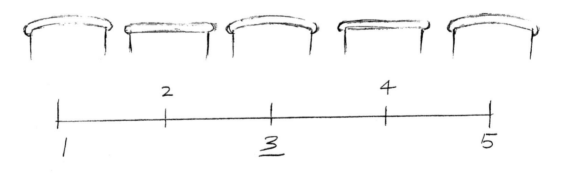

Result: 'Frying tonight.' Wobble, wobble, wobble.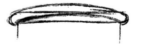

And if it's this wobbly with a simple thing, just imagine what it's going to be like when we are dealing with complex drawings. All the shapes will be doing St Vitus's dance. So the assistants' or inbetweener's job is really *volume control*.

A lot of assistants worry about the quality of their line – matching the animator's line quality. I always say never mind the line quality – just get the volumes right. Keeping the shapes and volumes consistent = volume control! When the thing is coloured in, it's the shapes that we see – it's the shapes that dominate.

Whenever we were under the gun and short of skilled helpers, we found if we outnumbered the dodgy inbetweens by three good drawings to two bad ones – we just scraped through with an acceptable result.

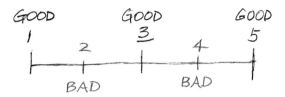

When we only had two good ones with three bad ones in between them – the bad ones out-numbered the good ones and the result was lousy.

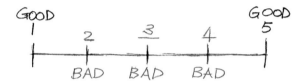

If the breakdown or passing position is wrong, all the inbetweens will be wrong too.

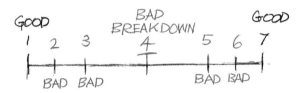

When we're not accurate, here's what happens: The animator supplies a chart and wants equal inbetweens. This is putting them in the right place.

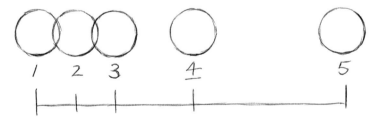

But let's say the assistant puts the breakdown or passing position slightly in the wrong place –

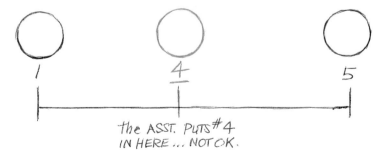

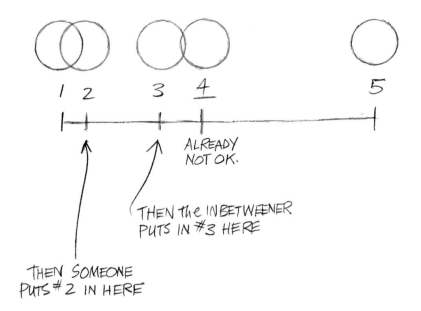

So: Number 4 is wrong.

 3 compounds it.

 2 compounds it more.

And instead of ending up with fluid actions like this –

– we'll get this all-over-the-place kind of thing.

One thing an animator should *never* do is to leave his assistant to make 'thirds'.

If we need to divide the chart into thirds –

– the animator should make one of the inbetween positions himself –

– in order to leave the assistant to put in the remaining position in the middle.

Leaving thirds to the assistant is cruel and is asking for trouble – but it's fair to make a chart like this, calling for an inbetween very close to an extreme:

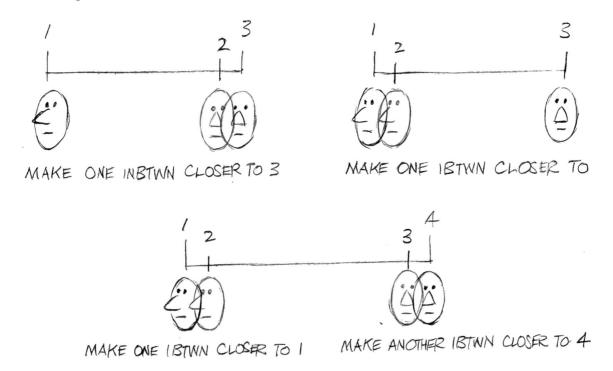

MAKE ONE INBTWN CLOSER TO 3

MAKE ONE IBTWN CLOSER TO

MAKE ONE IBTWN CLOSER TO 1

MAKE ANOTHER IBTWN CLOSER TO 4

KEYS

And now we come to the Great Circling Disease. For some reason, animators just *love* circles. We love to circle the numbers on our drawings. Maybe it's because, as old Grim Natwick said, 'Curves are beautiful to watch.' Or maybe it's just a creatively playful thing.

I once worked with a Polish animator who circled every single drawing he made!

'Is animation, man! Circle! Circle! Circle!'

You'll notice that so far I haven't circled *any* extreme positions. In this clear working system and method developed by the 1940s, the extremes are *not* circled, but the key drawing *is*. The drawings which *are* circled are the 'keys'.

Question: What is a key?

Answer: The storytelling drawing. The drawing or drawings that show what's happening in the shot.

If a sad man sees or hears something that makes him happy, we'd need just two positions to tell the story.

These are the keys and we circle them.

These are the drawings we make first. How we go interestingly from one to the other is what the rest of this book is about.

Take a more complex example:

Let's say a man walks over to a board, picks up a piece of chalk from the floor and writes something on the board.

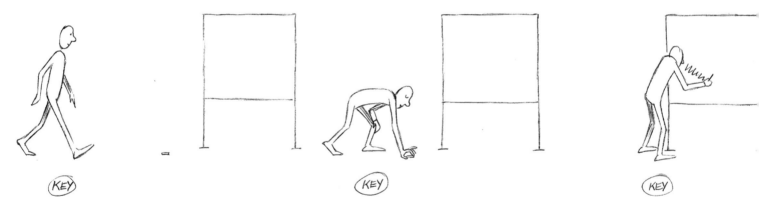

If it was a comic strip or if we wanted to show what's happening on a storyboard, we'd need only three positions. We'll keep it simple and use stick figures so we don't get lost in detail. These three positions become our keys and we circle them.

The keys tell the story. All the other drawings or positions we'll have to make next to bring the thing to life will be the extremes (not circled): the foot 'contacts', the passing positions or breakdowns and inbetweens.

58

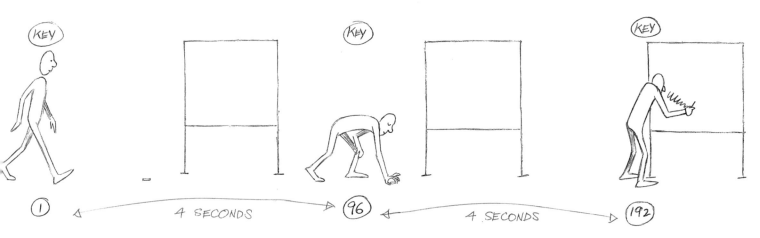

If we time this action out with a stopwatch, we might find that our first key position at the start will be drawing 1. Say it takes him 4 seconds to walk over and contact the chalk on the floor – we'd circle the second key drawing as 96. And when he's stood up, stepped over and written his stuff, it might take another 4 seconds – so our third key could be the last drawing in the shot – 192. The whole shot would then take 8 seconds.

Of course, we don't need to time it all out first, but before we dive into animatorland with all that stuff, we have to clearly set out with our keys what it is we're going to *do* – and we can test our three drawings on film, video or computer.

We haven't dealt with how he or she moves – whether the character is old or young, fat or thin, tall or short, worried or happy, beautiful or ugly, rich or poor, cautious or confident, scholarly or uneducated, quick or slow, repressed or uninhibited, limping or fit, calm or desperate, lazy or energetic, decrepit or shaking with the palsy, drunk or frightened, or whether it's a cold-hearted villain or a sympathetic person – in other words all the 'acting' stuff, plus all the trimmings – clothes, facial expressions etc.

But what we *have* done is made it very plain what *happens* in the shot before we start.

If we were to make a diagrammatic chart of the whole scene, it would end up looking something like this:

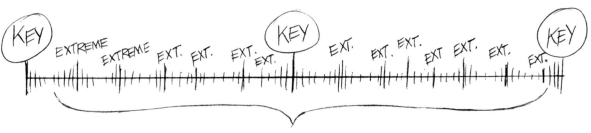

PLUS BREAKDOWNS AND INBETWEENS

Important animators are called key animators, and word got round that they just draw the keys – anything that they draw is a key – and slaves fill in the rest according to the little charts provided by the key animators. Wrong. A key animator is simply like a key executive – an important one.

Many good animators call all their extremes 'keys' – I sure used to. But it makes life so much clearer and easier if you separate the keys from the extremes. Actually, I never heard Ken Harris ever call a drawing a key, but he would say, 'Draw *that* one first. *That's* an important drawing.' And it was a key, really.

I've worked every system, good, bad or half-baked, and experience has convinced me that it's best – even crucial – to separate the storytelling keys from the extremes and all the other stuff. (Of course, as in our example above, the three keys will also function as extremes.) Separating them out stops us getting tangled up and missing the point of the shot, as we vanish into a myriad of drawings and positions.

There may be many keys in a scene – or maybe just one or two – it depends on what it is and the length of the scene. Its whatever it takes to put it over, to read what's to occur.

You can spend time on these keys.

I remember once visiting Frank Thomas and he was drawing a cat. 'Dammit,' he said. 'I've been working all day on this damn drawing – trying to get this expression right.'

I was shocked. All day! Wow! That was the first time I ever saw anyone working so hard on a single drawing. How was he ever going to get the scene done? Finally, the penny dropped. 'Of course, stupid, its his *key*!' It's the most important thing in the scene! He's got to get *that* right!

And it was encouraging to see anyone that great struggling to get it right!

3 WAYS TO ANIMATE

1. The natural way, called 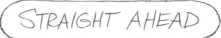 STRAIGHT AHEAD

We just start drawing and see what happens – like a kid drawing in the page corners of a schoolbook – stick the numbers on afterwards.

Disney director–animator Woolie Reitherman said, 'When I didn't know what I was doing in an action, I always went straight ahead. I'd just start on ones. Half the time I didn't know what I was doing. To me, it's fun. You find out something you wouldn't have found out otherwise.'

ADVANTAGES

— WE GET A NATURAL FLOW OF FLUID, SPONTANEOUS ACTION.

— IT HAS the VITALITY OF IMPROVISATION.

— IT'S VERY 'CREATIVE' – WE GO WITH The FLOW – TAKING ALL OF The ACTION AS IT COMES ALONG.

— OFTEN the UNCONSCIOUS MIND STARTS TO KICK IN: LIKE AUTHORS SAYING THEIR CHARACTER TELLS THEM WHAT'S GOING TO HAPPEN.

— IT CAN PRODUCE SURPRISES – 'MAGIC'.

— IT'S FUN.

DISADVANTAGES

— THINGS START TO WANDER.

— TIME STRETCHES and the SHOT GETS LONGER and LONGER.

— CHARACTERS GROW and SHRINK.

— WE CAN TEND TO MISS the POINT OF The SHOT and NOT ARRIVE AT the RIGHT PLACE AT the RIGHT TIME.

— The DIRECTOR HATES US BECAUSE HE/SHE CAN'T SEE WHAT'S HAPPENING.

— IT'S LOTS OF WORK TO CLEAN UP the MESS AFTERWARDS – and IT'S HARD TO ASSIST.

— IT'S EXPENSIVE – The PRODUCER HATES US.

— IT CAN BE HARD ON the NERVES – MAD ARTIST and NERVOUS BREAK-DOWN TIME AS WE CREATIVELY LEAP IN and THRASH AROUND IN the VOID – ESPECIALLY WITH LOOMING DEADLINES.

2. The planned way, called 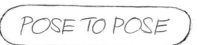 POSE TO POSE

First we decide what are the most important drawings – the storytelling drawings, the keys – and put them in. Then we decide what are the next most important positions that have to be in the scene. These are the extremes and we put them in – and any other important poses. Then we work out how to go from one pose to another – finding the nicest transition between two poses. These are the breakdown or passing positions. Then we can clinically make clear charts to cushion and ease in and out of the positions and add any finishing touches or indications for the assistant.

To illustrate how effective the pose to pose method is, the brilliant Disney art director–designer Ken Anderson told me that when he was making layout drawings of characters for animators working on *Snow White and the Seven Dwarfs*, he drew lots and lots of key poses of Grumpy for each shot. Ken's drawings were then given to one of the Grumpy animators. Ken found out later that the guy just put charts on the drawings, handed them to his assistants and went off to lunch, and took the credit, for what in effect, was Ken's fine animation.

ADVANTAGES

— WE GET CLARITY,
— The POINT OF The SCENE IS NICE and CLEAR.
— IT'S STRUCTURED, CALCULATED, LOGICAL.
— WE CAN GET NICE DRAWINGS and CLEARLY READABLE POSITIONS.
— ITS IN ORDER – The RIGHT THINGS HAPPEN AT The RIGHT TIME and IN the RIGHT PLACE IN The OVERALL TIME ALLOTTED.
— The DIRECTOR LOVES US.
— IT'S EASY TO ASSIST.
— ITS A QUICK WAY TO WORK and FREES US UP TO DO MORE SCENES.
— The PRODUCER LOVES US.
— WE KEEP SANE, OUR HAIR ISN'T STANDING ON END.
— WE EARN MORE MONEY AS WE ARE SEEN TO BE RESPONSIBLE PEOPLE and CLEARLY NOT MAD ARTISTS.

PRODUCERS HAVE TO DELIVER ON TIME and ON BUDGET, SO BRILLIANCE IS NOT REWARDED AS MUCH AS RELIABILITY. I SPEAK FROM EXPERIENCE WORKING BOTH SIDES OF the FENCE. THEY DON'T PAY US FOR 'MAGIC'. THEY PAY US FOR DELIVERY.

DISADVANTAGES

— BUT – AND IT'S A BIG BUT: WE MISS the FLOW.
— The ACTION CAN BE A BIT CHOPPY A BIT UNNATURAL.
— AND IF WE CORRECT THAT BY ADDING A LOT OF OVERLAPPING ACTION TO IT – IT CAN GO EASILY The OTHER WAY and BE RUBBERY and SQUISHY – EQUALLY UNNATURAL.
— IT CAN BE TOO LITERAL – A BIT COLD-BLOODED. NO SURPRISES.
— WHERE'S the MAGIC?

So it's pretty obvious the best way to work is going to be:

3. (The COMBINATION OF STRAIGHT AHEAD and POSE TO POSE)

First we plan out what we're going to do in small thumbnail sketches. (It's also a good idea to have done this with the other two methods.)

Then we make the big drawings – the storytelling drawings, the keys. Then we put in any other important drawings that *have* to be there, like anticipations or where hands or feet contact things – the extremes. Now we have the structure, just as we had with the pose-to-pose system.

But now we use these keys and important extremes as *guides* for things and places we want to aim at. After you get your overall thing – go again. *Do one thing at a time.* We'll work straight ahead on top of these guideposts, improvising freely as we go along.

We'll do *several* straight ahead runs on different parts – taking the most important thing first. We may have to change and revise parts of the keys and extremes as we go along, rubbing bits off and re-drawing or replacing them.

So: we make a straight ahead run on the primary thing.

Then take a secondary thing and do a straight ahead run on that.

Then take the third thing and work straight ahead on that.

Then the fourth thing, etc.

Then add the hair or tail or drapery or flapping bits at the end.

ADVANTAGES	DISADVANTAGES
— WORKING THIS WAY COMBINES the STRUCTURED PLANNING OF WORKING FROM POSE TO POSE WITH The NATURAL FREE FLOW OF The STRAIGHT AHEAD APPROACH.	— NONE THAT I KNOW OF...
— ITS A BALANCE BETWEEN PLANNING and SPONTANEITY.	
— ITS A BALANCE BETWEEN COLD BLOODEDNESS and PASSION.	

Let's take our man going over to the blackboard again.

What do I do first?

Answer: The keys – the storytelling drawings or positions that *have* to be there to show what's happening. Put it where you can see it . . . so it *reads*.

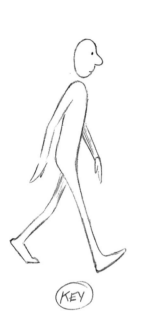

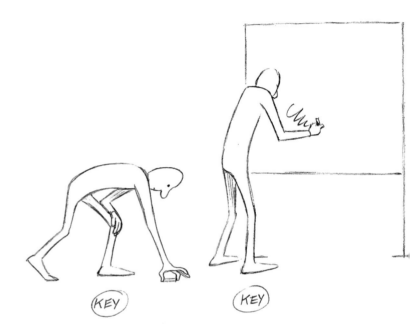

What do we do next?

Answer: Any other drawings that *have* to be in the shot. Obviously, he has to take steps to get over to the chalk – so we make the 'contact' positions on the steps where the feet are just touching the ground.

There's no weight on them yet – the heel is just contacting the ground. As with the fingers just contacting the chalk – they haven't closed on the chalk yet.

If we act all this out, we might find he takes five steps to get to the chalk and bend down. I notice that when I act it out, I automatically pull up my left pant leg as I bend down, then I put my hand on my knee before my other hand contacts the chalk. I would make an extreme where the hand just contacts the pant leg – before it pulls up the pants.

These will be our extremes. We're working rough, sketching things in lightly – although we probably have made rather good drawings of the keys. (I haven't here, because I'm trying to keep it simple, for clarity).

64

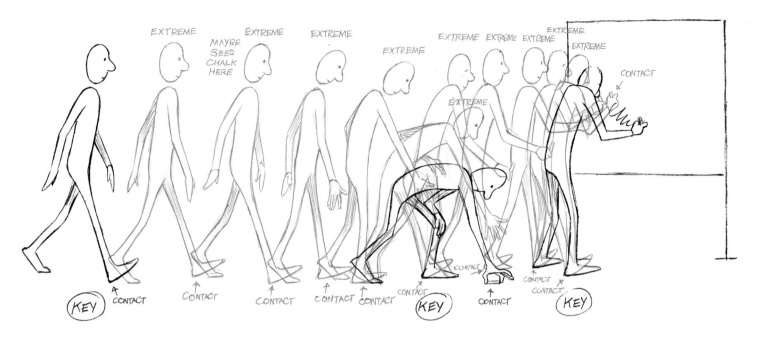

We could act it out, timing the steps and putting numbers on the extremes or we could leave the numbering till later. I would probably put numbers on it now and test it on the video to see how the timing feels as his steps get shorter – and make any adjustments.

What next?

We'll break it down, lightly sketching in our passing positions or 'breakdowns'. We won't get fancy about it now – the fancy stuff comes later in the book. For now, we'll just make the head and body raise up slightly on the passing positions of the steps – like it does on a normal walk.

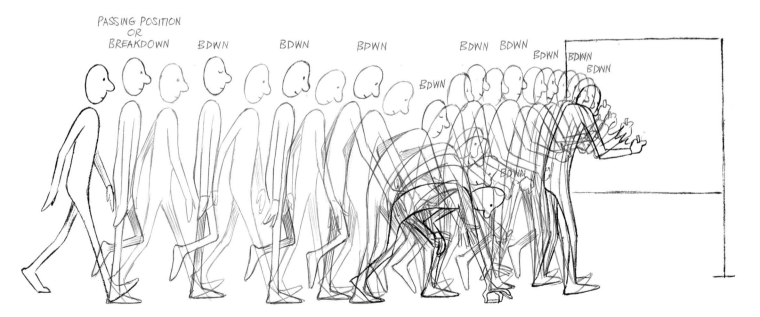

We'd probably have numbers on the drawings by now, and when we test it, we've got three or four positions for every second – so it's easy to see what our timing is. And to make any adjustments. And if the director wants to see how we're doing – it looks almost animated.

Now we'll make straight ahead runs on the different parts – using our extremes and breakdown positions as a guide – and altering them, or parts of them, if we need to as we go along. Take one thing at a time and animate it straight ahead.

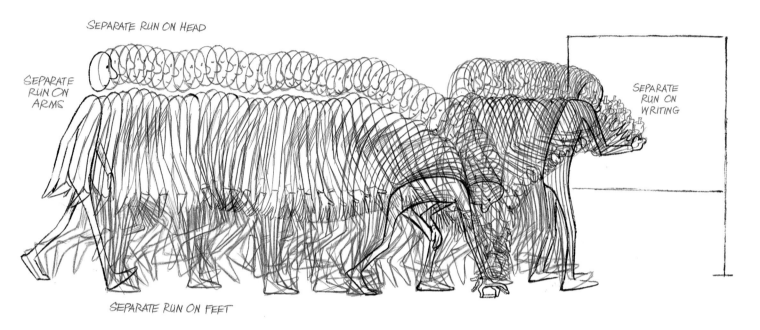

SEPARATE RUN ON HEAD

SEPARATE RUN ON ARMS

SEPARATE RUN ON WRITING

SEPARATE RUN ON FEET

Maybe he's mumbling to himself, or maybe he's talking – maybe his head just wobbles around with self love. Whatever it is, we'll treat it as a separate straight-ahead run, working on top of what we already have.

We'll make another straight-ahead run on the arms and hands. Maybe they'll swing freely in a figure eight or a pendulum movement; or maybe they hardly move before he reaches for the chalk. Maybe he pulls up his pants as he moves along – or scratches or snaps his fingers nervously, or cracks his knuckles. When we arrive at our key, we might rub out the arm and alter it to suit our arm action. Or delay his head. Or raise it early to look at the board.

We can do lots of interesting things with the legs and feet, but for now we just want them to function smoothly. (I'm avoiding the problem of weight at this stage because the up and down on the head and body that we have at the moment will be adequate for now, and the figure won't just float along.)

When he writes on the board, we'll treat that as a separate run. If he has long hair or a pony tail, we'll do that as a separate straight-ahead run. His clothes could be a separate run, baggy pant legs following along. If he'd grown a tail, that would be the last thing we'd put on.

66

I've shown these things in different colours to be as clear as possible. In my own work I sometimes use different coloured pencils for the separate runs – then pull it all together in black at the end. I was delighted to find that the great Bill Tytla often used colours for the separate bits, then pulled them all together afterwards.

To recap:
Having made the keys, put in the extremes, then put in the breakdowns or passing positions. Now that we've got our main thing – we go again, taking one thing at a time.

First, the most important thing.

Then, the secondary thing.

Then, the third thing.

Then, the fourth thing etc.

Then, add any flapping bits, drapery, hair, fat, breasts, tails etc.

The general principle is:
After you've got your first overall thing – go again. Do one thing at a time (testing as you go along). Then pull it all together and polish it up. Make clear charts for the assistant to follow up or do it all yourself.

It's like this:

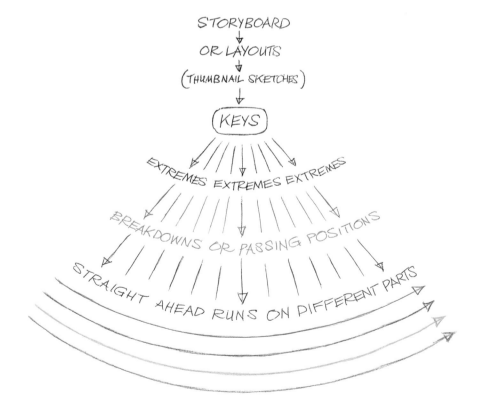

Of course, you can work any way you want. There are no rules – only methods. You might feel like ignoring all of this and just work straight ahead or work from pose-to-pose, or start one way and switch to the other – why not?

What's to stop us re-inventing the wheel? Lots of people are busy doing it. But on the other hand, why bother?

This method of going at it was developed through concentrated trial and error by geniuses and it's a wonderful basis on which to operate. Having used just about every approach going – including no system – I've found this is the best working method by far. Get it in your blood-stream and it frees you to express yourself. Use this technique to get past the technique!

Milt Kahl worked this way. Near the end of his life I told him, 'Now that I've been working the same way, I really do think that – apart from your talent, brain and skill – fifty per cent of the excellence in your work comes from your working method: the *way* you think about it, and the *way* you go about it.'

'Well . . .' he said thoughtfully, 'you're right. Hey, you've gotten smart!' Milt often told me that by the time he'd plotted everything out this way, he'd pretty much animated the scene – even including the lip sync. Then he'd finish putting numbers on the drawings, add bits and make little clinical charts for the assistant – easing things in and out. He complained he never really got to animate because when he'd finished plotting out all the important stuff – it *was* animated. He'd already done it.

I rest my case.

TESTING, TESTING, TESTING...

I always use the video to test my stuff at each stage – even the first scribbles – time them and test them. In the 1970s and 80s, Art Babbitt used to get mad at me for it – 'Goddamit, you're using that video as a crutch!' 'Yes,' I'd say, 'but is it not true that Disney first instituted pencil tests and that's what changed and developed animation? And don't you always say that pencil tests are our rehearsals?'

Assenting grunt.

'And what's the difference between rushing a test in to the cameraman at the end of the day when he's trying to get home, and if he does stay to shoot it, hang around the next day till the lab delivers the print and mid-morning interrupt the editor, who's busy cutting in the main shots, and then finally see your test – when we can use today's video and get a test in ten minutes?'

Art would turn away, 'I am not a Luddite.' (Machine wreckers protesting the Industrial Revolution.)

Whenever Ken Harris had to animate a walk, he would sketch out a quick walk cycle test and we'd shoot it, pop the negative in a bucket of developer, pull out the wet negative (black film with white lines on it), make a loop and run it on the moviola.

'I've done hundreds of walks,' Ken would say, 'all kinds of walks, but I still want to get a test of my basic thing before I start to build on it.'

Bill Tytla said, 'If you do a piece of animation and run over it enough times, you must see what's wrong with it.'

I actually think the video and computer have saved animation!

Certainly the success of *Who Framed Roger Rabbit* contributed substantially to the renaissance of animation, and having the video to test everything as we went along was crucial to us. We had a lot of talented but inexperienced young people, and with a handful of lead animators we were able to say, 'Take that drawing out, change that one, and put more drawings in here' etc. This enabled us to keep improving everything as we raced along, so we were able to collectively hit the target.

Milt always said he would never bother to look at his tests. 'Hell, I know what it looks like – I *did* it!' He would wait to see several of his shots cut together in a sequence but only to see 'how it's getting over'.

But that was his way. I have never reached that stage and probably never will. I test everything as I go along and it really helps. We're building these performances, so why not test our foundations and structure and decorations as we proceed? And since it reveals our mistakes – mistakes are very important since we *do* learn from our mistakes – we make our corrections and improvements as we build.

Of course, at this stage I wouldn't have a problem routining my way through a job without testing – but why?

The video or computer is there, so let's use it.

An interesting thing I've noticed is that when animators get older their perception of time slows up. They move slower and animate things slower. The young guys zip stuff around. So, the video is a useful corrective to us old bastards. And young ones when it's *too* fast.

Before we dive into walks and all the articulation stuff, there are some other important camera techniques we should know about.

the X-SHEET

On the next page is a 'classic' exposure sheet called the X-sheet or dope sheet – the first sight of which is guaranteed to put any beginner or artist off the whole business. When I was a kid and first saw one of these I thought, 'Oh no, I don't want to be an animator anymore. I'll just make the designs for other people to move around.'

Actually, it's awfully simple when you make friends with it.

It's just a simple and efficient form where animators write down the action and dialogue (or music beats) for a scene or shot – plus the information for shooting.

Each horizontal line represents a frame of film.

ONE FRAME

The columns 1 to 5 show five cel levels of animation we can use if we need them. (Usually you need just one or two.)

ACTION	DIAL	5	4	3	2	1	B G	CAMERA

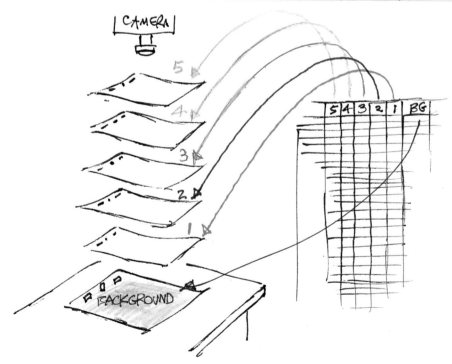

The ACTION column is for us to plan out our timing – how long we want things to take.

The DIAL column is for the measurement of the pre-recorded dialogue and sometimes the breakdown of music into beats etc.

This 'classic' X-sheet is designed to hold 4 seconds of action (1 second = 24 frames).

It has darker lines to show the footage, which is 6 feet of film (1 foot = 16 frames). Many animators always number the footage going down the page.

I've also written in the camera dial numbers – the frame numbers in the camera column.

Some animators time things out by thinking in seconds. Others think in feet = 2/3 of a second.

Ken Harris thought in feet and would tap the end of his pencil every foot. I think in both seconds and feet, but seconds is easier for me.

Also, you can think in 1/2 seconds = 12 frames to a half second. That's march time, which is quite easy.

(Computer animators please bear with me here – you obviously have your own systems of timing.)

| SEQUENCE | SCENE | | | OUR DRAWINGS | | | | CAMERA DIAL NUMBERS | SHE |
| ACTION | DIAL | 5 | 4 | 3 | 2 | 1 | BG | CAMERA INSTRUCTIONS | |

Vertical text down the DIAL column: W E U S E T H I S C O L U M N F O R T H E D I A L O G U E A N D / O R M U S I C

Timing markers on left edge: 1 SEC., ① FOOT, 2 SEC., ② FEET, 3 SEC., ③ FEET, ④ FEET, 4 SEC., ⑤ FEET, ⑥ FEET

BG column: B, A, C, K, G, R, O, U, N, D

Camera dial numbers: 1, 2, 3, 4, 5, 6, 7, 8, 9, 10, 11, 12, 13, ETC ... continuing 1 through 96

Camera instructions:
2 THE CAMERAMAN
3 FOLLOWS WHAT
4 WE'VE INDICATED
5 AND
6 IN THIS COLUMN
7 WE PUT ANY
8 CAMERA MOVES
9
10 LIKE TRUCK-INS
11 OR
12 ZOOMS IN OR OUT

66 OR PANS
67
71 EAST
75
77 OR WEST
82 OR CAMERA
84 SHAKES ETC.
89 NORTH
91 SOUTH
93 EAST
95 WEST ETC.

We'll plan out the action using the action column.

Ken Harris always said, 'Come on, now, you can have fun doing the drawings later, but do the important part first – time it all out.'

So we'd use a metronome or a stopwatch and I'd act it out several times, and we'd mark down on the sheet where things would happen.

Let's take our man walking over to pick up the chalk:

We've got him taking five steps to reach the chalk.

When I act it out, the first two steps are leisurely – 16 frames long (2/3 of a second).

Then during step 3 he sees the chalk, and this step is slightly quicker – 14 frames.

His fourth step is quickest – 12 frames.

On step 5 he slows up slightly – 14 frames and he's already started bending down, which takes over 2 feet till his hand contacts the chalk.

I've got him tucking up his pant leg above the knee as he goes down – which takes 8 or 10 frames.

Of course, we can change all this as we work, but this becomes our guide and the points to aim for as we go along.

Now we can put the numbers of these drawings on the page as I've done here.

Incidentally, although numbers 1 and 96 are keys and we've circled them, we don't circle the numbers on the X-sheet.

72

The five available 'cel' levels on this X-sheet are there so we can treat each character or element separately.

Why have different levels – why not draw everything on one level?

Answer: You can, but what do you do if you want to change the timing on one or two parts of the action and leave the other bits as they are? However, it's a good idea to try to keep to just one or two levels for simplicity.

If we wish to use all five levels, start with the main action on level 1. Say a man walks in from one side of the screen and a cat walks in from the other. We animate our main action man on level 1, and the cat on level 2, adding a 'C' after the cat numbers: 1-C, 2-C, 3-C etc., so as not to confuse it with the man drawing. The man drawings, or main action, don't need an identifying letter.

If a woman passes in front of them, we'd put her on level 3, adding a 'W' behind her numbers.
 If a truck was to stop in front of them, we'd use level 4 for the truck and add a 'T' to the truck drawings.
 If it's raining, we'd put the rain drawings on level 5, adding an 'R' after the numbers.

The X-sheet would look something like this:

		RAIN	TRUCK	WOMAN	CAT	MAN		
ACTION	**DIAL**	**5**	**4**	**3**	**2**	**1**	**B G**	**CAMERA INSTRUCTIONS**
		1-R	1-T	1-W	1-C	1	BG# 1	1
		2	2	2	2	2		2
		3	3	3	3	3		3
		4	4	4	4	4		4
		5	5	5	5	5		5
TRUCK ×		6	6-T	6	6	6		6
STOPS		7		7	7	7		7
		8		8	8	8		8
		etc	etc	etc	etc	etc		9

This system obviously enables the cameraman to stack his levels correctly – working from the bottom up – and take a frame of film with all the numbers across matching the dial number on his camera.
 But there is one very important thing here:

 Keep It Simple, Stupid!

Use simple numerical sequences! Animation is complicated enough without making it any worse.

My years in England taught me that the English just love complexity. A very brilliant friend, who is a top Oxford mathematician, called me up and said, 'We're about to penetrate your principality.' I said, 'You mean you're coming to visit?' 'Indeed.' 'Wow,' I said. 'You just used nine syllables to say what a North American would say in two! Vi-sit!'

We sure used to pen-e-trate-our-prin-ci-pal-it-y with our exposure sheets until Ken Harris joined the team.

They looked something like this:

CAR WINDSHIELD OVERLAY		BABY YAK	YAK RUNNING	TRUCK AND ZEBRA				
ACTION	DIAL	5	4	3	2	1	B G	CAMERA INSTRUCT
			WOL-1	BY-1	Y2B-1	TxB-1	BG-1A	1
					Y2B-2	TxB-1A		2
					Y2B-2½	TxB-2		3
				BY-2	Y2B-3			4
						TxB-2½		5
					Y2B-4	TxB-2¾		6
				BY-3	Y2B-4A			7
					Y2B-4B	TxB-3		8
					Y2B-4C	TxB-3A		9

Can you imagine trying to make any changes or improvements when you're weighed down with numbers like this? It would be like re-numbering the *Encyclopaedia Britannica*.

Not only were our numbers complicated, but our action went from two frames to three frames then to four frames, bumping along then back to two frames etc., giving a jerky stop-start result to the movements.

When we had just one level of action – say it's a tiger – everyone would call the drawings T1-1 and T1-2 and T1-3 etc. One day I asked, 'Why are we doing this?' The answer from the head of the department came, 'So we know it's a tiger.' 'But we can *see* it's a tiger! Why not number it simply 1 and 2 and 3?' Answer: 'That will just confuse the painting department.'

And it's not just the English who can overcomplicate! I once saw the working sheets of an established American animator who's written two books on the subject, and his numbers looked like this:

All smudged and rubbed out and re-entered . . .

30A	104
BX-31x	104⅛
BLANK	104¼
384	104½
BLANK	104¾
10	104⅞
11	X-1
11-B	X-1A

And then the first real live master animator arrived to work with us. On his first day Ken Harris lightly pencilled in simple numbers going down the page on 'twos', that is, two exposures per drawing. That was the first time I ever saw anyone go down the page on twos!

Ken usually planned his action on twos: twelve drawings per second, shooting each drawing for two exposures, instead of working on 'ones', one exposure for each drawing, which is twenty-four drawings per second – twice the amount of work.

Ken was from Warner Bros – used to tight budgets; the animators had to produce an average of 30 feet (20 seconds) a week or be fired.

Since most normal actions work well on twos, Warner animators tried to avoid putting actions on ones.

When he needed to go onto ones for fast actions (runs etc.), he'd just number it in on ones. i.e.

Then he'd go back on to twos

'Ok, Ken, but what do you do when you've worked it out on twos, but you find you want to add in ones to smooth it out more?'

Answer: Add 'A' drawings.

Great, so now all this TXL-1 and PP-2 3/4 stuff goes out the window. We're not weighed down with meaningless technology. It becomes simpler to work and easy to make changes and improvements and we start getting better.

But there is an even better and simpler system!

Milt Kahl called it his system, but I suspect that the good guys at Disney all discovered it around the same time – it's so logical.

Just use the camera dial numbers for the drawings. Go down the page on twos but use odd numbers.

Then if we do need to smooth something out or we need very fast action, we just add in the ones.

Milt told me, 'Whenever I see my drawings with odd numbers on them, I know I'm on twos and when I see even numbers, I know I'm on ones.'

I asked, 'What do you do when you want to get into a hold – just indicate you're holding that drawing with a line? And when you come back in do you start again on the dial number?'

Answer: 'Yes. Come back in on the dial number.'

Not only does this make it easy for shooting, but it's easier when you *do* need several levels of action. We've now got the same dial numbers horizontally across the frame of film.

5	4	3	2	1	
1 -E	1 D	1 - C	1 - B	1	1
			2		2
3	3		3	3	3
		4 - C	4		4
5	5		5	5	5
			6		6
7	7	7 - C	7	7	7
			8		8

CAMERA DIAL NUMBERS

So, just go down the page with odd numbers – on twos – and drop in ones when you need them.

It's simpler and frees you to concentrate on the work.
Boy, did my output and quality improve!

There are a couple of other things to mention before we start in on the great argument of ones versus twos.

There's a very important thing I learned from Ken Harris. I know it sounds crazy – but if you have a series of B drawings – don't put the B in front of the number. i.e.

B – 1
2
3
4
5

Put the B *after* the number. i.e.

1 – B
2
3
4
5

We want to think as simply as we can. Ken said, 'Look, you don't call me *Mister* Ken. Put the letter behind so all you think of is the numbers.' Put any formality or whatever behind. It may seem mad but it helps you do more work. Try it. All we're really doing is thinking of series of numbers from 1 to 10. Anything to keep it simple. Nobody could figure out how this sick old man could produce so much work – and of such high quality. He just kept everything as simple as could be.

Two more things:

The *only* time you should circle a drawing on the X-sheet is when a cycle of action re-starts – when we're repeating the same set of drawings. We circle drawing (1) to alert the cameraman that it's out of sequence with the normal dial numbers.

Then we circle the drawing in the correct dial number when we come back to a normal sequence.

My rule is: The only time you ever put a letter in front of a number is when you have an overlay cel (of something in front of the characters).

Then you put O-1 (for the overlay cel) or for a held cel (somebody's stationary feet, for example) and call it H-1.

	1	B G
	1	
	2	
	3	
	4	
	5	
	6	
	(1)	
	2	
	3	
	4	
	5	
	6	
	(1)	
	2	
	3	
	4	
	5	
	6	
	(19)	19 ← CAMERA DIAL NUMBER
	21	
	23	
	25	
	27	

TABLE HELD
OVERLAY FEET ACTION

3	2	1	B G
O – 1	H – 1	1	
		2	
		3	
		4	

The GREAT ONES and TWOS BATTLE

Some people always complicate the numbering by calling ones and twos, 'singles' and 'doubles'. In fact 'singles' is from a 1940s term for inbetweening when the animator did drawings 1 and 3 and 5, made an evenly-spaced chart and said to the assistant, 'I've left you singles.'

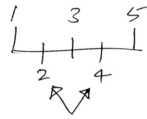

i.e. single in betweens

But when to use ones and when to use twos?
The rule of thumb is – use twos for normal actions and ones for very fast actions. For instance, runs always have to be on ones – normal 'acting' on twos.

Walks can function nicely on twos, but they're going to look better on ones.

Obviously, life is on ones (or whatever speed we film it on), but twos work well for most actions and, of course, it's half as much work as doing it on ones. And half as expensive! Working on ones is twice as much work and expense all the way down the production line.

Apparently, in the early 1930s as Disney's animators got better and better, costs were skyrocketing, and since twos work for most things, they tried to stay on twos whenever they could.

A lot of great animators even say that twos are really better than ones, that ones lead to a mushy result, that broad, fast actions on twos 'sparkle' and adding ones diminishes that vitality. Well, yes, this is true if the ones are just dumb, mechanical inbetweens.

My experience is different. I've found that if you *plan* for ones, the result is usually superior to twos.

I feel that twos are an economic answer to an artistic question. With twos being half the work, everybody gets to go home on time, and why would *I* make a case for ones? Hell, I was a studio *owner*.

When I was re-learning all this stuff, I would wait till my animation on ones was traced and painted, then I'd shoot it on ones as planned and then I'd take out every other cel and shoot the rest on twos to see if it 'sparkled' and was better.

In all but one case, ones worked better. The time the twos worked better was when I had an old lady pulling out a doctor's stethoscope from her pocket. The ones produced a very smooth movement.

It worked just fine, but then I removed every other painted inbetween and shot it on twos. It was better on twos! I cannot figure out why – it just was better.

So they're partly right, I guess. But I became addicted to using ones whenever I could – ones seem to make for compulsive viewing and that's what we're after.

Art Babbitt used to nag at me for using ones. 'That's too realistic – one of the things about animation is that it's *not* like life!' But I would often add ones to Art's work when he wasn't looking and it came out better – and *he* liked it better.

Computer animators have everything on ones – with perfect inbetweens – and it hasn't diminished the appeal of their work – rather the reverse. And twos tire the eye after a few minutes. I feel that ones are twice as much work, but the result is three times as good. Compulsive viewing, easy to watch.

I think my co-animator Neil Boyle said it best :
 'Twos work – ones *fly*.'
 And Ken Harris, who spent most of his life working on twos, would say to me when I'd be putting ones into his stuff, 'Oh, it's *always* better on ones.'

There's one thing that always makes me crazy. When you have a character animated on twos and the camera is panning with it on ones you get stroboscopic jitter. Either pan with it on twos (not great) or add in single inbetweens so it doesn't strobe!
 Some of the really good guys do this. It's a mystery to me. Why don't they add single inbetweens so it doesn't strobe?
 Maybe its because a lot of things don't show up on the pencil test. It's when it's coloured in that we see the bumps.

It's a combination of twos and ones. Not only but also.
Normal actions on twos – which is the bulk of our work anyway.
Fast or very smooth actions on ones.
Normal spacing on twos. Far apart spacing on ones.

An endless debate has gone on among classical animators about whether to register the drawings on top pegs or bottom pegs. At present, bottom pegs seem to have won out; most people seem to be animating using the bottom pegs to hold their drawings.

Frank Thomas has said, 'Getting off the top pegs and working on bottom pegs has actually *advanced* the art of animation because you can *roll* the drawings as you work and *see* what's happening – whether the creature is doing what you want.' And that's had a tremendous influence. (Disney animators all work on bottom pegs.)

Alternatively, Ken Harris spent his life on top pegs and would *flip* his drawings and see what's happening – whether the creature is doing what he wants. (Warner animators all worked top pegs).

Goddam lazy cameraman

Ken would sometimes go red in the face and explode, 'You know who started that whole bottom pegs business? A goddam lazy cameraman who didn't want to be bothered reaching all the way under the glass pressure plate to place the cels at the top! He's the bum who started bottom pegs!'

It comes down to something like this:

ROLLING...

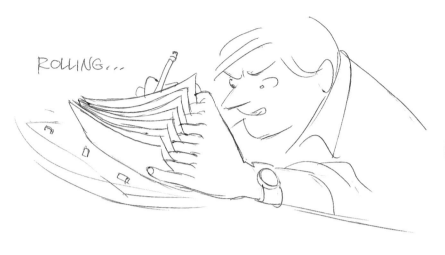

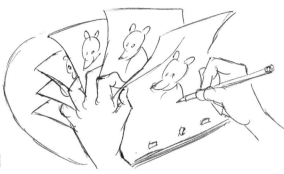

If you only have four fingers you can still roll four sheets at once, plus the bottom drawing – giving us five images.

VERSUS FLIPPING

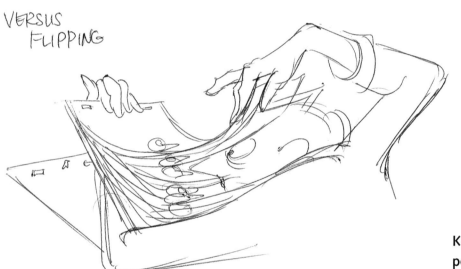

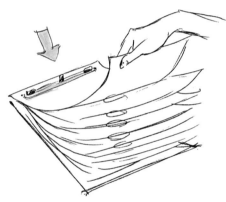

Ken would stretch an elastic band around his pegs to make flipping easier as he drew – without having to take the drawings off the pegs.

When Ken had calmed down, he used this example:

SAY I WAS OFFERING YOU A CIGAR FROM A CIGAR BOX – WOULD YOU LIKE ME TO PRESENT IT TO YOU

LIKE THIS? OR LIKE THIS?

And what's going to make it easiest to draw?

LIKE THIS?

OR LIKE THIS?

Add to this the fact that most of the discs that animators use are made of heavy metal with inset panning bars with screws to tighten and release them for sliding pans. It's pretty awkward with all these points sticking up and we unconsciously have to dodge the pegs as we draw.

OUCH.

OUCH! OUCH!

The engineer who made most of the equipment for my English studio arranged the panning bars differently every time. I had to fire a guy once, and his close friend – who was very talented – quit with him. To get even with me they ordered a special disc (on the firm) made with three panning bars for different field sizes, top and bottom – six in all! By the time you added in the screws it looked like this:

HOW WOULD YOU LIKE TO DRAW ON THIS? YOU COULD END UP IN INTENSIVE CARE.

82

But how often do you really use the panning bars? Not too often, in my experience.

One day about fifteen years ago I found layout artist and designer, Roy Naisbitt, working on a big piece of white plastic Perspex (Plexiglass) with a peg bar just taped on to it.

What a solution!

You tape the pegs on wherever you want, top or bottom.
Also, I keep a heavy metal disc with panning bars beside the desk for when I very occasionally need it for a mechanical pan.

This also allows you to tape on taller pegs to carry more drawings if you're on top pegs. The shorter peg bars are OK for bottom pegs, but the drawings keep falling all over the floor. Again, an elastic band helps.

I'm delighted to see that Roy's solution has spread through the industry, as I've seen several animators walking around in Hollywood with Perspex discs and a taped-on peg bar tucked under their arms.

It works just fine. I animated the first close-up on *Who Framed Roger Rabbit* in a Welsh hotel room with a Perspex disc on my knee – and top pegs!

I work both ways. Again, it's not only but also. Top pegs is great for drawing and bottom pegs is great for rolling. Take your pick.

Obviously, computer animators are free from all this tactile nonsense – but I'm sure you have equivalent stuff to cope with. Having started out as a drawing animator, Jim Richardson, now a computer animator, told me that when he first switched over to the computer, he found it was like 'animating with a microwave'.

MORE ON SPACING

Somebody once said an animator is something between an artist and a garage mechanic. Here's more nuts and bolts from the garage – but very interesting ones, and it really helps to know them.

Ken Harris showed me this one:

Say we've got a telephone pole moving up quickly in perspective. Where do we put our middle position?

You'd put it in about here, right?

Wrong. Even after fifteen years' experience I got it wrong. And nearly every professional I've asked since has gotten it wrong.

Here's where the middle position is:

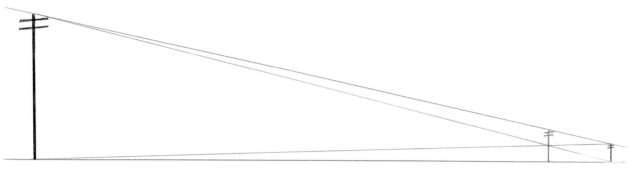

Rule in the lines like this and the cross point tells us it's here. At least technically. And just keep doing it:

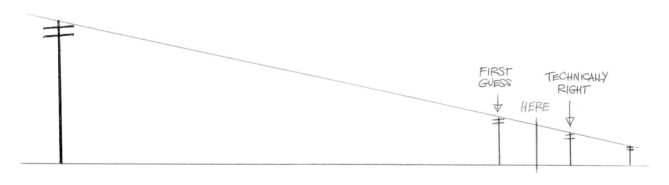

This works well for fast moves. However, for more normal moves it's best to cheat it – split the difference – and come back about half way to where our first guess was. Do that throughout and you'll get a better result.

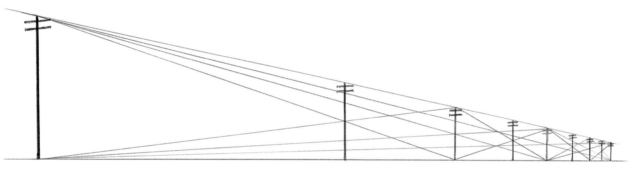

WE ALL KNOW FROM EXPERIENCE HOW THIS MIDDLE POSITION WORKS –

ROAR!

INCIDENTALLY – DUST STAYS IN the SAME PLACE – DOESN'T TRAVEL WITH the CAUSE OF IT. IT RISES UP – NOT OUT

THE SAME THING
APPLIES TO A FRONT
VIEW OF SOMEBODY
OR SOMETHING
COMING UP AT US -
FAST.

SAY A DISC
IS SPINNING UP
TOWARDS US -

MID
POINT

AND TO DO WITH THE SAME SORT OF THING:
TAKE 4 POSITIONS OF A BALL REVOLVING
AROUND A CENTRAL POINT -

SIDE
VIEW

TOP
VIEW
- LOOKING
DOWN

NOW ADD IN THE MIDDLE POSITIONS and SEE
HOW CLOSE THEY ARE TO THE OUTSIDE OF THE ARC.

ADD IN THE NEXT MID POSITIONS and THE FURTHEST
ONES WILL ALMOST COVER UP THE OUTSIDE BALLS.

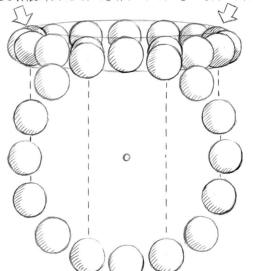

THE POINT IS THAT THE SPACING OF THE
INBETWEENS WILL CLUSTER AT THE EDGES
OF THE SWING AROUND

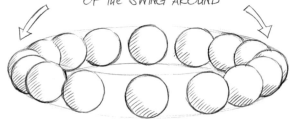

WE CAN INCREASE THE PERSPECTIVE BUT
IT STILL CLUSTERS AT THE EDGES OF THE ARC AROUND

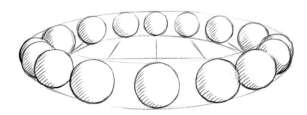

So when we're going to turn a head, it's going to be the same kind of thing:

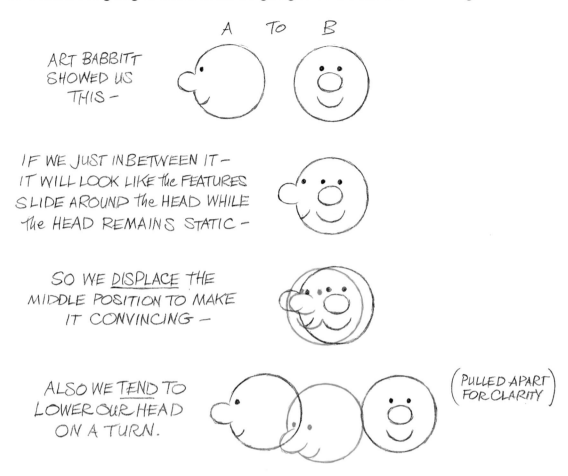

ART BABBITT SHOWED US THIS –

IF WE JUST INBETWEEN IT – IT WILL LOOK LIKE the FEATURES SLIDE AROUND the HEAD WHILE the HEAD REMAINS STATIC –

SO WE <u>DISPLACE</u> THE MIDDLE POSITION TO MAKE IT CONVINCING –

ALSO WE <u>TEND</u> TO LOWER OUR HEAD ON A TURN.

(PULLED APART FOR CLARITY)

Incidentally – on a head turn, Ken Harris showed me this:

Do it yourself or have somebody else hold up two fingers. Look first at one, relax, then turn the head round to look at the other finger. During the head turn, something interesting will happen. The person will blink. The eye, switching focus from one side to the other, will blink en route. (Unless they're frightened – then the eyes will stay open.)

SO WE'LL PROBABLY BLINK DURING the TURN –

A MALLET HITS A NAIL
WHICH BENDS –
AND WE WANT ONE IN BETWEEN
RIGHT IN THE MIDDLE.

OUR HELPER, WHO IS
PLUGGED INTO A CD,
PHONE OR WHATEVER,
DOES PRECISELY
WHAT'S REQUESTED AND
PUTS IT RIGHT
IN THE MIDDLE...

"WELL, I FOLLOWED
YOUR CHART."

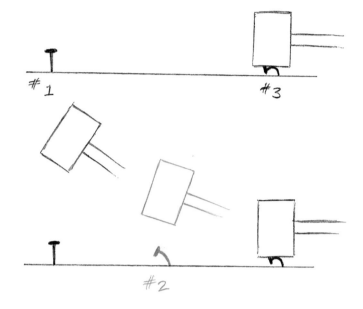

LATER THE SAME
PLUGGED-IN PERSON
PUTS IN A DROP OF
WATER BETWEEN
THESE TWO POSITIONS.

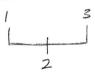

AND PUTS IT
RIGHT IN THE
MIDDLE
AGAIN

OBVIOUSLY
THE CHANGE
ONLY TAKES
PLACE ON THE
CONTACT.

GOT TO USE
COMMON
SENSE.

IT GOES ON AND ON:

SOFT RUBBER
BALL FALLING –

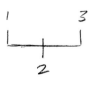

OF COUR
SHOULD

88

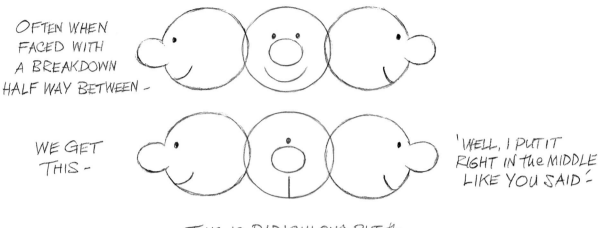

OFTEN WHEN
FACED WITH
A BREAKDOWN
HALF WAY BETWEEN –

WE GET
THIS –

'WELL, I PUT IT
RIGHT IN the MIDDLE
LIKE YOU SAID.'

THIS IS RIDICULOUS BUT the
EQUIVALENT OFTEN HAPPENS
WITH COMPLEX INBETWEENS.

Every drawing is important. We can't just have brainless drawings joining things up. In one sense there *are* no inbetweens – all the drawings are on the screen for the same amount of time.

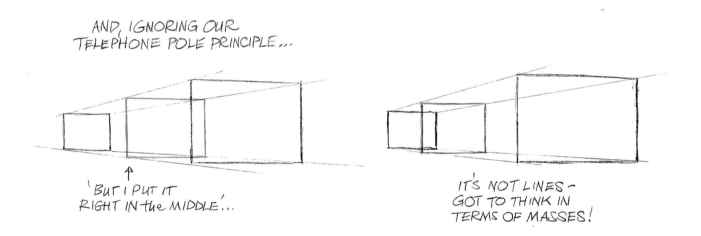

AND, IGNORING OUR
TELEPHONE POLE PRINCIPLE...

'BUT I PUT IT
RIGHT IN the MIDDLE'...

IT'S NOT LINES –
GOT TO THINK IN
TERMS OF MASSES!

WHEN A GOLF CLUB
HITS A HARD GOLF BALL –

AT the MOMENT
OF IMPACT WE MIGHT
DISTEND the SHAPE

BUT IT WOULD
GO BACK TO IT'S
OWN SHAPE WITHIN
VERY FEW FRAMES.

89

Ideally the inbetweener should understand and be able to complete eccentric actions.

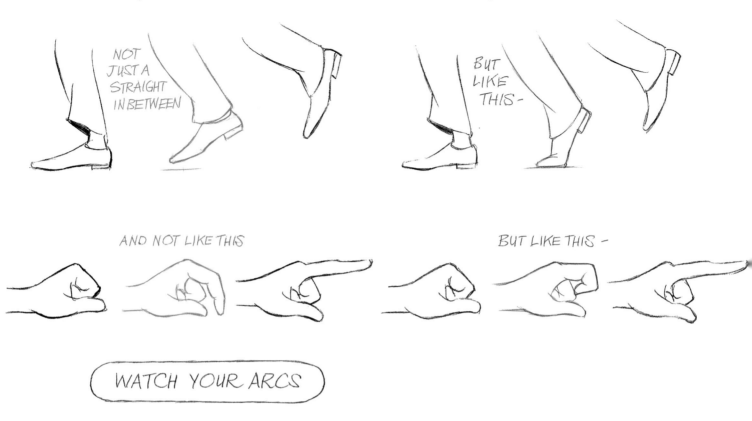

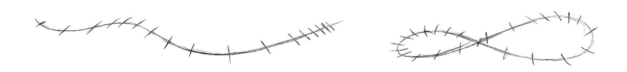

Most actions follow arcs. Generally, an action is in an arc. Most of the time the path of action is either in a wavelike arc or in a sort of figure 8:

But sometimes it is angular or straight. Straight lines give power.

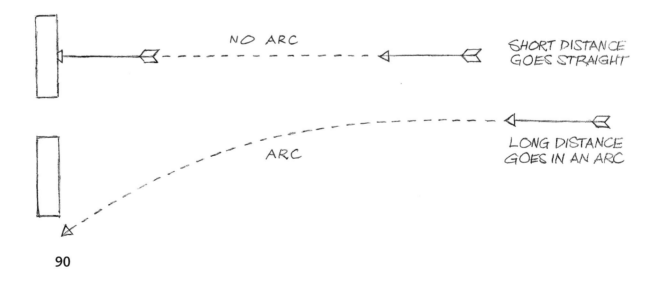

FLOPS

the ARC OF the ACTION GIVES US the CONTINUOUS FLOW

IN THIS ARM SWING the WRIST IS LEADING the ARC and the HAND DRAGS.

AND OF COURSE the BONES DON'T SHRINK and GROW — THEY MAINTAIN THEIR LENGTH

OBVIOUSLY WRONG

OBVIOUSLY RIGHT

THE ARC IS SO IMPORTANT! SAY WE HAVE POSITIONS 1, 3, 5 and 7 —

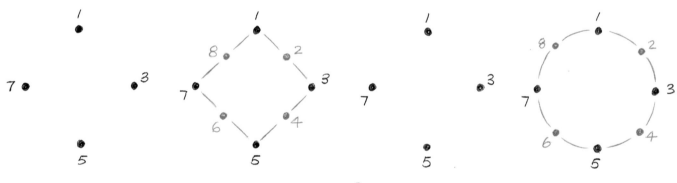

DO WE JOIN THEM UP LIKE THIS?

—OR LIKE THIS?

WE'LL GET AN UTTERLY DIFFERENT RESULT — SO WE ROLL OR FLIP the DRAWINGS TO MAKE SURE WHAT the ARC OF the ACTION OR PATH OF ACTION SHOULD BE.

OFTEN WE GET THIS —

USUALLY WE GET THIS —

NEITHER ONE THING NOR THE OTHER

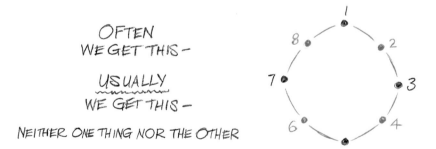

IF IT ISN'T IN the ARC OR PATH OF ACTION – the ANIMATION WILL NOT FLOW.
GOT TO GO WITH the FLOW, USING ARCS (UNLESS A STRAIGHT IS REQUIRED.)

The stuff on these pages looks awfully simple set out like this – 'Oh, I knew that.' But as soon as we get into sophisticated images and actions this all tends to go out the window.

I recently heard about a Hollywood assistant, a talented draftsman who was working on realistic horses (about the hardest thing there is to animate). He drew the stuff beautifully, but he just couldn't get the hang of keeping things in the right arcs. His directing animator, James Baxter, finally suggested he take a blue pencil and just trace the horse's eye positions separately and look what was happening to the flow. Clink! The penny dropped.

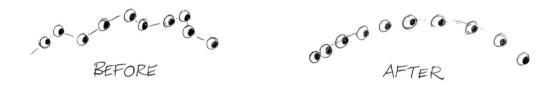

BEFORE *AFTER*

So we're back to the old bouncing ball again.

These basic things are so important. Most animators would say scornfully – 'Oh sure, the bouncing ball – everyone knows that.' But do they?

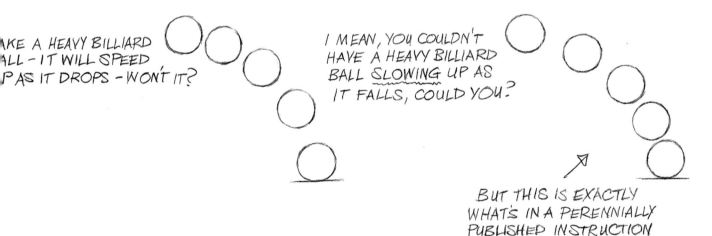

\KE A HEAVY BILLIARD
\LL – IT WILL SPEED
\P AS IT DROPS – WON'T IT?

I MEAN, YOU COULDN'T
HAVE A HEAVY BILLIARD
BALL SLOWING UP AS
IT FALLS, COULD YOU?

BUT THIS IS EXACTLY
WHAT'S IN A PERENNIALLY
PUBLISHED INSTRUCTION
BOOK FOR ANIMATORS.

AGAIN, IT'S ALL IN the TIMING and IN the SPACING!

(GETTING MORE MOVEMENT WITHIN the MASS)

Now we can start getting more sophisticated. We're going to keep finding ways to get movement *within* movement, action within action – getting more 'change', more bang for the buck.

Ken Harris showed me how to exaggerate a hit.
Say a creature shoots through the air to hit a cliff:

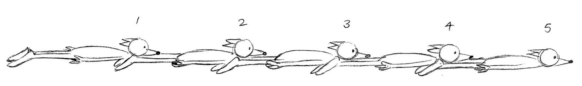

We'd need about five drawings – even spacing on the head – to get him over to the cliff. The figures overlap slightly to help carry the eye – on ones, of course, because it's a fast action. No inbetween between 5 and 6.

To get more impact, more power to the hit, add in another drawing where he just touches the cliff, just contacting it before he's flattened on the following frame. This will give more 'change' – action within action.

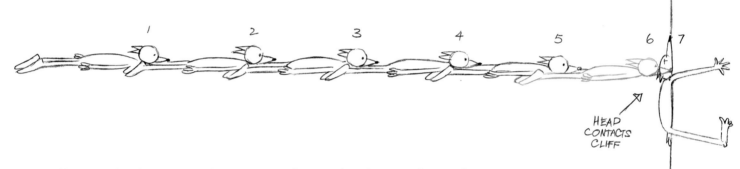

Now to give it yet more impact, we take out drawing number 5, throw it away, and *stretch out* the drawing that's touching the cliff. It becomes our new number 5.

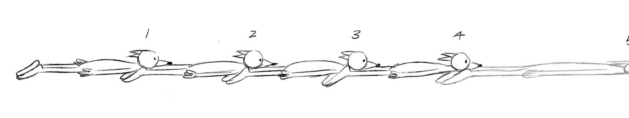

Now our action kind of leaps a one frame gap. We won't see it, but we'll feel it and it will give a much stronger impact to the hit.

There's an interesting thing here which takes us right back again to the bouncing ball.

In 1970 I showed Ken an early edition of Preston Blair's animation book when I was questioning whether we need that amount of squashing and stretching of things. (You can gather by now that I'm not too keen on 'rubber duck' stretching around – although twenty-five years later that was what was required on *Who Framed Roger Rabbit*, a cartoon of a cartoon.) I noticed that Ken, though famous as a broad action animator, used squash and stretch rather sparingly.

I had the page open on the bouncing ball. It was like this – which certainly works OK.

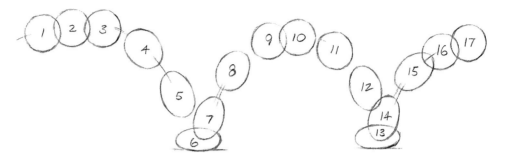

Ken said, 'Yeah, sure, but wait a minute – never mind that. We can make this much better. We need to have a contact in here before the squash.'

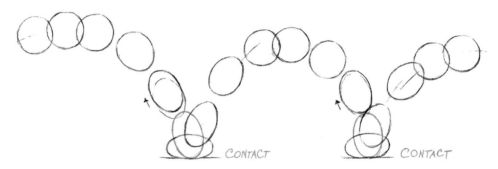

'Put in a contact where the ball just touches the ground and *then* it squashes. That'll give it more life.' (Move the preceding drawing back a bit to accommodate it.)

'And do we do the same when it takes off again?' Answer: 'Not in this case – just when it contacts. You get the "change", then it's off again.'

The animation grapevine flows like lightning: 'Did you know Ken Harris in London has corrected Preston Blair's bouncing ball?' Preston's next edition came out like this:

Perfect.

This is not done to show disrespect for a skilled animator like Preston, who was the first classical animator to make real animation knowledge accessible, or to put him down in any way. Ken was just showing an important device to get more action within the movement.

Ken continued, showing the same idea with a frog.

'Have him contact the ground before he squashes down. Then keep his feet contacting the ground as he takes off. That'll give more change to the action.'

Next, a jumping figure.

'Have at least one foot contacting the ground before the squash down, then leave at least one leg still contacting the ground as he takes off again.'

This is great because we're getting more 'change' – more contrast – straight lines playing against curves. We're doing it with bones as well as round masses. We can use straight lines and still get a limber result. More on this later. We don't have to be stuck with rubbery shapes to get smooth movement. This will also free us from having to draw in a prescribed cartoony style because it 'suits animation' and is 'animatable'.

I'm using crude drawings here because I want everything to be crystal clear. I just want to show the structure and not get lost in an overlay of attractive detail.

The ELONGATED INBETWEEN

In the 1930s, when animators started studying live action film frame by frame, they were startled by the amount of transparent blurs in the live images. In order to make their movements more convincing, they started using stretched inbetweens. Ken used to call them 'long-headed inbetweens'.

For a zip turn – on ones – although it also works for two frames:

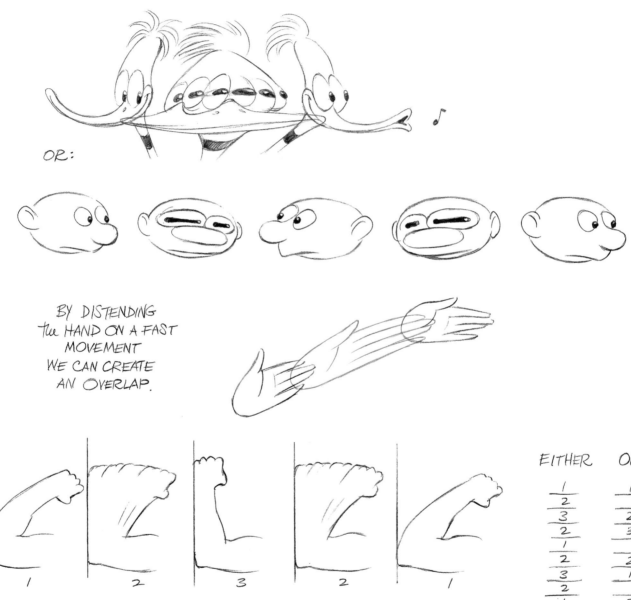

OR:

BY DISTENDING
The HAND ON A FAST
MOVEMENT
WE CAN CREATE
AN OVERLAP.

EITHER OR:

Let's take these drawings of pounding a door. Shoot the inbetween (2) on ones. This is one of the very few cases where you can shoot the sequence in reverse. It will work on ones – or with just the inbetween on ones and the extremes – (1) and (3), on twos.

In the late 1930s when tracing and painting the drawings on to cels was all done by hand, many painters became very adept at 'dry brushing' the desired transparent live action blur effect. Animators indicated the blur on their pencil drawings and the 'dry brushers' would cleverly blend the colours together to simulate the transparency in the blur.

(BLUR REQUIRED)

After the 1941 animators' strike and World War II, budgets shrank and so did the use of skilled backup painters. But a lot of animators just kept on indicating blurs and it became a cartoon convention to just trace this in heavy black lines – ignoring the fact that the dry brush artists were long gone.

Now it's become a cartoon cliché. A cartoon of a cartoon:

ZIP!

With characters just vanishing from the screen, Ken told me:
'We'd have this witch up in the air laughing and then she's *gone*. Instead of making a blur we just used to leave hairpins where she was.'

'We learned that from the Disney guys in a fish picture. They'd have these little fish swimming around and something would scare them and they were *gone* – that's all – with just a few bubbles for the path they took.'

In the early days, speed lines were a hangover from old newspaper strips:

Then they were used in animation to help carry your eye. But they're still around now when we don't really need them. You don't even need to show the arrow entering. We have nothing and then it's just there – maybe with the tail vibrating.

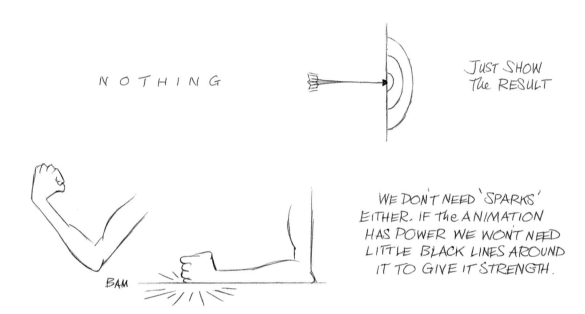

NOTHING

JUST SHOW THE RESULT

BAM

WE DON'T NEED 'SPARKS' EITHER. IF THE ANIMATION HAS POWER WE WON'T NEED LITTLE BLACK LINES AROUND IT TO GIVE IT STRENGTH.

However, I find the elongated or 'long-headed' inbetween is *very* useful – not just for a zippy cartoon effect, but also for use in realistic fast actions:

Again, we're returning to the original purpose – emulating the transparency of broad, live action blur movements. It's especially suitable with 'soft edge' loose drawings – where the outlines aren't sharp and enclosed like colouring book drawings.

The MAJOR BEGINNER'S MISTAKE

Doing too much action in too short a space of time, i.e. too great arm and leg swings in a run. The remedy: go twice as slow. Add in drawings to slow it down – take out drawings to speed it up.

Ken Harris told me that when Ben Washam was starting out at Warner's, he became famous in the industry for 'Benny's Twelve Frame Yawn'. Ben drew well and made twelve elaborate drawings of someone going through the broad positions of a yawn – an action something like this:

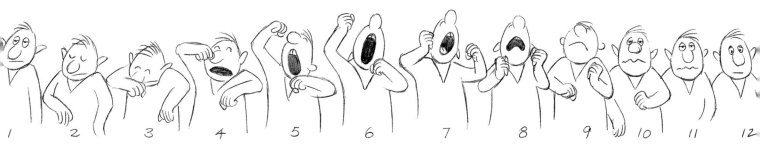

Then he shot it on ones. Zip! It flashed through in half a second!

So then he shot it on twos. ZZZip! It went through in one second!

So then he inbetweened it (twenty-four drawings now) and shot it on twos. ZZZZZZ! It went through in two seconds – almost right.

Then Ken showed him how to add some cushioning drawings at the beginning and end – and bingo, Ben's on his way to being a fine animator.

the "RUFF" APPROACH

Some animators want to save themselves a lot of the work so they draw very rough. ('Ruff' – they don't even want to spend the time spelling 'rough'. Too many letters in it to waste our valuable time . . .) And they leave lots and lots of work for the assistants.

I've never understood why some people in animation are so desperate to save work. If you want to save work, what on earth are you doing in animation? It's nothing *but* work!

In the early days at The Disney Studio, when animation was being transformed from its crude beginnings into a sophisticated art form, they used to say, take at least a day to *think* about what you're going to do – *then* do it.

One old animator, writing about the subject forty years later, advises that we should spend *days* thinking about it. He's read up on Freud and Jung and the unconscious mind and he writes seductively about how you should ruminate until the last minute and then explode into a frenzy of flowing creativity.

He told me that in a week's work he'd spend Monday, Tuesday, Wednesday and Thursday thinking about it and planning it in his mind. Then on Friday he'd *do* it. The only problem is that it then takes three weeks for somebody else to make sense of it.

I knew this guy pretty well – and he made it sound so creatively attractive that, though I felt it was artistic b.s., I thought I better try it out. I managed to ruminate, stewing and marinating my juices for about a day and a half and then couldn't stand it any more. I exploded into creative frenzy for a day, drawing into the night like a maniac. The result was pretty interesting, but it really did take three weeks to straighten it all out afterwards. And I don't think it was any better than if I had worked normally – maybe just a bit different.

I think Milt Kahl has the correct approach: 'I do it a lot. I think about it a lot, and I do it a lot.'

Ken Harris worked intensely from 7.30 am till noon, relaxed at lunch, hung around doing bits for a while, went home to watch TV (or play tennis when he was younger) and thought about what he was going to do the next day – then came in early, avoided social contact and did it.

He worked carefully and thought very hard about his stuff. He said he was surprised when he saw some of Ward Kimball's working drawings because they were exactly the same as his – very neat – very carefully done – usually something on every drawing in the shot.

When I first saw Milt's work on his desk I was startled by how much work he did. His drawings were finished, really. There was no 'clean up' – just 'touch up', and completing details and simple inbetweens or parts of them. Ditto Frank Thomas, ditto Ollie Johnston, ditto Art Babbitt. The two exceptions to this were Cliff Nordberg, a marvellous 'action' animator who worked with me for a while, and Grim Natwick. Cliff did work very roughly – so he was awfully dependent on having a good assistant and it always caused him a lot of concern. And Grim was a law unto himself.

There's an animation myth about the assistant always being able to draw better than the animator. (I never met one who did.) The myth is that the animator creates the 'acting' and the fine draftsperson improves the look of everything and nails it all down. Well, there aren't that many fine draftspeople around and if they're good enough to nail all the details down and draw well, they really should be animating – and probably are. (An exception to this is the assistant 'stylist' on commercials where the 'look' of the thing is it's raison d'être. There are a few excellent ones around.)

Rough drawings have lots of seductive vitality, blurs, pressure of line, etc. But when they're polished and tidied up you usually find there wasn't that much there to begin with.

As we go along through this book it'll be apparent how much work we have to do to get a really interesting result. No matter how talented – the best guys are always the ones that work the hardest. But hang the work, it's the unique *result* that we're after. Every time we do a scene, we're doing something unique – something nobody else has ever done. It's a proper craft.

HOW MUCH DO WE LEAVE TO The ASSISTANT?

Milt Kahl's answer: 'I do enough to have iron clad control over the scene.'

Ken Harris's answer: 'I draw anything which is not a simple inbetween.'

Milt again: 'I don't leave assistants very much. How much can I get away with leaving and still control the scene? If it's fast action, I do every drawing.'

The purpose of the assistant is to free the animator to get through more work by handling the less important bits – but as we have seen, he/she can't be just a brainless drawing machine. The computer produces *perfect* inbetweens, but obviously has to be programmed to put in the eccentric bits that give it the life.

Here's my tip on saving work – my rule of thumb:

TAKE The LONG SHORT CUT.

The long way turns out to be shorter.
 Because: something usually goes wrong with some clever rabbit's idea for a short cut and it turns out to take even longer trying to fix everything when it goes wrong.

I've found it's quicker to just do the work, and certainly more enjoyable because we're on solid ground and not depending on some smart guy's probably half-baked scheme.
 And again, if you don't want to do lots of work, what are you doing in animation?

One of the things I *love* about animation is that you have to be specific. If a drawing is out of place it's just *wrong* – clearly wrong – as opposed to 'Art' or 'Fine Art' where everything these days is amorphous and subjective.

For us, it's obvious whether our animation works or not, whether things have weight, or just jerk about or float around wobbling amorphously.

We can't hide in all that 'unconscious mind' stuff. Of course, we can dress up and *act* like temperamental prima donnas – but we can't kid anybody with the work. It's obvious whether it's good or bad.

And there's nothing more satisfying than getting it right!

WALKS

Advice from Ken Harris:
'A walk is the *first* thing to learn. Learn walks of all kinds, 'cause walks are about the toughest thing to do right.'

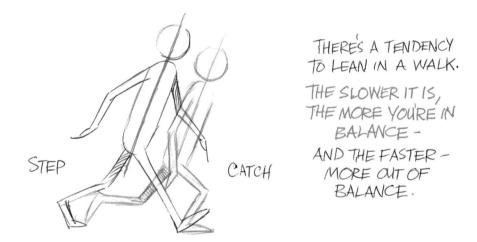

STEP CATCH

THERE'S A TENDENCY TO LEAN IN A WALK.

THE SLOWER IT IS, THE MORE YOU'RE IN BALANCE -

AND THE FASTER - MORE OUT OF BALANCE.

Walking is a process of falling over and catching yourself just in time. We try to keep from falling over as we move forward. If we don't put our foot down, we'll fall flat on our face. We're going through a series of controlled falls.

We lean forward with our upper bodies and throw out a leg just in time to catch ourselves. Step, catch. Step, catch. Step catch.

Normally we lift our feet off the ground just the bare minimum. That's why it's so easy for us to stub our toes and get tipped over. Just a small crack in the pavement can tip us over.

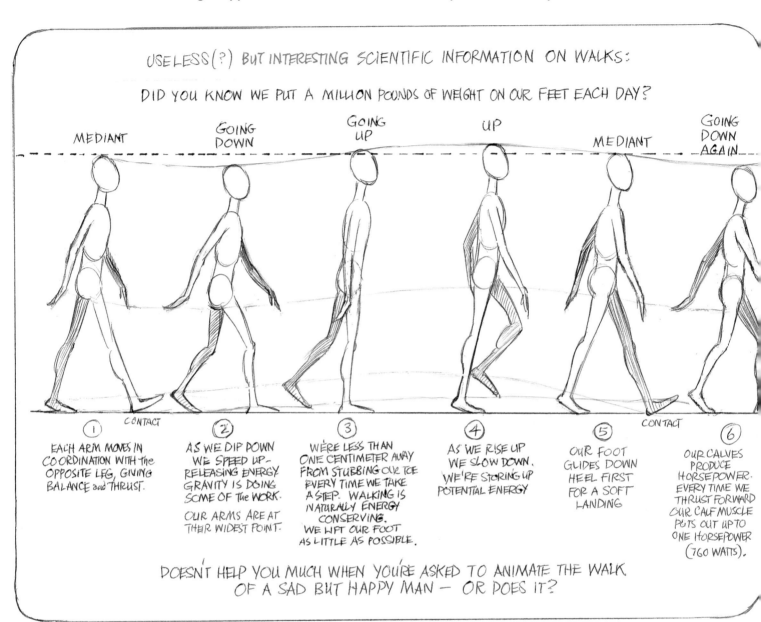

USELESS(?) BUT INTERESTING SCIENTIFIC INFORMATION ON WALKS:

DID YOU KNOW WE PUT A MILLION POUNDS OF WEIGHT ON OUR FEET EACH DAY?

MEDIANT — GOING DOWN — GOING UP — UP — MEDIANT — GOING DOWN AGAIN

CONTACT

① EACH ARM MOVES IN COORDINATION WITH THE OPPOSITE LEG, GIVING BALANCE and THRUST.

② AS WE DIP DOWN WE SPEED UP - RELEASING ENERGY GRAVITY IS DOING SOME OF THE WORK.

OUR ARMS ARE AT THEIR WIDEST POINT.

③ WE'RE LESS THAN ONE CENTIMETER AWAY FROM STUBBING OUR TOE EVERY TIME WE TAKE A STEP. WALKING IS NATURALLY ENERGY CONSERVING. WE LIFT OUR FOOT AS LITTLE AS POSSIBLE.

④ AS WE RISE UP WE SLOW DOWN. WE'RE STORING UP POTENTIAL ENERGY

⑤ OUR FOOT GLIDES DOWN HEEL FIRST FOR A SOFT LANDING

CONTACT

⑥ OUR CALVES PRODUCE HORSEPOWER. EVERY TIME WE THRUST FORWARD OUR CALF MUSCLE PUTS OUT UP TO ONE HORSEPOWER (760 WATTS).

DOESN'T HELP YOU MUCH WHEN YOU'RE ASKED TO ANIMATE THE WALK OF A SAD BUT HAPPY MAN — OR DOES IT?

 ALL WALKS ARE DIFFERENT.

NO TWO PEOPLE IN THE WORLD WALK THE SAME.

ACTORS TRY TO GET HOLD OF A CHARACTER BY FIGURING OUT HOW HE/SHE/IT WALKS - TRY TO TELL THE WHOLE STORY WITH THE WALK.

103

Why is it that we recognize our Uncle Charlie even though we haven't seen him for ten years – walking – back view – out of focus – far away? Because everyone's walk is as individual and distinctive as their face. And one tiny detail will alter everything. There is a massive amount of information in a walk and we read it instantly.

Art Babbitt taught us to look at someone walking in the street from the back view. Follow them along and ask yourself:

- ARE THEY OLD?
- YOUNG?
- WHAT'S THEIR FINANCIAL POSITION?
- STATE OF HEALTH?
- ARE THEY STRICT?
- PERMISSIVE?
- DEPRESSED?
- HOPEFUL?
- SAD?
- HAPPY?
- DRUNK?

Then run around to see the front and check.

So what do we look for?

The big eye-opener for me happened like this. (Unfortunately it's a little politically incorrect, but it's a great example, so here goes.)

I was in my parked car turning on the ignition, when out of my peripheral vision I semi-consciously noticed a man's head walking behind a wall.

It passed through my mind that he was gay. A gay walk. Now I'm quite short-sighted – my eyes were focused on the ignition key, and it was a busy street with lots of cars and people – and he was about fifty yards away! Wow! How did I know that? This is crazy. All I'd seen was his out-of-focus head moving along behind a wall for a split second!

I started to drive away, then stopped. Wait a minute – I'm supposed to be good at this. I'm supposed to know these things. I have to know *why*! I remembered Art's advice, re-parked, jumped out and ran a block and a half to catch up with the fellow. I walked along behind him, copying him. Sure enough, it was an effeminate walk. Then I got it. He was walking as if on a tightrope and *gliding* along.

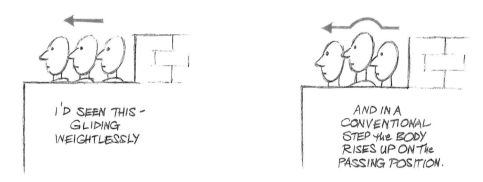

Now how could I have registered this with out-of-focus peripheral vision at fifty yards without even seeing his body? Simple, really. There was *no up and down action on the head*. Try walking on an imaginary tightrope and your head stays level. No ups and downs.

I'D SEEN THIS –
GLIDING
WEIGHTLESSLY

AND IN A
CONVENTIONAL
STEP the BODY
RISES UP ON The
PASSING POSITION.

From then on the first thing I always look for is how much up and down action there is on the head. The amount of up and down is the key!

WOMEN OFTEN TAKE SHORT STEPS IN A STRAIGHT LINE – LEGS CLOSE TOGETHER = LITTLE UP and DOWN ON The BODY

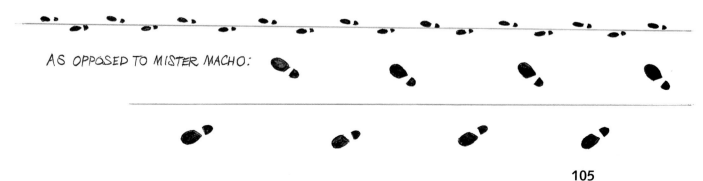

AS OPPOSED TO MISTER MACHO:

105

Women mostly walk with their legs close together, protecting the crotch, resulting in not much up and down action on the head and body. Skirts also restrict their movement.

Mr Macho, however, because of *his* equipment, has his legs well apart so there's lots of up and down head and body action on each stride.

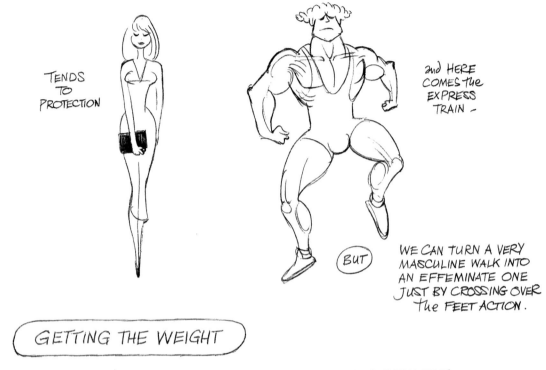

TENDS TO PROTECTION

and HERE COMES The EXPRESS TRAIN –

BUT

WE CAN TURN A VERY MASCULINE WALK INTO AN EFFEMINATE ONE JUST BY CROSSING OVER The FEET ACTION.

GETTING THE WEIGHT

WE DON'T GET WEIGHT BY A SMOOTH LEVEL MOVEMENT.

When we trace off a live action walk (the fancy word is rotoscoping), it doesn't work very well. Obviously, it works in the live action – but when you trace it accurately, it floats. Nobody really knows why. So we increase the ups and the downs – accentuate or exaggerate the ups and downs – and it works.

IT'S THE UP AND DOWN POSITION OF YOUR MASSES THAT GIVES YOU THE FEELING OF WEIGHT.

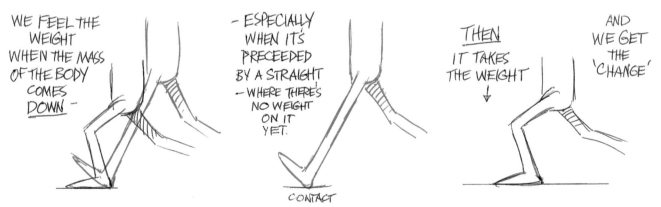

WE FEEL THE WEIGHT WHEN THE MASS OF THE BODY COMES DOWN –

– ESPECIALLY WHEN IT'S PRECEEDED BY A STRAIGHT – WHERE THERE'S NO WEIGHT ON IT YET.

CONTACT

THEN IT TAKES THE WEIGHT ↓

AND WE GET THE 'CHANGE'

IT'S THE DOWN POSITION WHERE THE LEGS ARE BENT AND THE BODY MASS IS DOWN – WHERE WE FEEL THE WEIGHT.

106

Before we start building walks and 'inventing' walks – here's what happens in a so-called 'normal' walk:

FIRST WE'LL MAKE THE 2 CONTACT POSITIONS –

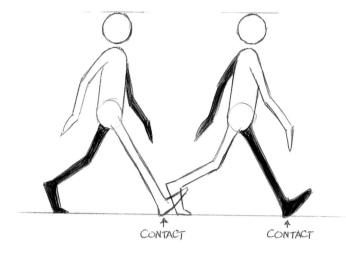

CONTACT CONTACT

IN A NORMAL, CONVENTIONAL WALK, THE ARMS ARE ALWAYS OPPOSITE TO THE LEGS TO GIVE BALANCE AND THRUST.

NEXT WE'LL PUT IN THE PASSING POSITION – – THE MIDDLE POSITION – OR 'BREAKDOWN' – THE HALF-WAY PHASE

PASSING POSITION (SLIGHTLY HIGHER THAN MID-POINT)

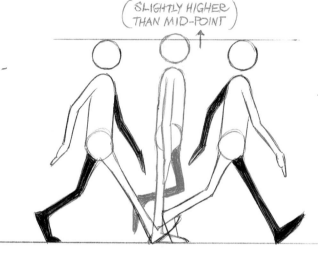

BECAUSE THE LEG IS STRAIGHT UP ON THE PASSING POSITION, IT'S GOING TO LIFT THE PELVIS, BODY and HEAD SLIGHTLY HIGHER.

NEXT COMES THE DOWN POSITION – WHERE THE BENT LEG TAKES THE WEIGHT

DOWN

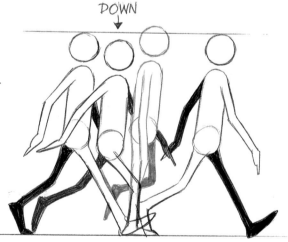

AND JUST TO COMPLICATE LIFE – IN A NORMAL WALK THE ARM SWING IS AT IT'S WIDEST ON THE DOWN POSITION (AND NOT ON the CONTACT POSITION AS WE'D PREFER.)

WE CAN IGNORE THIS AS WE PROCEED BUT WE MIGHT AS WELL UNDERSTAND THE NORM BEFORE WE START MESSING AROUND.

NEXT WE PUT IN
THE UP POSITION -
-THE PUSH-OFF.

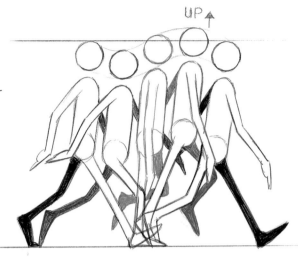

UP

The FOOT PUSHING OFF
LIFTS The PELVIS,
BODY and HEAD UP
TO IT'S HIGHEST POSITION
- THEN The LEG IS THROWN
OUT TO CATCH US ON
The CONTACT POSITION
- SO WE DON'T FALL
ON OUR FACE.

LET'S SPREAD
IT OUT AND
EXAGGERATE IT
A LITTLE MORE
SO IT'S
CLEARER...

CONTACT DOWN PASS POS UP CONTACT

CONTACT CONTACT

SO, IN A NORMAL 'REALISTIC' WALK
The WEIGHT GOES (DOWN) JUST AFTER the STEP -
and the WEIGHT GOES (UP) JUST AFTER the CONTACT.
 JUST AFTER the PASSING POSITION.

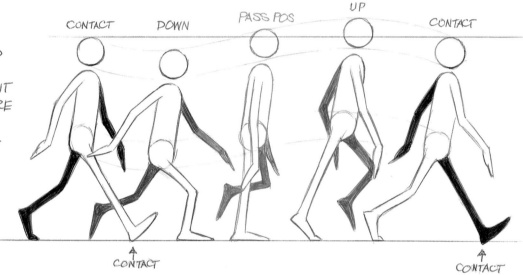

HERE IT IS
AGAIN -
EXAGGERATED)

CONTACT
— MEDIANT —

The DOWN

The LEG BENDS
ABSORBING
The FORCE
of The MOVE

PASS POSITION
(GOING UP)

The UP

CONTACT
— MEDIANT —

SET THE TEMPO

THE FIRST THING TO DO IN A WALK IS SET A BEAT.
GENERALLY PEOPLE WALK ON 12'S - MARCH TIME (HALF A SECOND PER STEP. TWO STEPS PER SECOND.)

BUT LAZY ANIMATORS DON'T LIKE TO DO IT ON 12'S.
IT'S HARD TO DIVIDE UP. YOU HAVE TO USE 'THIRDS' — THINK PARTLY IN THIRDS.

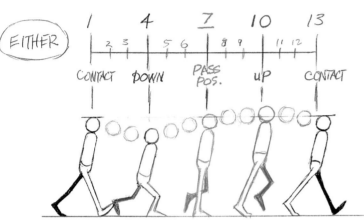

EITHER

THE IN BETWEENS ARE GOING TO BE ON THIRDS.

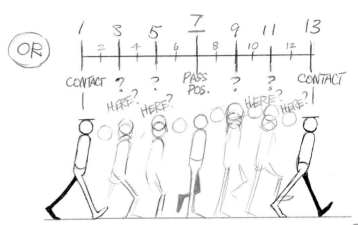

OR

OOPS — NOW WHERE DO WE PUT THE DOWN OR UP?
HEY, THIS IS GETTING HARD — ESPECIALLY
WHEN WE GET INTO THE ARMS AND HEAD, AND
'ACTING' AND DRAPERY — MAYBE THERE'S AN
EASIER WAY?

THERE IS AN EASIER WAY — HAVE HIM/HER WALK ON 16'S — OR WALK ON 8'S.
MUCH EASIER TO WALK ON 16'S — IT'S EASY TO DIVIDE UP — SAME THING ON 8'S.
(EACH STEP = 2/3 SEC) (3 STEPS PER SEC.)

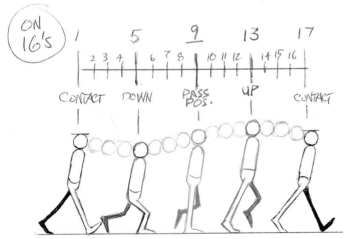

ON 16'S

WHEW, THAT MAKES LIFE EASIER.
NICE EVEN DIVISIONS NOW —

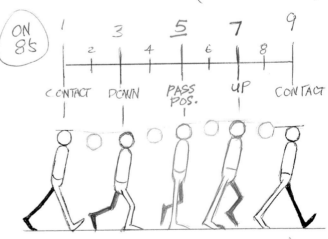

ON 8'S

(REDUCED UP AND DOWN ACTION - SINCE)
(IT'S TAKING PLACE IN A SHORTER TIME)

THIS IS WHY CARTOON WALKS ARE OFTEN ON 8'S.
BUMP, BUMP, BUMP, 3 STEPS A SECOND.

109

4	FRAMES	=	A VERY FAST RUN (6 STEPS A SECOND)
6	FRAMES	=	A RUN OR VERY FAST WALK (4 STEPS A SECOND)
8	FRAMES	=	SLOW RUN OR 'CARTOON' WALK (3 STEPS A SECOND)
12	FRAMES	=	BRISK, BUSINESS-LIKE WALK — 'NATURAL' WALK (2 STEPS A SECOND)
16	FRAMES	=	STROLLING WALK — MORE LEISURELY (⅔ OF A SECOND PER STEP)
20	FRAMES	=	ELDERLY OR TIRED PERSON (ALMOST A SECOND PER STEP)
24	FRAMES	=	SLOW STEP (ONE STEP PER SECOND)
32	FRAMES	=	…'SHOW ME The WAY….TO GO HOME'….

The best way to time a walk (or anything else) is to act it out and time yourself with a stop-watch. Also, acting it out with a metronome is a great help.

I naturally think in seconds – 'one Mississippi' or 'one little monkey' or 'a thousand and one, a thousand and two' etc.

TAP

Ken Harris thought in feet, probably because he was so footage conscious – having to produce thirty feet of animation a week. He'd tap his upside-down pencil *exactly* every two thirds of a second as we'd act things out.

Milt Kahl told me that on his first week at Disney's he bought a stopwatch and went downtown in the lunch break and timed people walking – normal walks, people just going somewhere. He said they were *invariably* on twelve exposures – right on the nose. March time.

As a result, he used to beat off twelve exposures as his reference point. Anything he timed was just so much more or so much less than that twelve exposures. He said he used to say 'Well, it's about 8s.' He said it made it easy for him – or *easier* anyway.

Chuck Jones said the *Roadrunner* films had a musical tempo built into them. He'd time the whole film out, hitting things on a set beat so they had a musical, rhythmic integrity already built in. Then the musician could hit the beat, ignore it or run the music against it.

Chuck told me that they used to have exposure sheets with a coloured line printed right across the page for every sixteen frames and another one marking every twelve frames. He called them '16 sheets' or '12 sheets' I guess '8 sheets' would be the normal sheets.

I mentioned once to Art Babbitt that I liked the timing on the *Tom and Jerrys*. 'Oh yeah,' he said dismissively, 'All on 8s.'

That kind of tightly synchronized musical timing is rare today. They call it 'Mickey Mousing' where you accent everything – it's a derogatory term nowadays and considered corny. But it can be extremely effective.

In trying out walks, it's best to keep the figure simple. It's quick to do and easy to fix – easy to make changes.

ALSO, IN DOING THESE WALKS – TAKE A FEW STEPS ACROSS The PAGE OR SCREEN –

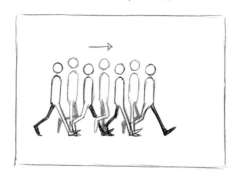

DON'T TRY TO WORK OUT A CYCLE WALKING IN PLACE WITH The FEET SLIDING BACK, ETC. THAT ALL BECOMES TOO TECHNICAL. WE WANT OUR BRAIN FREE TO CONCENTRATE ON AN INTERESTING WALK PROGRESSING FORWARD.

WE CAN WORK OUT A CYCLE FOR The WALK LATER... PERHAPS JUST FOR The FEET and BODY. BUT THEN HAVE The ARMS and the HEAD PERFORMING SEPARATELY.

CYCLES ARE MECHANICAL and LOOK JUST LIKE WHAT THEY ARE – CYCLES.

CHUCK JONES TELLS OF HIS TINY 3 YEAR OLD GRANDDAUGHTER SAYING, "GRANDAD, WHY DOES The SAME WAVE KEEP LAPPING ON The ISLAND?"

Incidentally, if you are using colours as I am here, it works just fine when you film them. I often have a lot of colours going at first, and you still see the action clearly.

Now we're going to start taking things out of the normal:

The PASSING POSITION OR BREAKDOWN

THERE'S A VERY SIMPLE WAY TO BUILD A WALK. START WITH JUST 3 DRAWINGS –

FIRST
WE MAKE OUR
TWO
CONTACT
POSITIONS –

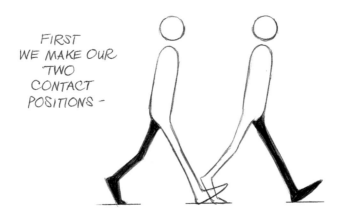

111

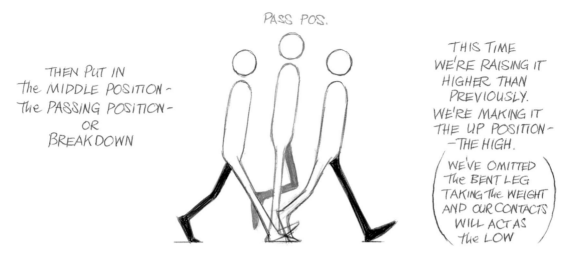

THEN PUT IN
the MIDDLE POSITION -
The PASSING POSITION -
OR
BREAKDOWN

PASS POS.

THIS TIME
WE'RE RAISING IT
HIGHER THAN
PREVIOUSLY.
WE'RE MAKING IT
THE UP POSITION -
- THE HIGH.

WE'VE OMITTED
The BENT LEG
TAKING THE WEIGHT
AND OUR CONTACTS
WILL ACT AS
the LOW

When we join these up with connecting drawings, the walk will still have a feeling of weight because of the up and down. We can make tremendous use of this simple three drawing device.

BUT LOOK WHAT HAPPENS IF WE GO DOWN ON THE PASSING POSITION!

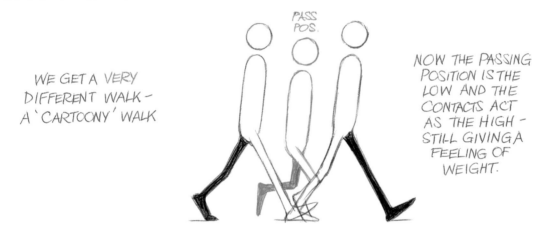

WE GET A VERY
DIFFERENT WALK -
A 'CARTOONY' WALK

PASS
POS.

NOW THE PASSING
POSITION IS THE
LOW AND THE
CONTACTS ACT
AS THE HIGH -
STILL GIVING A
FEELING OF
WEIGHT.

THE CRUCIAL THING IS THIS MIDDLE POSITION AND WHERE WE PUT IT.

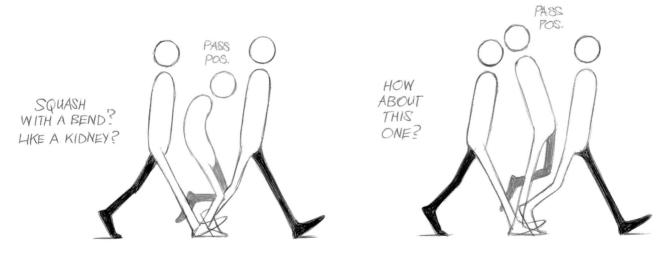

SQUASH
WITH A BEND?
LIKE A KIDNEY?

PASS
POS.

HOW
ABOUT
THIS
ONE?

PASS
POS.

THESE CONTACTS ARE ALL THE SAME BUT THE MIDDLE POSITION UTTERLY CHANGES THE WALK.

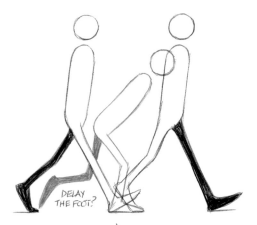

DELAY THE FOOT?

(OBVIOUSLY WE'LL NEED THE TIME TO ACCOMODATE BROAD MOVES LIKE THIS)

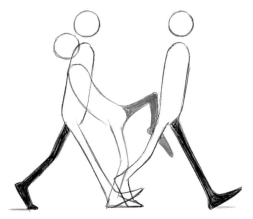

IN A SLOW STEP WE MIGHT GO AS FAR AS THIS—ALMOST A SNEAK.

WHAT IF THE FEET SWING OUT SIDEWAYS ON THE PASSING POSITIONS?

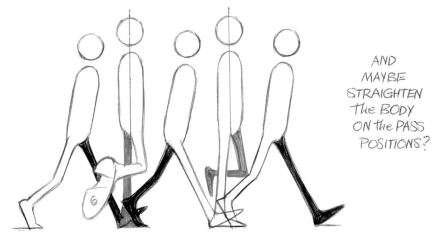

AND MAYBE STRAIGHTEN THE BODY ON THE PASS POSITIONS?

OR JUST TILT THE HEAD AND SHOULDERS SIDEWAYS ON THE PASS POSITIONS—

THE KEY THING IS WHERE DO WE WANT TO PUT THE MIDDLE POSITION—

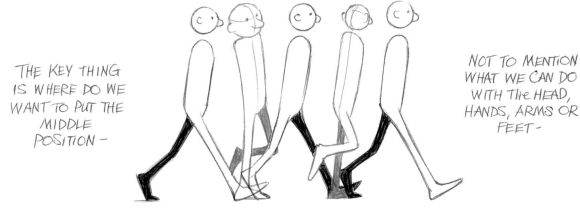

NOT TO MENTION WHAT WE CAN DO WITH THE HEAD, HANDS, ARMS OR FEET—

THE VARIATIONS ARE ENDLESS—

113

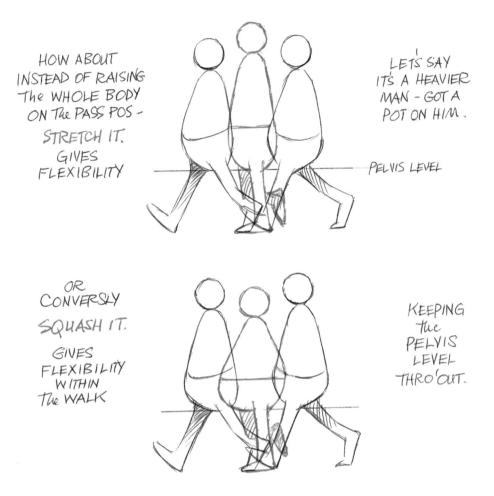

HOW ABOUT INSTEAD OF RAISING THE WHOLE BODY ON THE PASS POS - STRETCH IT. GIVES FLEXIBILITY

LETS SAY ITS A HEAVIER MAN - GOT A POT ON HIM.

PELVIS LEVEL

OR CONVERSLY SQUASH IT. GIVES FLEXIBILITY WITHIN THE WALK

KEEPING THE PELVIS LEVEL THRO'OUT.

To my knowledge, I think Art Babbitt may have been the first one to depart from the normal walk or the cliché cartoon walks. Certainly he was a great exponent of the 'invented' walk. He became famous for the eccentric walks he gave Goofy – which made Goofy into a star. He even put the feet on backwards! He made it look perfectly acceptable and people didn't realize they were backwards!

Art's whole credo was: 'Invent! Every rule in animation is there to be broken – if you have the inventiveness and curiosity to look beyond what exists.' In other words, 'Learn the rules and then learn how to break them.'

This opened up a whole Pandora's box of invention.

Art always said, 'The animation medium is very unusual. We can accomplish actions no human could possibly do. *And* make it look convincing!'

This eccentric passing position idea is a terrifically useful device. We can put it anywhere and where we put it has a huge effect on the action. And who says we can't put it anywhere we want? There's nothing to stop us.

114

For that matter, we can *keep on* breaking things down into weird places – provided we allow enough screen time to accommodate the movement.

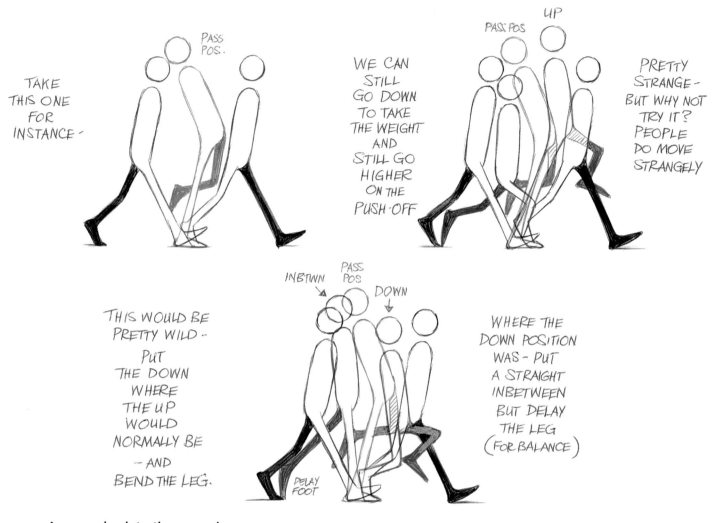

TAKE THIS ONE FOR INSTANCE –

PASS POS.

WE CAN STILL GO DOWN TO TAKE THE WEIGHT AND STILL GO HIGHER ON THE PUSH·OFF

PASS POS UP

PRETTY STRANGE – BUT WHY NOT TRY IT? PEOPLE DO MOVE STRANGELY

THIS WOULD BE PRETTY WILD – PUT THE DOWN WHERE THE UP WOULD NORMALLY BE – AND BEND THE LEG.

INBTWN PASS POS DOWN

DELAY FOOT

WHERE THE DOWN POSITION WAS – PUT A STRAIGHT INBETWEEN BUT DELAY THE LEG (FOR BALANCE)

Anyway, back to the normal:

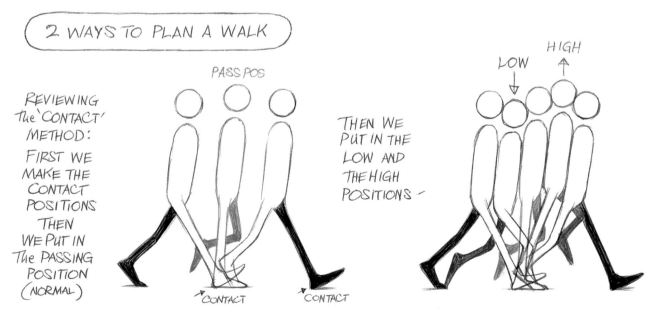

2 WAYS TO PLAN A WALK

REVIEWING The 'CONTACT' METHOD: FIRST WE MAKE THE CONTACT POSITIONS THEN WE PUT IN The PASSING POSITION (NORMAL)

PASS POS

CONTACT CONTACT

THEN WE PUT IN THE LOW AND THE HIGH POSITIONS –

LOW HIGH

I've found that this contact method is *the one that gets you through – takes you home*. It's especially suitable for natural actions – which is what we mostly have to do. I've found it to be the best way to do most things.

Milt Kahl worked this way. 'In a walk, or anything, I make the contact positions first – where the feet contact the ground with no weight on them yet. It's kind of a middle position for the head and body parts – neither an up or down. I know where the highs and lows are and then I break it down. Another reason I do it is because it makes a scene easy to plan.'

'I always start off with that contact because it's a dynamic, moving thing. And it's much better than starting with the weight already on the foot, which would be a very static pose!'*

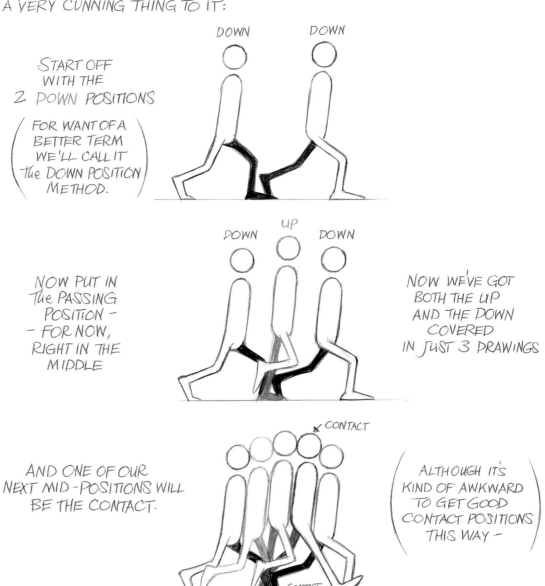

* WHICH IS EXACTLY WHAT THE SECOND SYSTEM DOES.

THIS IS THE WAY ART BABBITT OFTEN PLANNED A WALK – AND IT HAS A VERY CUNNING THING TO IT:

DOWN DOWN

START OFF WITH THE 2 DOWN POSITIONS

(FOR WANT OF A BETTER TERM WE'LL CALL IT The DOWN POSITION METHOD.)

DOWN UP DOWN

NOW PUT IN The PASSING POSITION – – FOR NOW, RIGHT IN THE MIDDLE

NOW WE'VE GOT BOTH THE UP AND THE DOWN COVERED IN JUST 3 DRAWINGS

CONTACT

AND ONE OF OUR NEXT MID-POSITIONS WILL BE THE CONTACT.

(ALTHOUGH IT'S KIND OF AWKWARD TO GET GOOD CONTACT POSITIONS THIS WAY –)

CONTACT

116

The cleverness of this approach is that we've already taken care of the up and down in the first three drawings. Of course, we can put the passing position up, down or sideways – anywhere we want. But having the downs already set helps us invent; it gives us a simple grid on which to get complicated, if we want.

We know it'll already have weight and so we're free to mess around and invent eccentric actions, or actions that couldn't happen in the real world.

Again, we're not stuck with one method or the other. Why not have both? Not only but also . . .

I highly recommend the contact approach for general use, but starting with the down position is very useful for unconventional invention.

From now on we'll use both approaches.

IT'S KIND OF ACADEMIC, BUT IF WE TAKE BOTH METHODS...

AND PUSH THEM TOGETHER–

CONTACT METHOD DOWN POS. METHOD

– WE GET ALL THE UP and DOWN PHASES OF A NORMAL WALK.
 IT'S THE SAME THING. WE'RE JUST STARTING OFF ONE PHASE EARLIER OR ONE PHASE LATER.

117

the DOUBLE BOUNCE

'Truckin' on down.' The double bounce walk shows energetic optimism – the North American 'can do' attitude. They used this walk like mad in the early 1930s – lots of characters (bugs and things) all trucking around doing jazzy double bounces.

THE IDEA IS 2 BOUNCES PER STEP. YOU BOUNCE TWICE.
YOU GO DOWN (OR UP) TWICE INSTEAD OF ONCE TO THE STEP.

SAY IT'S A 16 FRAME STEP (ON ONES BECAUSE THERE'S A LOT GOING ON.)
WE'LL START WITH THE BENT LEG DOWN – SPREAD THE LEGS APART FOR CLARITY:

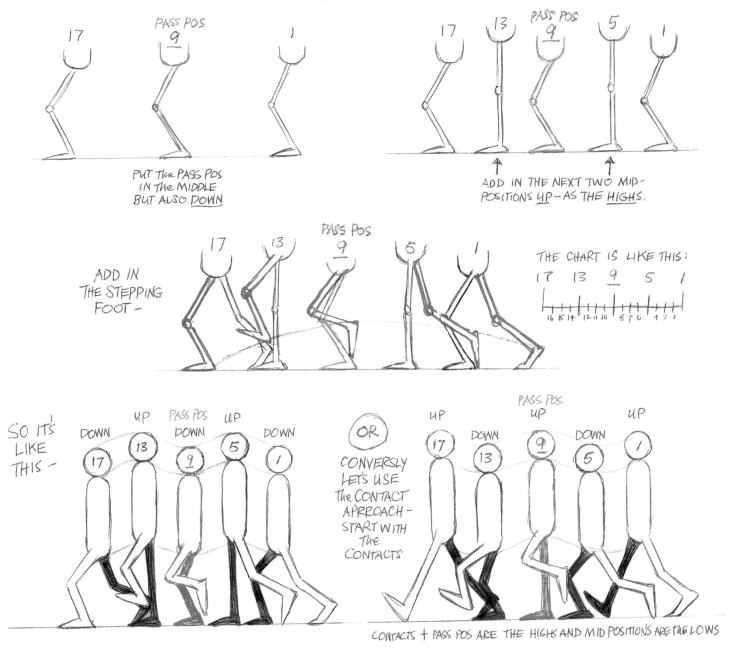

PUT THE PASS POS
IN THE MIDDLE
BUT ALSO DOWN

ADD IN THE NEXT TWO MID-
POSITIONS UP – AS THE HIGHS.

ADD IN
THE STEPPING
FOOT –

THE CHART IS LIKE THIS:

SO IT'S
LIKE
THIS –

OR

CONVERSLY
LET'S USE
THE CONTACT
APPROACH –
START WITH
THE
CONTACTS

CONTACTS + PASS POS ARE THE HIGHS AND MID POSITIONS ARE THE LOWS

I MADE THIS DOUBLE BOUNCE WALK BY COMBINING THE TWO APPROACHES.
I DID THE STRAIGHT LEG CONTACTS FIRST, BUT ALSO MADE THEM THE LOW - THE DOWN.

THIS IS ON ONES - TAKING ONE STEP OF A WALK ON 12's

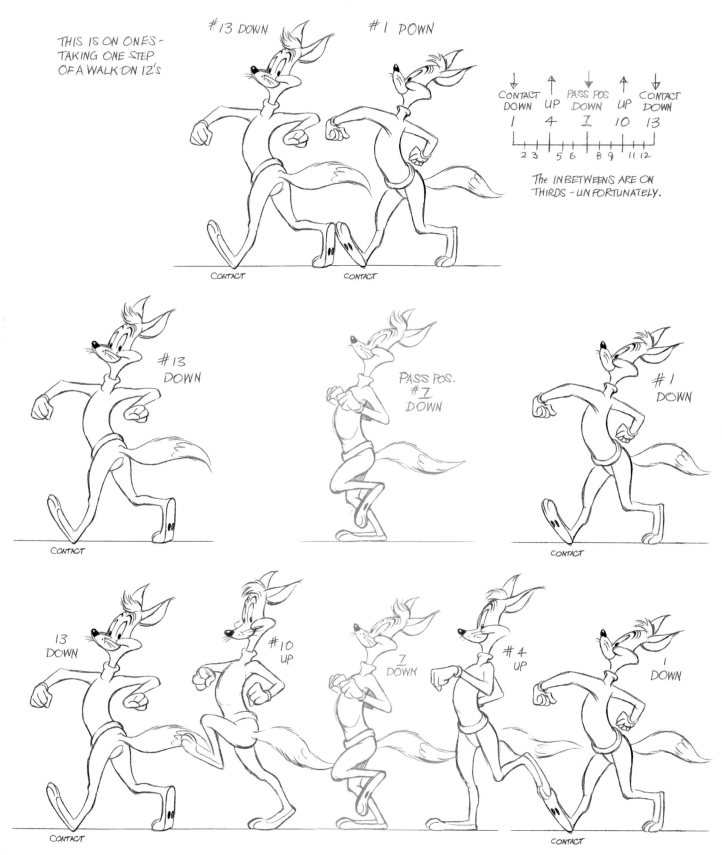

#13 DOWN

#1 DOWN

CONTACT DOWN ↓ 1
UP ↑ 4
PASS POS DOWN ↓ 7
UP ↑ 10
CONTACT DOWN ↓ 13

2 3 5 6 8 9 11 12

The IN BETWEENS ARE ON THIRDS - UNFORTUNATELY.

CONTACT CONTACT

#13 DOWN

PASS POS. #7 DOWN

#1 DOWN

CONTACT CONTACT

13 DOWN

#10 UP

7 DOWN

#4 UP

1 DOWN

CONTACT CONTACT

119

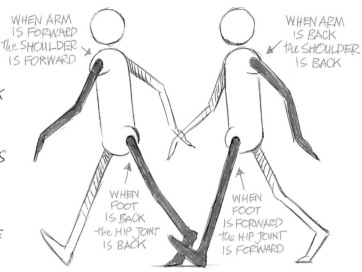

WHEN ARM IS FORWARD THE SHOULDER IS FORWARD

WHEN ARM IS BACK THE SHOULDER IS BACK

WHEN FOOT IS BACK the HIP JOINT IS BACK

WHEN FOOT IS FORWARD the HIP JOINT IS FORWARD

WE'LL START OUT WITH THIS SIMPLE CLICHÉ WALK — NOTHING FANCY YET.

THE ARMS NORMALLY WILL MOVE OPPOSITE TO THE LEGS — BUT SIMPLY BY HAVING THE SHOULDERS OPPOSING THE LEGS WILL GIVE IT MORE LIFE

(FRONT VIEW PULLING IT APART FOR CLARITY)

NOW LET'S TILT THE SHOULDERS FOR SOME VITALITY —

WE'RE TAKING OUR BASIC PLAN NOW AND ADDING IN THINGS TO BUILD ON The SYSTEM.

PASS POS.

HIP and SHOULDER LINE OPPOSE EACH OTHER

ON THE PASSING POSITION HIPS AND SHOULDERS ARE MORE OR LESS STRAIGHT

NOW LET'S DO SOMETHING WITH THE HEAD TO MAKE THIS SIMPLE FORMULA WALK MORE INTERESTING —

LET'S TILT THE HEAD:

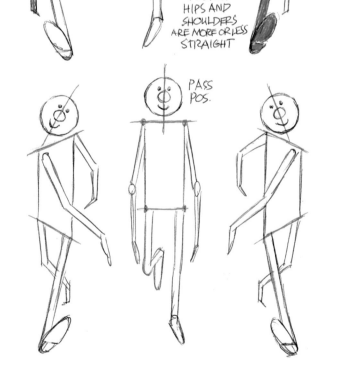

PASS POS.

HOW ABOUT THIS?
LETS DELAY
the TILT OF the HEAD
ON THE
PASSING POSITION

PASS POS. PASS POS.

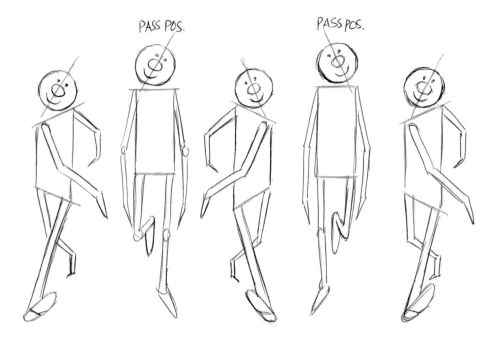

LET'S DO
SOMETHING ELSE
WITH THE HEAD —
STICK THE HEAD OUT
ON The
PASSING POSITION

(GIVES A SLIGHT
PIGEON EFFECT)

PASS POS.

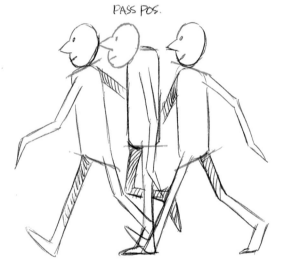

ONE SMALL
DETAIL THATS
DIFFERENT
WILL GIVE A
WHOLE DIFFERENT
FEELING TO
the FORMULA

OR

THE HEAD
GOES FORWARD
AND CONTINUES
AT THE
END OF THE STEP

HEAD TILTS
AS IT
GOES OUT

PASS POS

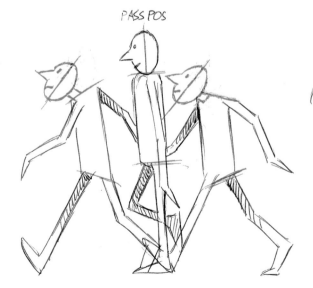

BACK VIEW

121

ANY SMALL DETAIL ALTERS A WALK—
LIKE MOVING THE HEAD UP OR DOWN—
OR TILTING IT FROM SIDE TO SIDE—

OR MOVING IT
BACK AND FORTH—

OR A COMBINATION
OF ANY OF THIS.

CAN THINK
OF IT
AS A CUBE.

THE EGOTIST'S WOBBLE HEAD—

YOU SEE THIS A LOT WITH
POLITICIANS, ACTORS OR PEOPLE
WHO IMAGINE
THE CAMERA IS ON THEM
ALL THE TIME.

SOME COMEDIANS DO IT
WHEN THEY GET A BIG
AUDIENCE RESPONSE.

IN HOLLYWOOD
I'VE EVEN SEEN
THE MAILMAN
DOING IT.

UP PASS POS DOWN

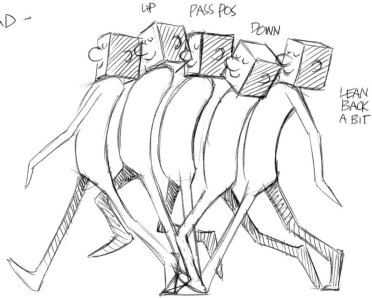

LEAN
BACK
A BIT

FLOATING ALONG
IN LOVE WITH ITSELF
'ITS WONDERFUL,
TO BE WONDERFUL'
WILL WORK NICELY
WITH
NOT MUCH UP and DOWN

SLIGHT UP SLIGHT
 DOWN

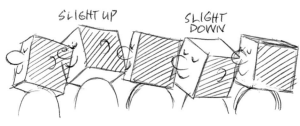

WHEN I WAS A KID
I ALWAYS WONDERED
WHY ANIMATORS DREW
HEADS LIKE THIS—
WITH CONSTRUCTION
LINES ON THEM.

NOW I KNOW
WHY—
THEY'RE TURNING
MASSES
ALL THE TIME.

122

 A CAUTIONARY NOTE FROM KEN HARRIS:

FOR WALKS, DON'T MAKE CYCLES OF BODY AND HEAD ACTION
IN CIRCLES OR FIGURE 8's —

IF YOU DO IT WILL LOOK LIKE A BIRD OR PIGEON WALK (UNLESS YOU WANT THAT.)

DON'T

DON'T

DO

FOR SAFETY KEEP THE <u>MASS</u>
<u>MOSTLY</u> STRAIGHT UP AND DOWN.

BUT BEARING THIS IN MIND WE SHOULD STILL BE BRAVE AND TRY THINGS...

BUILDING ON OUR BASIC PLAN, WE'VE ALREADY ADDED IN MORE ACTION
IN THE HEAD, SHOULDERS, ARMS, HIPS AND FEET:

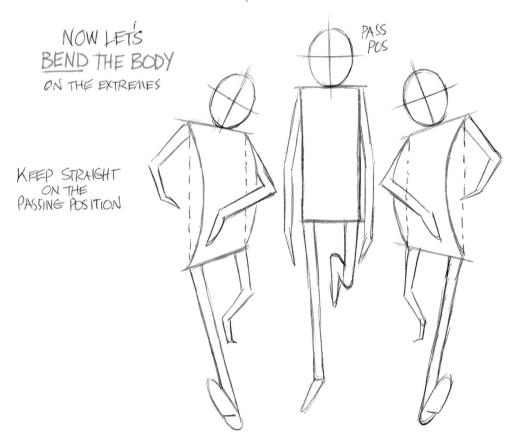

NOW LET'S
<u>BEND</u> THE BODY
ON THE EXTREMES

PASS
POS

KEEP STRAIGHT
ON THE
PASSING POSITION

AND NOW WE'RE GOING TO DO THINGS TO THE LEGS and ARMS THAT LOOKS WEIRD.

123

WE'RE GOING TO 'BREAK' THE LEG.
WE'RE GOING TO BEND IT WHETHER IT WOULD BEND THAT WAY OR NOT.

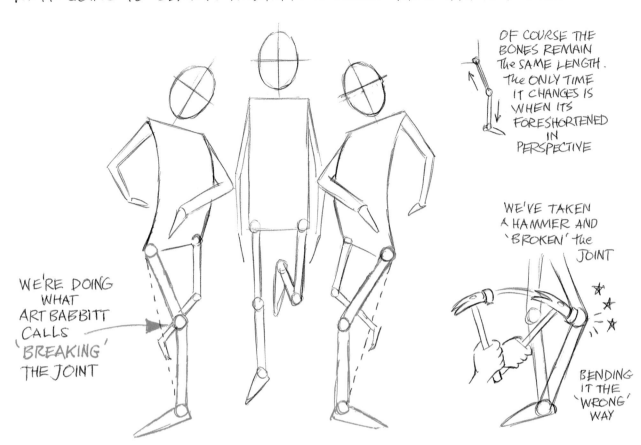

OF COURSE THE BONES REMAIN THE SAME LENGTH. THE ONLY TIME IT CHANGES IS WHEN ITS FORESHORTENED IN PERSPECTIVE

WE'VE TAKEN A HAMMER AND 'BROKEN' THE JOINT

WE'RE DOING WHAT ART BABBITT CALLS 'BREAKING' THE JOINT

BENDING IT THE 'WRONG' WAY

IT LOOKS WEIRD ENOUGH, BUT IF WE DRAW A BALLET DANCER ON TOP OF IT, IT LOOKS JUST FINE.

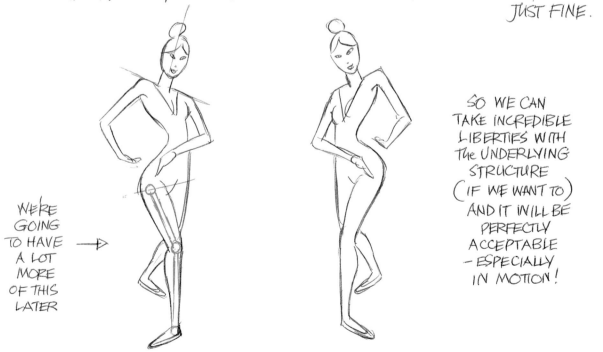

WE'RE GOING TO HAVE A LOT MORE OF THIS LATER

SO WE CAN TAKE INCREDIBLE LIBERTIES WITH THE UNDERLYING STRUCTURE (IF WE WANT TO) AND IT WILL BE PERFECTLY ACCEPTABLE – ESPECIALLY IN MOTION!

EVERYTHING WE'RE DOING IS TO GET MORE CHANGE, MORE ACTION WITHIN THE ACTION.

TO LIMBER THINGS UP - GET MORE LIFE INTO IT.

Grim Natwick said:

'We used to bet ten dollars against ten cents that you could take any character and walk it across the room and get a laugh out of it.

'We used to have about twenty-four different walks. We'd have a certain action on the body, a certain motion on the head, a certain kind of patter walk, a big step or the "Goofy" walk that Art Babbitt developed.

'While the opposite arm naturally moves with the opposite leg, we'd break the rules eight or ten different ways to make the walk interesting.'

WE'RE TAKING OUR BASIC PLAN NOW AND ADDING IN THINGS TO BUILD UPON THE SYSTEM.

SAY WE HAVE A KIND OF ANGRY WALK - WE'D NORMALLY DO THIS:

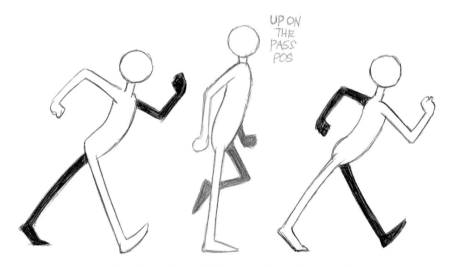

BUT LOOK WHAT HAPPENS WHEN WE DO JUST 2 THINGS -

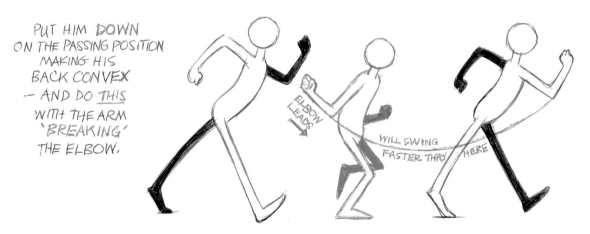

PUT HIM DOWN ON THE PASSING POSITION MAKING HIS BACK CONVEX -- AND DO THIS WITH THE ARM 'BREAKING' THE ELBOW.

125

LET'S TAKE THIS ANGRY WALK MUCH FURTHER—

THIS IS THE KIND OF THING ART BABBITT DID ALL HIS LIFE — MAKING IMPOSSIBLE MOVES LOOK CONVINCING and BELIEVABLE. HE'D SAY, "BE A LITTLE BIT TRUTHFUL"..

SO IT DOESN'T JUST LOOK LIKE ONE STEP REPEATING WE SLIGHTLY CHANGE the SILHOUETTE ON the 2ND CONTACT (#15) SO THE COUNTER ARM POSITIONS ARE DIFFERENT FROM CONTACT #1. ON THE CONTACTS THE BACK LEG IS 'BROKEN' AND THE FOOT SWIVELLED BACKWARDS.

HE'S ON TWOS — EACH STEP TAKING 14 FRAMES.

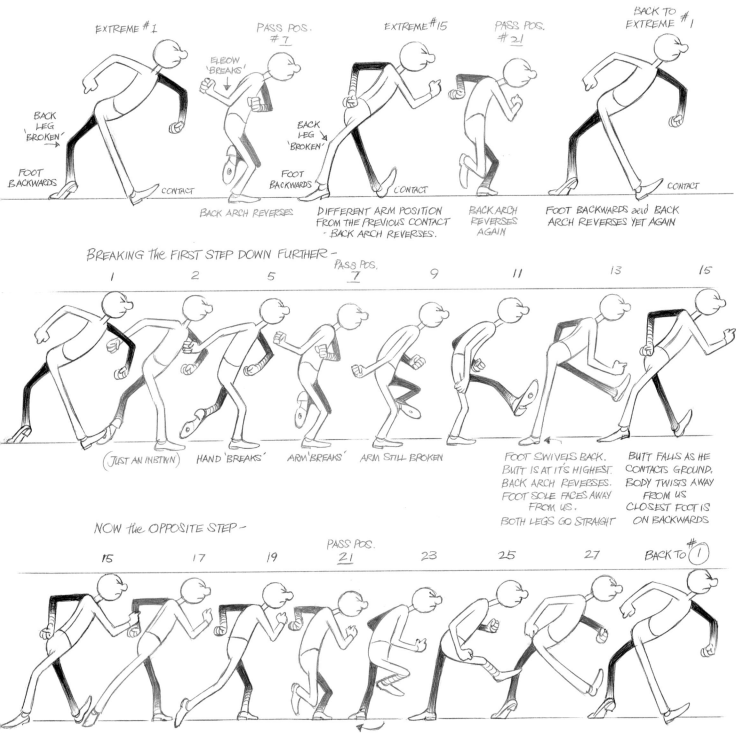

EXTREME #1

BACK LEG 'BROKEN'

FOOT BACKWARDS

CONTACT

PASS POS. #7

ELBOW 'BREAKS'

BACK LEG 'BROKEN'

FOOT BACKWARDS

BACK ARCH REVERSES

EXTREME #15

CONTACT

DIFFERENT ARM POSITION FROM THE PREVIOUS CONTACT - BACK ARCH REVERSES.

PASS POS. #21

BACK ARCH REVERSES AGAIN

BACK TO EXTREME #1

CONTACT

FOOT BACKWARDS and BACK ARCH REVERSES YET AGAIN

BREAKING the FIRST STEP DOWN FURTHER—

| 1 | 2 | 5 | PASS POS. 7 | 9 | 11 | 13 | 15 |

(JUST AN INBTWN) HAND 'BREAKS' ARM 'BREAKS' ARM STILL BROKEN

FOOT SWIVELS BACK. BUTT IS AT IT'S HIGHEST. BACK ARCH REVERSES. FOOT SOLE FACES AWAY FROM US. BOTH LEGS GO STRAIGHT

BUTT FALLS AS HE CONTACTS GROUND. BODY TWISTS AWAY FROM US CLOSEST FOOT IS ON BACKWARDS

NOW the OPPOSITE STEP—

| 15 | 17 | 19 | PASS POS. 21 | 23 | 25 | 27 | BACK TO #1 |

The ARM SWING DOESN'T 'BREAK' — AND the FOOT SWIVELS BACK EARLIER — THE REST OF the PATTERN IS the SAME.

126

INCIDENTALLY, ON A PROFILE WALK IT HELPS TO HAVE ONE FOOT
A LITTLE IN FRONT – AND ANGLED SIDEWAYS A BIT. (I'VE BEEN KEEPING THINGS
VERY DIAGRAMMATIC TILL NOW)

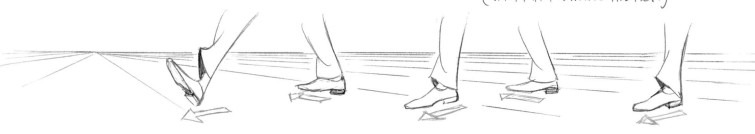

LET'S KEEP TAKING THINGS OUT OF THE ORDINARY –
WHY NOT A SIMPLE REVERSAL OF THE UP AND DOWN OF A NORMAL WALK?

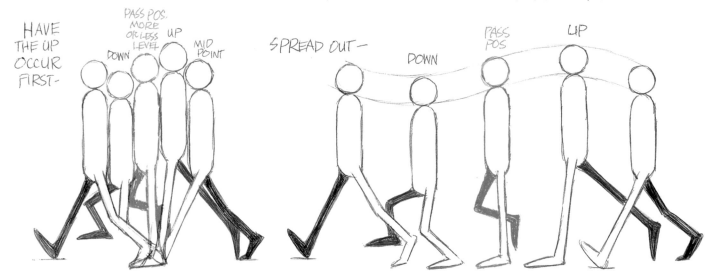

HAVE THE UP OCCUR FIRST–

PASS POS. MORE OR LESS LEVEL

DOWN

UP

MID POINT

SPREAD OUT–

DOWN

PASS POS

UP

STILL KEEPING TO OUR 3 MAIN POSITIONS –

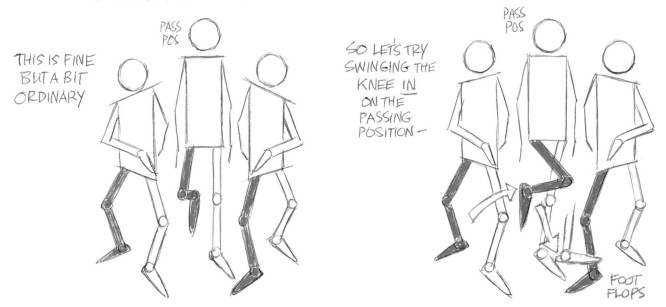

THIS IS FINE BUT A BIT ORDINARY

PASS POS

SO LET'S TRY SWINGING THE KNEE IN ON THE PASSING POSITION –

PASS POS

FOOT FLOPS

127

DIGGING DEEPER INTO WALKS

HERE'S A KIND OF STRUT.

LET'S BEND THE BODIES OUTWARDS ON THE EXTREMES - HEADS, SHOULDERS, HIPS TILTED.
PUT THE PASSING POSITION DOWN AND SWING THE LEG INWARDS AND 'BREAK' THE SUPPORT
LEG - KIND OF KNOCK-KNEED - THIS'LL GIVE AN INTERESTING RESULT.

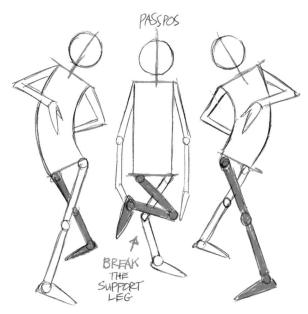

NOW LET'S TAKE THE SAME EXTREMES AND PUT THE PASSING POSITION UP AND WE'LL
STRAIGHTEN THE SUPPORT LEG TO LIFT HIM UP AND SWING THE PASSING LEG INWARDS
AS PREVIOUSLY.

BUT MAKE THE NEXT BREAKDOWN DOWN (AS NORMAL) WITH THE LEG ANGLING OUTWARDS
AND THE OTHER BREAKDOWN JUST COMING FORWARDS (THE BODY JUST INBETWEEN)
 - EXCEPT FOR THE LEG)

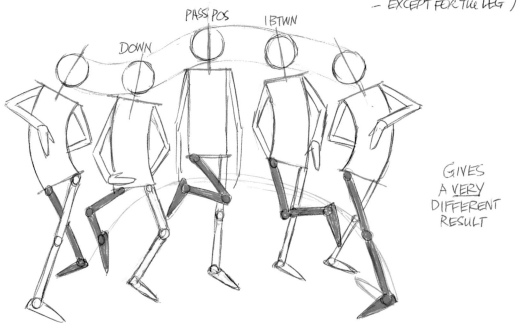

GIVES
A VERY
DIFFERENT
RESULT

128

WE CAN GO ON FOREVER THIS WAY, ALTERING BITS AND SWITCHING THINGS AROUND ON OUR BASIC 3 DRAWING PLAN.

HOW ABOUT THIS? KEEP THE SAME 2 STARTING EXTREMES BUT USE THE BENT LEGS POSITION. PUT THE PASSING POSITION UP.

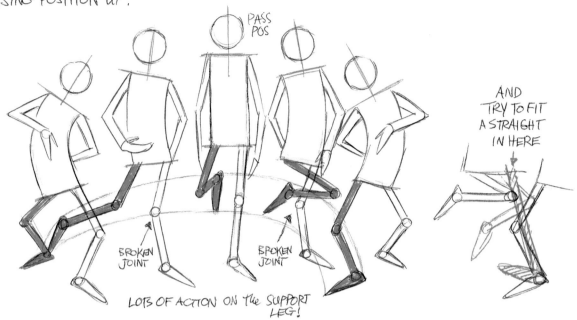

PASS
POS

AND TRY TO FIT A STRAIGHT IN HERE

BROKEN JOINT

BROKEN JOINT

LOTS OF ACTION ON THE SUPPORT LEG!

HOW ABOUT ONE LIKE THIS?
START WITH KNOCK KNEES - ('BROKEN' JOINTED LEGS)

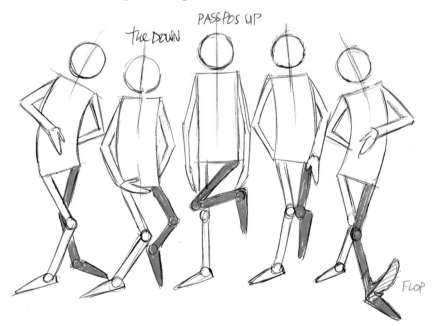

THE DOWN

PASS POS UP

FLOP

WHAT WE'RE TRYING TO PUT OVER HERE IS A WAY OF THINKING ABOUT IT. A SIMPLE GRID ON WHICH TO BUILD QUITE NORMAL WALKS - OR WILDLY ECCENTRIC ONES - AND ALL THAT LIES BETWEEN.

129

HERE'S A KIND OF FEMININE WALK ON THE SAME BASIC FIGURE—

PASS POS

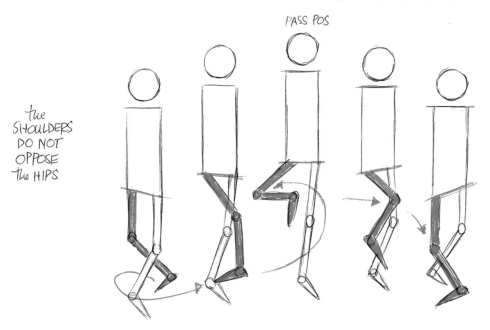

the SHOULDERS DO NOT OPPOSE the HIPS

THE VARIATIONS ARE ENDLESS...

TILT SHOULDERS AND HEAD ON PASS POS.

AND I MAGINE WHAT WE CAN GET UP TO WHEN WE STOP TREATING THE BODY LIKE A BLOCK.

WE START TWISTING THINGS—

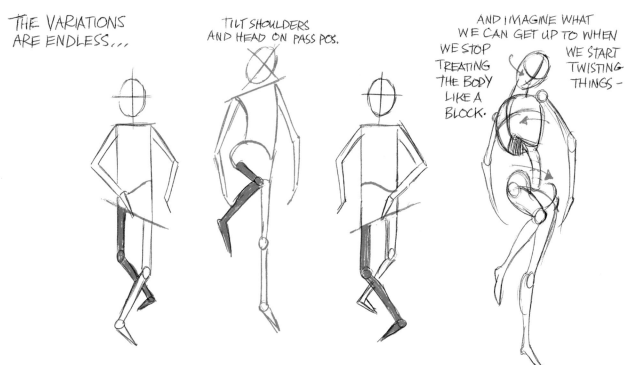

EVEN IF THE ACTIONS ARE IMPOSSIBLE (BROKEN JOINTS, ETC.) TO DO — ITS A GOOD IDEA TO ACT OUT ALL THE BUSINESS TO SEE WHETHER IT WILL FIT INTO THE TIME ALLOTTED. DISCARD ALL MODESTY AND ACT IT OUT.

WHEN I ASKED MILT KAHL ABOUT A MARVELLOUS FEMALE WALK HE'D ANIMATED, HE SAID, "I CLOSED THE DOOR, BUT IF YOU'D SEEN ME DOING IT YOU'D HAVE WANTED TO KISS ME."

130

LETS TRY
THIS ONE -

MAKE
THE
PASSING
POSITION
DOWN
BUT ALTER
THE LEFT LEG
LIKE THIS -

PULLED
APART -

ADD IN #5
AS AN
IN BETWEEN
BUT
MAKE #13
THE HIGH
and KEEP
ITS FOOT
FLAT

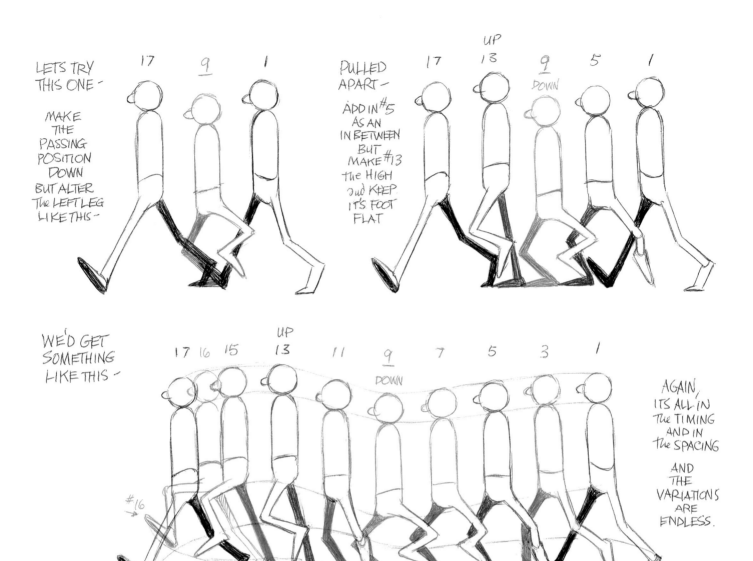

WE'D GET
SOMETHING
LIKE THIS -

AGAIN,
ITS ALL IN
THE TIMING
AND IN
THE SPACING

AND
THE
VARIATIONS
ARE
ENDLESS.

#16

KEEP FOOT
FLAT

DELAY
FOOT

LETS SIMPLY CHANGE the TILT OF THE BODY ON the PASSING POSITION -

(ON 8's)

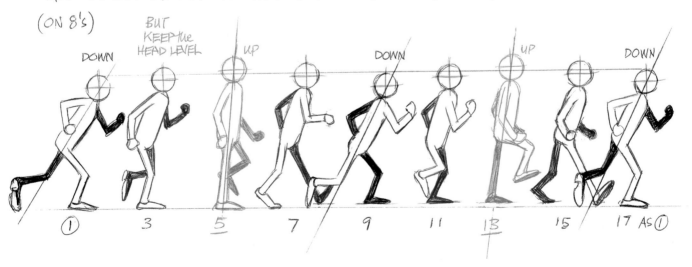

DOWN BUT
 KEEP the
 HEAD LEVEL UP DOWN UP DOWN

① 3 5 7 9 11 13 15 17 AS ①

AND WE SHOULDN'T BE AFRAID TO TAKE LIBERTIES AND DISTORT THINGS- ESPECIALLY FOR FAST ACTION.
(ON ONES)

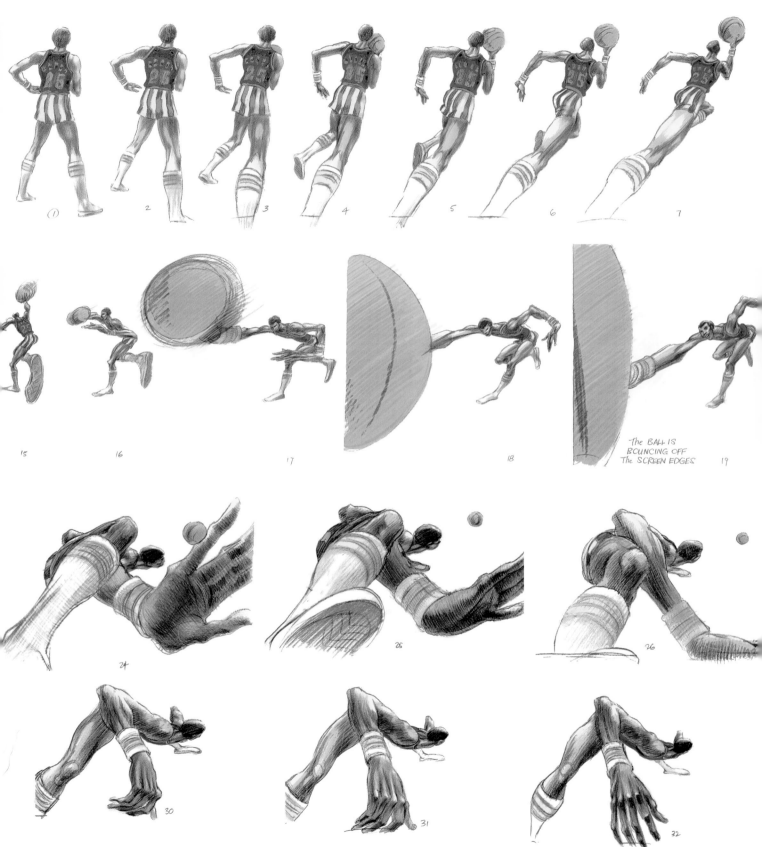

The BALL IS
BOUNCING OFF
The SCREEN EDGES

I'M INCLUDING THIS BASKETBALL FIGURE I ANIMATED - JUST TO SHOW HOW FAR WE CAN GO (IT WORKED FINE.)

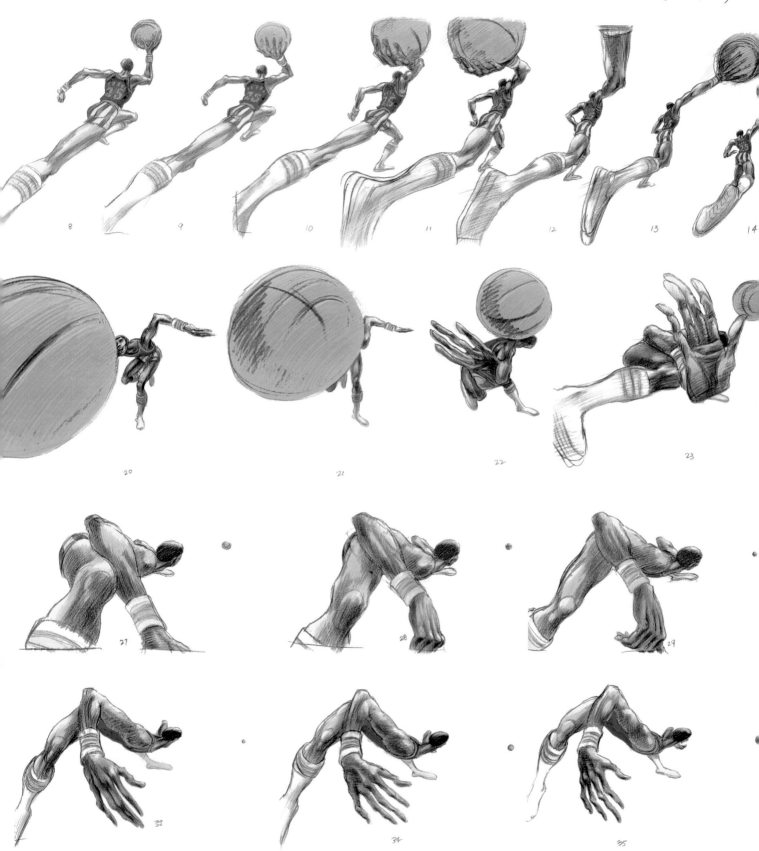

133

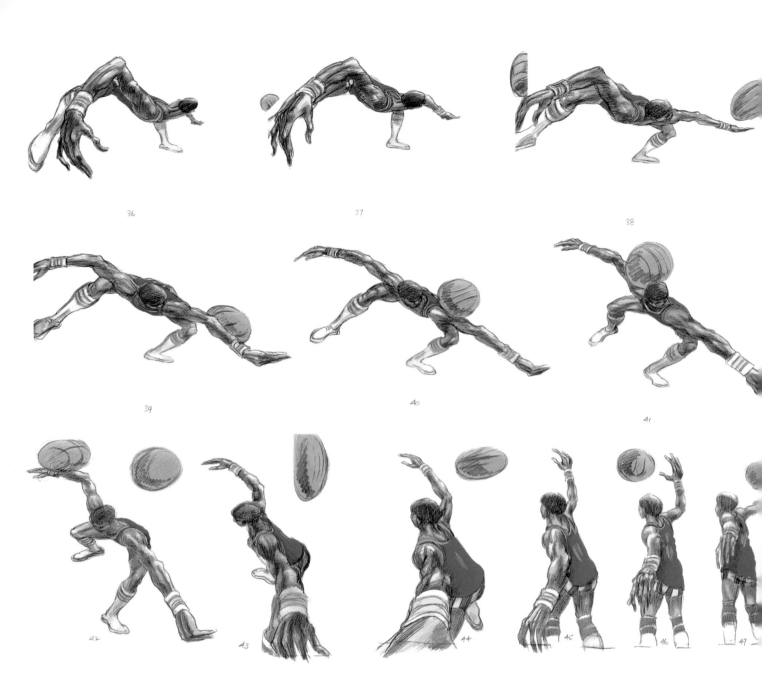

CONCLUSION:

WE CAN TAKE GREAT LIBERTIES
WITH FAST ACTIONS — EVEN
WITH REALISTIC FIGURES.

IT'S OBVIOUS THAT FOR REALLY
FAST ACTIONS YOU HAVE TO
 MAKE EVERY DRAWING —
AN ASSISTANT (FOR THIS) MIGHT
BE A HELP SHADING MUSCLES
OR STRIPES BUT NOT MUCH ELSE.
MILT KAHL.
 'IF IT'S FAST ACTION
 I MAKE EVERY DRAWING'

INNUMERABLE POSSIBILITIES EXIST.

WE'RE NOT COPYING LIFE, WE'RE MAKING A COMMENT ON IT.

AND IF WE MAKE A MISTAKE, WHO CARES? IT'S JUST A TEST. MAKE THE CORRECTIONS AND TEST AGAIN. HALF THE TIME WE'LL FALL ON OUR FACES - BUT THE OTHER HALF OF THE TIME IT'LL WORK AND BE NEW.

HERE'S A RULE BREAKER -

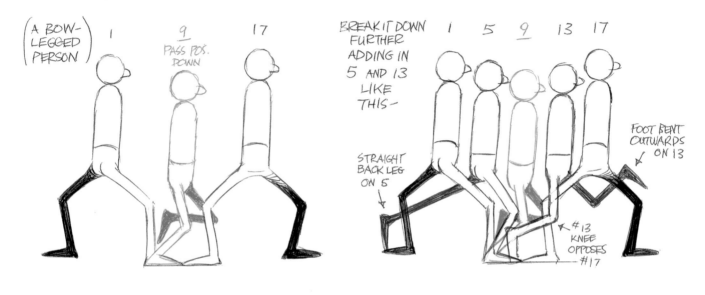

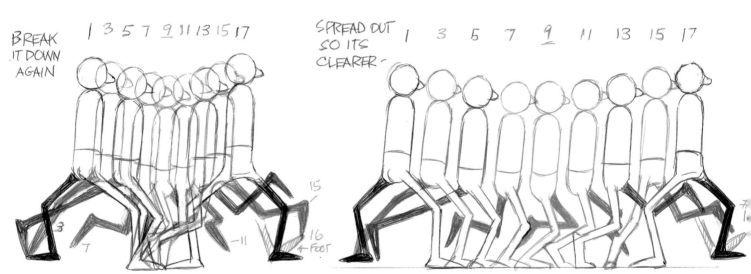

AND WE HAVEN'T DONE ANYTHING WITH THE HEAD OR ARMS. MAYBE WITH SUCH ACTION ON THE FEET WE SHOULD KEEP THE ARMS and HEAD VERY CONSERVATIVE - MAYBE, MAYBE NOT. THIS WILL WORK ON TWO'S - BUT BE BETTER WITH ONES ADDED BECAUSE OF THE BROAD SPACING

BACK TO NORMALCY FOR A BIT—

THE HEEL

The HEEL IS THE LEAD PART.
The FOOT IS SECONDARY and FOLLOWS ALONG,
The HEEL LEADS and the ACTUAL FOOT DRAGS BEHIND
and FLOPS FORWARD — BUT The HEEL CONTROLS IT.

A POWER

FOR WALKS and RUNS—

LOCK the HEEL FLAT ON the GROUND FOR The FEELING OF WEIGHT.
KEEP The FOOT BACK TILL The LAST POSSIBLE MOMENT.

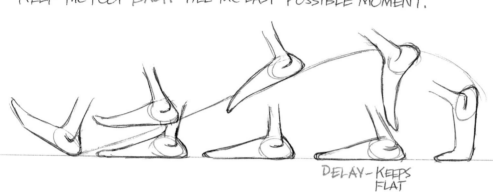

AND
RELUCTANTLY
LEAVES the
GROUND

DELAY — KEEPS
FLAT

AND
DRAPERY
IS
ALWAYS
LATE —

DRAG

DRAG

DRAG

FLOP

PANTLEG
CATCHES UP —
GIVES AN
ADDITIONAL
BIT OF LIFE

FOOT ACTION

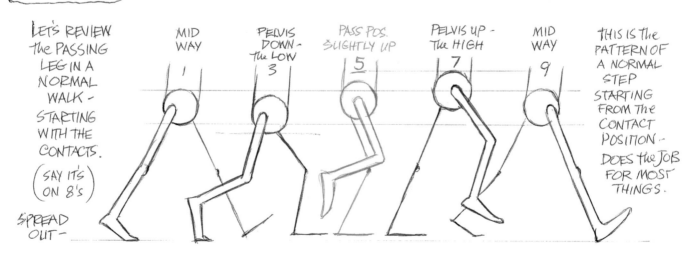

LET'S REVIEW
the PASSING
LEG IN A
NORMAL
WALK —
STARTING
WITH THE
CONTACTS.
(SAY IT'S
ON 8'S)

SPREAD
OUT—

MID
WAY
1

PELVIS
DOWN —
The LOW
3

PASS POS.
SLIGHTLY UP
5

PELVIS UP —
The HIGH
7

MID
WAY
9

THIS IS THE
PATTERN OF
A NORMAL
STEP
STARTING
FROM The
CONTACT
POSITION —
DOES the JOB
FOR MOST
THINGS.

136

BUT LET'S START
WITH THE 2 DOWNS -

As Milf says,
IT'S KIND OF A
STATIC POSITION -

BUT WITH THE
PASSING POSITION UP
WE'VE TAKEN
CARE OF OUR
UPS AND DOWNS.

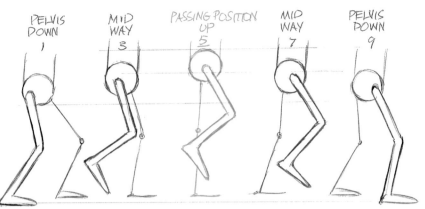

PELVIS DOWN — 1
MID WAY — 3
PASSING POSITION UP — 5
MID WAY — 7
PELVIS DOWN — 9

NOW WE
DON'T HAVE
TO THINK
ABOUT THE
UPS and DOWNS
AND WE CAN
CONCENTRATE
ON DOING
THINGS WITH
THE FEET.

THIS TIME MAKE BOTH FEET FLAT

PUSH IT ALL
TOGETHER
AS IT
WOULD BE
TO TAKE A
NORMAL
STEP -

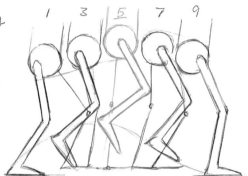

1 3 5 7 9

THEN ADD IN
STRAIGHT
IN BETWEENS
AND WE GET
A PATHETIC
APPROACH
TO A WALK -

WEAK,
BORING...

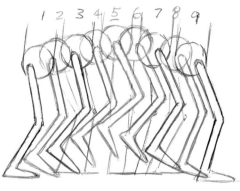

1 2 3 4 5 6 7 8 9

NOW START
WITH THE
EXACT
SAME
THING -

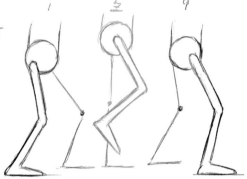

1 5 9

BUT
ALTER
THE NEXT
TWO
BREAKDOWNS -
3 AND 7

= MORE
CHANGE,
MORE
VITALITY

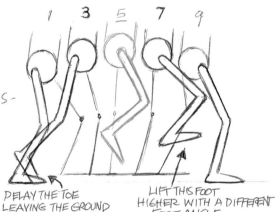

1 3 5 7 9

DELAY THE TOE
LEAVING THE GROUND

LIFT THIS FOOT
HIGHER WITH A DIFFERENT
FOOT ANGLE

ADD IN
STRAIGHT
IN BETWEENS

(BEARING IN MIND
THAT THE HEEL
LEADS AND THE
FOOT FOLLOWS
AND
WATCH
THE ARCS !)

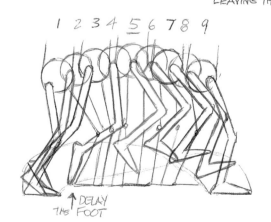

1 2 3 4 5 6 7 8 9

DELAY
THE FOOT

IT'S OBVIOUS
WE'VE GOT MORE
LIFE IN IT
NOW.

137

NOW LET'S MAKE IT MORE SPRIGHTLY.

MAKE #3 STRAIGHT AS IT PUSHES OFF

and MAKE #7 STRAIGHT AS IT CONTACTS the GROUND.

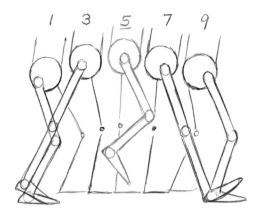

NOW WE'VE GOT SOME CHANGES!

BENT TO STRAIGHT
—TO BENT
—TO STRAIGHT
—TO BENT.

(ALTHOUGH SO FAR THIS ISN'T REALLY VERY DIFFERENT THAN WE'D END UP WITH IF WE'D STARTED FROM OUR CONTACT METHOD.)

ANYWAY - ADD IN STRAIGHT IN BETWEENS

EXCEPT KEEP the FOOT SOLE FLAT ON #2 AND HAVE THE FOOT ON #8 FLAT LIKE #9

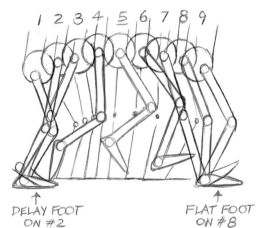

DELAY FOOT ON #2

FLAT FOOT ON #8

WE'VE GOT CHANGE AND VITALITY -

the LEG AND FOOT PASS FAST THROUGH the MIDDLE AND CLUSTER AT the BEGINNING and END of the STEP.

NOW WE'LL FIND METHOD IN THE MADNESS -

HERE'S WHAT ART BABBITT MIGHT DO -

START WITH the SAME 3 BASIC POSITIONS

BUT PUT #1's FOOT ON BACKWARDS →

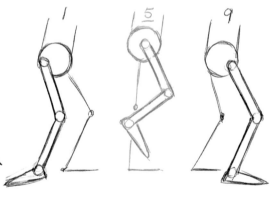

LEAVE the PASSING POSITION AS IS, BUT DELAY the FOOT ON #3 and MAKE the FOOT ON #7 BACKWARDS AGAIN.

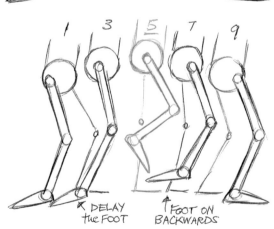

DELAY the FOOT

FOOT ON BACKWARDS

NOW ADD IN
2, 4. 6 and 8

2 AND 8
ARE ALSO
ECCENTRIC

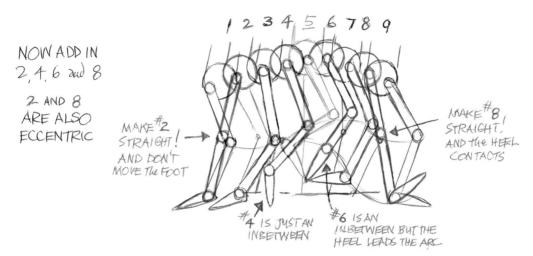

MAKE #2
STRAIGHT!
AND DON'T
MOVE The FOOT

MAKE #8
STRAIGHT!
AND The HEEL
CONTACTS

#4 IS JUST AN
INBETWEEN

#6 IS AN
INBETWEEN BUT THE
HEEL LEADS THE ARC

THIS WAY OF WORKING AND THINKING IS THE BASIS OF THE KIND OF THING ART DID WITH HIS 'GOOFY' WALKS. IT HAD A TERRIFIC INFLUENCE ON ANIMATORS.

ART ALWAYS SAID,

'WHEN WE'VE GOT AN OPPORTUNITY TO INVENT — CERTAINLY WE'VE GOT THE RIGHT MEDIUM FOR IT.
THAT'S WHAT SEPARATES US FROM LIVE ACTION — WE CAN INVENT.'

NORMALLY A FOOT PICKS UP SLOWLY —

THEN TRAVELS QUICKLY THROUGH THE MIDDLE

AND PUTS DOWN FAST.

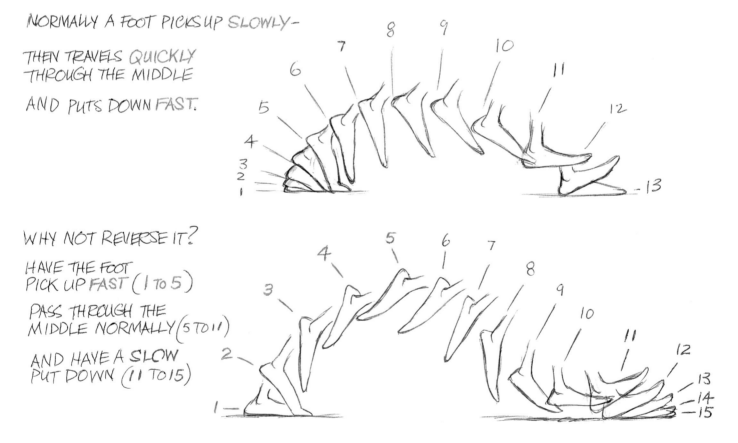

WHY NOT REVERSE IT?

HAVE THE FOOT PICK UP FAST (1 TO 5)

PASS THROUGH THE MIDDLE NORMALLY (5 TO 11)

AND HAVE A SLOW PUT DOWN (11 TO 15)

AND THIS IS EXACTLY WHAT THE LIVE ACTION MIME ON THE NEXT 2 PAGES IS DOING —

139

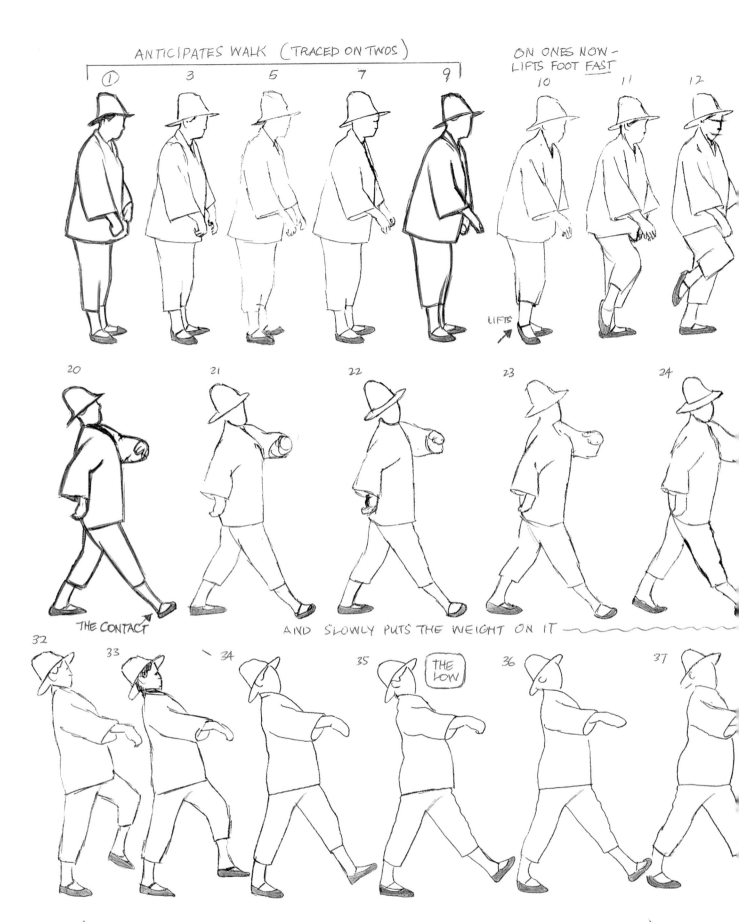

ANTICIPATES WALK (TRACED ON TWOS)

ON ONES NOW — LIFTS FOOT FAST

① 3 5 7 9 10 11 12

LIFTS

20 21 22 23 24

THE CONTACT

AND SLOWLY PUTS THE WEIGHT ON IT

32 33 34 35 THE LOW 36 37

(HER STARTING STEP TAKES 12 FRAMES — HER FOLLOWING STEP TAKES 19 FRAMES)

140

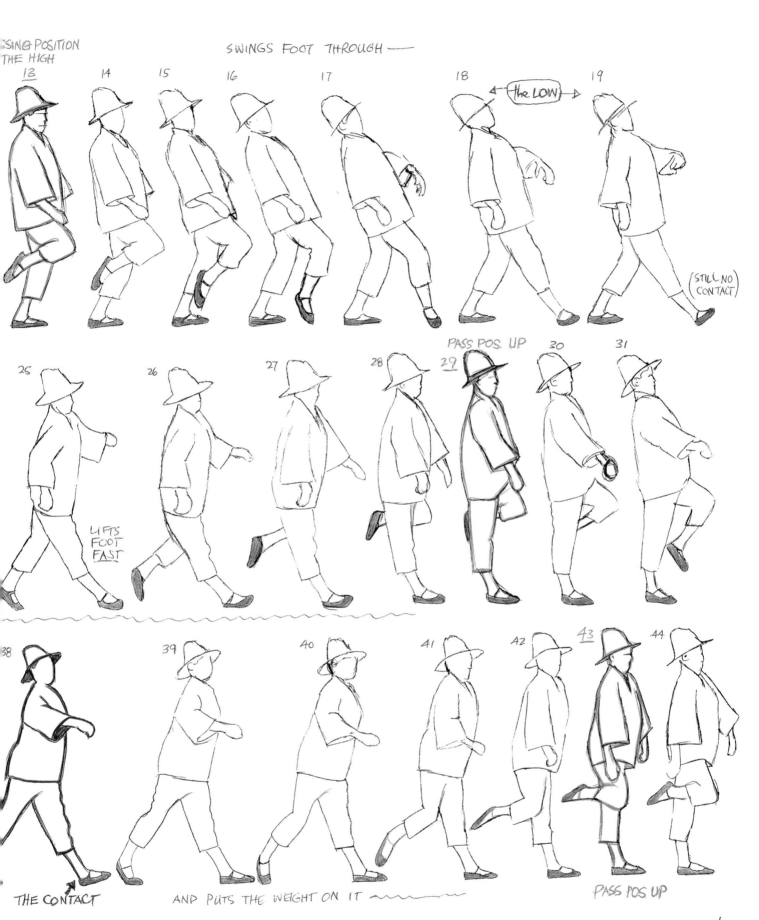

SSING POSITION THE HIGH

SWINGS FOOT THROUGH ⎯

13 14 15 16 17 18 the LOW 19

(STILL NO CONTACT)

25 26 27 28 PASS POS. UP 29 30 31

LIFTS FOOT FAST

38 39 40 41 42 43 44

THE CONTACT AND PUTS THE WEIGHT ON IT ⌇⌇⌇ PASS POS UP

AND IF SHE CAN DO ALL THIS "LIVE" HOW MUCH FURTHER SHOULD WE BE ABLE TO GO IN ANIMATION!

141

NORMAL WALK SPACING

WE HAVEN'T YET QUITE SHOWN THE SPACING AND CUSHIONING ON A NORMAL WALK.
HERE'S A FORMULA SPACING FOR THE 'CONVENTIONAL' WALK ON 12'S. (SPREAD APART)

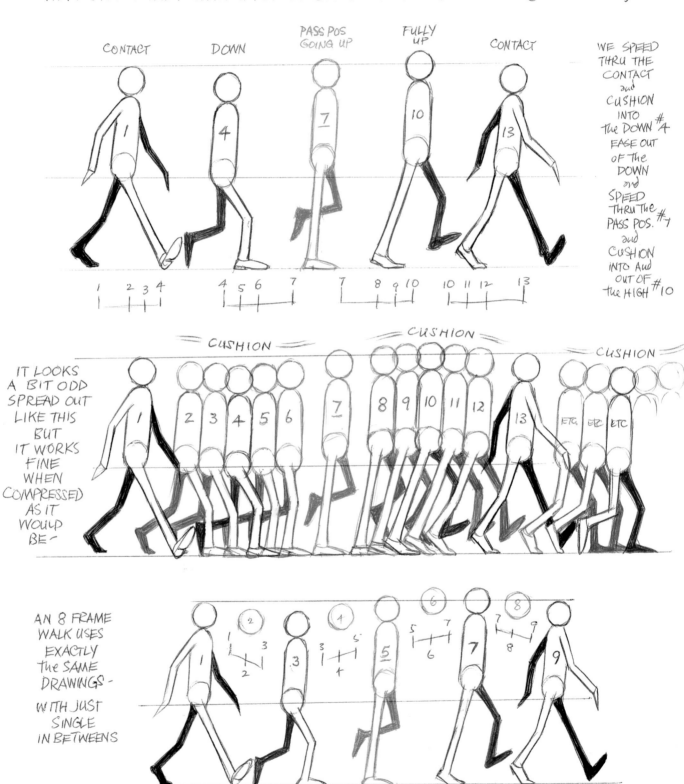

CONTACT DOWN PASS POS GOING UP FULLY UP CONTACT

WE SPEED THRU THE CONTACT and CUSHION INTO THE DOWN #4 EASE OUT OF THE DOWN and SPEED THRU THE PASS POS. #7 and CUSHION INTO and OUT OF THE HIGH #10

1 2 3 4 4 5 6 7 7 8 9 10 10 11 12 13

IT LOOKS A BIT ODD SPREAD OUT LIKE THIS BUT IT WORKS FINE WHEN COMPRESSED AS IT WOULD BE -

CUSHION CUSHION CUSHION

AN 8 FRAME WALK USES EXACTLY THE SAME DRAWINGS -

WITH JUST SINGLE IN BETWEENS

BACK TO INVENTION –

WHAT ABOUT STARTING WITH THE DOWN POSITION AND TAKING IT DOWN FURTHER?

KIND OF A GROUCHO MARX WALK –

OR MAYBE, LIKE GROUCHO – THE PASSING POSITION NEVER STRAIGHTENS

NOW LET'S START TO TWIST THINGS –

BUTT TWISTS AWAY

START WITH THE FOOT KIND OF ON BACKWARDS

FOOT SWIVELS

FOOT LANDS TWISTED IN THE WRONG DIRECTION

VARIATION ON THE SAME SORT OF THING –

IBTWN CLOSER UP

REACH FOR GROUND THIS WAY

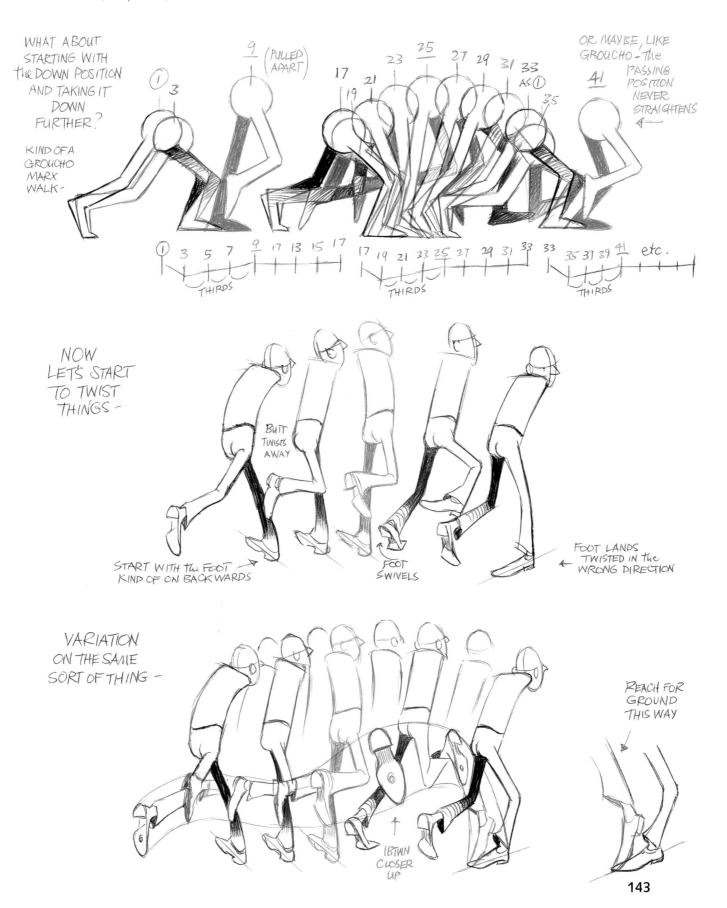

143

LET'S KEEP FOOLING WITH HOW THE FOOT GOES DOWN -

DOWN UP DOWN UP

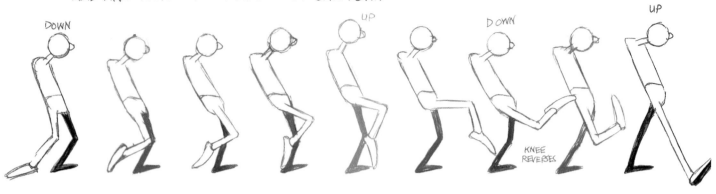

KNEE REVERSES

OR THIS FOR THE OTHER FOOT -

UP DOWN UP

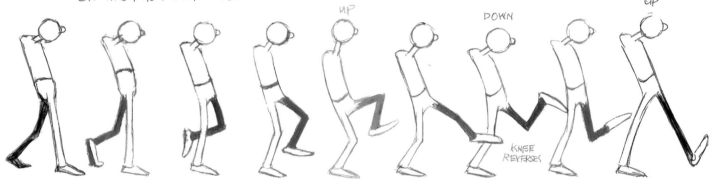

KNEE REVERSES

WALKING BACKWARDS WITH THE FEET ON BACKWARDS -

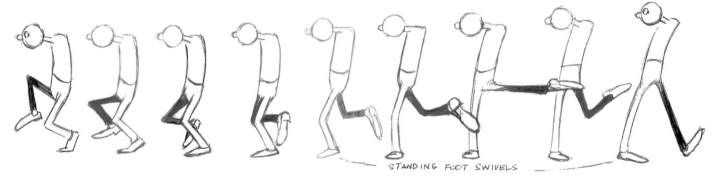

STANDING FOOT SWIVELS

NO HUMAN COULD DO IT BUT IT WORKS CONVINCINGLY -

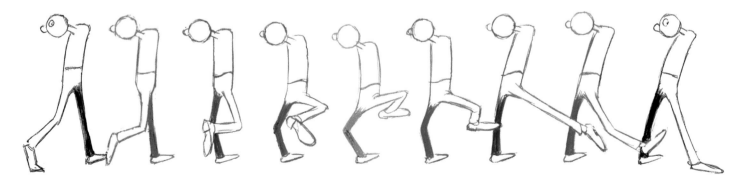

144

AGAIN, WE CAN INVENT WHAT DOESN'T TAKE PLACE IN THE REAL WORLD.

ART BABBITT SAID, "A GOOD DANCER INVENTS. IT'S NOT NATURAL FOR A PERSON TO LEAP INTO THE AIR – DO SCISSORS WITH THEIR FEET AND THEN LAND ON THEIR TOES. WE CAN DO ANYTHING WE WANT AS LONG AS WE MAKE IT 'WORK' – MAKE IT LOOK BELIEVABLE."

LET'S WALK A DANCER 'ON POINT' – ON TWOS

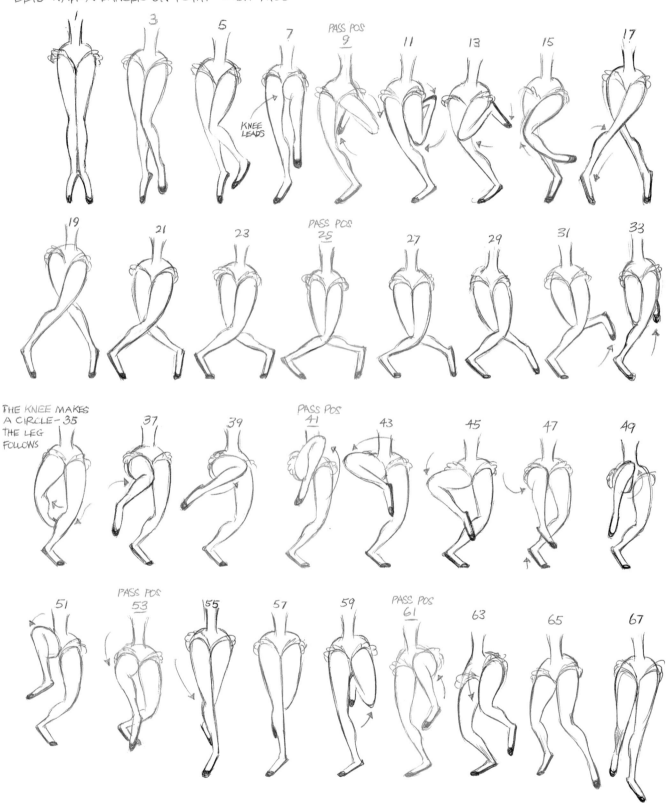

145

THE WEIGHT SHIFTS FROM ONE FOOT TO ANOTHER IN A NORMAL STRIDE.

EACH TIME WE RAISE A FOOT IT THRUSTS THE WEIGHT OF OUR BODY FORWARD AND TO THE SIDE OVER THE OTHER FOOT.

AND the SHOULDERS MOSTLY OPPOSE the HIPS and BUTTOCKS.

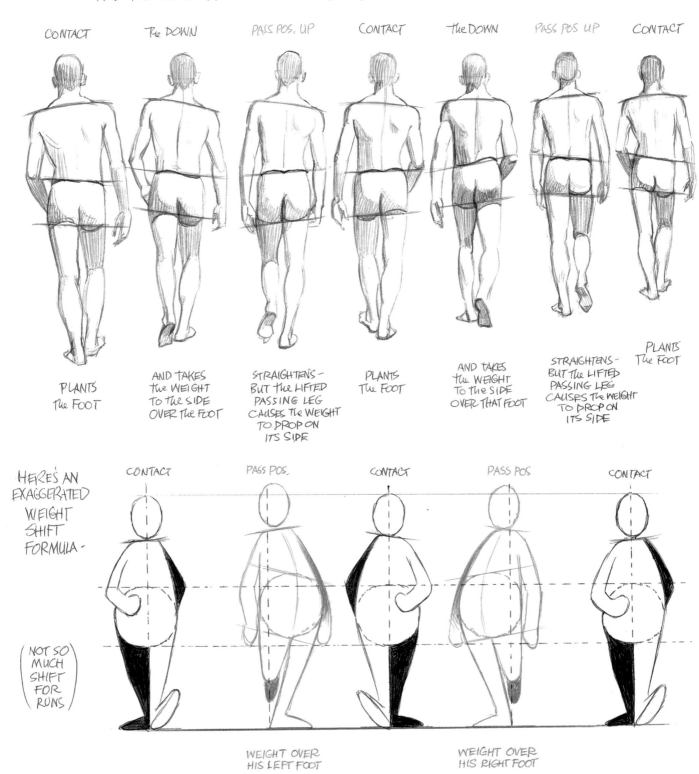

CONTACT The DOWN PASS POS. UP CONTACT The DOWN PASS POS UP CONTACT

PLANTS The FOOT

AND TAKES The WEIGHT TO THE SIDE OVER The FOOT

STRAIGHTENS – BUT The LIFTED PASSING LEG CAUSES The WEIGHT TO DROP ON ITS SIDE

PLANTS The FOOT

AND TAKES The WEIGHT TO THE SIDE OVER THAT FOOT

STRAIGHTENS – BUT The LIFTED PASSING LEG CAUSES The WEIGHT TO DROP ON ITS SIDE

PLANTS The FOOT

HERE'S AN EXAGGERATED WEIGHT SHIFT FORMULA –

CONTACT PASS POS. CONTACT PASS POS CONTACT

(NOT SO MUCH SHIFT FOR RUNS)

WEIGHT OVER HIS LEFT FOOT

WEIGHT OVER HIS RIGHT FOOT

TILT the BELT LINE
BACK AND FORTH
FAVOURING the LEG
THAT IS LOWEST.

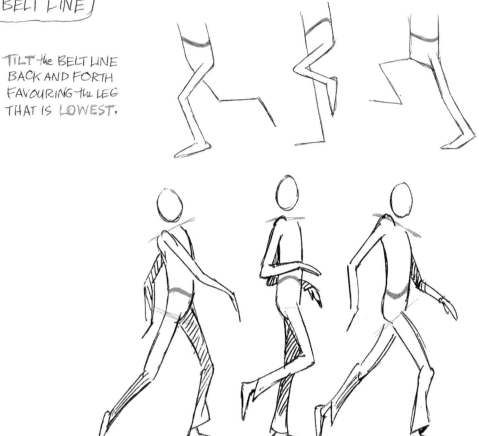

NORMALLY the BELT LINE IS DOWN WITH THE FOOT THAT IS DOWN
AND UP WITH THE FOOT THAT IS UP.

AND
NORMALLY
the SHOULDER
OPPOSES
The PELVIS

(BUT WE
CAN DO WHAT
WE LIKE

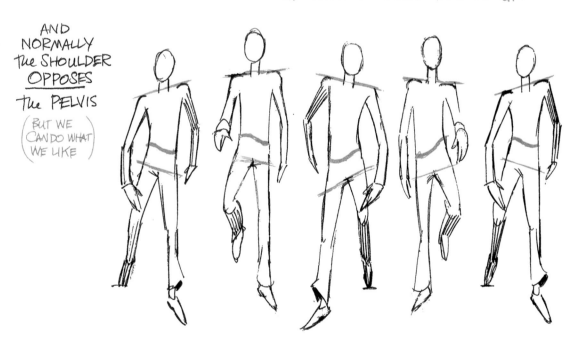

WHILE the SHOULDER RISES UP
IN the PASSING POSITION
the HAND IS AT the LOWEST PART of the ARC

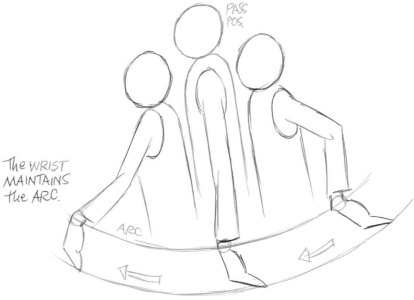

PASS
POS.

The WRIST
MAINTAINS
the ARC.

ARC

MOST ACTIONS
FOLLOW ARCS
- GENERALLY
AN ACTION
IS IN AN ARC

AS THEY SWING TO BALANCE the THRUST
OF THE WALK - the ARMS WILL TEND
TO BE IN A WAVELIKE
PENDULUM - LIKE MOVEMENT.

MOST OF the TIME the
PATH OF ACTION IS EITHER
AN ARC OR A SORT OF
FIGURE 8
- BUT SOMETIMES
ANGULAR OR STRAIGHT

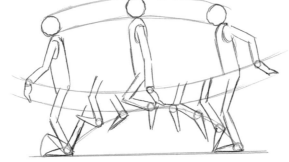

WITH the LEG
the HEEL
MAINTAINS
the ARC

AND JUST TO MAKE LIFE DIFFICULT, WE SHOULD REMEMBER THAT 'NORMAL' - the GOVERNMENT -
ISSUE WALK - the ARM SWING IS AT ITS WIDEST ON the DOWN POSITION, NOT ON the CONTACT POSITION.

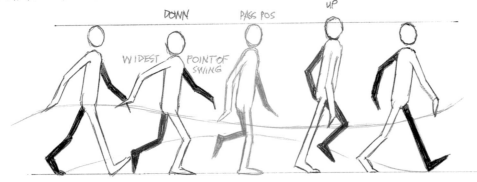

DOWN PASS POS UP

WIDEST POINT OF
 SWING

BUT
OF COURSE
WE'RE NOT
STUCK
WITH
THIS -

ARM MOVEMENTS
CAN BE BROAD
OR PRACTICALLY
NON-EXISTANT -

TO GET MORE
FLEXIBILITY
BRING THIS
HAND <u>ALL</u>
THE WAY
ROUND

AND THIS HAND
ALL THE WAY
BACK

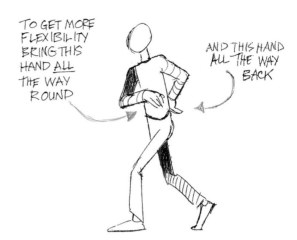

TAKE the FEET
OFF the
PARALLEL -
TWIST
THE FEET
and
TWIST
THE HANDS -

NOT IN
PROFILE

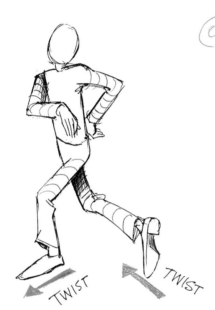

TWIST TWIST

OR

DON'T MOVE
THE HANDS
MUCH

MAYBE JUST FROM
HERE TO HERE

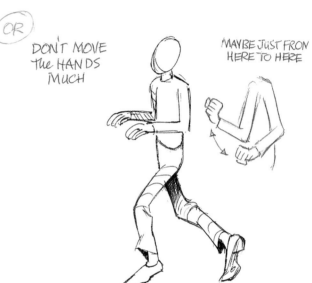

HOW ABOUT the ARMS
UP LIKE THIS
ON AN UP
PASSING
POSITION -

AND DOWN
ON THE EXTREMES.

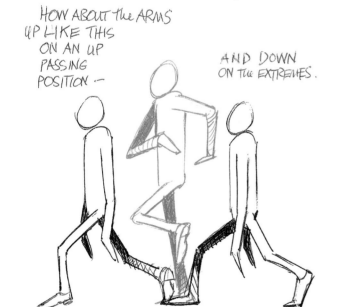

OR SAME THING
WITH A DOWN
PASSING
POSITION -

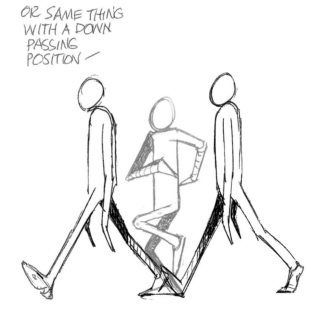

149

HOW ABOUT HAVING
the ARMS RIGHT UP
ON the EXTREMES
and the
ARMS RIGHT DOWN
on the
PASSING
POSITION
(WHICH IS)
(ALSO DOWN)

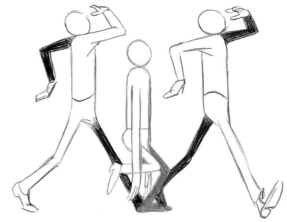

HERE'S A JAUNTY WALK
DOING JUST THAT - AND A LOT OF the THINGS WE'VE BEEN TALKING ABOUT: BELT LINE, SHOULDERS OPPOSE HIPS -
TILTING and DELAYING HEAD, TWISTING FEET - REVERSING BODY.

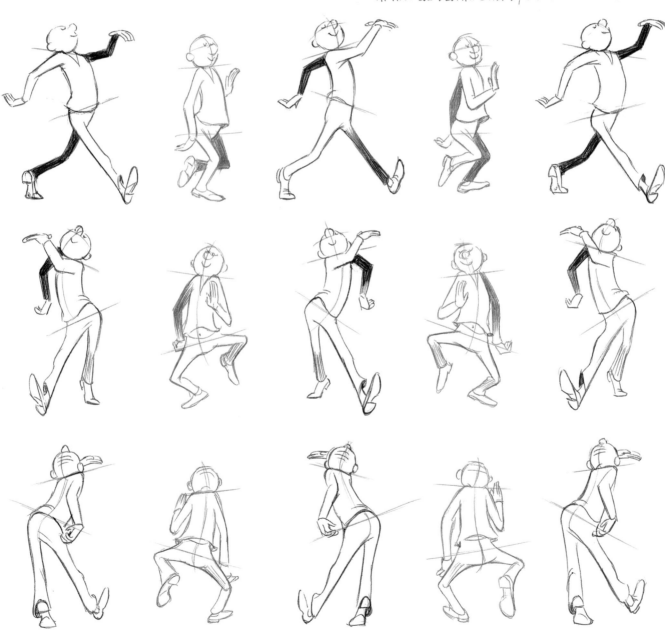

TO GET SOME FLEXIBILITY IN AN ARM SWING
WE'D DRAG THE HAND —

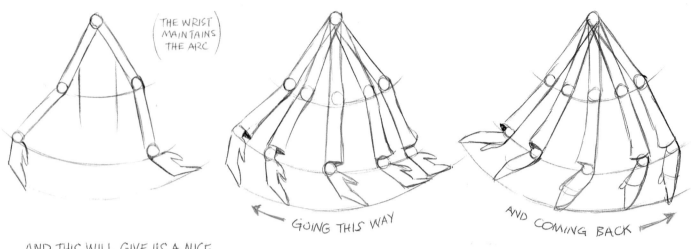

(THE WRIST MAINTAINS THE ARC)

← GOING THIS WAY

AND COMING BACK →

AND THIS WILL GIVE US A NICE
LITTLE OVERLAP OF THE HANDS
AT EACH END OF THE SWING —

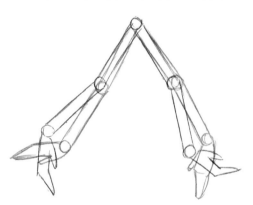

AND WE CAN GET A BIT
MORE FLEXIBILITY
INTO IT BY
DROPPING THE SHOULDER
ON THE PASS POSITION —
MAKING
A DEEPER ARC.

DROP SHOULDER ON PASS POS.

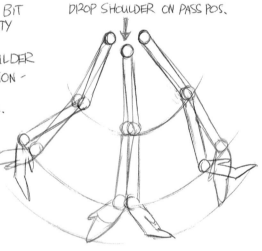

BUT HERE'S THE SECRET —

WHEN WE GO
FORWARD WE'LL
'BREAK' (BEND)
THE ELBOW JOINT
WHETHER IT LOOKS
RIGHT OR WRONG
AND WHETHER IT
WOULD BEND
THAT WAY OR NOT.

AND WHEN WE COME BACK, WE'LL 'BREAK'
(BEND) IT AGAIN — ALTHOUGH GOING THIS WAY
IT LOOKS QUITE
NORMAL —
A NATURAL
'BREAK' OR
BEND.

151

SO, FOR GREATER FLEXIBILITY—

C B A

BY BREAKING THE JOINT
WE CAN GET LIMBER MOVEMENT FROM <u>STRAIGHT</u> LINES.
WE WON'T HAVE TO DRAW IN A RUBBERY CARTOONY WAY TO BE LIMBER.

LET'S MAKE THIS REALLY CLEAR — AS WE'RE GOING TO HAVE A LOT OF THIS...

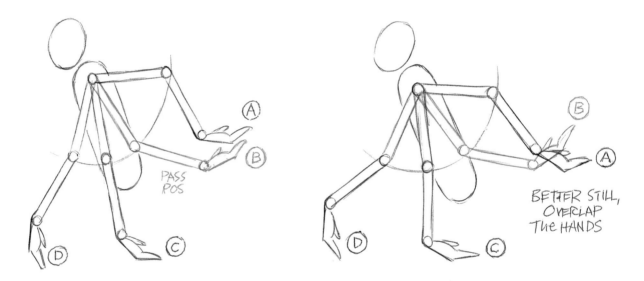

PASS POS

BETTER STILL,
OVERLAP
THE HANDS

BUT WON'T IT LOOK STRANGE? NOT ON THE SCREEN. WHEN INBETWEENED IT'S PROBABLY
GOING TO BE FOR 4 FRAMES OR SO, 1/6 OF A SECOND. TOO QUICK TO 'READ.' BUT WE'LL 'FEEL'
IT— WE'LL FEEL THE INCREASED FLEXIBILITY — INCREASED 'CHANGE'.

(I THINK OF IT AS
"THE DOUBLE X")

SOMEONE ASKED FRED ASTAIRE HOW ON EARTH HE
COULD DANCE AND MOVE LIKE THAT — AND HE SAID,
'OH, I JUST START BY PUTTING BOTH FEET IN THE AIR.'

BUT IF YOU ANALYSE FRED ASTAIRE FRAME BY FRAME
YOU'LL SEE THAT HE'S BREAKING JOINTS ALL THE TIME
ALL OVER THE PLACE.
SENSING THIS,
THEY PERCEPTIVELY CALLED HIM 'THE HUMAN MICKEY MOUSE'.

XX

152

HERE'S AN ADAPTATION OF A SUPERBLY ANIMATED FLAMBOYANT ARM SWING —
BREAKING THE JOINTS LIKE MAD —

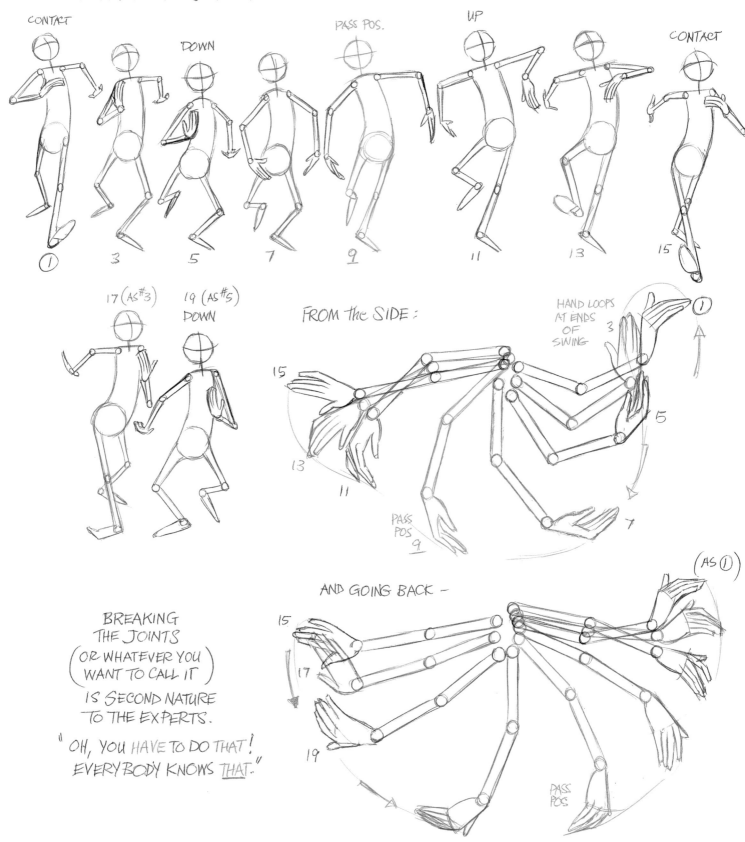

CONTACT

DOWN

PASS POS.

UP

CONTACT

① 3 5 7 <u>9</u> 11 13 15

17 (AS #3) 19 (AS #5)
DOWN

FROM THE SIDE:

HAND LOOPS AT ENDS OF SWING

15 13 11

PASS POS <u>9</u>

① 3 5 7

BREAKING
THE JOINTS
(OR WHATEVER YOU
WANT TO CALL IT)
IS SECOND NATURE
TO THE EXPERTS.

"OH, YOU HAVE TO DO THAT!
EVERYBODY KNOWS THAT."

AND GOING BACK —

15 17 19

(AS ①)

PASS POS

153

KEEPING TO STICK FIGURES

I FIND THAT ONCE THE DRAWINGS ARE EVEN REMOTELY INTERESTING – IT'S HARDER TO SEE PAST ANY CHARM OR STYLE AND SEE THE STRUCTURE OF THE UNDERLYING MOVEMENT CLEARLY. EVEN ADDING AN EYEBALL SEEMS TO CREATE CHARACTER AND THROW ONE OFF THE CHASE FOR THE STRUCTURE. AND ITS THE STRUCTURE WE'RE AFTER HERE, ACTING and PRETTY DRAWINGS OR DESIGNS CAN COME LATER.

WE CAN ALTER THE TIMING OF AN ARM SWING –
SAY WE MAKE THE ARMS SWING SLOWER THAN THE FEET…

WE ANIMATE THE WALK ON 8's – TAKING 4 STEPS (PULLED APART)

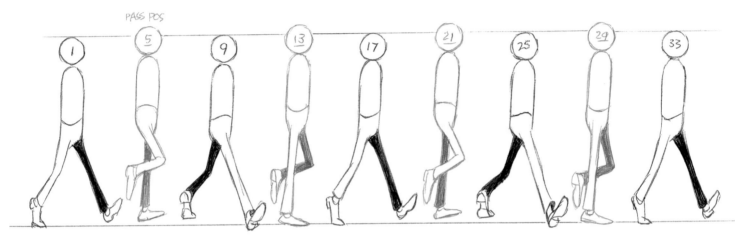

NOW WE'LL ADD THE ARMS BUT WE'LL PUT THEM ON 16's –

SO WITH THE FEET ON 8's AND THE ARMS ON 16's, THE ARM SWING TAKES TWICE AS LONG AS THE FEET.

THE ARM EXTREMES ARE ON THE SAME DRAWINGS AS THE FEET BUT ON #17, THE ARMS 'TWIN' UNNATURALLY ON THE SAME SIDE AS THE FEET

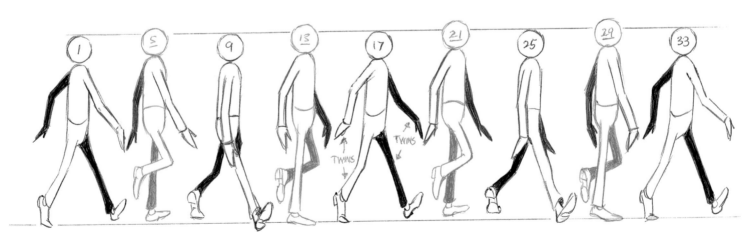

THIS SORT OF THING IS VERY EFFECTIVE ON A RUN!

154

NOW LET'S DO THE CONVERSE -

WE'LL HAVE THE ARMS PUMPING AWAY TWICE AS FAST AS THE LEGS.

WE'LL MAKE THE WALK ON 16'S AND WORK THE ARMS ON 8'S.

TAKE ONE STEP - (SPREAD FAR APART FOR CLARITY)

WE'LL NEED MORE INBETWEENS TO SHOW THIS.

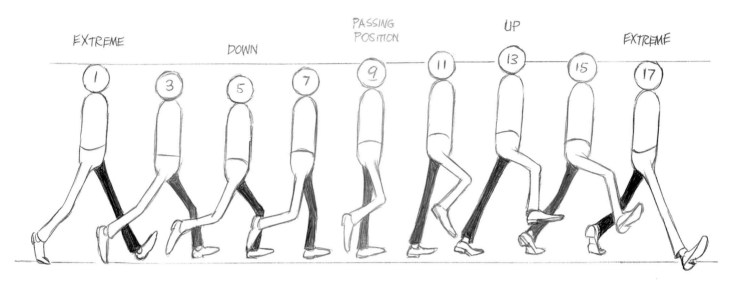

NOW ADD THE ARMS -

THE EXTREME POSITIONS ARE ON 1, 9, and 17.

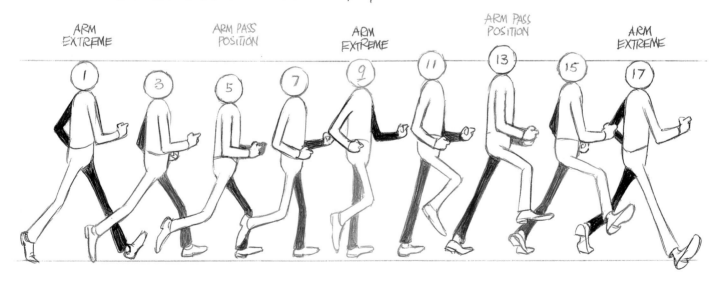

THIS NEEDS SINGLE INBETWEENS - MUST BE ON ONES BECAUSE OF SO MUCH ARM ACTION IN A SHORT SPACE OF TIME. (THIS WON'T WORK ON A RUN, FOR THE SAME REASON)

EXAGGERATED COUNTERACTION - AS IN A FAT MAN'S WALK

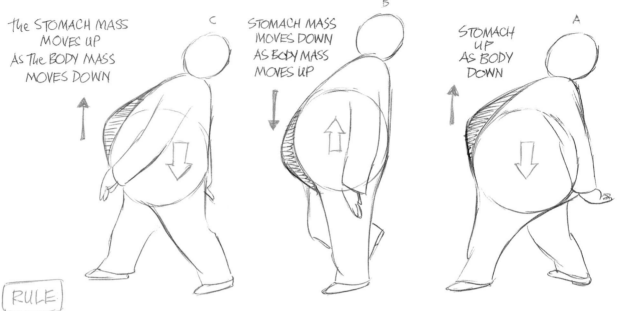

The STOMACH MASS MOVES UP AS The BODY MASS MOVES DOWN

STOMACH MASS MOVES DOWN AS BODY MASS MOVES UP

STOMACH UP AS BODY DOWN

RULE

WHEN THE CHARACTER GOES UP - THE DRAPERY OR HAIR OR SOFT BITS GO DOWN.

AGAIN, EXAGGERATING - BUTTOCKS AND BREASTS AND HAIR COUNTER The BODY UPS AND DOWNS -

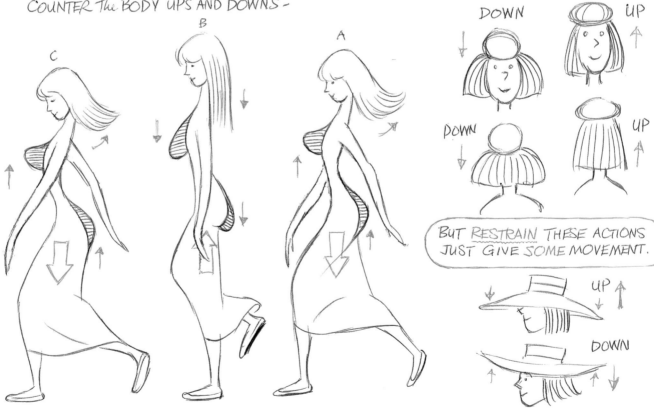

DOWN UP

DOWN UP

BUT RESTRAIN THESE ACTIONS JUST GIVE SOME MOVEMENT.

UP

DOWN

AS WE NEAR THE END OF THESE WALKS LET'S LOOK AT WHAT THE END IS DOING...

TAKE A WOMAN WALKING —

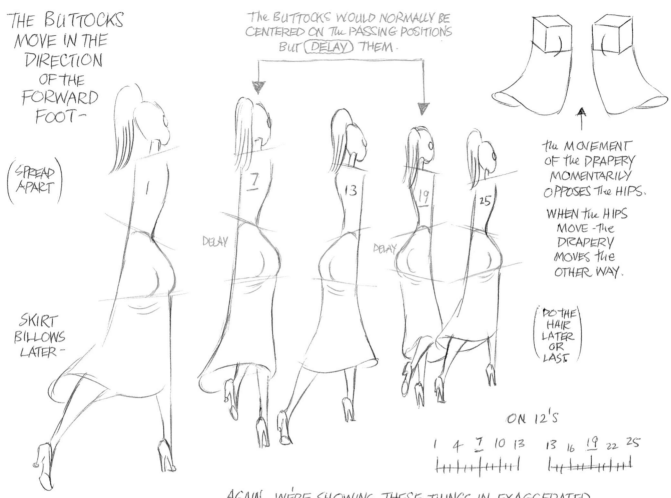

THE BUTTOCKS MOVE IN THE DIRECTION OF THE FORWARD FOOT —

(SPREAD APART)

SKIRT BILLOWS LATER —

The BUTTOCKS WOULD NORMALLY BE CENTERED ON The PASSING POSITIONS BUT (DELAY) THEM.

1 7 13 19 25

DELAY DELAY

The MOVEMENT OF The DRAPERY MOMENTARILY OPPOSES The HIPS.

WHEN The HIPS MOVE — The DRAPERY MOVES The OTHER WAY.

(DO THE HAIR LATER OR LAST)

ON 12'S

1 4 7 10 13 13 16 19 22 25

AGAIN, WE'RE SHOWING THESE THINGS IN EXAGGERATED FORM. IT'S ACCORDING TO TASTE HOW BROADLY OR HOW SUBTLY WE USE THESE DEVICES...

AND REMEMBERING THAT WOMEN TEND TO WALK ON A STRAIGHT LINE — 'TIGHTROPE WALKING.'

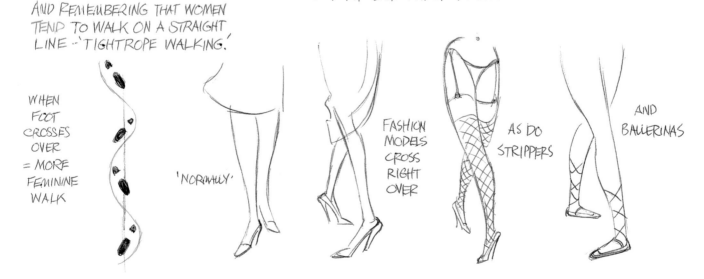

WHEN FOOT CROSSES OVER = MORE FEMININE WALK

'NORMALLY'

FASHION MODELS CROSS RIGHT OVER

AS DO STRIPPERS

AND BALLERINAS

HERE'S A FORMULA FOR A BOUNCY WALK - ON 8'S

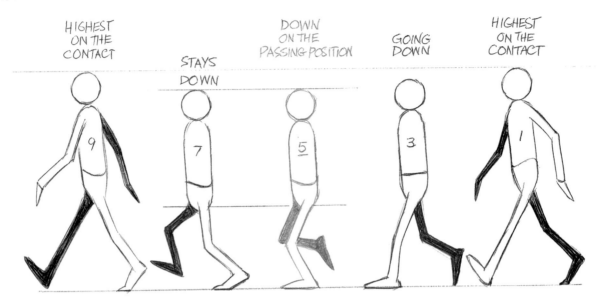

HIGHEST ON THE CONTACT — STAYS DOWN — DOWN ON THE PASSING POSITION — GOING DOWN — HIGHEST ON THE CONTACT

THE REST ARE STRAIGHT INBETWEENS

IN the 50's WHEN THEY SWUNG RIGHT AWAY FROM 'NATURALISM' THEY INVENTED SOME CHARMING WALKS — ESPECIALLY WITH CHILDREN. THEY OFTEN DID THIS - THE CHARACTER WOULD TAKE A STEP - THEN POP UP IN The AIR FOR 4 TO 6 FRAMES OR SO, THEN CLICK DOWN AGAIN and TAKE ANOTHER STEP.

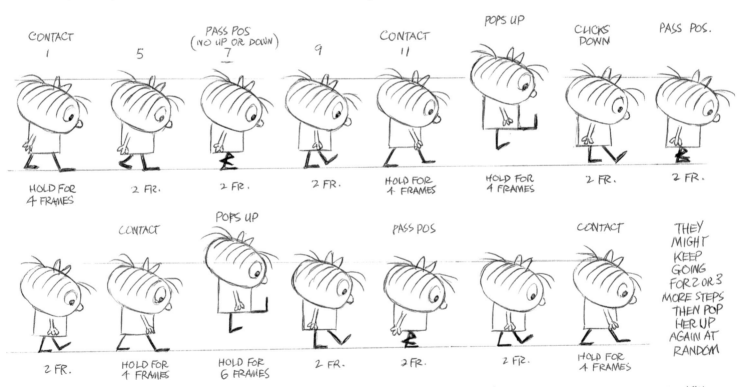

THE CHARM OF THIS IS IT'S 'STYLISED STIFFNESS'. INVENTIVE THOUGH IT IS, IT'S HARD TO EXTEND ON THIS APPROACH. IF WE DON'T STRETCH AND OVERLAP AND DELAY PARTS, THINGS JUST LOOK LIKE A PIECE OF PASTEBOARD OR A PAPER CUT-OUT MOVING AROUND.

158

HERE'S A BOXER'S WALK WITH the HEAD FLOATING LEVEL and the BUTT and PELVIS ACTIVELY MOVING UP and DOWN and FROM SIDE TO SIDE AS the MAIN FEATURE. The BUTT ACTION GIVES IT the WEIGHT. BUT JUST TO COMPLICATE THINGS WE'VE MADE the EXTREMES WITH WHAT WOULD NORMALLY BE OUR PASSING POSITION — and the 'CONTACT' IS NOW the PASSING POSITION. OF COURSE THERE ARE NO RULES. WE CAN BUILD FROM ANY POINT.

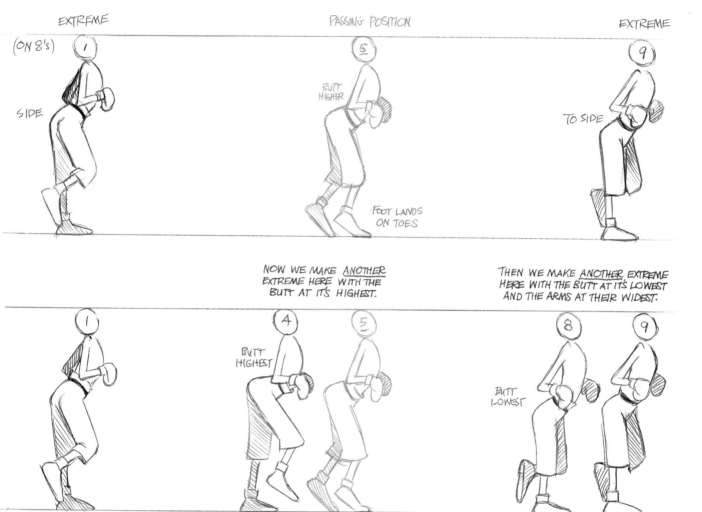

NOW WE MAKE ANOTHER EXTREME HERE WITH THE BUTT AT ITS HIGHEST.

THEN WE MAKE ANOTHER EXTREME HERE WITH THE BUTT AT ITS LOWEST AND THE ARMS AT THEIR WIDEST.

NOW THAT WE HAVE the HIGHS and LOWS WE JOIN IT ALL UP and EFFICIENTLY GET the RESULT WE WANT.

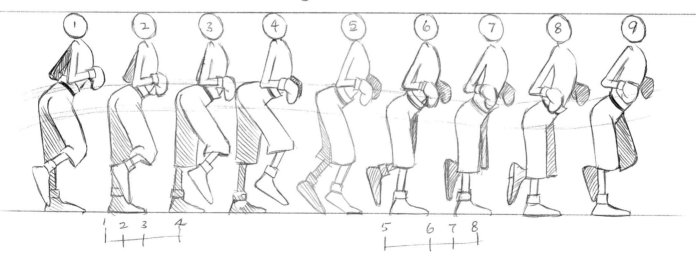

159

HERE'S A TECHNICAL AID FOR PLANNING A WALK IN PERSPECTIVE (IF WE WANT TO BE TECHNICAL ABOUT IT)

HORIZON VANISHING POINT HORIZON

DRAW 2 LINES - ONE ALONG the TOP OF the POSTS - the OTHER ALONG the BOTTOM. BOTH MEET AT The VANISHING POINT.

THEN DRAW ANOTHER LINE (BLUE) HALF-WAY BETWEEN

ETC V.P.

NOW DRAW A LINE FROM The TOP OF the FIRST POST GOING THROUGH the CENTRE OF The SECOND POST TO The LOWER LINE.

NOW WE KNOW WHERE TO PUT the THIRD POST — AND ALL THE REST.

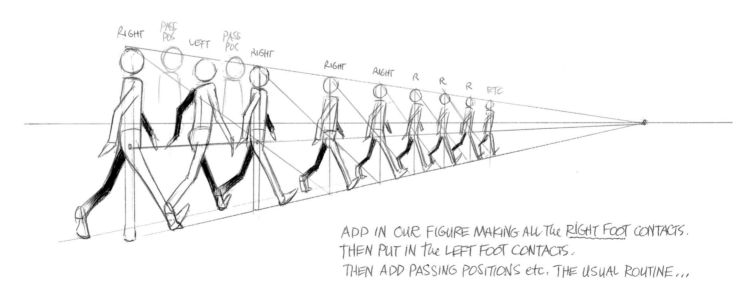

RIGHT PASS POS LEFT PASS POS RIGHT RIGHT RIGHT R R R ETC

ADD IN OUR FIGURE MAKING ALL the RIGHT FOOT CONTACTS. THEN PUT IN the LEFT FOOT CONTACTS. THEN ADD PASSING POSITIONS etc. THE USUAL ROUTINE...

160

HAVING GONE THROUGH ALL THIS WALK BUILDING and FORMULAS etc. WE END UP AT
The MAIN ISSUE = NO TWO CHARACTERS WALK the SAME. ALL WE CAN DO IS GENERALISE -

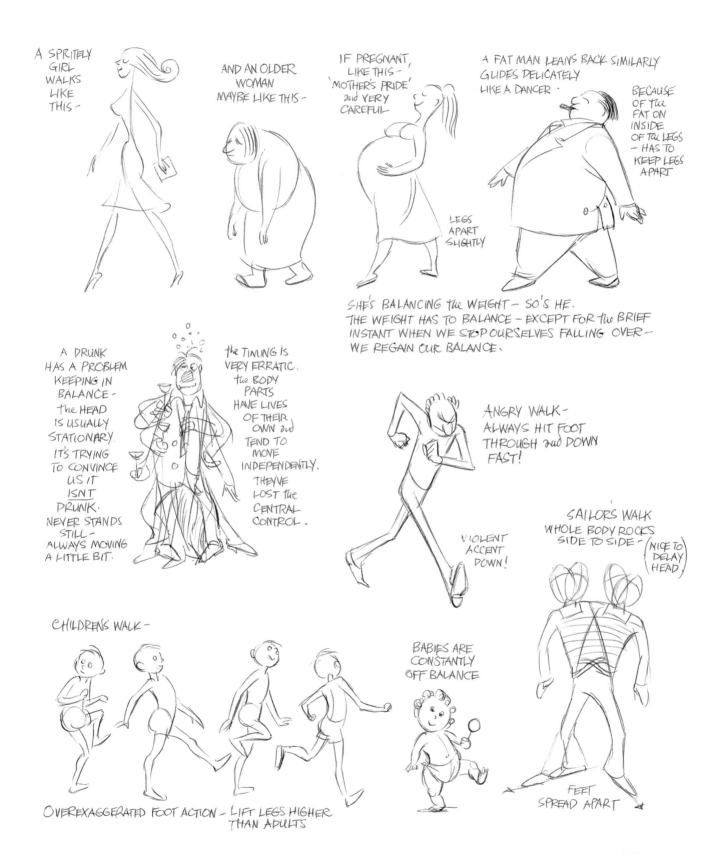

A SPRITELY GIRL WALKS LIKE THIS -

AND AN OLDER WOMAN MAYBE LIKE THIS -

IF PREGNANT, LIKE THIS - 'MOTHER'S PRIDE' and VERY CAREFUL

LEGS APART SLIGHTLY

A FAT MAN LEANS BACK SIMILARLY GLIDES DELICATELY LIKE A DANCER -

BECAUSE OF THE FAT ON INSIDE OF THE LEGS - HAS TO KEEP LEGS APART

SHE'S BALANCING the WEIGHT - SO'S HE.
THE WEIGHT HAS TO BALANCE - EXCEPT FOR the BRIEF
INSTANT WHEN WE STOP OURSELVES FALLING OVER -
WE REGAIN OUR BALANCE.

A DRUNK HAS A PROBLEM KEEPING IN BALANCE - the HEAD IS USUALLY STATIONARY. IT'S TRYING TO CONVINCE US IT ISN'T DRUNK. NEVER STANDS STILL - ALWAYS MOVING A LITTLE BIT.

the TIMING IS VERY ERRATIC, the BODY PARTS HAVE LIVES OF THEIR OWN and TEND TO MOVE INDEPENDENTLY. THEY'VE LOST the CENTRAL CONTROL.

ANGRY WALK - ALWAYS HIT FOOT THROUGH and DOWN FAST!

VIOLENT ACCENT DOWN!

SAILOR'S WALK WHOLE BODY ROCKS SIDE TO SIDE - (NICE TO DELAY HEAD)

CHILDREN'S WALK -

OVEREXAGGERATED FOOT ACTION - LIFT LEGS HIGHER THAN ADULTS

BABIES ARE CONSTANTLY OFF BALANCE

FEET SPREAD APART

161

TIMING IS SO IMPORTANT IN WALKS
KEN HARRIS SAID, "BASE WALKS ON 12'S -
(AS DID MILT KAHL) THEN EVERYTHING IS JUST
SO MUCH FASTER OR IS
SO MUCH SLOWER THAN 12."

AGAIN, ITS NOT JUST HOW THEY LOOK -
ITS HOW IS THE PERSON *FEELING*?

 SAD
 LONELY
 HAPPY
 THOUGHTFUL
 DRUNK
 SPRIGHTLY
 OLD
 YOUNG
 ADDLED
 SURPRISED
 HOPEFUL
 CONFIDENT
 EMPATHETIC
 CONCEITED
 NERVOUS
 ILL
 ANGRY
 LAME
 INHIBITED
 MILITARISTIC
 DEPRESSED
 JOYOUS
 SHY?

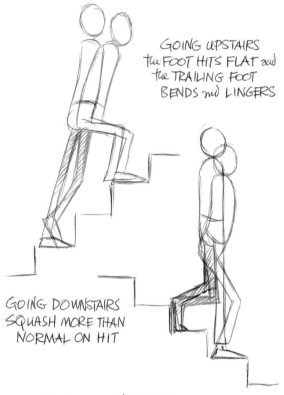

GOING UPSTAIRS
the FOOT HITS FLAT and
the TRAILING FOOT
BENDS and LINGERS

GOING DOWNSTAIRS
SQUASH MORE THAN
NORMAL ON HIT

TAKE A DRUNK FOR EXAMPLE -
THERE ARE SO MANY DIFFERENT
KINDS -

 The SILLY DRUNK
 The LASCIVIOUS DRUNK
 The SELF-PITYING DRUNK
 The EXPANSIVE, HAPPY DRUNK
 The OUT-OF-CONTROL ATHLETIC DRUNK
 The OVERLY GRACIOUS POLITE DRUNK
 The VERY DIGNIFIED DRUNK
 The VICAR (I SAW A VICAR WALK INTO A WALL)
 The INHIBITED SOCIETY MATRON
 The FIGHTING DRUNK
 The SENTIMENTALIST
 The FIRST TIME DRUNK
 etc. etc.

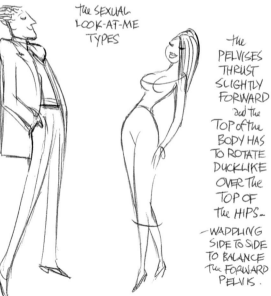

The SEXUAL
LOOK-AT-ME
TYPES

The
PELVISES
THRUST
SLIGHTLY
FORWARD
and the
TOP of the
BODY HAS
TO ROTATE
DUCKLIKE
OVER The
TOP OF
The HIPS ~

~ WADDLING
SIDE TO SIDE
TO BALANCE
The FORWARD
PELVIS.

TO SUM UP:

WAYS TO GET VITALITY IN A WALK

the RECIPE

1 LEAN the BODY

2 USE STRAIGHT LEGS ON CONTACTS and PUSH OFF POSITIONS
 (GOING FROM STRAIGHT TO BENT OR BENT TO STRAIGHT)

3 TWIST the BODY — TILT the SHOULDERS and HIPS
 HAVE the SHOULDERS OPPOSE the HIPS
 SWIVEL the HIPS

4 FLOP the KNEE IN OR OUT

5 TILT the BELT LINE FAVOURING the LEG THAT'S LOWEST

6 FLOP the FEET

7 DELAY the FEET AND TOE LEAVING the GROUND
 UNTIL the VERY LAST INSTANT

8 TIP the HEAD OR MAKE IT GO BACK and FORTH

9 DELAY PARTS DON'T HAVE EVERYTHING WORKING
 TOGETHER AT the SAME TIME.

10 USE COUNTERACTION - FAT, BUTTOCKS, BREASTS,
 DELAYED CLOTHES, PANT LEGS, HAIR etc.

11 BREAK the JOINTS

12 MORE UPS and DOWNS (FOR WEIGHT)

13 USE DIFFERENT TIMINGS ON LEGS VERSUS ARMS VERSUS
 HEAD VERSUS BODY Etc.

14 TWIST the FEET - TAKE THEM OFF the PARALLEL.

15 IF WE TAKE A NORMAL CLICHÉD ACTION and ALTER
 ONLY ONE TINY PART - WE GET SOMETHING DIFFERENT!

I WANT TO CLOSE OFF ON WALKS WITH THIS EXAMPLE OF A 'MILT KAHL TYPE' STRUT.

IN HIS CAREER HE ANIMATED MANY ENERGETIC SUPEROPTIMISTIC 'CAN DO' WALKS. I'VE ADAPTED
and COMBINED SEVERAL OF THESE INTO A COMPOSITE ONE (USING A GENERIC FIGURE - NOT A CHARACTER)
- A 'MAQUETTE' TO SHOW The WORK PROCESS OF A MASTER. IT'S CERTAINLY NOT TO PROVIDE YET
ANOTHER FORMULA, BUT AS AN INSIGHT INTO HOW A MASTER WORKS and THINKS - HOW HE STARTS
ON A SIMPLE BASIS WITH The CONTACTS and LOADS IT WITH DEPTH and INTEREST AS HE BUILDS.

AND IT'S FULL OF The STUFF WE'VE BEEN TALKING ABOUT.

FIRST HE MAKES
The CONTACTS -
(WE'LL TAKE 2 STEPS)
- ON 12's

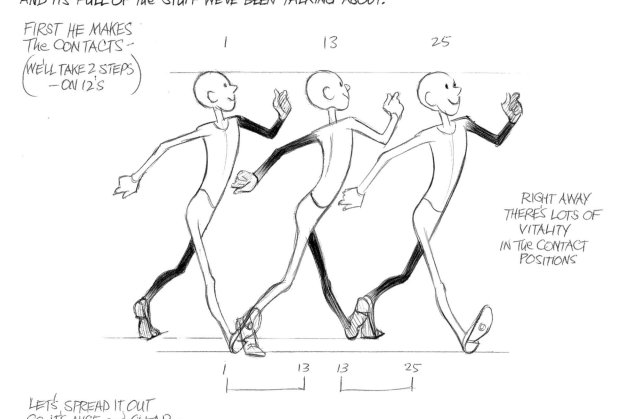

RIGHT AWAY
THERE'S LOTS OF
VITALITY
IN The CONTACT
POSITIONS

LET'S SPREAD IT OUT
SO IT'S NICE and CLEAR -

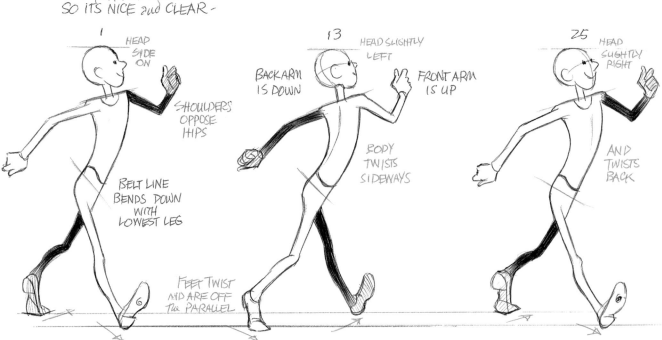

HEAD
SIDE
ON

SHOULDERS
OPPOSE
HIPS

BELT LINE
BENDS DOWN
WITH
LOWEST LEG

FEET TWIST
AND ARE OFF
The PARALLEL

HEAD SLIGHTLY
LEFT

BACK ARM
IS DOWN

FRONT ARM
IS UP

BODY
TWISTS
SIDEWAYS

HEAD
SLIGHTLY
RIGHT

AND
TWISTS
BACK

164

THE PASSING POSITIONS GO IN NEXT -

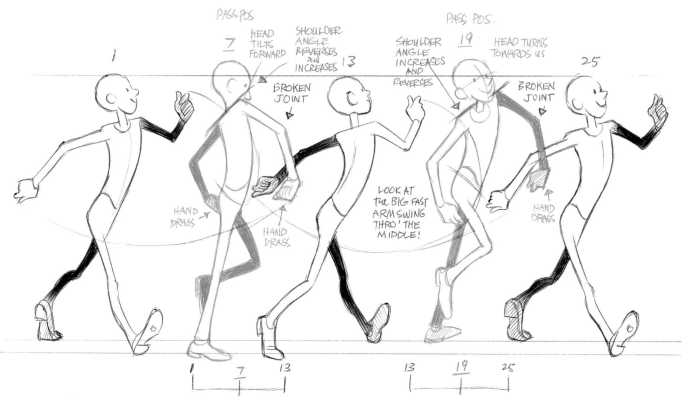

PASS POS
1 7 HEAD TILTS FORWARD SHOULDER ANGLE REVERSES and INCREASES 13
PASS POS. 19 HEAD TURNS TOWARDS US 25

SHOULDER ANGLE INCREASES AND REVERSES

BROKEN JOINT

BROKEN JOINT

HAND DRAGS

HAND DRAGS

LOOK AT THE BIG FAST ARM SWING THRO' THE MIDDLE!

HAND DRAGS

1 7 13 13 19 25

(THIS WOULD ALREADY MAKE A GREAT WALK AS IT IS — WITHOUT EVEN ADDING IN MORE HIGHS OR LOWS!)

NOW WE'LL ADD IN THE LOWS — THE DOWN POSITIONS.

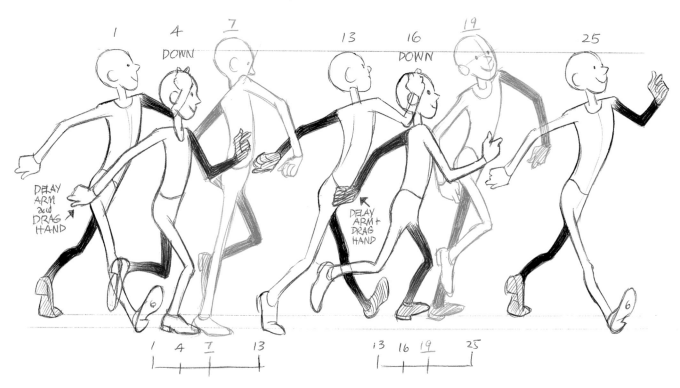

1 4 7 13 16 19 25
DOWN DOWN

DELAY ARM and DRAG HAND

DELAY ARM + DRAG HAND

1 4 7 13 13 16 19 25

165

NOW WE'LL PUT IN THE UP POSITIONS -

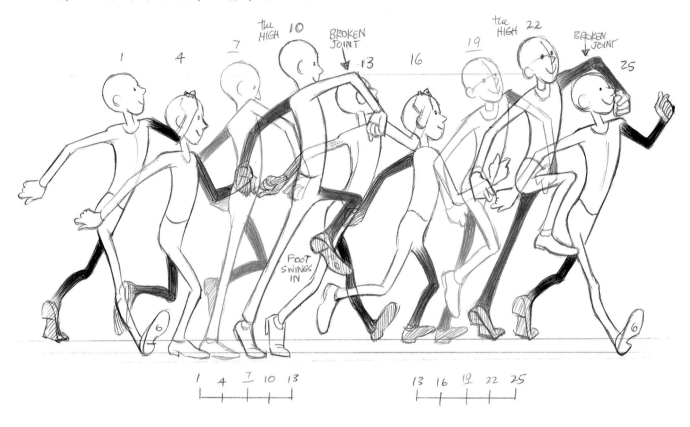

1 4 7 <u>the</u> HIGH 10 BROKEN JOINT 13 16 <u>19</u> <u>the</u> HIGH 22 BROKEN JOINT 25

FOOT SWINGS IN

1 4 <u>7</u> 10 13 13 16 <u>19</u> 22 25

THEN ADD IN The IN BETWEENS (ON THIRDS)

1 4 <u>7</u> 10 13
2 3 5 6 8 9 11 12

13 16 <u>19</u> 22 25
14 15 17 18 20 21 23 24

AND YOU CAN BET THEY'RE
GOING TO BE THOUGHTFUL
IN BETWEENS -
NOT MECHANICAL ONES.

EXAMPLE :

WITH THE LAST 2 INBTWNS
The RIGHT LEG IS NOT
JUST INBETWEENED.
The REST IS.

NOW The WHOLE THING
IS PACKED WITH VITALITY
and `CHANGE'!

"SOPHISTICATED USE
OF The BASICS."

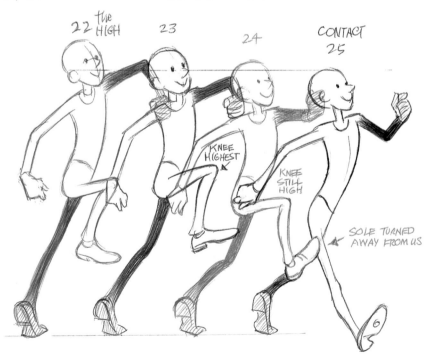

22 <u>the</u> HIGH 23 24 CONTACT 25

KNEE HIGHEST

KNEE STILL HIGH

SOLE TURNED AWAY FROM US

SNEAKS

THERE ARE 3 DEFINITE CATEGORIES OF SNEAKS:

① The TRADITIONAL SNEAK ② The BACKWARDS SNEAK ③ The TIP TOE SNEAK

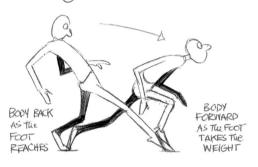 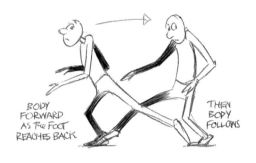 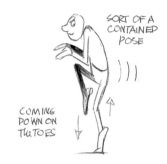

BODY BACK AS the FOOT REACHES

BODY FORWARD AS the FOOT TAKES the WEIGHT

BODY FORWARD AS The FOOT REACHES BACK

THEN BODY FOLLOWS

SORT OF A CONTAINED POSE

COMING DOWN ON The TOES

AVERAGE VERSION · 24 FRAMES for EACH STEP.
FAST VERSION · 16 FRAMES PER STEP.
SLOW VERSON 32 FRAMES FOR EACH STEP.

EXPRESSES FEAR OR MISCHIEF
– MORE OR LESS OPPOSITE
TO A FORWARDS SNEAK.

ON TOES and PLAYFUL –
SURE OF HIM/HERSELF
10 FRAMES – 12, 13, 14 FRAMES.
WHATEVER WE WANT
REALLY FAST ONES ON 3's or 4's

A TRADITIONAL SNEAK HAS A VERY INTERESTING CONSTRUCTION.

THE MAIN THINGS ARE –

Ⓐ The BODY GOES BACK and FORTH.
The BODY GOES BACK WHEN THE FOOT
GOES UP. THE ARMS ARE USED FOR BALANCE.

Ⓑ WHEN The FOOT REACHES and CONTACTS
The GROUND, the BODY IS STILL BACK and
the HEAD IS HELD BACK, DELAYED JUST A LITTLE BIT.

Ⓒ AFTER the FOOT CONTACTS the GROUND
the BODY FOLLOWS – GOING FORWARD
AS the FOOT TAKES the WEIGHT.
NEXT the BODY WILL GO BACK (AS Ⓐ)
AS the OTHER FOOT GOES FORWARD.

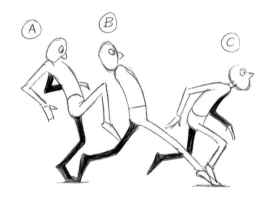

AS WITH A WALK THERE ARE
3 IMPORTANT DRAWINGS –
The 2 CONTACTS
AND A VERY INTERESTING
PASSING POSITION.

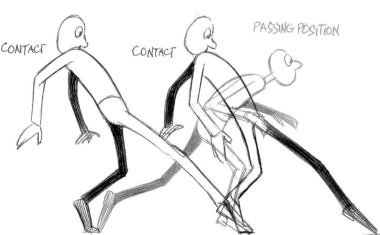

CONTACT CONTACT PASSING POSITION

KEN HARRIS SHOWED US THIS FORMULA FOR A SLOW SNEAK:

IT TAKES 2 FEET = 32 FRAMES = $1\frac{1}{3}$ SECONDS FOR EACH STEP.

ON TWO'S — (BUT OF COURSE IT'LL BE EVEN BETTER ADDING INBETWEENS ON ONES)

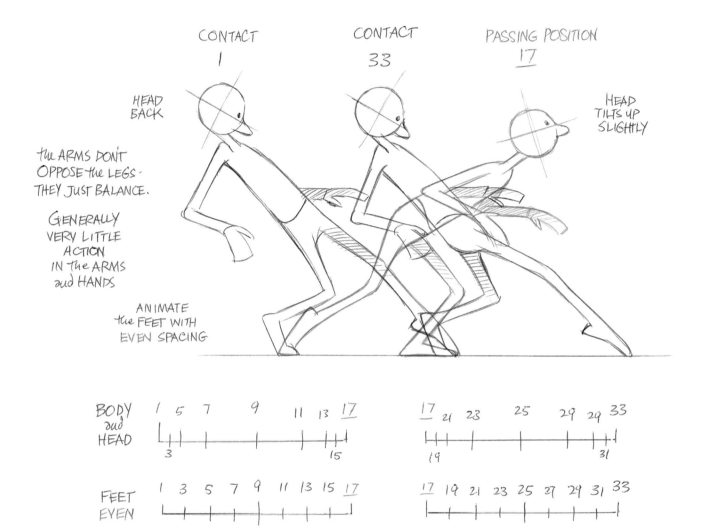

CONTACT
1

CONTACT
33

PASSING POSITION
17

HEAD
BACK

HEAD
TILTS UP
SLIGHTLY

THE ARMS DON'T
OPPOSE THE LEGS.
THEY JUST BALANCE.

GENERALLY
VERY LITTLE
ACTION
IN THE ARMS
AND HANDS

ANIMATE
THE FEET WITH
EVEN SPACING

BODY
AND
HEAD

1 5 7 9 11 13 <u>17</u>
3 15

<u>17</u> 21 23 25 29 29 33
19 31

FEET
EVEN

1 3 5 7 9 11 13 15 <u>17</u>

<u>17</u> 19 21 23 25 27 29 31 33

IT'S A GOOD EXAMPLE OF COUNTERACTION—
AS HE MOVES ALONG, THE HEAD GOES FORWARD AND THE HANDS GO BACK

THIS IS THE BASIS. IT WILL WORK NICELY JUST INBETWEENING THE 3 POSITIONS AS IS—
AND NOT ADDING ANY FANCY BITS OF INNER ACTION.

IF THE HANDS WERE OPEN
IT WOULD LOOK FRIGHTENED.

OF COURSE WE CAN ADD ANYTHING
WE WANT WITHIN — BUT THIS DOES THE JOB
WITH JUST 3 DRAWINGS AND THE CHARTS.

WE COULD USE ARCS OR JUST STRAIGHT
MECHANICAL INBETWEENS. IT'LL WORK WELL.

168

BUT OF COURSE, WE COULD DELAY PARTS—

CROSSOVER HEAD
BACK and LOOKING DOWN

HEAD IS
STILL GOING
BACK ON
START
POSITION

HEAD
CONTINUES
FORWARD

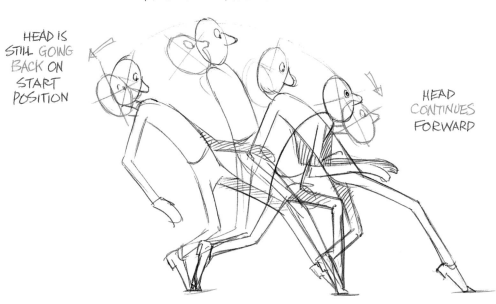

COULD STAY FULLY ON the TOES ALL the TIME TO ENHANCE the FEELING OF CAUTION—

TRY IT ON
FRONT VIEW—

WAISTLINE SHOWS
WHATS HAPPENING—

WHAT ABOUT
A ¾ VIEW?

IN ¾ VIEW WE HIT
DRAWING PROBLEMS—
PERSPECTIVE, VOLUMES,
etc. WHICH IS WHY
LOTS OF ANIMATORS
STAY IN PROFILE

(IT'S A GOOD IDEA
TO PLAN IT FIRST
IN PROFILE)

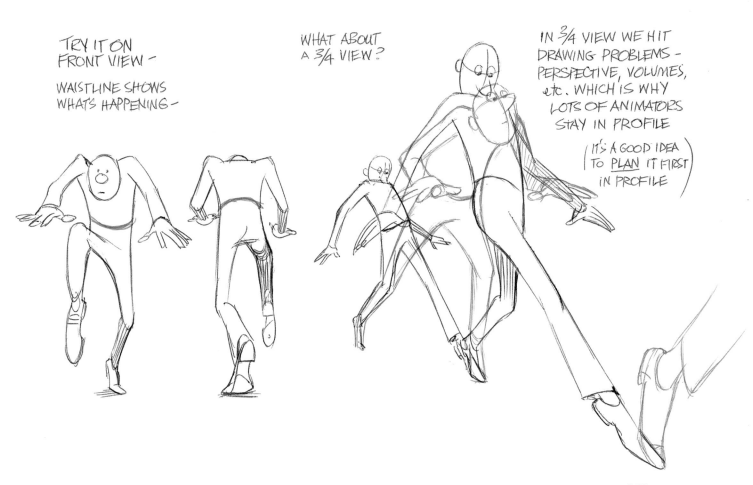

HERE'S AN ADAPTATION OF A BILL TYTLA SNEAK -
THERE ARE 4 PLANNING DRAWINGS. IT'S ON 36 FRAMES = 1½ SECONDS PER STEP.

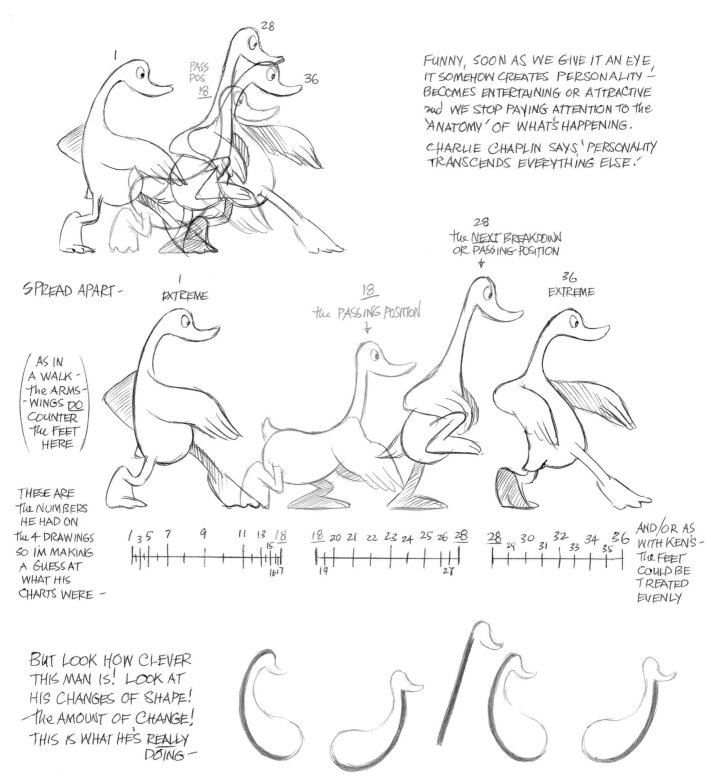

FUNNY, SOON AS WE GIVE IT AN EYE,
IT SOMEHOW CREATES PERSONALITY —
BECOMES ENTERTAINING OR ATTRACTIVE
and WE STOP PAYING ATTENTION TO the
'ANATOMY' OF WHAT'S HAPPENING.

CHARLIE CHAPLIN SAYS,' PERSONALITY
TRANSCENDS EVERYTHING ELSE.'

28
the NEXT BREAKDOWN
OR PASSING POSITION

SPREAD APART -

EXTREME

18
the PASSING POSITION

36
EXTREME

(AS IN
A WALK -
the ARMS -
-WINGS DO
COUNTER
the FEET
HERE)

THESE ARE
the NUMBERS
HE HAD ON
the 4 DRAWINGS
SO I'M MAKING
A GUESS AT
WHAT HIS
CHARTS WERE -

AND/OR AS
WITH KEN'S -
the FEET
COULD BE
TREATED
EVENLY

BUT LOOK HOW CLEVER
THIS MAN IS! LOOK AT
HIS CHANGES OF SHAPE!
- the AMOUNT OF CHANGE!
THIS IS WHAT HE'S REALLY
DOING -

- GOING FROM CURVE TO OPPOSITE CURVE TO STRAIGHT TO CURVED TO OPPOSITE etc.

170

AFTER ART BABBITT FINISHED HIS FIRST MONTH OF INTENSIVE TRAINING AT MY LONDON STUDIO FOUR OF US SAT UP ALL-NIGHT and ANIMATED A QUICK SATIRE FOR HIM OF HIS SEMINARS.

I DID THIS HORSE SNEAK AS AN EXERCISE IN "OVER"-ANIMATION — WHICH CAME OUT KIND OF FUNNY — SHOWS HOW FAR WE CAN GO — SITTING RIGHT ON the BASICS. (ON TWO'S)

SNEAKING ON 12'S and 14'S

HERE ARE JUST the EXTREMES and the BREAKDOWNS — the MID-POSITIONS. I'VE CIRCLED the EXTREMES FOR CLARITY —

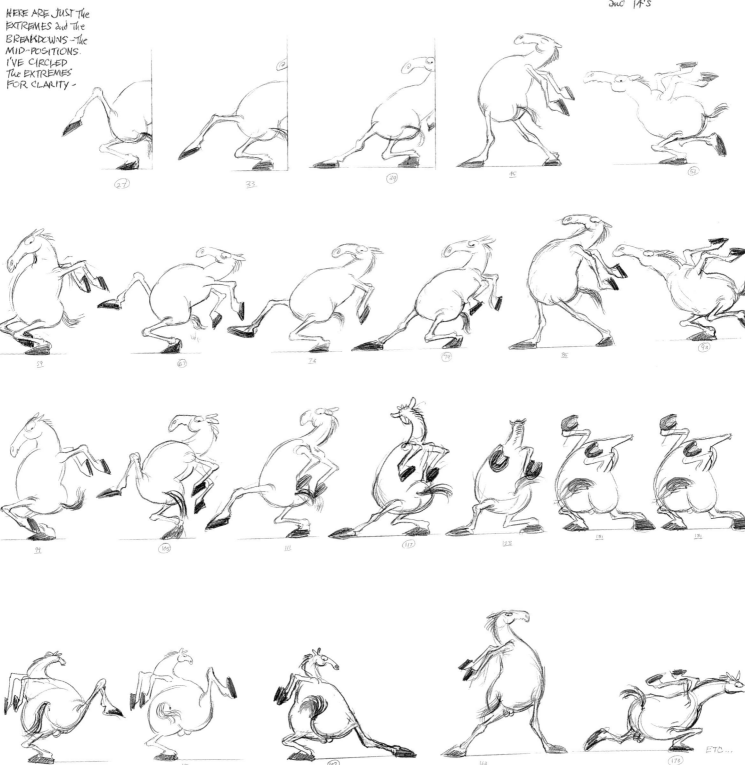

171

HERE'S A MORE CONSERVATIVE SNEAK ON 24'S - 1 SEC FOR EACH STEP ⟮KEN HARRIS MADE THIS ONE⟯ IT'S TYPICAL OF KEN - NOT A LOT OF FANCY STUFF BUT DOES THE JOB PERFECTLY.

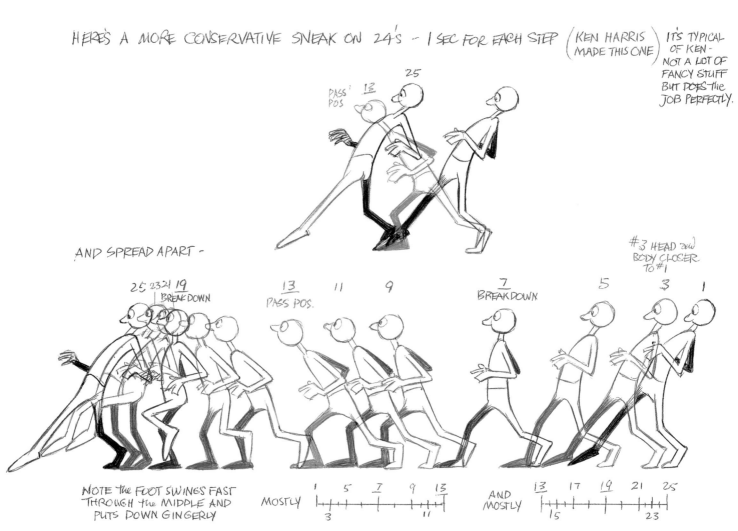

AND SPREAD APART -

#3 HEAD 2⁰ BODY CLOSER TO #1

NOTE THE FOOT SWINGS FAST THROUGH THE MIDDLE AND PUTS DOWN GINGERLY

THE BIG MOVE THROUGH THE MIDDLE INDICATES THAT THIS SHOULD HAVE SINGLE INBETWEENS AND BE ON ONES

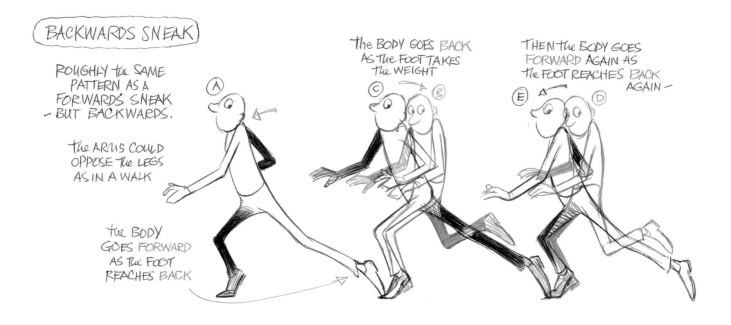

⟮BACKWARDS SNEAK⟯

ROUGHLY THE SAME PATTERN AS A FORWARDS SNEAK - BUT BACKWARDS.

THE ARMS COULD OPPOSE THE LEGS AS IN A WALK

THE BODY GOES FORWARD AS THE FOOT REACHES BACK

THE BODY GOES BACK AS THE FOOT TAKES THE WEIGHT

THEN THE BODY GOES FORWARD AGAIN AS THE FOOT REACHES BACK AGAIN -

the TIP TOE SNEAK

IT'S SOMETHING BETWEEN A WALK and A RUN and A SNEAK.

The FEET WORK
UP and DOWN
LIKE PISTONS
—HAS TO BE
ON ONES.

CAN BE AS QUICK
AS 4's = 6 STEPS PER SEC.
OR ON 6's, 8's 10's
12's, 14's, WHATEVER.
BUT ITS MORE
SUITABLE FOR
FAST TIMING —

HERE'S the WELL-KNOWN
FORMULA FOR the SHORT-
LEGGED CREATURE (ON 4's)

ITS NOT MUCH OF
A PROBLEM WITH
A SMALL OR SHORT
CREATURE WITH
SHORT LEGS —

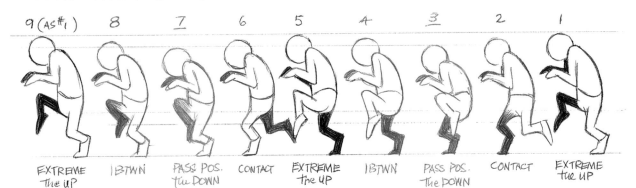

9 (AS #1)	8	7	6	5	4	3	2	1
EXTREME the UP	I BTWN	PASS POS. the DOWN	CONTACT	EXTREME the UP	I BTWN	PASS POS. the DOWN	CONTACT	EXTREME the UP

BUT WITH A TALLER FIGURE
WITH LONG LEGS WE'VE GOT
the FAMILIAR PROBLEM OF
TOO MUCH ACTION IN TOO
SHORT A SPACE OF TIME.

The FEET TEND TO 'FLICK'
DOWN WITH the TOP LEG
JUST LOOKING LIKE IT'S
HANGING THERE —

SO, TO GET AROUND THIS
WE TAKE A BIT LONGER
FOR the ACTION.
- PLUS WE CAN TWIST the PELVIS
- PLUS WE CAN VARY the CYCLE POSITIONS.

WE CAN
CHANGE the
SILHOUETTES
SLIGHTLY ON
ALL PHASES
OF EACH
STEP —
LOWER the
KNEE ETC.

E.G.
1ST
STEP

NEXT
STEP
- COUNTER
STEP

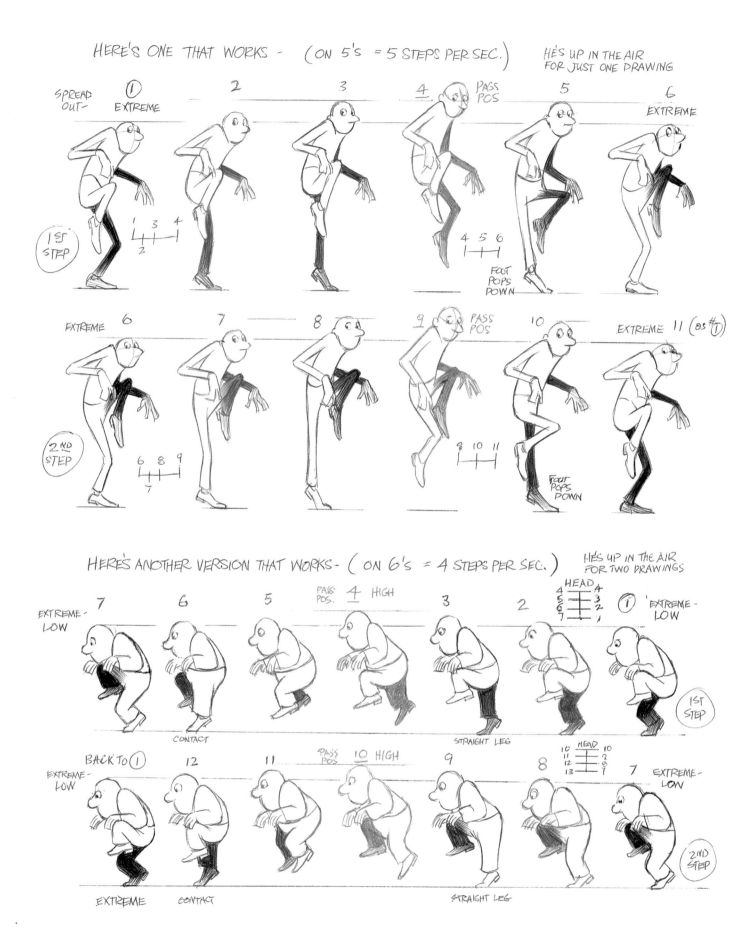

HERE'S ONE THAT WORKS - (ON 5's = 5 STEPS PER SEC.) HE'S UP IN THE AIR
FOR JUST ONE DRAWING

SPREAD OUT- ① EXTREME 2 3 4 PASS POS 5 6 EXTREME

1ST STEP

1 3 4
2

4 5 6
FOOT POPS DOWN

EXTREME 6 7 8 9 PASS POS 10 EXTREME 11 (as #①)

2ND STEP

6 8 9
7

8 10 11

FOOT POPS DOWN

HERE'S ANOTHER VERSION THAT WORKS - (ON 6's = 4 STEPS PER SEC.) HE'S UP IN THE AIR
FOR TWO DRAWINGS

EXTREME-LOW 7 6 5 PASS POS. 4 HIGH 3 2 ① EXTREME-LOW

HEAD
4 4
5 3
6 2
7 1

CONTACT STRAIGHT LEG 1ST STEP

BACK TO ① 12 11 PASS POS 10 HIGH 9 8 7 EXTREME-LOW

EXTREME-LOW

HEAD
10 10
11 9
12 8
13 7

EXTREME CONTACT STRAIGHT LEG 2ND STEP

174

WE CAN GET SOME COUNTERACTION GOING ON A FAST SNEAK (THIS IS EXAGGERATED)

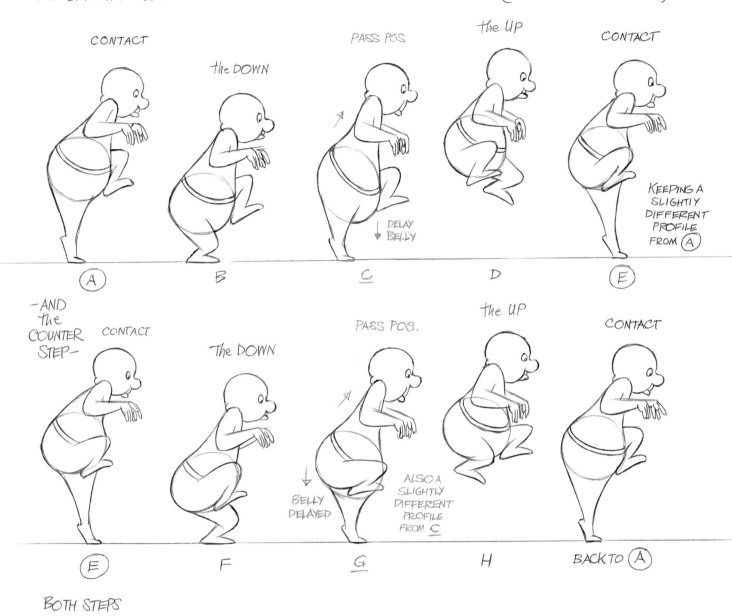

CONTACT

the DOWN

PASS POS

the UP

CONTACT

DELAY BELLY

KEEPING A SLIGHTLY DIFFERENT PROFILE FROM (A)

(A) B C D (E)

—AND the COUNTER STEP—

CONTACT

The DOWN

PASS POS.

the UP

CONTACT

BELLY DELAYED

ALSO A SLIGHTLY DIFFERENT PROFILE FROM C

(E) F G H BACK TO (A)

BOTH STEPS

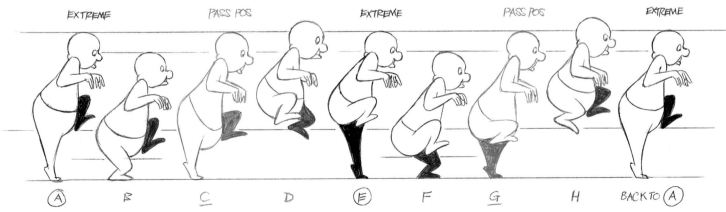

EXTREME PASS POS EXTREME PASS POS EXTREME

(A) B C D (E) F G H BACK TO (A)

(ANYWAY, THIS IS THE IDEA – WHICH CAN APPLY IN A REDUCED WAY TO A LESS CARTOONY ACTION and FIGURE.)

175

RUNS AND JUMPS AND SKIPS

IN A WALK ALWAYS ONE FOOT IS ON THE GROUND. ONLY ONE FOOT LEAVES THE GROUND AT A TIME.

IN A RUN BOTH FEET ARE OFF THE GROUND AT SOME POINT FOR 1, 2 OR 3 POSITIONS.

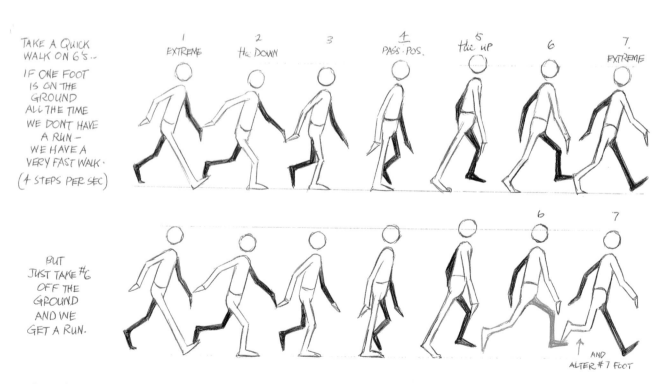

TAKE A QUICK WALK ON 6'S —

IF ONE FOOT IS ON THE GROUND ALL THE TIME WE DON'T HAVE A RUN — WE HAVE A VERY FAST WALK.

(4 STEPS PER SEC)

1 EXTREME 2 the DOWN 3 4 PASS·POS. 5 the UP 6 7. EXTREME

BUT JUST TAKE #6 OFF THE GROUND AND WE GET A RUN.

6 7

AND ALTER #7 FOOT

IT DOESN'T HAVE TO BE THAT WAY, BUT THAT WOULD BE THE DISTINGUISHING CHARACTERISTIC BETWEEN A RUN and A WALK.

176

HERE'S the SAME THING WITH A BIT MORE VITALITY - MORE LEAN - BIGGER ARM SWING -
BUT STILL JUST WITH the FEET OF the GROUND FOR ONE FRAME.
A 'NORMAL' RUN ON 6'S (4 STEPS PER SEC)

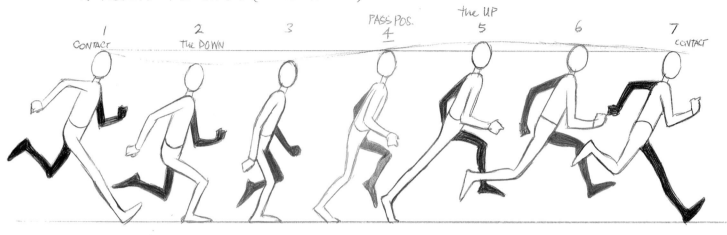

WE COULD TAKE The SAME THING and PUT The DOWN POSITION ON #3 and The UP RIGHT NEXT TO IT ON #4.

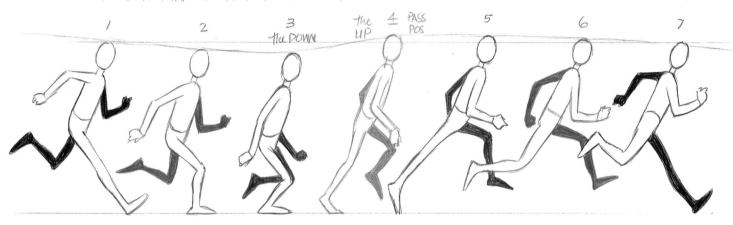

HERE'S A SIMILAR THING WITH MORE 'CARTOON' PROPORTIONS -
A CARTOON RUN ON 6'S - BUT WITH the FEET OFF the GROUND FOR 2 POSITIONS - PLUS VIOLENT ARM SWING.

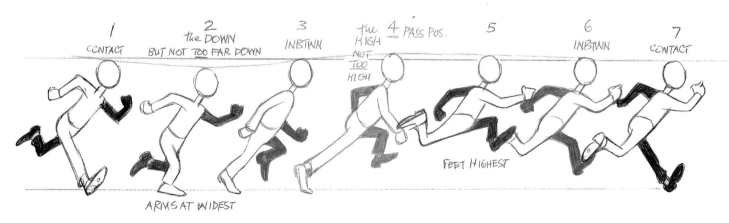

177

ANOTHER RUN ON 6's -

HERE'S THE 'REAL' VERSION OF THE SAME THING -

NOTE THE REDUCED ARM ACTION - WITH HARDLY ANY UP and DOWN ON THE BODY - PLUS BOTH FEET ARE OFF THE GROUND FOR 2 FRAMES.

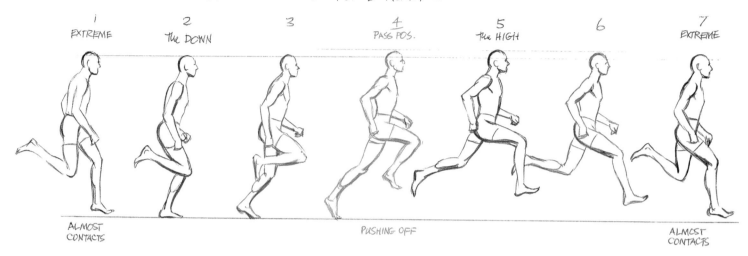

1	2	3	4	5	6	7
EXTREME	THE DOWN		PASS POS.	THE HIGH		EXTREME

ALMOST CONTACTS PUSHING OFF ALMOST CONTACTS

WITH RUNS WE CAN DO ALL THE THINGS WE DID WITH WALKS.

THE HEAD CAN GO UP and DOWN, SIDE TO SIDE, BACK and FORTH. THE BODY CAN BEND and TWIST IN OPPOSITE DIRECTIONS, THE FEET FLOP IN and OUT etc.

BUT WE CAN'T DO AS MUCH BECAUSE WE DON'T HAVE SO MANY POSITIONS TO DO IT IN BECAUSE THE RUN IS FASTER (A WALKER ON 12's MIGHT RUN ON 6's)

RULE OF THUMB ON A RUN - WHEN WE RAISE THE BODY IN THE UP POSITION RAISE IT ONLY ½ HEAD OR EVEN ⅓ OF A HEAD NEVER A WHOLE HEAD. THAT'S TOO MUCH.

178

OF COURSE,
 RUNS HAVE TO BE ON ONES BECAUSE OF SO
 MUCH ACTION IN A SHORT SPACE OF TIME.

AS WITH WALKS,
 WE CAN CURVE THE BODY
 REVERSE IT ON THE OPPOSITE STEP
 and KEEP IT STRAIGHT ON THE PASS. POSITION.

HEAD SLIGHTLY UP ON THE PASSING POSITION.

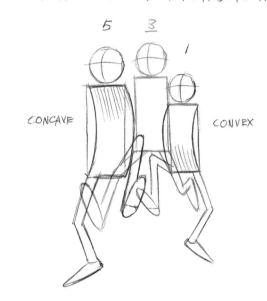

CONCAVE CONVEX

(OR) WE CAN TWIST THE BODY SIDEWAYS
 ON THE EXTREMES TO GET A FUNNY
 EFFECT —

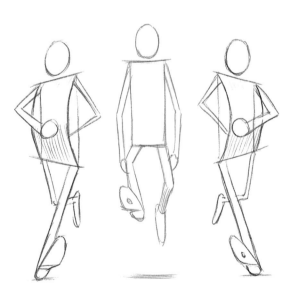

(OR) AS WITH A WALK —
 WE CAN VARY IT BY HAVING THE BODY
 GO DOWN ON THE INTERMEDIATE POSITION
 BUT STILL TREAT THE FEET THE SAME WAY.

AND
SHOULDERS
OPPOSE
HIPS

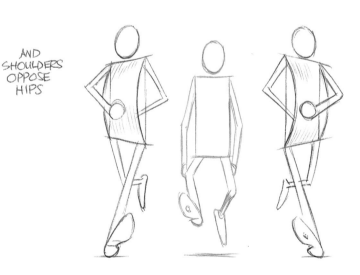

179

LET'S TAKE A TRADITIONAL CARTOON RUN - (SPREAD APART)

COULD BE ON 4's -
OR ON 8's
WITH INBETWEENS

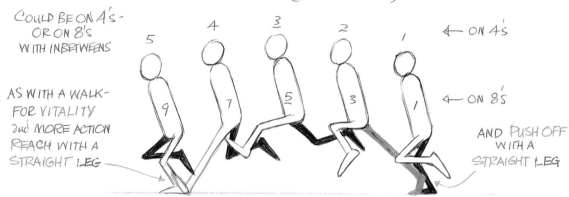

← ON 4's

← ON 8's

AS WITH A WALK -
FOR VITALITY
and MORE ACTION
REACH WITH A
STRAIGHT LEG -

AND PUSH OFF
WITH A
STRAIGHT LEG

WE CAN PLAN
A RUN FROM
ANY POSITION
IN THE RUN -

START WITH
THE CONTACTS -
AS THE EXTREMES

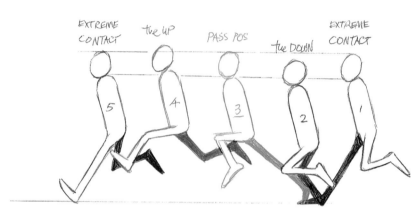

OR
START FROM
THE DOWN
POSITIONS -
AS THE
EXTREMES

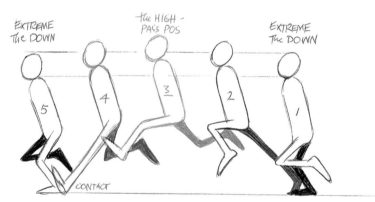

OR
START FROM
THE UP
POSITIONS -
THE FEET
SPREAD
IN THE AIR
POSITIONS
AS THE EXTREMES

(OR START WITH THE PUSH-OFFS)

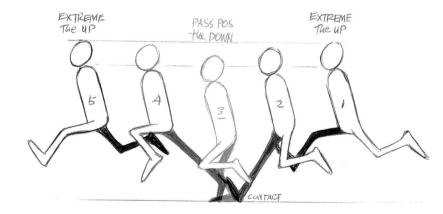

IN A FAST RUN (SAY, ON 4's) #5 SHOULD NOT BE EXACTLY the SAME SILHOUETTE AS IT'S COUNTER - #1. VARY IT SOMEHOW - MAKE IT HIGHER OR LOWER.

AND IN A FAST RUN The POSITIONS SHOULD OVERLAP SLIGHTLY TO HELP CARRY The EYE.

(SPREAD OUT) 5 4 3 2 1

(OVERLAPPING - AS IT WOULD BE) 5 4 3 2 1

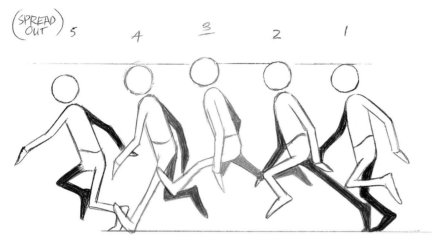

IN A 'NORMAL' RUN The ARMS (AS IN A WALK) COUNTER EACH OTHER.

WE CAN HAVE SOME FOOT SLIPPAGE ON A FAST RUN - BUT NOT ON A WALK.

HERE'S the CLICHÉ (CLICHÉS GIVE US A LEG TO STAND ON)

BUT TO VARY IT - WHAT ABOUT HAVING The LEGS EXACTLY OPPOSITE TO the STANDARD RUN?

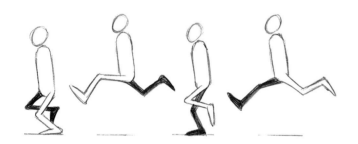

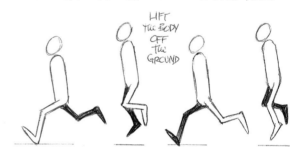

LIFT The BODY OFF The GROUND

HERE'S A 4 DRAWING RUN WHERE The NORMAL PASSING-POSITION IS USED AS the DOWN - INCLUDING the ARMS.

AND ON The MIDDLE POSITION PUSH The HEAD and BODY MORE FORWARD (BUT NOT TOO MUCH)

DOWN 5 4 PASS POS-UP 3 2 DOWN 1

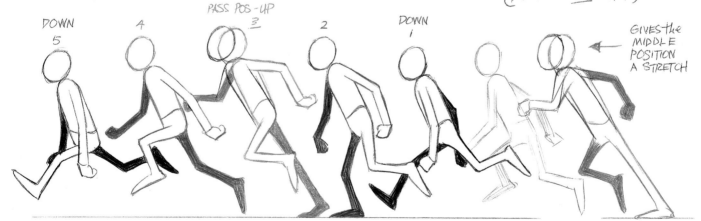

GIVES the MIDDLE POSITION A STRETCH

181

THERE CAN BE A
HUGE FORWARD LEAN –

IN 'REALITY'
 The FASTER the FIGURE RUNS
 The MORE IT LEANS FORWARD.

(AND IT DOESN'T HAVE TO BE)
(IN BALANCE ALL The TIME)

OBVIOUSLY,
 WE CAN TAKE THINGS MUCH FURTHER –
 HERE'S A RUN ON 6's (PLANNED FROM The SPREAD FOOT POSITIONS)

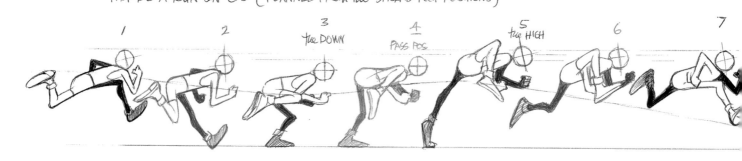

BECAUSE OF the LONG LEGS IT NEEDS AT LEAST 6 POSITIONS TO MAKE IT WORK –
GOT TO KEEP The HEEL MOVING IN AN ARC. THE HEEL LEADS – The TOE FOLLOWS.

HOW ABOUT THIS ONE –
 A 6 DRAWING RUN

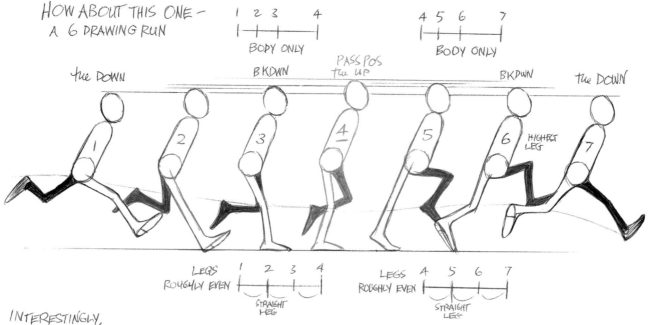

INTERESTINGLY,
 ART BABBITT FELT THAT 6 FRAMES IS REALLY A NICER RUN THAN A 4 OR 5 DRAWING RUN.
 AND KEN HARRIS, A TOP EXPONENT OF 'WARNER' FAST ACTION ALWAYS PREFERRED TO DO RUNS ON 6's and 8's.

WHAT ABOUT THE ARMS? DO THEY PUMP BACK and FORTH? SWING VIOLENTLY? DANGLE LOOSELY?
DO THEY SWING FROM SIDE TO SIDE? DO THEY HARDLY MOVE AT ALL?

IN A CLICHÉ OR STANDARD RUN
THE ARMS (AS IN A WALK)
ARE OPPOSITE TO THE LEGS.

LET'S TRY A RESTRICTED ARM MOTION.
THE ARM STILL OPPOSES THE LEG
BUT MOVEMENT IS RESTRICTED.

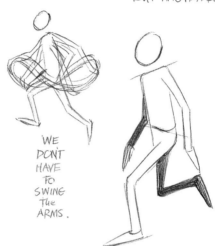

WE
DON'T
HAVE
TO
SWING
THE
ARMS.

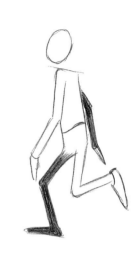

ARMS BENT AT ELBOW - VERY RESTRICTED.

RESTRICTED IN A WOMAN'S RUN -

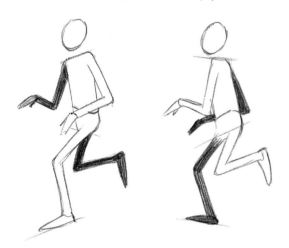

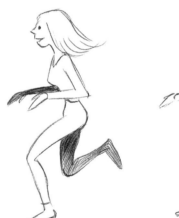

ON A VERY FAST RUN
THERE'S A DANGER OF TOO MUCH
ARM MOVEMENT.

IT CAN BE TOO FAST and CONFUSING.
THE LEG ACTION SHOULD PREDOMINATE.

SEEN
THIS?

HOW ABOUT the ARMS SWINGING FROM SIDE TO SIDE - AND FORCE the PERSPECTIVE.

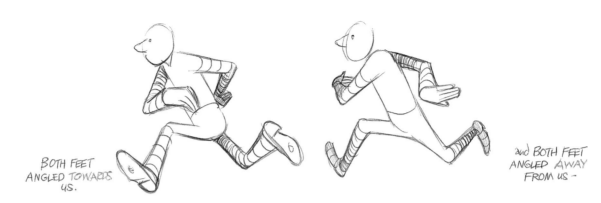

BOTH FEET ANGLED TOWARDS US.

and BOTH FEET ANGLED AWAY FROM US -

HERE'S AN ANGRY RUN ON 8's (3 STEPS PER SEC.) NEEDS the TIME TO ACCOMODATE the WILD ARM and LEG ACTION

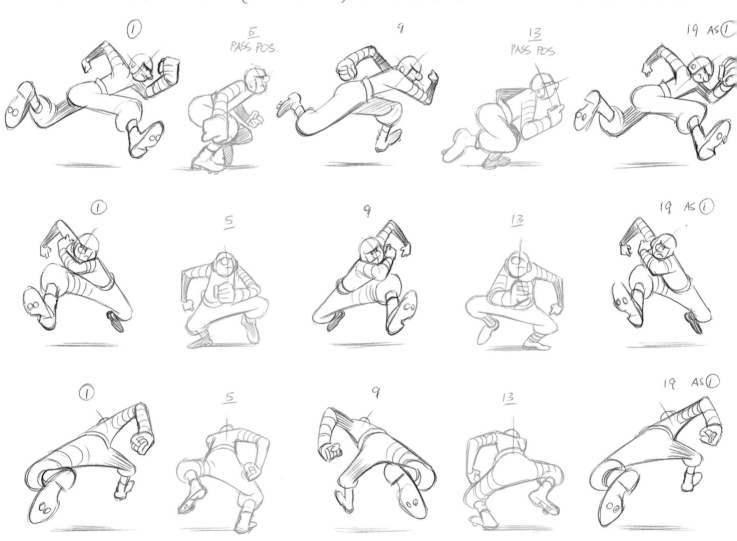

WHAT ABOUT VARYING EVERY OTHER PASSING POSITION AS THE RUN PROGRESSES?
HAVE EVERY OTHER PASSING POSITION GO DOWN — EVEN THOUGH BOTH FEET ARE OFF THE GROUND.

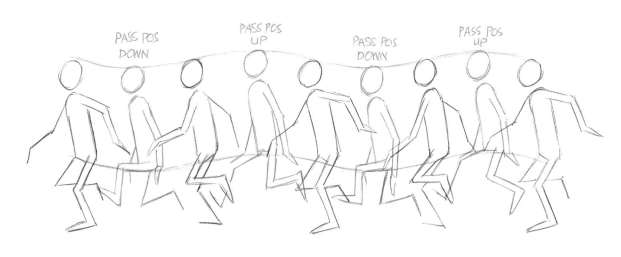

PASS POS DOWN PASS POS UP PASS POS DOWN PASS POS UP

OR

AS WE DID WITH A WALK — LET'S HAVE THE ARMS PUMPING AWAY TWICE AS FAST AS THE FEET —

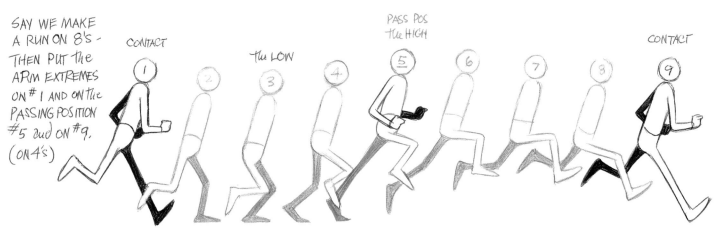

SAY WE MAKE A RUN ON 8's — THEN PUT THE ARM EXTREMES ON #1 AND ON THE PASSING POSITION #5 and ON #9. (ON 4's)

CONTACT 1 2 THE LOW 3 4 PASS POS THE HIGH 5 6 7 8 CONTACT 9

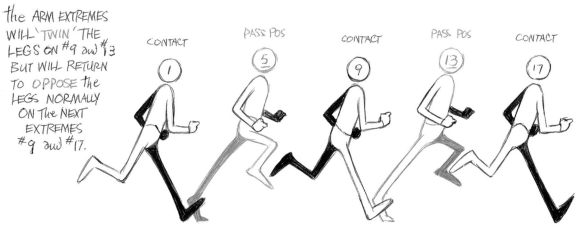

the ARM EXTREMES WILL 'TWIN' THE LEGS ON #9 and #13 BUT WILL RETURN TO OPPOSE THE LEGS NORMALLY ON THE NEXT EXTREMES #9 and #17.

CONTACT 1 PASS POS 5 CONTACT 9 PASS POS 13 CONTACT 17

THE AMOUNT OF ARM MOVEMENT WILL HAVE TO BE RESTRICTED SINCE IT'S PUMPING EVERY 4 FRAMES (6 TIMES A SECOND)

WE COULD MAKE A RUN ON 12's — AND PUT THE ARM ACTION ON 6's (4 PUMPS A SECOND) — WOULD BE VERY EFFECTIVE.

185

CONVERSLY - WE COULD MAKE A RUN AND HAVE THE ARMS GOING TWICE AS SLOW AS THE FEET.

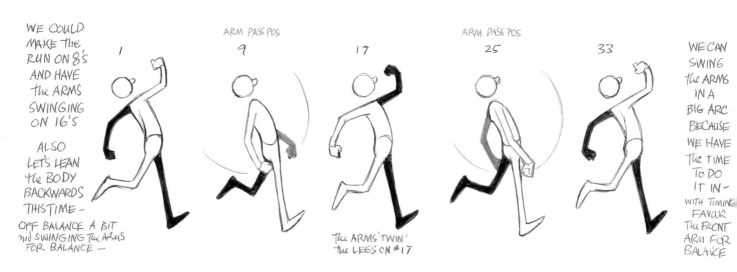

WE COULD MAKE THE RUN ON 8'S AND HAVE THE ARMS SWINGING ON 16'S

ALSO LET'S LEAN THE BODY BACKWARDS THIS TIME -

OFF BALANCE A BIT and SWINGING THE ARMS FOR BALANCE -

ARM PASS POS
1 9 17 25 33

The ARMS 'TWIN' The LEGS ON #17

WE CAN SWING The ARMS IN A BIG ARC BECAUSE WE HAVE The TIME TO DO IT IN - WITH TIMING FAVOUR The FRONT ARM FOR BALANCE

HERE'S A 5 DRAWING RUN
 SHOWING HOW WE CAN VARY The SILHOUETTES ON A FAST RUN -
- AGAIN, SO THAT The EYE DOESN'T READ IT AS JUST The SAME ONE LEG and ONE ARM GOING AROUND.

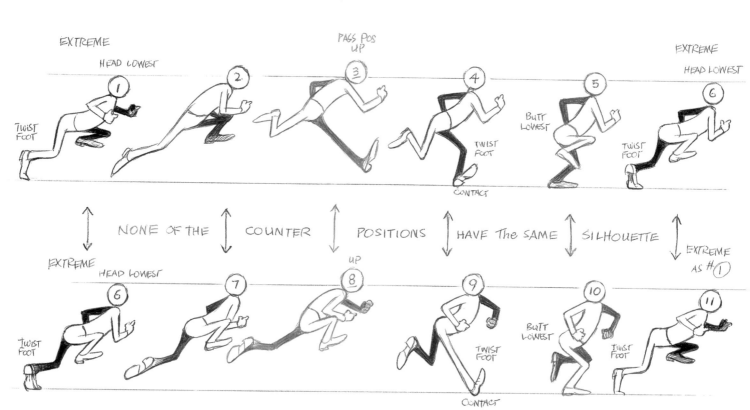

EXTREME HEAD LOWEST PASS POS UP EXTREME HEAD LOWEST
TWIST FOOT
1 2 3 4 BUTT LOWEST 5 TWIST FOOT 6
TWIST FOOT
CONTACT

NONE OF THE COUNTER POSITIONS HAVE The SAME SILHOUETTE

EXTREME HEAD LOWEST UP EXTREME AS #①
TWIST FOOT
6 7 8 9 BUTT LOWEST 10 TWIST FOOT 11
TWIST FOOT
CONTACT

ALSO The BACKS GO FROM CONCAVE TO CONVEX, The FEET TWIST and The ARMS and LEGS ARE QUITE DIFFERENT

186

HERE'S A JOGGING RUN ON 6's -

BECAUSE THIS RUN IS SLIGHTLY SLOWER THAN the PRECEEDING WILDER ONE ON 5's
AND BECAUSE the LENGTH OF the STRIDES IS MUCH REDUCED - (BOTH FEET ARE IN the AIR
FOR JUST ONE FRAME) - the CONVERSE SILHOUETTES CAN BE MORE ALIKE - (But STILL DIFFERENT)

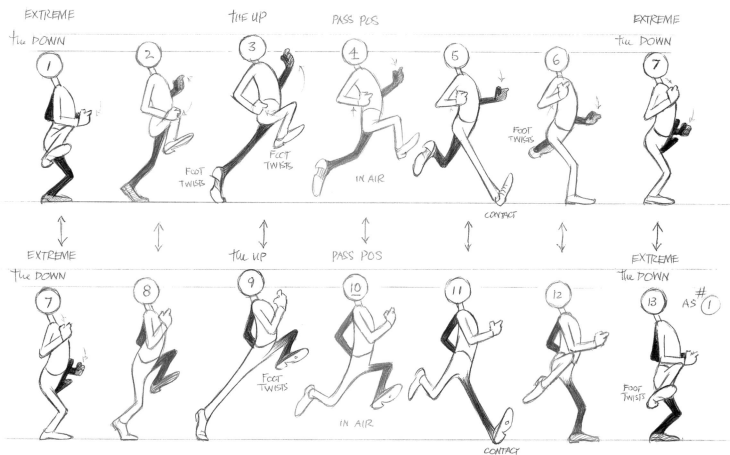

The FEET TWIST and the ARMS PUMP AROUND IN A SMALL CIRCLE THE HEAD JUST GOES UP AND DOWN.

A YOUNG GIRL MIGHT RUN ON 8's — REDUCED ACTION — WITH ONLY ONE DRAWING OFF the GROUND.

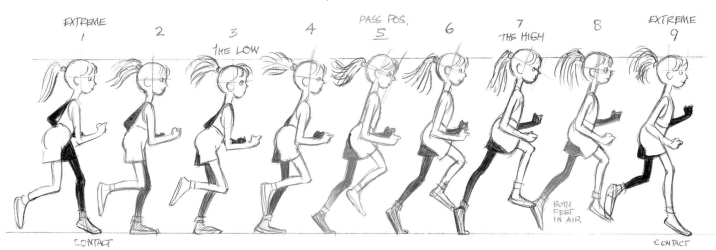

TAKE A FAT MAN RUNNING ON 6's -

THERE'S GOING TO BE LOTS OF UP and DOWN ON the WEIGHT, BECAUSE HE'S SO HEAVY the DOWN POSITION IMMEDIATELY FOLLOWS the UP POSITION. THEN HE HAS TO LIFT HIMSELF UP OVER the NEXT 5 FRAMES IN ORDER TO FALL DOWN HEAVILY AGAIN. THEN HIS HEAD LEANS FORWARD TO HELP the PUSH-UP.

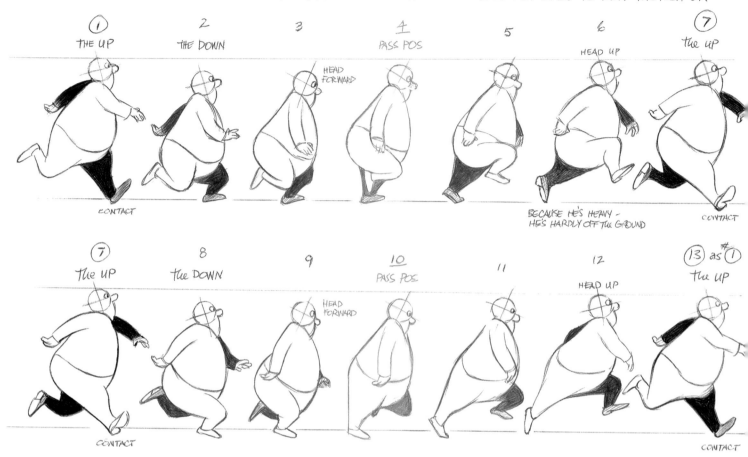

AN IMPORTANT THING - WHEN A RUNNER ROUNDS A CORNER THEY LEAN TOWARDS the CENTRE -
IN THE DIRECTION OF the TURN -

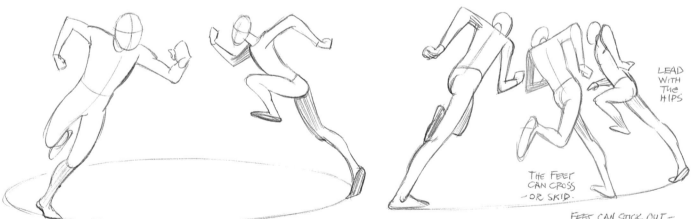

LIKE A MOTORBIKE, THEY LEAN ON the TURN (DEPENDING ON the SPEED)

LEAD WITH THE HIPS

THE FEET CAN CROSS - OR SKID.

FEET CAN STICK OUT - TAKE ALL SORTS OF LIBERTIES - BUT THE EYE WILL FOLLOW the BODY.

SOMEONE SAID THAT 'THE CHASE' IS AN INVENTION THAT IS ORGANIC TO MOVIES.
CERTAINLY THERE ARE THOUSANDS OF RUNNING AROUND 'CHASE' CARTOONS
PRODUCING ENDLESS and INVENTIVE VARIATIONS ON FAST RUNS.

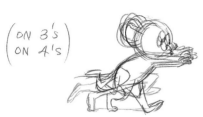

(ON 3's)
(ON 4's)

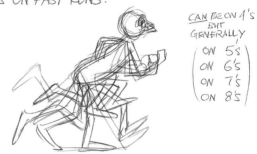

CAN BE ON 4's
BUT
GENERALLY,
(ON 5's)
(ON 6's)
(ON 7's)
(ON 8's)

THE FAST RUNS ARE MORE SUITABLE FOR SHORT
FIGURES WHICH NEED FEWER POSITIONS TO
FUNCTION IN LESS TIME BECAUSE IT ALL OVERLAPS.

AND THE LONGER-LEGGED FIGURE NEEDS SLIGHTLY
MORE TIME TO FUNCTION — ONE OR TWO MORE
POSITIONS TO HELP CARRY THE EYE.

THE 4 DRAWING FORMULA RUN

EFFECTIVE FOR SHORT-LEGGED FIGURES

THIS IS SO FAST (6 STEPS PER SECOND) THAT THERE'S NOT ENOUGH TIME TO SWING
THE ARMS AROUND VIOLENTLY — SO THEY FOUND ITS BEST TO STRETCH THE ARMS OUT
IN FRONT. THE LEG ACTION WORKS UNDER and BEHIND THE BODY (OK TO HAVE SLIPPAGE
ON THE FEET.)

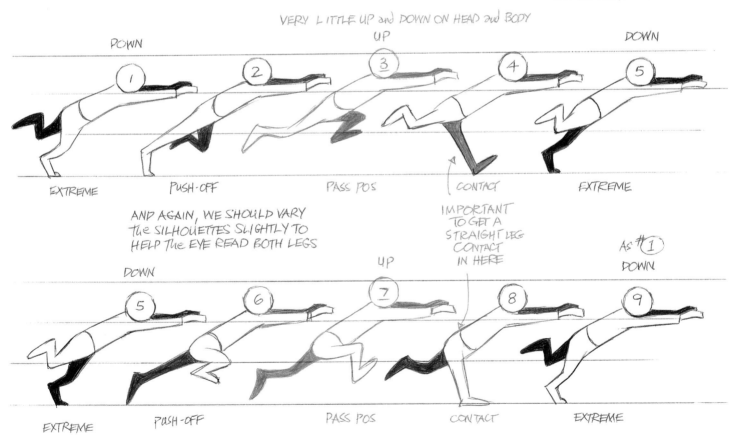

VERY LITTLE UP and DOWN ON HEAD and BODY

DOWN UP DOWN

1 2 3 4 5

EXTREME PUSH-OFF PASS POS CONTACT EXTREME

AND AGAIN, WE SHOULD VARY
THE SILHOUETTES SLIGHTLY TO
HELP THE EYE READ BOTH LEGS

IMPORTANT
TO GET A
STRAIGHT LEG
CONTACT
IN HERE

AS #1

DOWN UP DOWN

5 6 7 8 9

EXTREME PUSH-OFF PASS POS CONTACT EXTREME

189

VARIATIONS ON 4 DRAWING RUNS – THIS ONE IS PLANNED FROM the UP IN AIR POSITIONS BUT IT'S STILL ON the SAME BASIC PATTERN AS THE PRECEDING FORMULA.

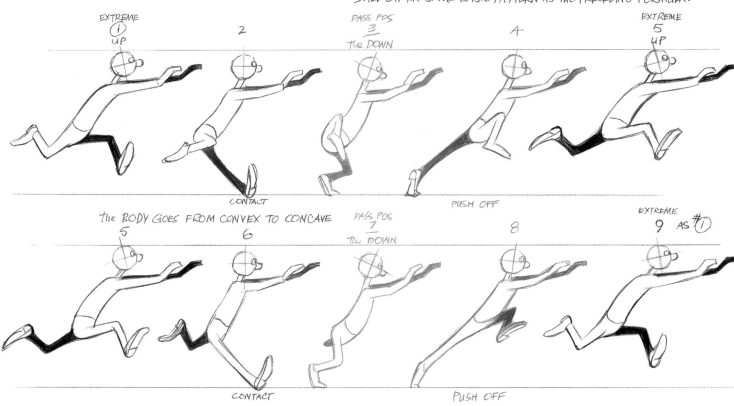

EXTREME
①
UP

2

PASS POS
3
Tw DOWN

4

EXTREME
5
UP

CONTACT

PUSH OFF

the BODY GOES FROM CONVEX TO CONCAVE

5

6

PASS POS
7
Tw DOWN

8

EXTREME
9 AS #①

CONTACT

PUSH OFF

HERE'S A VERY WILD ONE – WITH ARM SWINGS – PLANNED FROM the PUSH OFF POSITIONS BUT STILL BASED ON THE FORMULA PATTERN

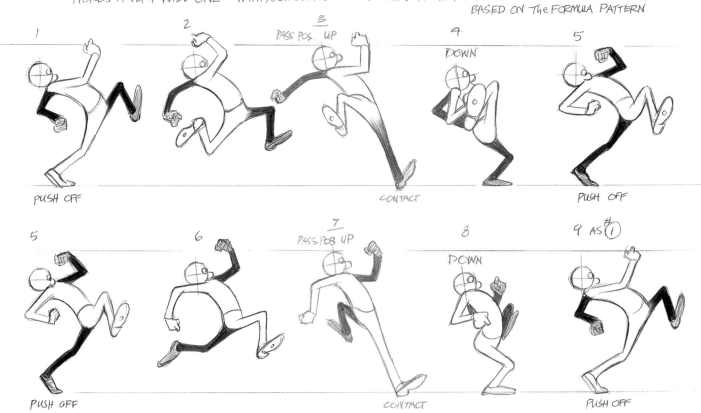

1

2

PASS POS
3
UP

4
DOWN

5

PUSH OFF

CONTACT

PUSH OFF

5

6

7
PASS POS UP

8
DOWN

9 AS #①

PUSH OFF

CONTACT

PUSH OFF

190

I MADE THIS RUN ON 4'S — IT'S PLANNED FROM THE PUSH OFFS #①and⑤

IT COULD HAVE DONE WITH A BIT MORE UP and DOWN and STRETCH ON THE BODY BUT THE LEG ACTION CARRIES IT.

IT'S A CYCLE - REDRAWN WITH HAIR, ARM WITH KITE, COATTAILS and ANIMATED PERSPECTIVE FLOOR ADDED AFTERWARDS.

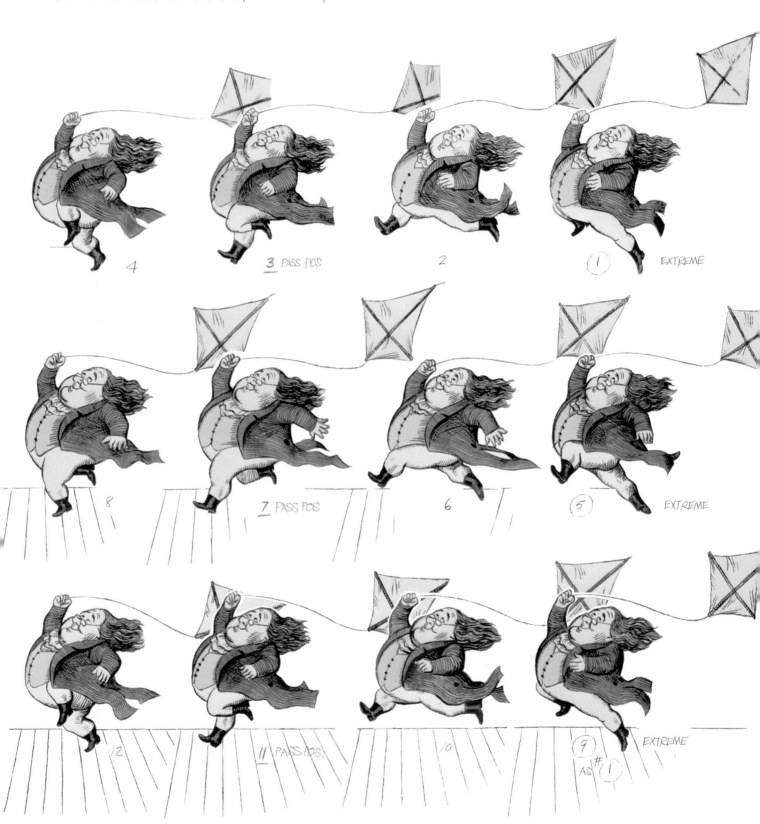

4

3 PASS POS

2

① EXTREME

8

7 PASS POS

6

⑤ EXTREME

12

11 PASS POS

10

⑨ EXTREME
AS #①

INCIDENTALLY, ABOUT CYCLES —

LONG CYCLES ARE GREAT. SHORT CYCLES OBVIOUSLY READ AS CYCLES —
BUT IF WE TAKE SEVERAL STRIDES WITH VARIATIONS IN THE EXTREMES 2nd
PASSING POSITIONS, ETC. — THEN HOOK BACK TO #①, IT STOPS OR DELAYS
THE EYE READING IT AS A CYCLE.

THE 3 DRAWING RUN

= 8 STEPS PER SECOND! WE CAN'T GET MUCH FASTER THAN THIS BECAUSE —

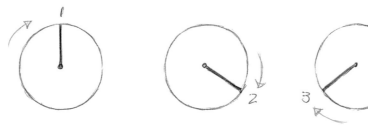

TO MAKE A WHEEL OR A SPOKE APPEAR TO GO AROUND IN A CIRCLE
WE NEED A MINIMUM OF 3 DRAWINGS / POSITIONS.

TWO WON'T DO IT.
IT JUST FLICKERS — AS OR

SO WE NEED TO FIND 3 NICE WORKABLE LEG POSITIONS TO MAKE IT GO AROUND.

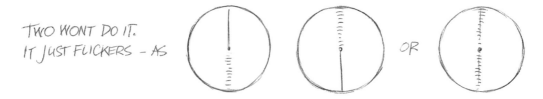

IN PRACTICE, IT WORKS OUT LIKE THIS:

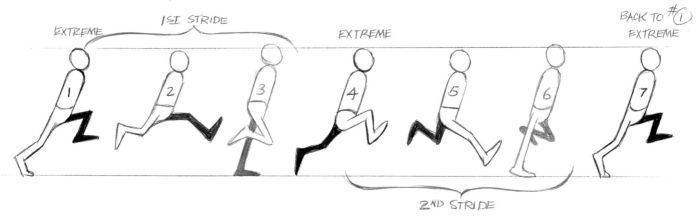

192

THERE ARE COUNTLESS VARIATIONS ON THIS — BASICALLY JUST GETTING THE 3 DRAWINGS TO GO AROUND.

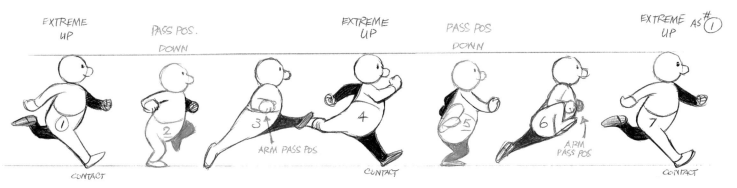

OF COURSE IT WORKS BEST WITH SHORT CARTOONY FIGURES —

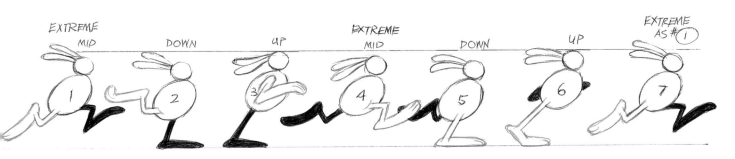

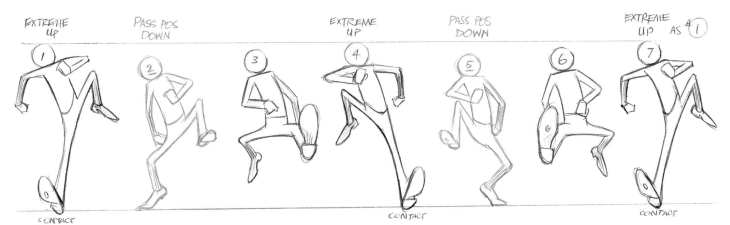

BUT IT'LL STILL WORK WITH A TALLER FIGURE —

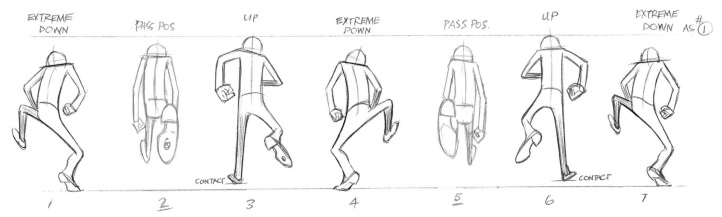

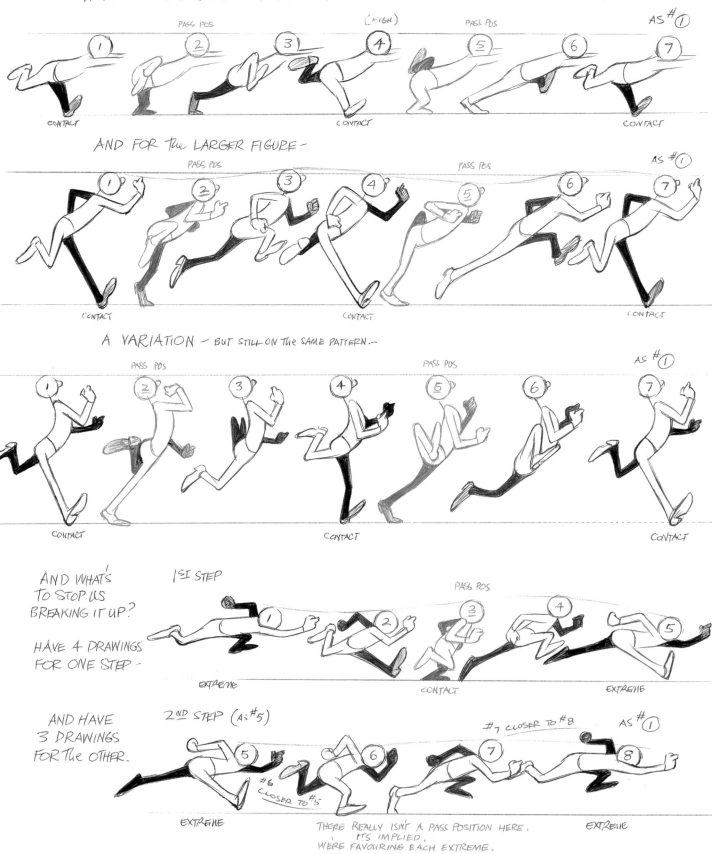

HERE'S THE STANDARD VERSION FOR BROAD LEG ACTION ON A 3 DRAWING RUN-

PASS POS · (HIGH) · PASS POS · AS #①

CONTACT · CONTACT · CONTACT

AND FOR THE LARGER FIGURE-

PASS POS · PASS POS · AS #①

CONTACT · CONTACT · CONTACT

A VARIATION - BUT STILL ON THE SAME PATTERN-

PASS POS · PASS POS · AS #①

CONTACT · CONTACT · CONTACT

AND WHAT'S TO STOP US BREAKING IT UP?

HAVE 4 DRAWINGS FOR ONE STEP-

1ST STEP · PASS POS

EXTREME · CONTACT · EXTREME

AND HAVE 3 DRAWINGS FOR THE OTHER.

2ND STEP (AS #5) · #7 CLOSER TO #8 · AS #①

#6 CLOSER TO #5

EXTREME · EXTREME

THERE REALLY ISN'T A PASS POSITION HERE.
IT'S IMPLIED.
WE'RE FAVOURING EACH EXTREME.

194

AND WE CAN STILL GO EVEN FASTER -

WE CAN USE 3 POSITIONS FOR the FIRST STRIDE and ONLY TWO FOR the NEXT.

HERE'S OUR FIRST 3 POSITIONS - the CONTACT EXTREMES WITH TWO INBETWEEN POSITIONS #2 and #3

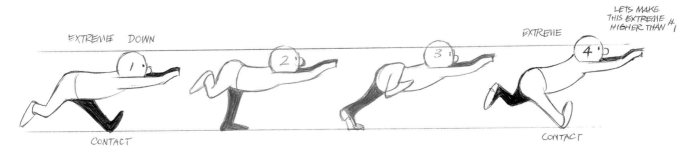

THEN TAKE EXTREME #4 AND ONLY MAKE ONE INBETWEEN BETWEEN IT and EXTREME #1 (AND MAKE IT the HIGHEST)

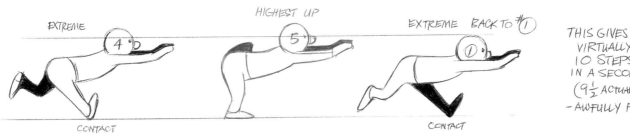

THIS GIVES US
VIRTUALLY
10 STEPS
IN A SECOND
($9\frac{1}{2}$ ACTUALLY)
- AWFULLY FAST -

SO WE GET:

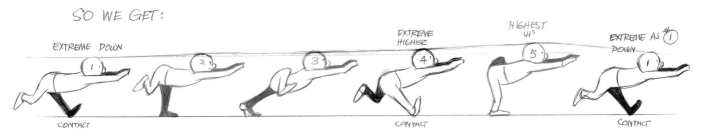

AND WE CAN SWITCH FROM ONE SIDE TO the OTHER WITH the SHORTER OR LONGER STEP -

(The 2 DRAWING RUN) the FASTEST POSSIBLE RUN - (AT LEAST WITH FILM RUNNING AT 24 FRAMES PER SECOND) = 12 STEPS per sec.

IN the 40's DIRECTOR TEX AVERY PUSHED the LIMITS - INVENTIVELY DEFYING GRAVITY - GOING FASTER and FASTER FOR HIS SPLIT SECOND GAGS - and THEY WANTED TO GET 2 DRAWING RUNS THAT WORKED.

CRUDELY, IT'S -

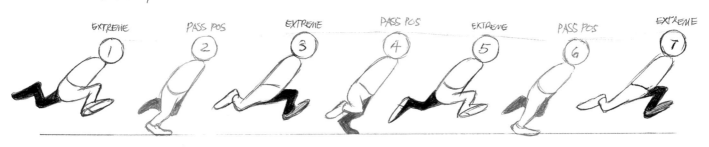

195

WITH A TWO DRAWING RUN -

THE PROBLEM WITH THE LEG ACTION IS THAT IT'S GOING TO FLICKER
AND LOOK LIKE WHAT IT IS — JUST 2 DRAWINGS SHOWING MORE OR LESS AT ONCE.

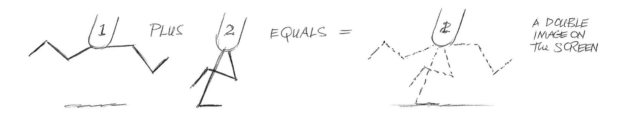

BUT THEY STILL WANTED TO GET THE HUMANLY IMPOSSIBLE SPEED -

ONE SOLUTION IS NOT TO PUT THE PASSING POSITION OF THE LEGS IN THE MIDDLE -
BUT TO FAVOUR TWO OF THE LEG POSITIONS CLOSER TOGETHER....

SO THAT THE EYE READS THE TWO DRAWINGS and THEN IT JUMPS THE BIG GAP.

I.E. —

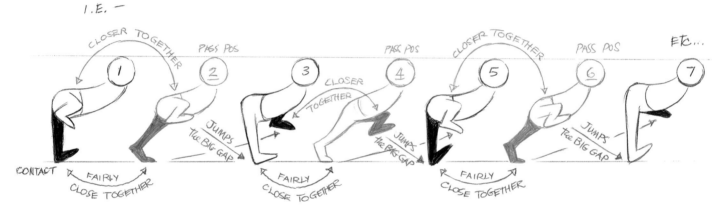

AND THE WEIGHT-BEARING FEET ARE ALSO PRETTY CLOSE TOGETHER.

VERY CLEVER!
AND IT'S THE SAME THING WITH A BACK OR FRONT VIEW -

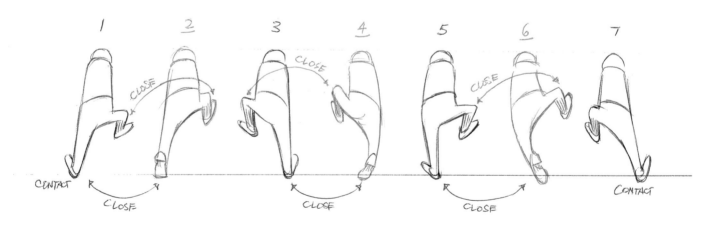

THE SAME IDEA WORKS PRETTY NICELY ON A ¾ VIEW –

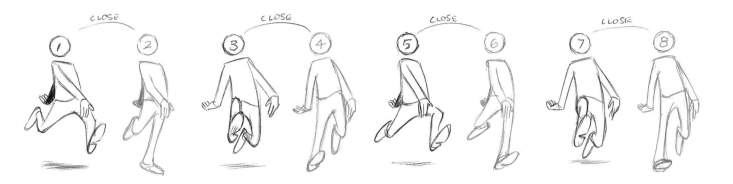

BUT FOR A SIDE VIEW WITH A TALLER FIGURE WITH LONGER LEGS IT'S BEST TO REVERT TO A 3 DRAWING RUN.

BUT FROM THE FRONT OR THE BACK VIEW THE 2 DRAWING DEVICE WORKS ASTONISHINGLY WELL. NOT POSSIBLE, BUT BELIEVABLE... 12 STEPS IN A SECOND!

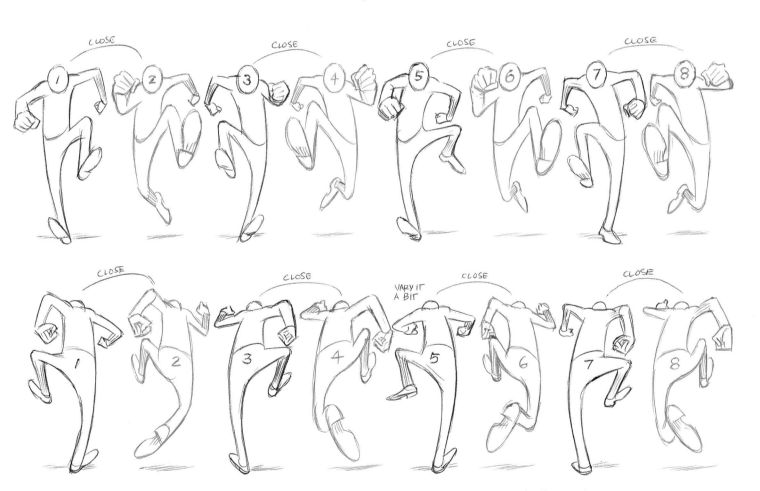

SO, THE ACTUAL PASSING POSITION IS OMITTED – IMPLIED – BY THE 2 CLOSE TOGETHER DRAWINGS AT EACH END – AND THE EYE JUMPS THE GAP WHERE THE PASS POSITION WOULD NORMALLY BE.

197

THE SAME THING CAN BE
HELPED ALONG BY OVERLAPPING
CONTRARY SHAPES –

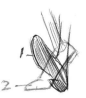

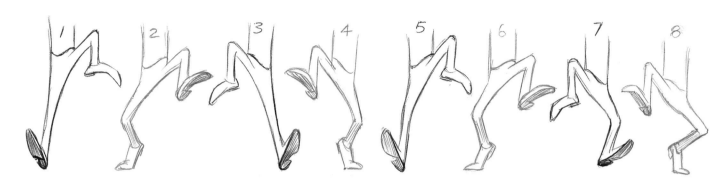

ANOTHER WAY TO DO the 2 DRAWING RUN IS TO KEEP VARYING the SILHOUETTES
AS WE GO ALONG – THEN the EYE READS IT AS A SORT OF CONVINCING SCRAMBLE –

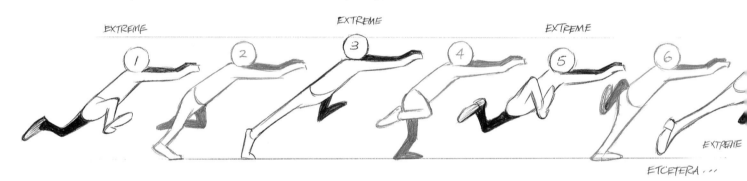

EXTREME EXTREME EXTREME

EXTREME

ETCETERA ...

ANOTHER TACTIC IS TO FLAIL the ARMS AROUND
FRANTICALLY – PROGRESSING the BODY and HEAD
LEAN FORWARD AS SHE GOES – OR BACKWARDS –
TO DIVERT the EYE and TAKE the CURSE OFF
the 2 DRAWING 'FLICKERING' FOOT ACTION.

the HEAD COULD MOVE
IN A TIGHT CIRCLE –
USING A MINIMUM OF
4 DRAWINGS TO DO IT.
– AND THAT CIRCLE ACTION
COULD ALSO PROGRESS
FORWARD – OR BACK –

INCIDENTALLY, HERE'S A SUGGESTION OF A PATTERN FOR ARMS FLAILING DURING A RUN. (IF IT'S A RUN ON TWO'S - THE ARMS WOULD FLAIL TWICE AS SLOW AS THE RUN.)

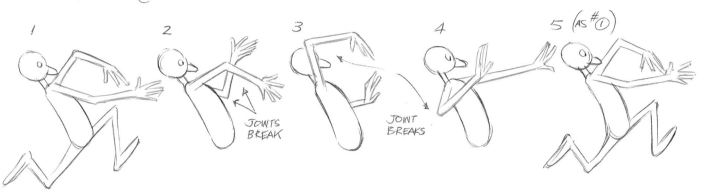

1 2 3 4 5 (AS #①)

JOINTS BREAK JOINT BREAKS

FOR A FINAL VARIATION ON A 2 DRAWING RUN - THE FASTEST POSSIBLE RUN - WE CAN GET INTO BLURS.

1 2

WE CAN HAVE JUST TWO DRAWINGS - (ON ONES)
BUT IT'S QUITE EFFECTIVE TO FILM THESE ON 2 FRAME DISSOLVES ⟶
SO THE DRAWINGS ARE ON TWOS - FOR 2 FRAMES EACH
BUT SOFTENED BY THE DISSOLVES -

DISSOLVE the 1ST DRAWING OUT

and DISSOLVE the 2ND DRAWING IN

THE RESULT IS THAT EVERY OTHER FRAME IS A 50/50 DOUBLE IMAGE EXPOSURE.

FRAME 1 IS IN FOCUS
FRAME 2 IS 50/50%
FRAME 3 IS IN FOCUS
FRAME 4 IS 50/50%
FRAME 5 IS IN FOCUS
ETC. ETC.
= GIVES A SILKY SOFTENING EFFECT

WE CAN, OF COURSE, ADD MORE BLUR POSITIONS.
I'VE FOUND THAT 2 FRAME DISSOLVES CAN BE
USED IN ALL SORTS OF ACTION TO SOFTEN THINGS
- ESPECIALLY WHEN THE ACTION IS CLOSE TOGETHER - IT ACTS AS A KIND OF VARNISH.

SUMMING UP ON RUNS:

The RECIPE

1 RUNS ARE ALWAYS ON ONES. (EXCEPT FOR THE 2 FRAME DISSOLVE DEVICE) WHICH IS REALLY JUST A TRICK.

2 WE CAN DO EVERYTHING WE DO ON WALKS EXCEPT REDUCED - ROUGHLY BY HALF.

3 IS THE HEAD PUMPING UP and DOWN?
OR ROCKING SIDE TO SIDE?
OR REVOLVING IN A SMALL CIRCLE?

4 ARE THE LEGS PUMPING UP and DOWN?
OR PUSHING OUT BROADLY?

5 ARE THE ARMS TO BE CONFINED?
STIFF DOWN THE BODY?
OR ARE THEY THRASHING AROUND IN BROAD ACTION?

6 WHAT IS THE BELT LINE DOING?

7 SHOULD WE SPEND MORE TIME IN THE AIR?
OR DO WE SPEND MORE TIME ON THE GROUND?

8 WE SHOULD BE INVENTIVE, DARING, TAKE CHANCES!

9 THEN OF COURSE - WHO IS RUNNING?

FAT?	GANGSTER?
OLD?	CRIPPLE?
THIN?	BISHOP?
YOUNG?	FINANCIER?
ATHLETE?	THIEF?
UNCO-ORDINATED?	CHILD?
SPINSTER?	DRUNK?
GLAMOUR QUEEN?	HIPPY?
COP?	THE QUEEN OF ENGLAND?

10 AND OF COURSE, WHAT ARE THEY RUNNING FROM —
OR TO? AND TO WHAT PURPOSE...
WILL HAVE A DRAMATIC EFFECT ON THE RUN.

HERE'S AN EXTENDED (RUN, JUMP, SKIP and LEAP) ON THE NEXT 6 PAGES (ALL ON ONES)

THIS OLD LADY LOOKS A BIT LIKE AN ANIMATED ROAD MAP, BUT HER ACTION SITS RIGHT ON THE BASICS-
EVERYTHING WE'VE BEEN TALKING ABOUT.

FIRST WE BUILD HER STARTING RUN - ON 4's - BEGINNING WITH THE CONTACTS #1, 5 and 9:

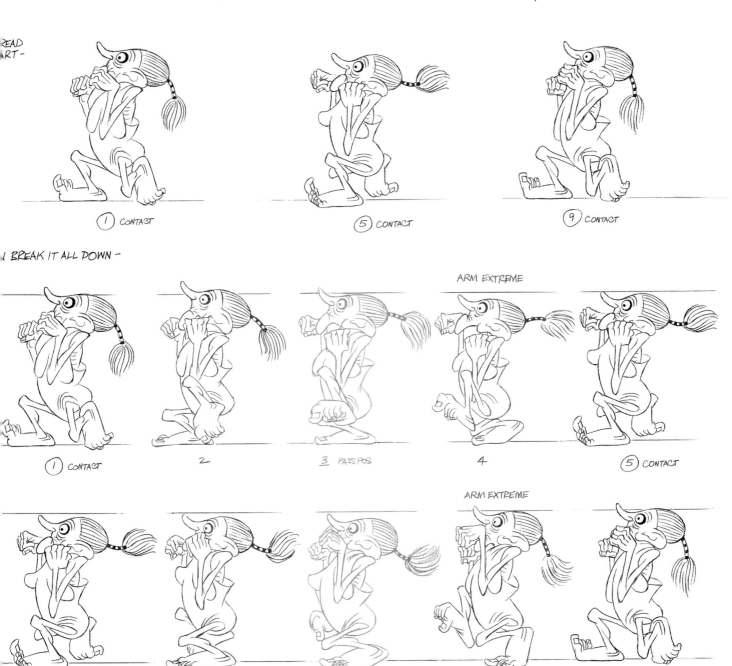

① CONTACT

⑤ CONTACT

⑨ CONTACT

BREAK IT ALL DOWN -

ARM EXTREME

① CONTACT

2

3 PASS POS

4

⑤ CONTACT

ARM EXTREME

⑤ CONTACT

6

7 PASS POS

8

⑨ CONTACT

SHE STARTS OUT WITH A VERY CONTAINED OLD PERSON'S RUN - LIKE AN EX-ATHLETE.

HER HEAD GOES UP and DOWN and AROUND IN A TIGHT CIRCLE (TIP OF NOSE)
AND HER HAND ACTION - EXTREMES #4 and 8 - PUNCHES FORWARD - — LIKE A BOXER'S.

HAVING WORKED OUT THE BODY, HEAD, LEG and ARM ACTION, WE ADD THE BOBBING PIGTAIL
and CHIN ACTION and FLAPPING ANCIENT BREASTS LATER - AS USUAL, DOING ONE THING AT A TIME.

201

SHE GOES UP and DOWN MORE AS SHE TAKES BIGGER STEPS -

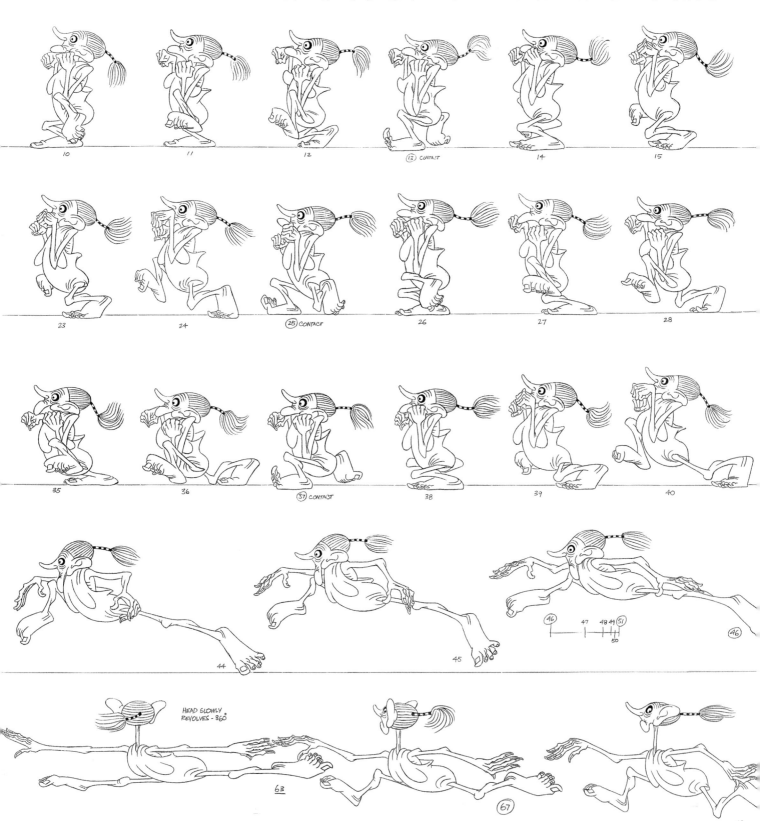

202

AND SHE GOES LOWER AS SHE PREPARES TO JUMP...

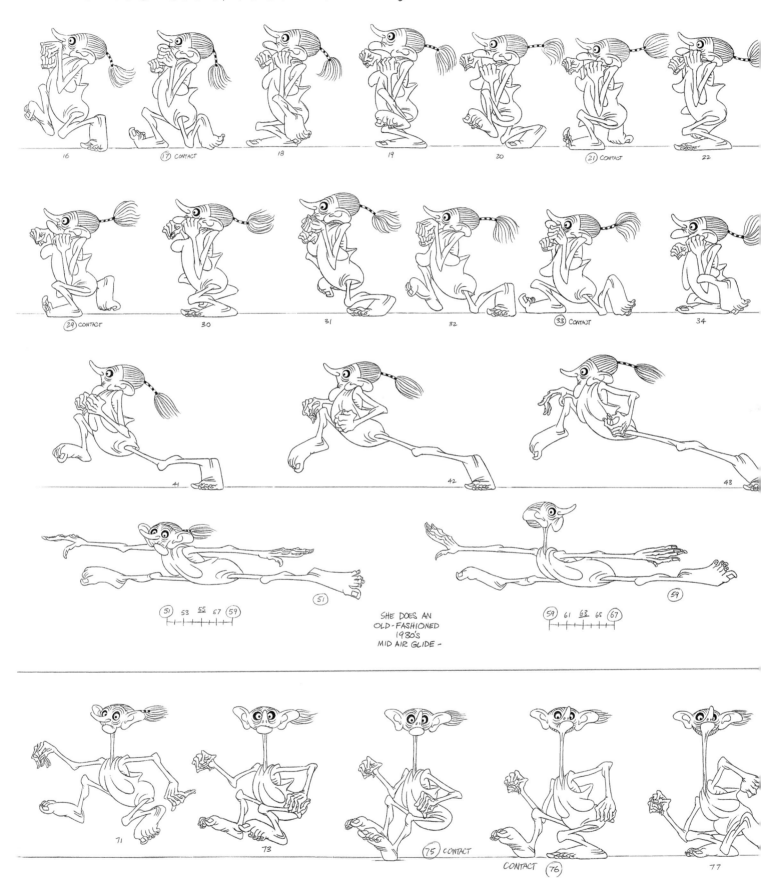

SHE DOES AN
OLD-FASHIONED
1930's
MID AIR GLIDE –

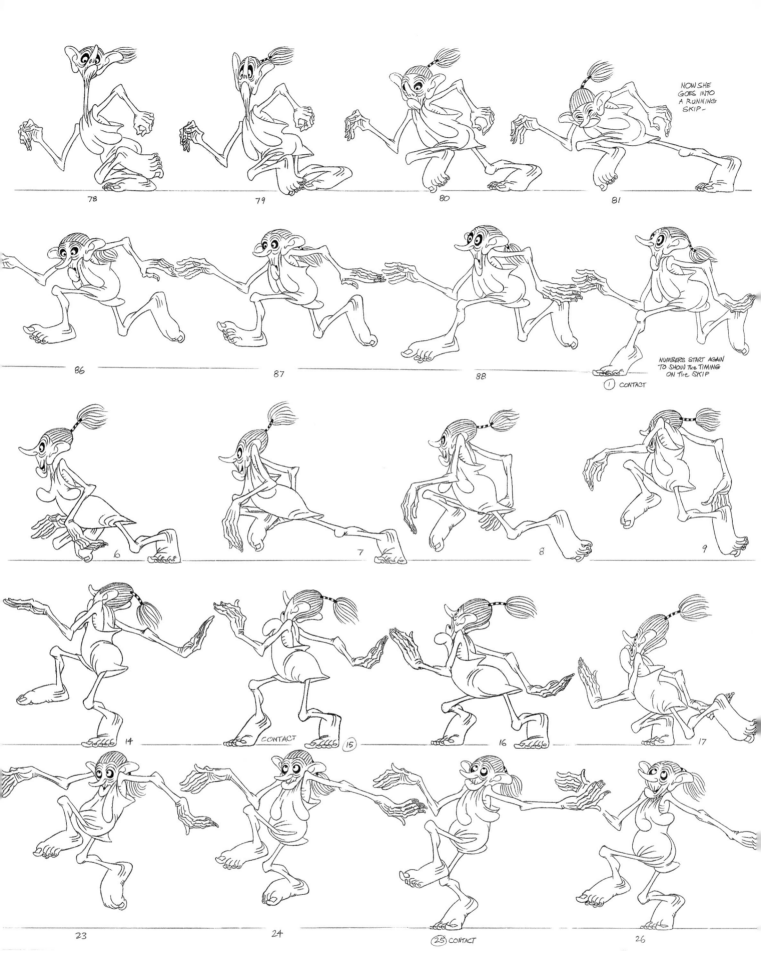

NOW SHE GOES INTO A RUNNING SKIP—

78 79 80 81

86 87 88 ① CONTACT

NUMBERS START AGAIN TO SHOW THE TIMING ON THE SKIP

6 7 8 9

14 CONTACT ⑮ 16 17

23 24 ㉕ CONTACT 26

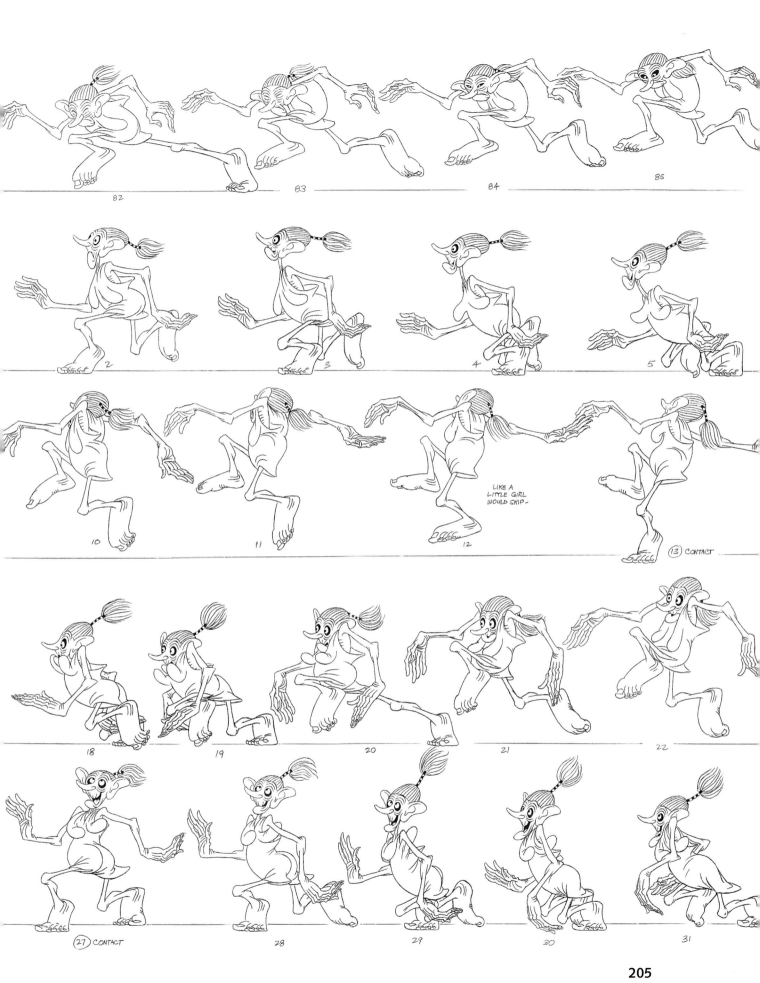

LIKE A
LITTLE GIRL
WOULD SKIP –

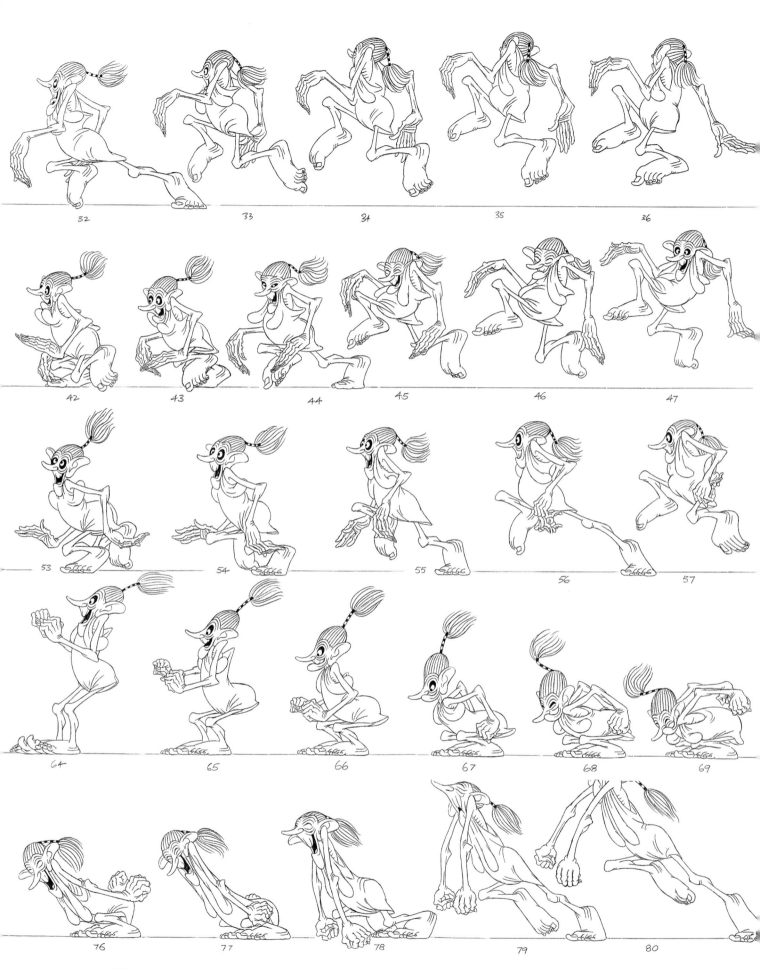

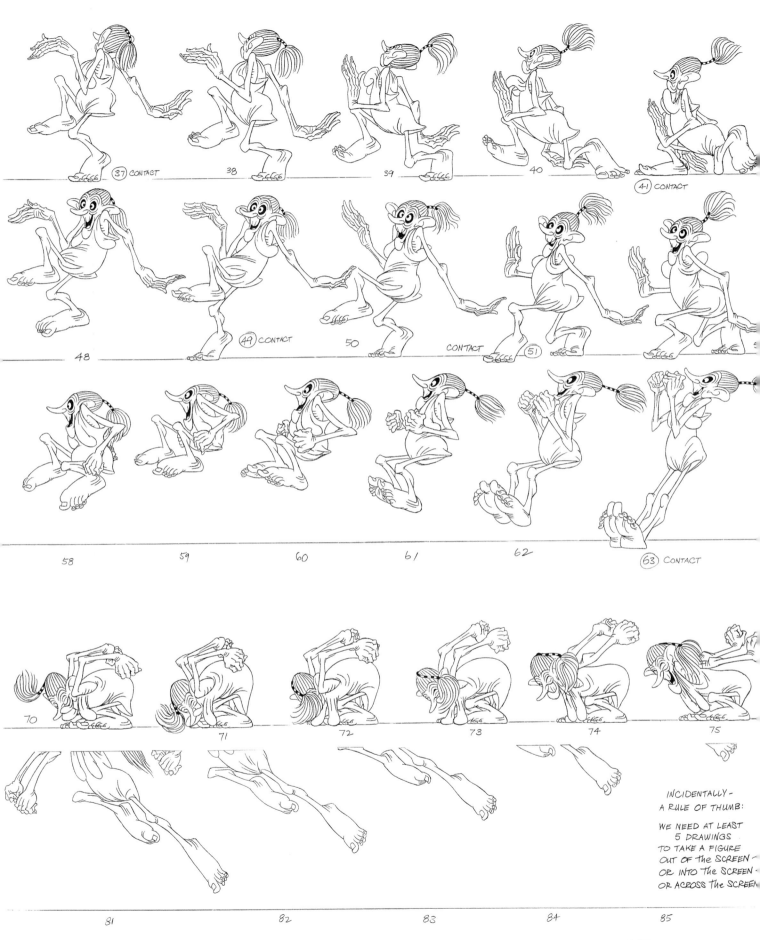

37 CONTACT 38 39 40 41 CONTACT

48 49 CONTACT 50 CONTACT 51

58 59 60 61 62 63 CONTACT

70 71 72 73 74 75

81 82 83 84 85

INCIDENTALLY -
A RULE OF THUMB:

WE NEED AT LEAST
 5 DRAWINGS
TO TAKE A FIGURE
OUT OF THE SCREEN -
OR INTO THE SCREEN -
OR ACROSS THE SCREEN

THIS OLD LADY MAY LOOK A BIT LIKE A
WALKING ANATOMY LESSON - BUT SHE'S
REALLY A DUCK/MOUSE/RABBIT/CAT FORMULA.

SHE'S A STANDARD '40's HOLLYWOOD PEAR
SHAPE, BUT WITH KNEES and ELBOWS-
and WITH the FLOPPY HAIR ETC. THERE'S
A CONTRAST BETWEEN SOFT and HARD BITS.

HERE'S the PATTERN OF HER GIRLISH SKIP-

RUNS IN and HOPS FROM HER LEFT FOOT AND LANDS ON the SAME LEFT FOOT.
2 FRAMES LATER HER RIGHT FOOT LANDS AND SHE HOPS FROM IT and LANDS
ON the SAME RIGHT FOOT - THEN IMMEDIATELY PUTS DOWN the LEFT FOOT
and HOPS FROM IT, LANDING ON the SAME LEFT FOOT, Then SAME WITH the RIGHT, ETC.
(HER BODY KEEPS REVERSING ITSELF)

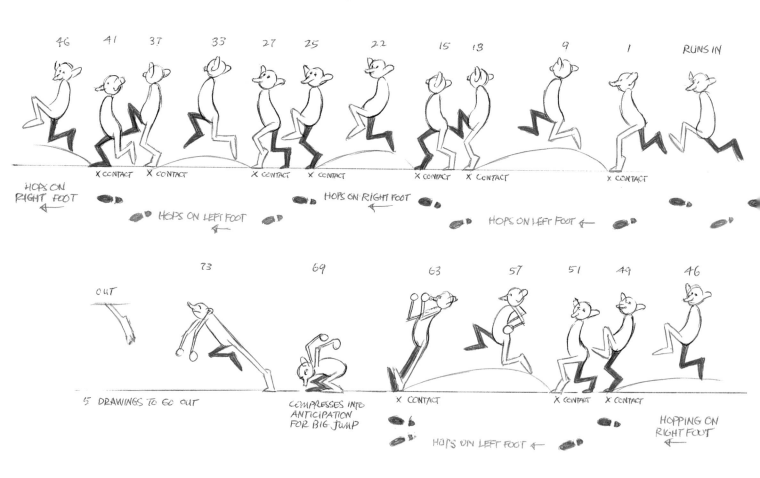

208

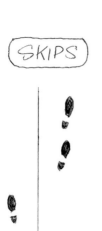

SKIPS

A SKIP IS TWO BOUNCES ON ONE FOOT
THERE ARE ALL KINDS OF SKIPS BUT The BASIC ONE IS
STEP - HOP, STEP - HOP, STEP - HOP, STEP - HOP, etc.

WHEN WE GO FORWARD OUR FOOT SKIDS A BIT.

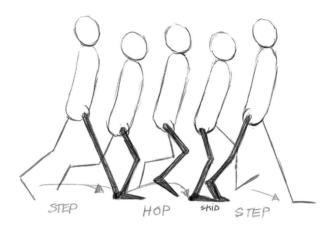

STEP HOP SKID STEP

WE STEP AND HOP ON ONE FOOT -
THEN WE CHANGE FEET 2nd HOP ON The OTHER FOOT
USUALLY, WE TAKE TWICE AS LONG ON The STEP
AS WE DO ON The SKIP.

OR WE HOP BROADLY LIKE The OLD LADY'S SKIP (HOPPING ON 16's — ON ONES)

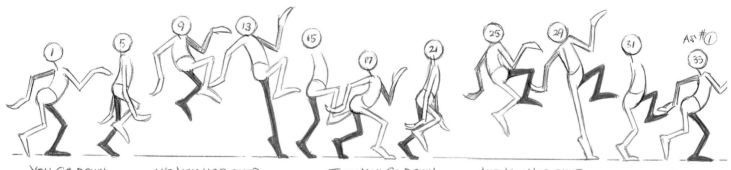

YOU GO DOWN AND YOU HOP OVER - THEN YOU GO DOWN AND YOU HOP OVER ETC.
ON ONE FOOT LANDING ON The SAME FOOT ON The OTHER FOOT LANDING ON THAT FOOT

MANY THINGS CAN HAPPEN WITHIN The ACTION — MOVEMENT OF ARMS, HEAD, ETC.
TO MAKE IT INTERESTING —

THERE ARE SO MANY VARIATIONS - VARIOUS TYPES - SO MANY POSSIBILITIES.
A LITTLE GIRL SKIPPING ROPE USES A DOUBLE BOUNCE. WITH QUITE DEFINITE ACCENTS.
A PRIZEFIGHTER SKIPPING ROPE HARDLY LEAVES The GROUND. - HARDLY ANY MOVEMENTS.
THERE'S A DOUBLE BOUNCE ON EACH FOOT. - VERY SLIGHT, VERY SLICK.

209

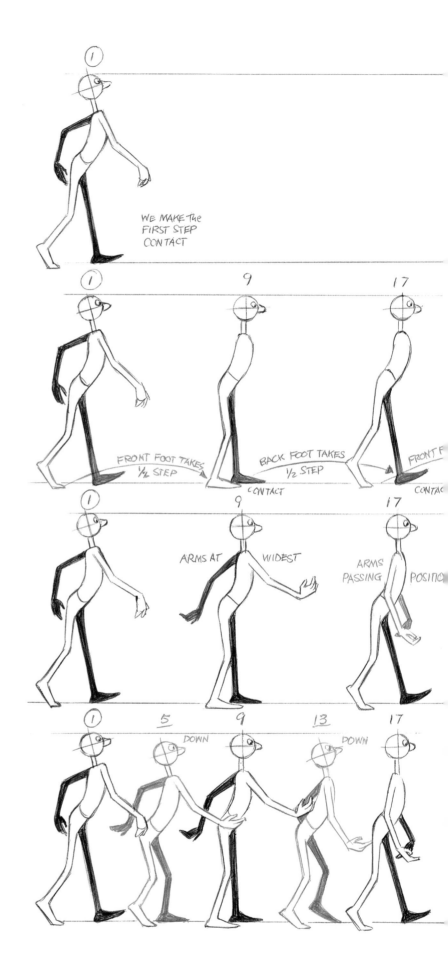

LET'S SAY WE DO A SUBTLE SKIP WALK

WE WANT THE FIGURE TO STEP and HOP,
CHANGE FEET, STEP and HOP,
CHANGE FEET, STEP and HOP, etc.
HAVING ACTED IT OUT (WHICH I'VE JUST DONE -
HOPPING AROUND THE ROOM TO DO THIS)
WHAT DO WE DO FIRST?
Answer: The CONTACTS.
WHICH ONES? THERE'LL BE SEVERAL...
Answer: The IMPORTANT ONES -
AS WITH A NORMAL WALK, MAKE THE
TWO MAIN CONTACT POSITIONS.
OK, WHAT'S THE TEMPO?
Answer: WELL, TO ACCOMODATE THE SKIPS
LET'S DO IT ON 24'S (1 SECOND FOR EACH)
FULL STRIDE

OK, NOW WHAT?
Answer: WELL, WE'VE GOT 24 FRAMES.
LET'S PUT IN THE NEXT 2 STEP CONTACTS.
LET'S MAKE THEM 8 FRAMES APART -
THAT GIVES US 3 CONTACTS PER SECOND
(WHICH IS ABOUT WHAT IT WAS WHEN
I HOPPED AROUND THE ROOM)

LET'S LEAVE OUT THE ARM ACTION FOR NOW.

FINE, NOW ALL WE HAVE TO DO IS PUT IN
THE PASSING POSITIONS BETWEEN EACH
CONTACT...

BUT WAIT A MINUTE, LET'S BE CLEVER -
LET'S BREAK THE ACTION UP A BIT-
LET'S MAKE THE ARM SWING AT IT'S
WIDEST ON THE 2ND CONTACT POSITIONS #9 and #33

AND THAT WILL MAKE CONTACTS #17 and #41
THE PASSING POSITIONS FOR THE ARMS.

OK, NOW WE'LL PUT IN THE PASSING POSITIONS.
THEY WOULD NATURALLY GO DOWN A BIT
BETWEEN EACH CONTACT.
AND THAT GIVES US 3 DOWNS PER SECOND
GIVING US A TRIPLE BOUNCE DURING
EACH OVERALL STRIDE - NICE.

NOW ALL WE HAVE TO DO IS MAKE
INTELLIGENT INBETWEENS CUSHIONING
THE ARM SWINGS AT EACH END.
THIS WORKS WELL ON TWO'S (BUT WE
COULD POLISH IT FURTHER BY ADDING ONES)

210

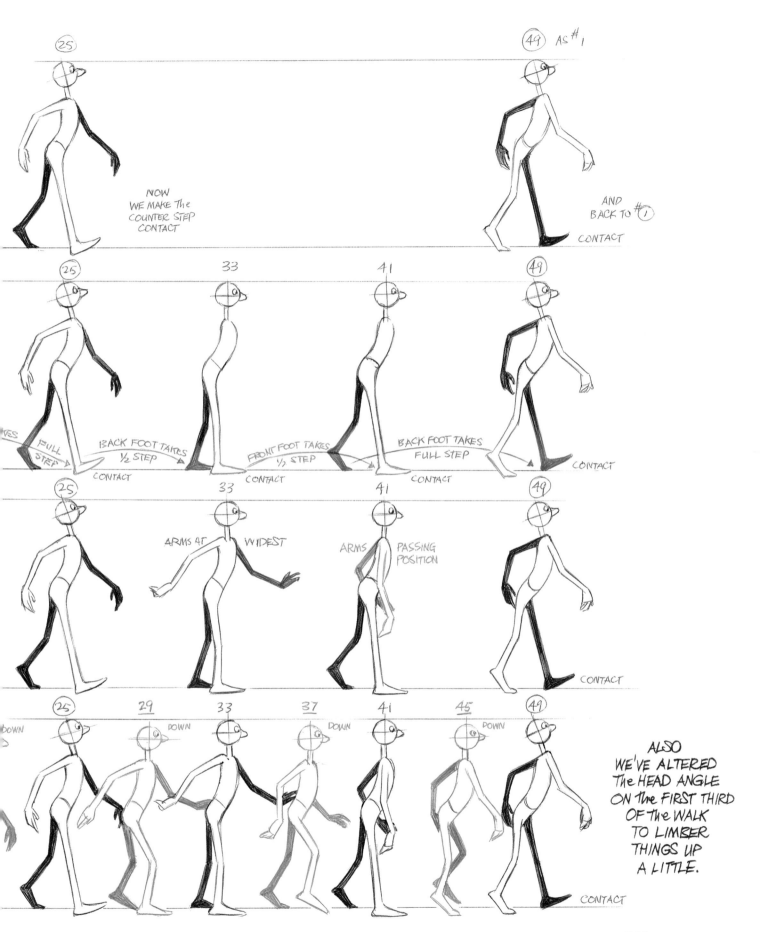

25

49 AS #1

NOW
WE MAKE THE
COUNTER STEP
CONTACT

AND
BACK TO #1

CONTACT

25 33 41 49

FULL STEP BACK FOOT TAKES ½ STEP FRONT FOOT TAKES ½ STEP BACK FOOT TAKES FULL STEP

CONTACT CONTACT CONTACT CONTACT

25 33 41 49

ARMS AT WIDEST ARMS PASSING POSITION

CONTACT

25 29 33 37 41 45 49

DOWN DOWN DOWN DOWN

ALSO
WE'VE ALTERED
THE HEAD ANGLE
ON THE FIRST THIRD
OF THE WALK
TO LIMBER
THINGS UP
A LITTLE.

CONTACT

211

WE COULD ALTER the TIMING ON A SKIP (A SKIP IS KIND OF LIKE A RHYTHMIC DANCE)
IF WE HAD THIS - - A WALKING DANCE.)

8 FRAMES 8 FMS 8 8 Change foot 8 8 8 8
HOP HOP HOP HOP HOP HOP HOP HOP

 Change foot Change foot

BUT TO CHANGE the RHYTHM SLIGHTLY, IT COULD BE -

8 8 10 FRAMES 8 Change foot 8 8 10 FMS 8
HOP HOP HOP HOP HOP HOP HOP HOP

 Change foot Change foot

(JUMPS) IN A BROAD JUMP the PERSON STARTS WITH A RUN and WHILE RUNNING
 WORKS INTO AN ANTICIPATION. (NICE TO HAVE the SPINE SHAPE KEEP REVERSING)

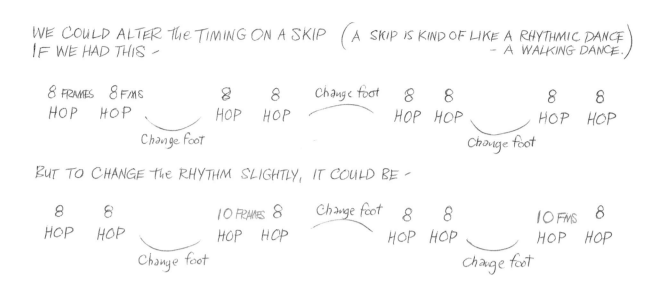

RUNS GOES UP GOES DOWN SCRUNCHES DOWN COMES
IN TO GO DOWN TO GO UP ON LANDING UP

SAME SORT OF THING IN A HURDLE. The RUNNER IS MAKING PROGRESS -
BUT PAUSES JUST LONG ENOUGH TO CLEAR the HURDLE - QUITE SIMILAR
TO A HORSE IN A HORSE SHOW -

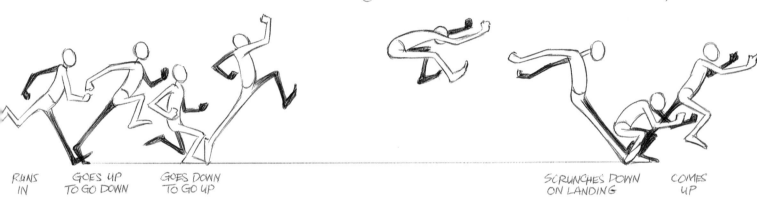

PULLED APART FOR CLARITY

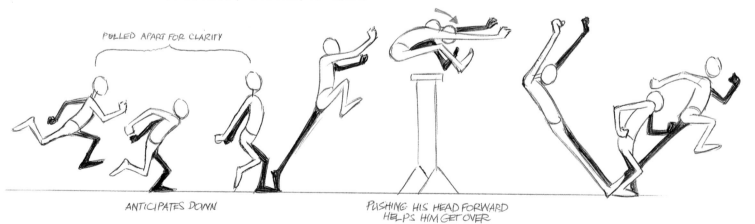

ANTICIPATES DOWN PUSHING HIS HEAD FORWARD
 HELPS HIM GET OVER

HE'LL REACH and STRETCH and LAND and GO INTO A RUN AGAIN.
THERE IS ANTICIPATION BUT IT DOESN'T LAST VERY LONG.

GET LOTS OF LEAN INTO The BODIES.

THERE'S AN OLD 'GOLDEN AGE' ANIMATION MAXIM:
'WHEN YOU THINK YOU'VE GONE FAR ENOUGH - GO TWICE AS FAR!'

THEN THEY SAY, 'IF IT'S TOO FAR - YOU CAN ALWAYS PULL IT BACK LATER.'
WELL, I NEVER SAW ANYONE PULL IT BACK.

BEING BELLIGERENT, I'D SAY, 'WELL YOU CAN ALWAYS INCREASE IT LATER.'
(AND I NEVER SAW ANYONE INCREASE IT LATER EITHER.)

ANYWAY, IT HELPS TO GET LOTS OF LEAN INTO The BODIES.

A 'CARTOONY' JUMP LIKE THIS WORKS FINE, ARM ACTION IS GOOD, LEGS ARE OK.

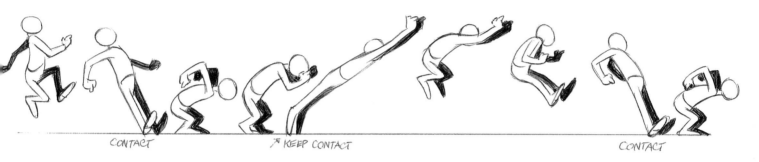

CONTACT KEEP CONTACT CONTACT

BUT LET'S DELAY ONE OF The LEGS -

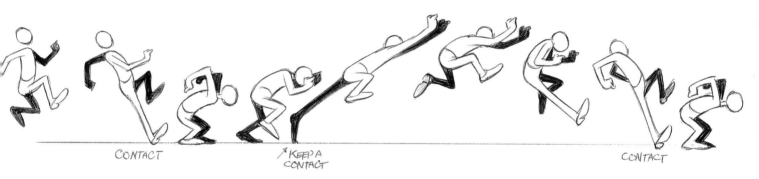

CONTACT KEEP A CONTACT CONTACT

- HELPS BREAK IT UP WITH MORE ACTION WITHIN The JUMP.

(WEIGHT) ON A JUMP

TO AVOID FLOATING and GIVE WEIGHT -
IF A PERSON JUMPS IN The AIR
WE'VE GOT TO GET ACTION WITHIN The GENERAL ACTION.
GET The ARMS GOING
OR The FEET GOING
WITHIN The GENERAL JUMP.
THIS HELPS GIVE IT WEIGHT and AVOIDS FLOATING.

LET'S TAKE 2 JUMPS STARTING FROM A STANDING POSITION:
BOTH TAKE ABOUT THE SAME TIME = 1½ SECONDS TO DO THE JUMP.

IT'S GOING TO BE EASIER
TO SHOW THIS WITH
'CARTOON CHARACTER'
PROPORTIONS.

THIS 1ST JUMP IS ON TWO'S.
(BUT OF COURSE, ONES
COULD BE ADDED IN
TO 'VARNISH' IT.)

NOTHING WRONG WITH IT -
IT FUNCTIONS WELL.
I LIKE IT BECAUSE
IT'S NOT OVERANIMATED.
- SIMPLE, CLEAR and SOLID.

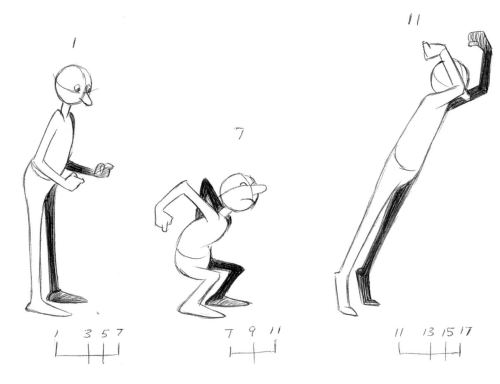

BUT NOW LET'S LOOSEN
THE WHOLE THING UP -

WE CAN GO QUITE FAR
BY PLANNING IT ON ONES
and ADDING IN

MORE STRETCH -
MORE COMPRESSION -
DELAYED PARTS -
MORE ARM REVERSALS -
SECONDARY ACTION -
SHIRT, ANY EXTRA BITS.

THE RESULT IS MUCH
MORE FLUID and LOOSE
(and cartoony)

IT'S ALL A MATTER OF TASTE.
IT'S WHAT YOU LIKE and
HOW MUCH OR HOW LITTLE
YOU USE THESE DEVICES
TO GET YOUR RESULT.

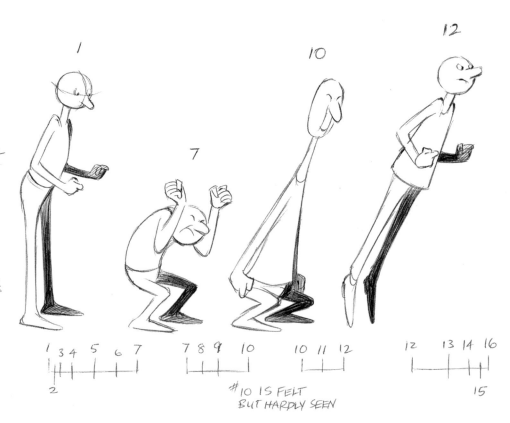

#10 IS FELT
BUT HARDLY SEEN

214

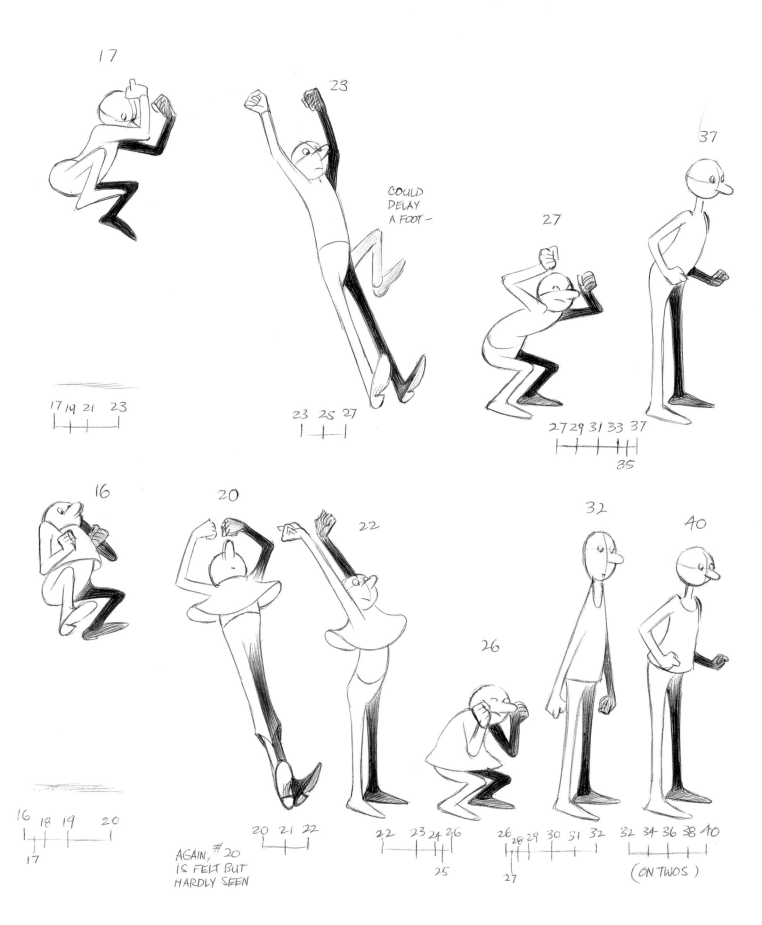

17

23

COULD
DELAY
A FOOT—

27

37

17 19 21 23

23 25 27

27 29 31 33 37

35

16

20

22

26

32

40

16 18 19 20

17

AGAIN, #20
IS FELT BUT
HARDLY SEEN

20 21 22

22 23 24 26

25

26 28 29 30 31 32

27

32 34 36 38 40

(ON TWOS)

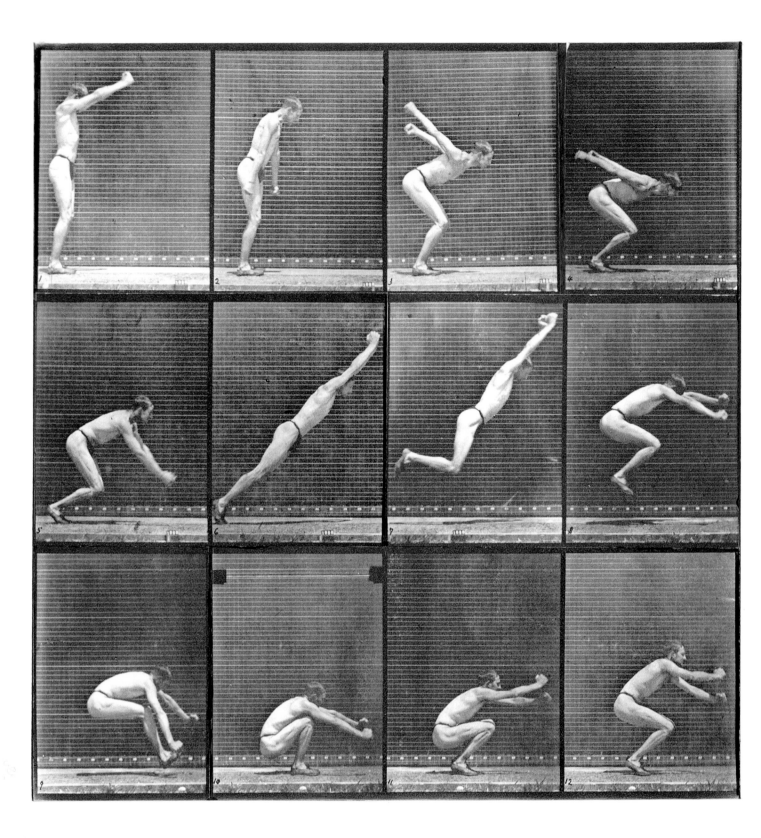

1887 Eadweard Muybridge `HUMAN AND ANIMAL LOCOMOTION`

THE MUYBRIDGE BOOKS ARE A TREASURE TROVE OF ACTION INFORMATION. THERE'S NEVER BEEN ANYTHING LIKE THEM BEFORE OR SINCE. SHOOTING THE ACTION IN FRONT OF BACKGROUND GRIDS SHOWS US JUST WHERE THE UPS and THE DOWNS ARE ON THE DIFFERENT PARTS OF THE BODY.

216

FLEXIBILITY

AS I SEE IT, THERE ARE 2 BIG ANIMATION FLAWS –

WE EITHER HAVE The 'KING KONG' EFFECT
WHERE EVERYTHING MOVES AROUND
The SAME AMOUNT

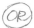

EVERYTHING IS FLASHING AROUND
ALL OVER The PLACE

WE WANT TO HAVE A STABLE IMAGE
and STILL HAVE FLEXIBILITY

THIS IS HOW WE GET IT:

The FOLLOWING DEVICES ARE GUARANTEED TO LIMBER UP, LOOSEN UP and
GIVE 'SNAP' and VITALITY TO OUR PERFORMANCE WHILE KEEPING The FIGURE
STABLE and SOLID.

WE'VE ALREADY INTRODUCED SOME OF THESE DEVICES WITH WALKS and RUNS, BUT I WANT TO TAKE EACH OF THEM SEPARATELY and DIG INTO THEM.

FIRST, (The BREAKDOWN)

A GREAT WAY TO GET FLEXIBILITY IS WHERE WE'RE GOING TO PLACE

The BREAKDOWN DRAWING
OR PASSING POSITION
OR MIDDLE POSITION
OR INTERMEDIATE POSITION
(WHATEVER YOU WANT TO CALL IT)

– BETWEEN 2 EXTREMES.

WHERE DO WE GO IN The MIDDLE? CRUCIAL! AS WE'VE SEEN WITH the WALKS, IT GIVES CHARACTER TO the MOVE. IT'S A TRAVELLER – A TRANSITIONAL POSITION. AND WHERE WE PUT IT IS SO IMPORTANT. IT'S The SECRET OF ANIMATION, I TELL YOU!

IT STOPS THINGS JUST GOING BORINGLY FROM A to B.
GO SOMEWHERE ELSE THAT'S INTERESTING EN ROUTE FROM A TO B.

EMERY HAWKINS, A MASTER ANIMATOR OF 'CHANGE' SAID TO ME,

"DICK, DON'T GO FROM A TO B.
GO FROM A to X to B.
GO FROM A to G to B.
GO SOMEWHERE ELSE IN The MIDDLE!"

A SIMPLE, POWERFUL TOOL:

I FIRST GOT ONTO THIS BY WORKING WITH KEN HARRIS, WHEN HE'D CUT UP MY DRAWINGS, OR BITS OF THEM, and HE'D STICK THEM DOWN IN A DIFFERENT PLACE.

I ENDED UP FEELING SO STRONGLY ABOUT The BREAKDOWN THAT FOR YEARS I WENT AROUND RANTING and RAVING THAT I COULD WRITE A WHOLE BOOK ABOUT IT. (IT HAS ONLY JUST OCCURRED TO ME THAT THIS IS IT.)

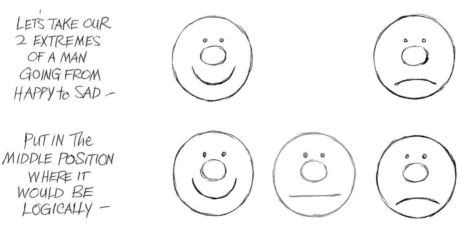

LET'S TAKE OUR 2 EXTREMES OF A MAN GOING FROM HAPPY to SAD –

PUT IN The MIDDLE POSITION WHERE IT WOULD BE LOGICALLY –

OK, BUT DULL

218

EXTREME	BREAKDOWN	EXTREME

RIGHT, LET'S GO SOMEWHERE ELSE IN THE MIDDLE.

= MORE INTEREST. MORE 'CHANGE'

WE COULD EVEN JUST KEEP THE SAME MOUTH and DELAY THE CHANGE –

= A QUICKER CHANGE – MORE VITALITY

OR THE CONVERSE – ADVANCE THE CHANGE

= A QUICKER UNHAPPINESS.

LET'S KEEP THE SAME MOUTH BUT PUSH IT UP –

= IT WOULD AFFECT THE CHEEKS and MAYBE THE EYES AND GIVE MORE CHANGE TO UNHAPPY

KEEP THE SAME MOUTH BUT DROP IT DOWN

= IT WOULD DISTEND THE FACE STRETCHING THE CHEEKS, NOSE, EYES.

OR TAKE THE UNHAPPY MOUTH and PUSH IT UP –

= A TOTALLY DIFFERENT CHANGE

STRAIGHTEN IT and PUSH IT UP. –

= GULP...

STRAIGHT and LOWER?

= OH, OH...

219

EXTREME BREAKDOWN EXTREME

DO WE GO UP
ON ONE SIDE? = THINKS
 ABOUT IT,

INCREASE
The SMILE? = FALSE
 CONFIDENCE

REDUCE IT? = HMMM....

LET'S REDUCE
the
UNHAPPY MOUTH = I KNEW IT,,,

EVEN JUST
A SIMPLE BLINK = GIVES SOME
 MOBILITY

WE CAN START
TO STRETCH THINGS = OOPS.

LET'S START
TO BE
IMAGINATIVE.. = SOMETHING I ET?
 OR
 HAD A DRINK?

 = YOUR SECRET IS
 SAFE WITH ME

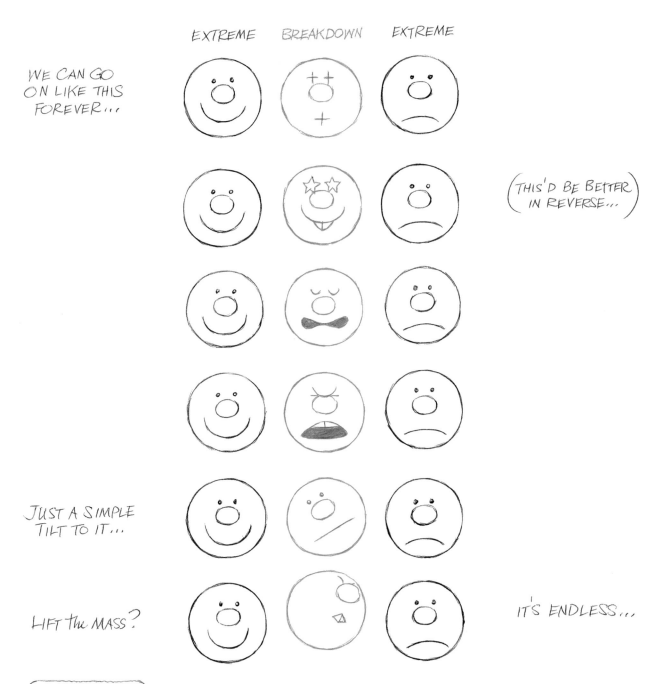

EXTREME BREAKDOWN EXTREME

WE CAN GO
ON LIKE THIS
FOREVER...

(THIS'D BE BETTER
IN REVERSE...)

JUST A SIMPLE
TILT TO IT...

LIFT the MASS?

IT'S ENDLESS...

(CONCLUSION:)

WHERE WE GO WITH the MIDDLE 'TRAVELLING' POSITION
HAS A PROFOUND EFFECT ON the ACTION and CHARACTER.

I HANG MY HAT ON THIS!
MAKE the EXTREMES (OR CONTACTS) THEN the BREAKDOWN (OR
PASSING POSITION.) THEN MAKE the NEXT BREAKDOWN BETWEEN
The EXTREME and the MAIN BREAKDOWN. KEEP BREAKING IT
DOWN INTO EVER SMALLER BITS.
(THEN DO SEPARATE 'STRAIGHT-AHEAD' RUNS ON SEPARATE BITS)

221

30 YEARS AGO WHEN I WAS FIRST CATCHING ON TO ALL THIS STUFF, I WORKED BRIEFLY WITH ABE LEVITOW, KEN HARRIS'S EARLY PROTÉGÉ. ABE DREW BEAUTIFULLY and I WAS IMPRESSED BY BOTH The QUALITY AND The QUANTITY OF HIS WORK. 'FAST AND GOOD.' WORKING ON TOUGH STUFF, ABE PRODUCED 20 to 25 SECONDS A WEEK WHILE The OTHERS MANAGED TO STRUGGLE THROUGH 5 SECONDS. AND ABE'S WAS BETTER.

I ALWAYS REMEMBER ABE SAYING TO ME ON A TUESDAY:

"DICK, I'VE DONE ALL The EXTREMES.
TOMORROW I'M GOING TO BREAK THEM ALL DOWN.
THEN The REST OF The WEEK I'LL ADD IN The BITS and PIECES."

AGAIN,

LET'S SAY A HEAD JUST MOVES FORWARD A BIT —

A

A B

JUST PUTTING the BREAKDOWN IN The MIDDLE IS DULL

SO WE CAN DO THIS —

OR WE CAN DO THIS —

THIS 'SIMPLE OVERLAP' GIVES US ACTION WITHIN AN ACTION. MORE 'CHANGE' — MORE LIFE.

THIS IS The RAW IDEA.
WE CAN DO IT VERY SUBTLY

OR WE CAN DO IT BROADLY

GIVES US 'MORE BANG FOR OUR BUCK'

— GIVES US MOVEMENT WITHIN A MOVEMENT.

PULLED APART —

AGAIN, GOING FROM HERE TO HERE —

A B

OR

KEN HARRIS WOULD OFTEN DO A VERY INTERESTING THING:

THOUGH HE WAS VERY CONFIDENT OF HIS
ANIMATION ABILITIES, KEN HAD LESS
CONFIDENCE IN HIS DRAWING.

HE LIKED TO MAKE FULL USE OF THE
ROUGH SKETCHES BY CHUCK JONES, HIS
DIRECTOR AT WARNER'S - and LATER ON,
MY DIRECTING DRAWINGS.

I'D OFTEN FIND KEN MAKING AN EXACT
TRACING OF MY DRAWING "A" OR "B" and USING
IT AS THE PASSING POSITION - (OR BREAKDOWN)
BUT HE'D PLACE IT TO FAVOUR DRAWING "A" LIKE
THIS →

OR HE'D PLACE IT TO FAVOUR DRAWING "B" LIKE
THIS →

FAR FROM BEING A LIMITATION, THIS
ACTUALLY WAS AN ASSET TO KEN. IT GAVE
HIS WORK A STABILITY - INSTEAD OF HAVING
FACILE DRAWINGS FLASHING AROUND ALL
OVER THE PLACE - 'OVERANIMATING!'

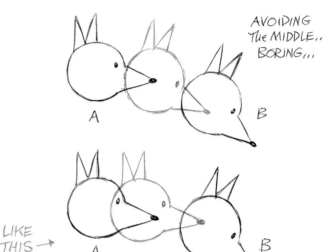

AVOIDING
THE MIDDLE..
BORING...

WATCHING HIM DO THIS - and SEEING THE RESULTS, I GRADUALLY LEARNED
TO UNDERSTATE and GET SUBTLE MOVEMENT WHICH WAS STILL 'LIMBER'.

(SIMPLE OVERLAP)

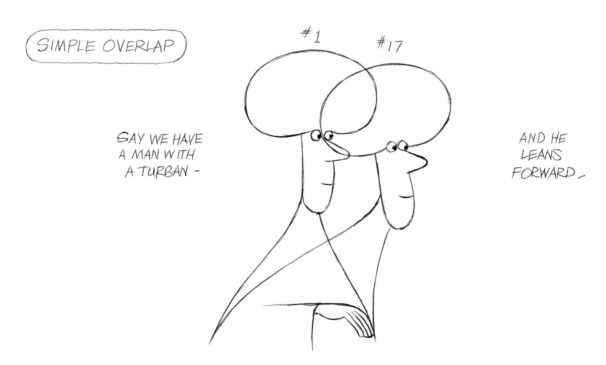

#1 #17

SAY WE HAVE
A MAN WITH
A TURBAN -

AND HE
LEANS
FORWARD -

223

IF WE TILT the HEAD #9
IN the MIDDLE — and
MAKE IT CLOSER TO #1

WE GET THIS
WITH the HEAD —
and LOOK WHAT HAPPENS
TO the TURBAN MASS —
ITS SMACK IN the MIDDLE.

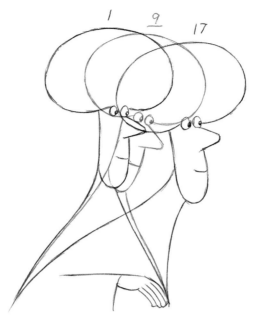

THIS CREATES
A REALLY NICE
OVERLAPPING
OF the MASSES
ON A VERY
SIMPLE MOVE.

and WE'VE USED
ONLY 3 POSITIONS.
The REST WOULD BE
STRAIGHT
IN BETWEENS.

WE'VE DONE THIS ON A BLAND DESIGN OF A SIMPLE CHARACTER — WITH NO CHANGE
OF EXPRESSION — NOT EVEN A BLINK — MAKING A VERY ORDINARY MOVE.
AND YET IT WILL HAVE A LOT OF LIFE JUST BECAUSE OF the SPACING.

(SO) WE LOOK FOR WAYS TO PLACE the MIDDLE BREAKDOWN POSITION —
(OR POSITIONS) WHERE WE CAN GET AN OVERLAP OF the MASSES.
= MOVEMENT WITHIN MOVEMENT.

4 DRAWING OVERLAP ON A CALIFORNIA-ISSUE MOUSE

A

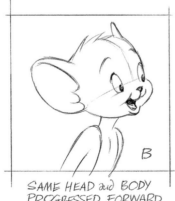

B

SAME HEAD and BODY
PROGRESSED FORWARD

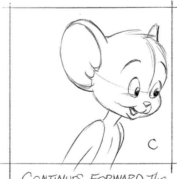

C

CONTINUES FORWARD the
SAME AMOUNT TILTED DOWN

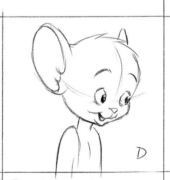

D

PULLS BACK TILTING DOWN
JUST A BIT MORE.

OF COURSE, THIS BREAKDOWN POSITION KIND OF THING CAN GET OUT OF HAND.
LIKE EVERYTHING ELSE, IT'S HOW, WHEN and WHERE WE USE IT.

WHEN I WAS ASSISTING KEN
HARRIS and THERE'D BE A HAND
SETTLING LIKE THIS -

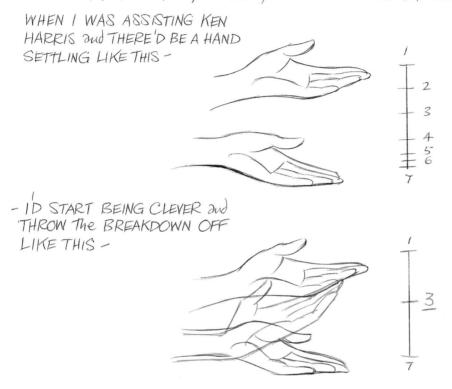

- I'D START BEING CLEVER and
THROW THE BREAKDOWN OFF
LIKE THIS -

KEN WOULD FREAK OUT, "GODDAMN IT, DICK, I JUST WANT A STRAIGHT INBETWEEN
IN THERE! JUST GIVE ME A STRAIGHT INBETWEEN! THE GUY JUST RELAXES HIS HAND!
I DON'T WANT ALL THIS CRAZY FLASHING AROUND ALL OVER THE PLACE KIND OF STUFF!"
(KEN HAD AWFULLY GOOD TASTE.)

BUT WHEN I DID GET TO KNOW HOW, WHEN and WHERE TO USE IT, I CAN ALMOST
SAY I MADE MY LIVING WITH THE BREAKDOWN DRAWING.

I OFTEN HAD TO PRODUCE MASSIVE AMOUNTS OF FOOTAGE AT THE LAST MINUTE.
I BECAME 'THE TELEPHONE ANIMATOR' ANIMATING AT THE SAME TIME AS DOING
THE BUSINESS ON THE PHONE. CLIENTS WOULD RANT, "WE CAME TO YOU BECAUSE
OF HIGH STANDARDS - WE DON'T CARE IF YOUR MAN'S IN THE HOSPITAL OR IN
TIMBUKTOO - IT'S YOUR SHINGLE ON THE DOOR, BUSTER, - YOU FIX IT!"

WE USUALLY HAD GOOD STORYTELLING KEYS and EXTREMES, SO ALL I HAD TO DO
WAS JOIN A LOT OF STUFF UP IN AN INTERESTING WAY. I FOUND THAT ALMOST
ANYTHING WILL WORK. PUT IT SOMEWHERE ELSE IN THE MIDDLE, FAIRLY
INTELLIGENTLY. IT NEVER LET ME DOWN.

OF COURSE, THE WORK WOULDN'T BE AS GOOD AS IF I'D HAD THE TIME TO ANALYSE
and THINK WHAT THE HELL I WAS DOING, BUT AT 5 IN THE MORNING, WITH JET LAG,
HOLDING THE LAB BATH and A GRUMPY CLIENT PHONING IN 4 HOURS, IT GETS YOU THROUGH.

NOW WE COME TO A DIFFERENT THING WITH A SIMILAR NAME -

OVERLAPPING ACTION

THIS IS WHERE THINGS MOVE IN PARTS.

- WHERE EVERYTHING DOES NOT HAPPEN AT THE SAME TIME.

TAKE A HOLLYWOOD BULLDOG TURNING
QUICKLY AROUND TO SEE SOMETHING -

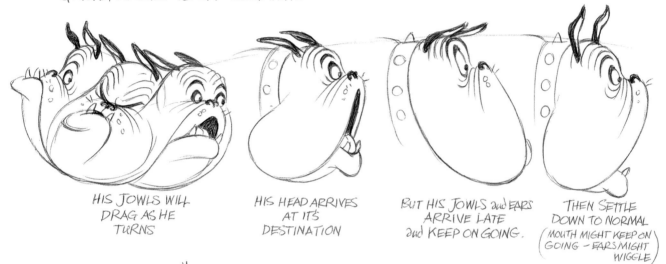

HIS JOWLS WILL
DRAG AS HE
TURNS

HIS HEAD ARRIVES
AT IT'S
DESTINATION

BUT HIS JOWLS and EARS
ARRIVE LATE
and KEEP ON GOING.

THEN SETTLE
DOWN TO NORMAL
(MOUTH MIGHT KEEP ON
GOING - EARS MIGHT
WIGGLE)

THE JARGON IS - "The JOWLS and EARS "DRAG"
and THEN THEY "FOLLOW THROUGH"

THEY'RE The RESULT OF The MAIN ACTION
- GENERATED BY The MAIN ACTION.

'OVERLAPPING ACTION' MEANS ONE PART STARTS FIRST and OTHER PARTS FOLLOW.

LET'S TAKE A TYPICAL UTTERLY BLAND, BORING DESIGN LIKE THEY HAD FOR TV COMMERCIALS
IN The 1950's -

THIS DULL
CREATURE
IS GOING
TO TURN
and FACE US.

NOT MUCH
TO WORK
WITH
- IS IT?

226

WE COULD CONTRIBUTE TO THE BOREDOM BY PUTTING IN AN EQUALLY DULL BREAKDOWN
RIGHT IN THE MIDDLE and GO HOME.

AS MILT KAHL SAID, "THE MOST DIFFICULT THING TO DO IN ANIMATION IS NOTHING.
— YOU KNOW, THATS A VERY TRUE STATEMENT."

RIGHT, BUT HERE'S HOW WE CAN MAKE 'NOTHING' AT LEAST INTERESTING...
WE CAN TAKE THE CURSE OFF THIS VERY ORDINARY BIT OF ACTION
BY SIMPLY BREAKING THE ACTION INTO PARTS.

PASS POS.

THE EYES WOULD
PROBABLY MOVE
FIRST, BUT WE'RE
STUCK WITH DOTS —

SO LET'S SIMPLY MOVE
THE FOOT FIRST

DELAY THE HEAD
and THE REST

THEN LET'S MOVE THE
STOMACH and HIPS,
STILL DELAY THE HEAD
BUT THROW IN A BLINK

THEN EVERYTHING
SETTLES
and THE HEAD
FOLLOWS LAST.

 SINCE MOST OF OUR BODY ACTIONS START FROM THE HIPS ...

PASS POS

WE'LL MOVE THE HIPS and
STOMACH
FIRST.

TAKES A STEP.
STILL DELAY
THE HEAD.

OTHER FOOT SLIDES
OVER WHILE HEAD IS
IN MID TURN.
THROW IN A SLOW
BLINK.

SETTLES.

227

WE HAVEN'T EVEN TILTED HIS HEAD OR CHANGED HIS EXPRESSION — BUT SIMPLY BY OVERLAPPING PARTS WE'VE INJECTED LIFE INTO A PEDESTRIAN SITUATION.

PASS POS.

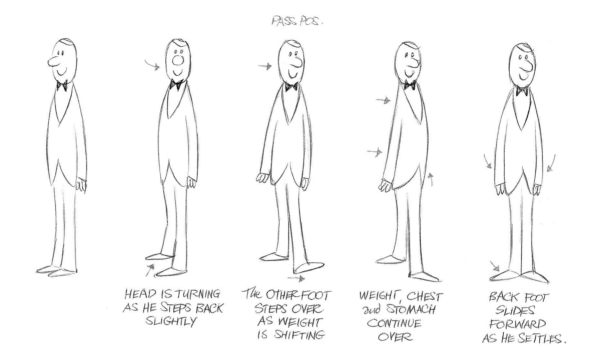

HEAD IS TURNING AS HE STEPS BACK SLIGHTLY

The OTHER FOOT STEPS OVER AS WEIGHT IS SHIFTING

WEIGHT, CHEST and STOMACH CONTINUE OVER

BACK FOOT SLIDES FORWARD AS HE SETTLES.

WE CAN GO ON LIKE THIS FOREVER...

PASS POS.

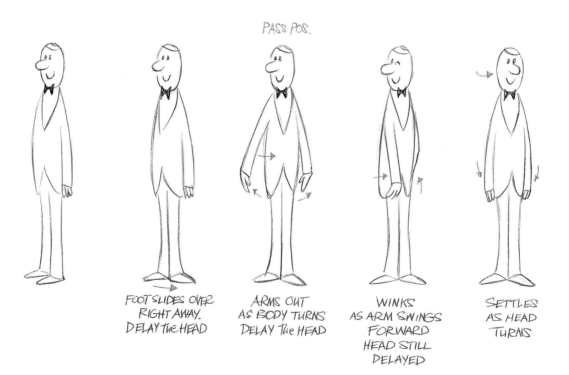

FOOT SLIDES OVER RIGHT AWAY. DELAY THE HEAD

ARMS OUT AS BODY TURNS DELAY THE HEAD

WINKS AS ARM SWINGS FORWARD HEAD STILL DELAYED

SETTLES AS HEAD TURNS

NO MATTER HOW DEADLY THE ACTION IS THAT'S CALLED FOR - WE CAN MAKE IT
MORE INTERESTING BY OVERLAPPING -

PASS POS.

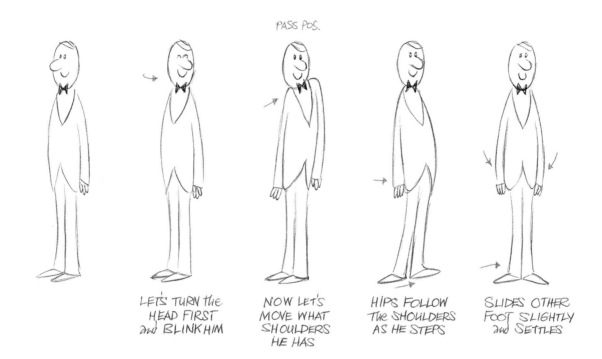

LET'S TURN THE
HEAD FIRST
and BLINK HIM

NOW LET'S
MOVE WHAT
SHOULDERS
HE HAS

HIPS FOLLOW
THE SHOULDERS
AS HE STEPS

SLIDES OTHER
FOOT SLIGHTLY
and SETTLES

JUST ONE LITTLE DETAIL THAT'S DIFFERENT WILL CHANGE EVERYTHING.

PASS POS.

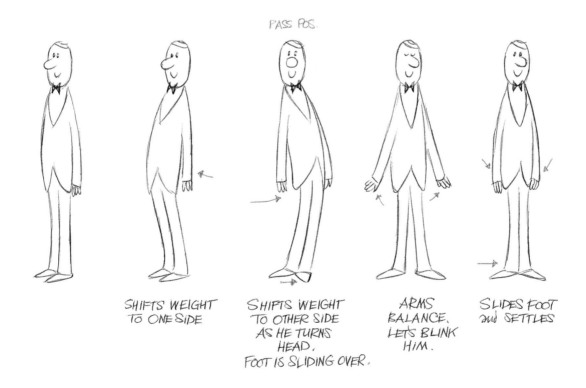

SHIFTS WEIGHT
TO ONE SIDE

SHIFTS WEIGHT
TO OTHER SIDE
AS HE TURNS
HEAD.
FOOT IS SLIDING OVER.

ARMS
BALANCE.
LET'S BLINK
HIM.

SLIDES FOOT
and SETTLES

(80) TO MAKE EVEN the DULLEST ACTION OR FIGURE INTERESTING, WE BREAK the BODY INTO SECTIONS — INTO DIFFERENT ENTITIES and MOVE SECTIONS — ONE AT A TIME, CONSTANTLY OVERLAPPING.

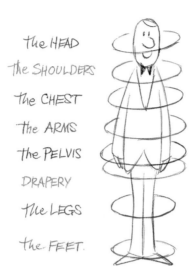

The HEAD

the SHOULDERS

the CHEST

the ARMS

the PELVIS

DRAPERY

The LEGS

the FEET.

AND WE CAN BREAK IT UP INTO EVEN SMALLER SECTIONS IF WE LIKE.

CONCLUSION:

PEOPLE UNFOLD, ONE PART STARTS FIRST, GENERATING the ENERGY FOR OTHER PARTS TO FOLLOW — WHICH THEN 'FOLLOW THROUGH.' WHEN A FIGURE GOES FROM ONE PLACE TO ANOTHER, A NUMBER OF THINGS TAKE PLACE and EVERYTHING ISN'T HAPPENING AT the SAME TIME. WE HOLD BACK ON AN ACTION. THINGS DON'T START OR END AT the SAME TIME. VARIOUS PARTS OF the BODY OVERLAP EACH OTHER, SO THIS IS WHAT'S CALLED IN The CRAFT — 'OVERLAPPING ACTION.'

SIMPLE COUNTERACTION

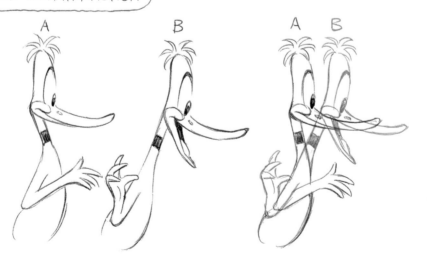

A B A B

THERE'S NOT MUCH TO SAY ABOUT COUNTERACTION. OBVIOUSLY WE DO IT NATURALLY TO BALANCE OURSELVES.

ONE PART GOES FORWARD AS ANOTHER PART BALANCES BY GOING BACK.

— OR ONE PART GOES UP AS ANOTHER BALANCES BY GOING DOWN.

NOW WE COME TO ONE OF THE MOST FASCINATING DEVICES IN ANIMATION —

> BREAKING OF JOINTS
> TO GIVE FLEXIBILITY

AND EVEN MORE INTERESTING:

> SUCCESSIVE BREAKING OF
> JOINTS TO GIVE FLEXIBILITY

i.e. WE KEEP ON DOING IT TO LOOSEN THINGS UP.

IT'S QUITE A MOUTHFUL. THE PIONEER DISNEY ANIMATORS DISCOVERED THIS DEVICE and ALL THE GOOD GUYS WERE DOING IT, BUT ART BABBITT WAS THE ONE WHO GAVE IT A NAME.

WHEN I NOTICED MILT KAHL DOING IT, I REMARKED ON IT, and MILT SAID, "OH, WELL, YOU'VE GOT TO DO THAT." I THINK IF I'D SAID, "OH, I NOTICE THAT YOU'RE BREAKING THE JOINTS HERE SUCCESSIVELY IN ORDER TO GIVE FLEXIBILITY," HE'D HAVE THROWN ME OUT OF THE ROOM.

IT'S NOT WHAT IT'S CALLED — BUT WHAT IS IT?

PUT SIMPLY, IT'S THIS —

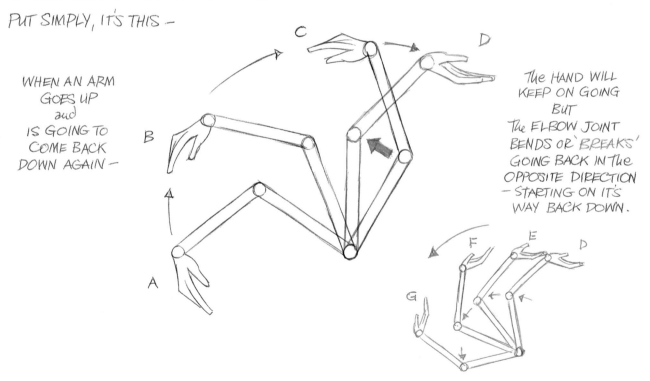

WHEN AN ARM GOES UP and IS GOING TO COME BACK DOWN AGAIN —

THE HAND WILL KEEP ON GOING BUT THE ELBOW JOINT BENDS OR 'BREAKS' GOING BACK IN THE OPPOSITE DIRECTION — STARTING ON IT'S WAY BACK DOWN.

'BREAKING' MEANS BENDING THE JOINT WHETHER OR NOT IT WOULD ACTUALLY BEND IN REALITY.
AND THEN WE'RE GOING TO KEEP ON DOING IT CONTINUOUSLY — 'SUCCESSIVELY' — TO MAKE THINGS LIMBER.

GRIM NATWICK, The FIRST ANIMATOR TO REALLY DRAW WOMEN, ALWAYS SAID,
'CURVES ARE BEAUTIFUL TO WATCH!'

IN The 1920's GRIM'S FRIEND, ANIMATOR BILL NOLAN DEVELOPED 'RUBBER HOSE' ANIMATION.
IT WAS NOVEL and FUNNY SINCE NOBODY HAD ANY BONES and EVERYTHING FLOWED WITH
ENDLESS CURVING ACTIONS — LOTS OF VARIATIONS ON FIGURE 8's, ROUND FIGURES MAKING
ROUNDED ACTIONS.

BUT NOW WE CAN GET CURVES WITH STRAIGHT LINES!

SUCCESSIVE BREAKING JOINTS ENABLE US TO GET The EFFECT OF CURVED ACTION
BY USING STRAIGHT LINES,
WE'RE FREED FOREVER FROM The TYRANNY OF HAVING TO ANIMATE RUBBERY FIGURES.
I ALWAYS FIGURED THAT 'DRAWINGS THAT WALK and TALK' SHOULD BE ANY TYPE OF FIGURE
IN ANY STYLE, MADE OF FLESH AND BONES. THIS OPENS UP A PANDORA'S BOX OF STUFF.
WHAT A TOOL! WE CAN HAVE BONES and 'STRAIGHTS' IN OUR FIGURES and STILL HAVE
FLUID, FLOWING MOVEMENT.

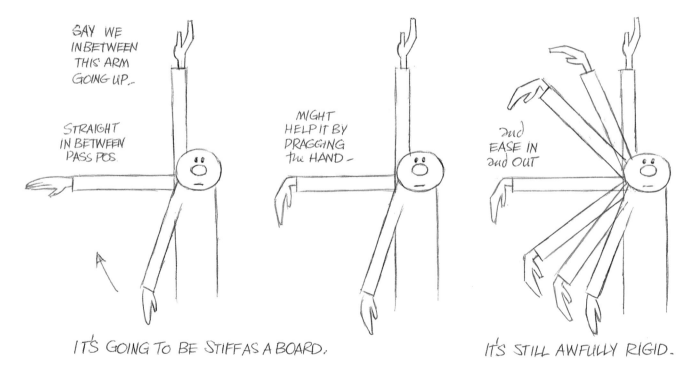

SAY WE
IN BETWEEN
THIS ARM
GOING UP —

STRAIGHT
IN BETWEEN
PASS POS.

MIGHT
HELP IT BY
DRAGGING
The HAND —

and
EASE IN
and OUT

IT'S GOING TO BE STIFF AS A BOARD.

IT'S STILL AWFULLY RIGID.

232

WE WON'T DUCK the PROBLEM WITH A RUBBERISED ARM—

BUT WE'LL
BREAK (BEND)
the JOINTS
STARTING WITH
The ELBOW

BREAKDOWN
OR PASS POS.

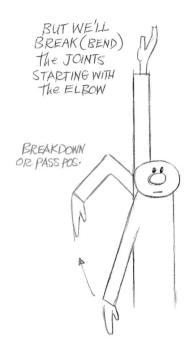

and BREAK
IT AGAIN...

The
ELBOW
ARRIVES
FIRST

THIS HAND
IS JUST
ABOVE

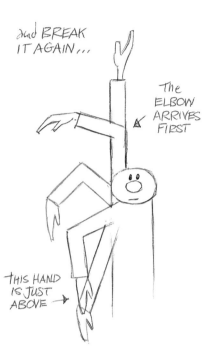

...and BREAK
IT AGAIN.

THEN The
WRIST
ARRIVES
BEFORE
The HAND

LOOK WHERE
THIS HAND IS.

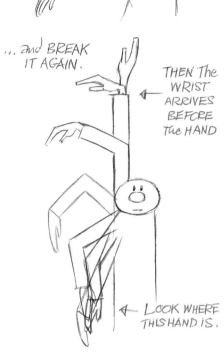

NOW WE GO DOWN The OTHER SIDE – SUCCESSIVELY BREAKING The JOINTS:

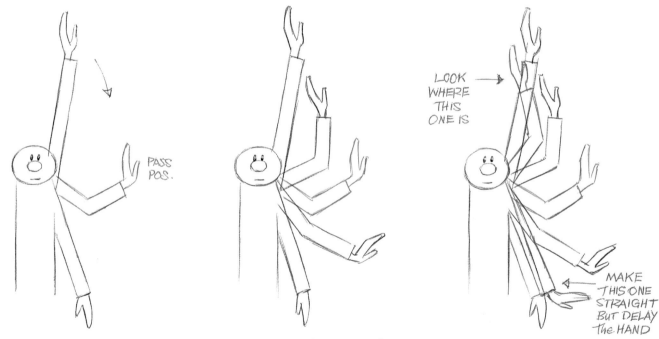

PASS
POS.

LOOK
WHERE
THIS
ONE IS

MAKE
THIS ONE
STRAIGHT
BUT DELAY
The HAND

IN THIS EXAMPLE ALL The BENDS OR 'BREAKS' ARE PHYSICALLY POSSIBLE.
WE HAVEN'T HAD TO ACTUALLY BEND OR BREAK ANYTHING The WRONG WAY YET.

(BUT WE CAN)

LET'S DO IT AGAIN: The ELBOW LEADS and the JOINTS BREAK IN SUCCESSION —

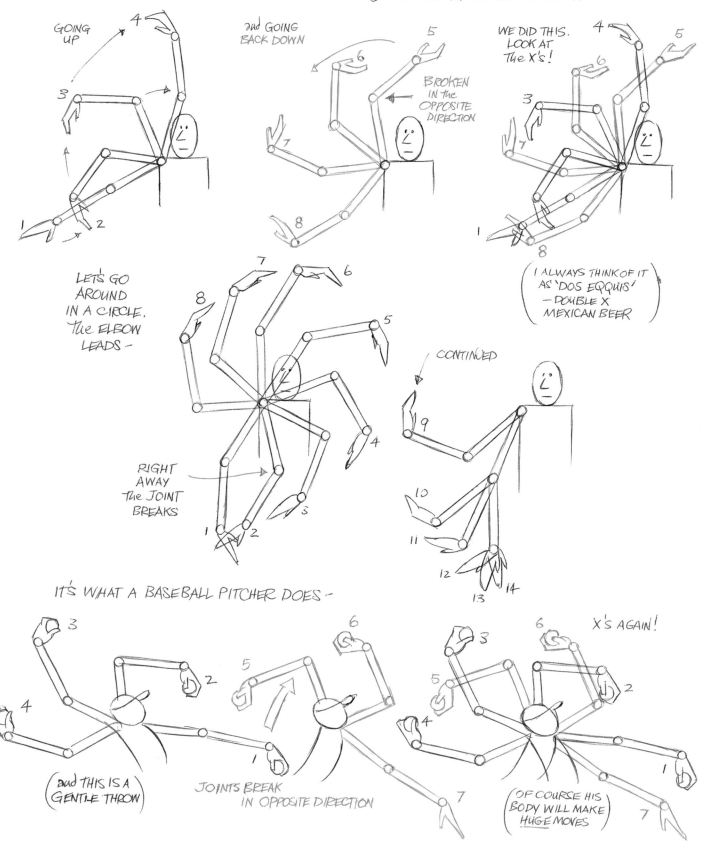

GOING UP

2nd GOING BACK DOWN

WE DID THIS. LOOK AT THE X'S!

BROKEN IN The OPPOSITE DIRECTION

(I ALWAYS THINK OF IT AS 'DOS EQQUIS' — DOUBLE X MEXICAN BEER)

LET'S GO AROUND IN A CIRCLE. The ELBOW LEADS —

RIGHT AWAY The JOINT BREAKS

CONTINUED

IT'S WHAT A BASEBALL PITCHER DOES —

(2nd THIS IS A GENTLE THROW)

JOINTS BREAK IN OPPOSITE DIRECTION

X'S AGAIN!

(OF COURSE HIS BODY WILL MAKE HUGE MOVES)

A THING TO REMEMBER IN BREAKING the JOINTS SUCCESSIVELY IS -
WHERE DOES the ACTION START?
WHAT STARTS MOVING FIRST?
IS IT the ELBOW? The HIPS? The SHOULDER? HEAD?

IN MOST BIG ACTIONS OF The BODY The SOURCE, the START OF the ACTION IS IN The HIPS.

DANCERS SAY "GO FROM YOUR HIPS, LOVE.
FROM The HIPS, DEARIE."

TAKE A MAN SLAPPING A TABLE: The ACTION STARTS FROM HIS HIPS -

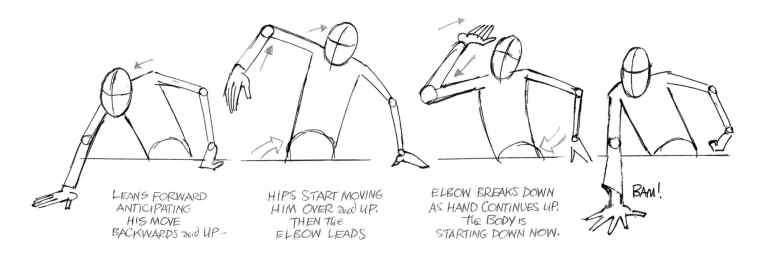

LEANS FORWARD
ANTICIPATING
HIS MOVE
BACKWARDS and UP -

HIPS START MOVING
HIM OVER and UP.
THEN The
ELBOW LEADS

ELBOW BREAKS DOWN
AS HAND CONTINUES UP,
The BODY IS
STARTING DOWN NOW.

BAM!

WE HAVE LOTS OF LEEWAY TO ACCENTUATE and EXAGGERATE BREAKING JOINTS
BECAUSE IT HAPPENS ALL The TIME IN REALITY.

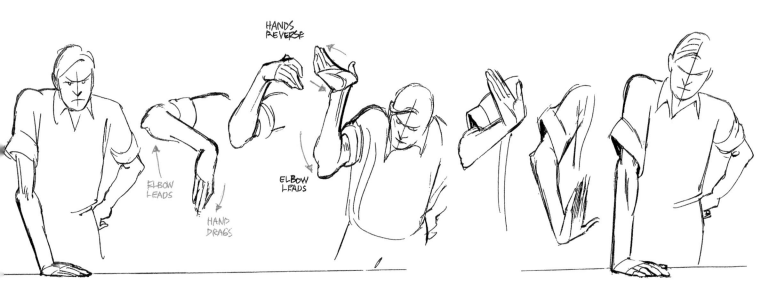

HANDS
REVERSE

ELBOW
LEADS

HAND
DRAGS

ELBOW
LEADS

LET'S KEEP ON HITTING THE TABLE -
IT'S AN AWFULLY GOOD EXAMPLE OF HOW WE CAN ACHIEVE THE SAME FLEXIBILITY
AS 'RUBBER HOSE' ANIMATION BY BREAKING THE JOINTS WHEREVER WE CAN -

GOING UP - THE ELBOW LEADS AND THE HAND DRAGS.

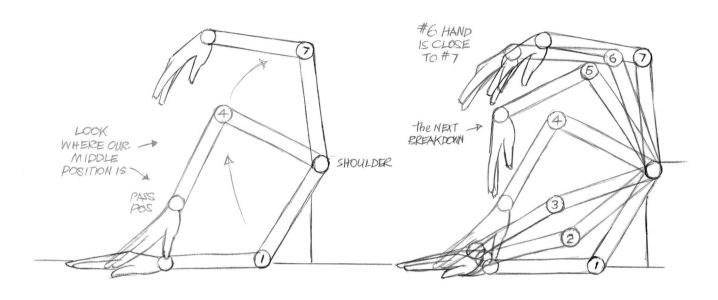

LOOK WHERE OUR MIDDLE POSITION IS

PASS POS

SHOULDER

#6 HAND IS CLOSE TO #7

THE NEXT BREAKDOWN

GOING DOWN - THE ELBOW STILL LEADS.

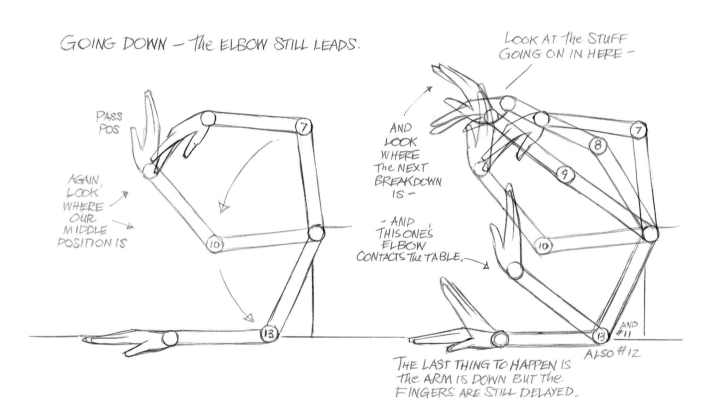

PASS POS

AGAIN, LOOK WHERE OUR MIDDLE POSITION IS

LOOK AT THE STUFF GOING ON IN HERE -

AND LOOK WHERE THE NEXT BREAKDOWN IS -

- AND THIS ONE'S ELBOW CONTACTS THE TABLE.

AND #11

ALSO #12

THE LAST THING TO HAPPEN IS THE ARM IS DOWN BUT THE FINGERS ARE STILL DELAYED.

236

ONE MORE TIME - SHOWING the IDEA SIMPLY.

NOW HE'S GOING TO BANG HIS FIST ON the TABLE -

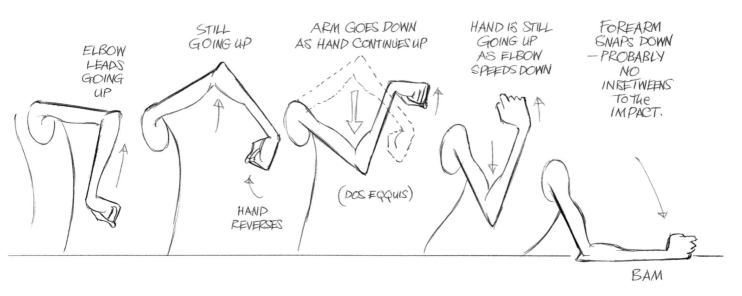

ELBOW LEADS GOING UP

STILL GOING UP

ARM GOES DOWN AS HAND CONTINUES UP

HAND IS STILL GOING UP AS ELBOW SPEEDS DOWN

FOREARM SNAPS DOWN - PROBABLY NO INBETWEENS TO the IMPACT.

HAND REVERSES

(DOS EQQUIS)

BAM

(OR)

AS ON the PRECEEDING PAGE The ELBOW HITS THE TABLE FIRST - FOLLOWED BY the FOREARM and FIST = MORE UNFOLDING.

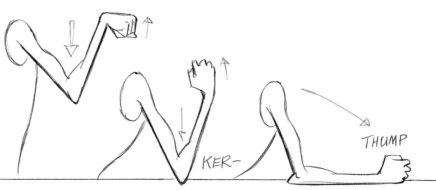

KER-

THUMP

IF ALL the JOINTS DO NOT BREAK AT the SAME TIME WE'LL GET ALL the FLEXIBILITY WE'LL EVER NEED.

IT'S LIKE WHAT WE DO WHEN WE MAKE A PENCIL APPEAR RUBBERY.
AND IT'S JUST WHAT A BALINESE, HINDU OR ORIENTAL TEMPLE DANCER OR A VAUDEVILLE ECCENTRIC DANCER DOES - AND FRED ASTAIRE! THEY'VE ONLY GOT STRAIGHT BONES and JOINTS TO WORK WITH - TO GIVE The ILLUSION OF CURVACEOUS, LIMBER MOVEMENT.

BEATING ON A BASS DRUM HAS A VERY SIMILAR ACTION TO SMACKING THE TABLE.

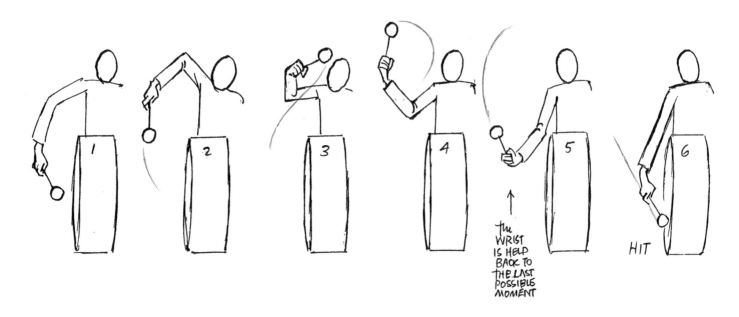

THE WRIST IS HELD BACK TO THE LAST POSSIBLE MOMENT

HIT

THIS BENT JOINT BUSINESS CAN LOOK AWFULLY COMPLICATED AT FIRST BUT YOU QUICKLY GET USED TO IT and USE IT EVERY CHANCE YOU GET. IT BECOMES SECOND NATURE and SIMPLE.

IN `REALISM´ –

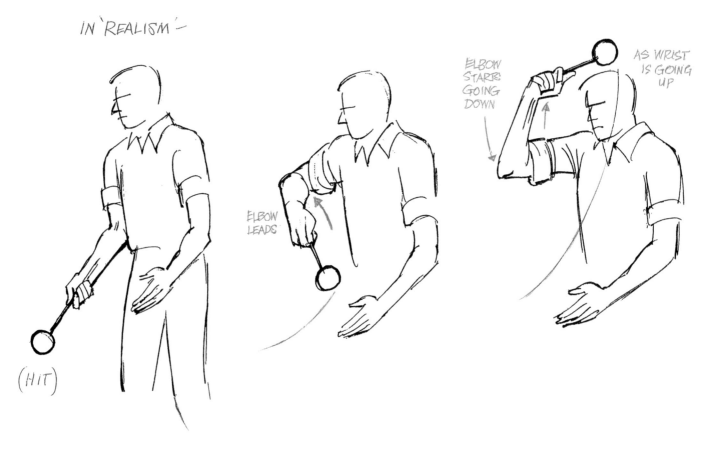

(HIT)

ELBOW LEADS

ELBOW STARTS GOING DOWN

AS WRIST IS GOING UP

OF COURSE, DRUMMERS DO ALL KINDS OF SPINS and FLOURISHES -
BUT THIS IS the BASIC PATTERN -

GOING UP - COMING DOWN -

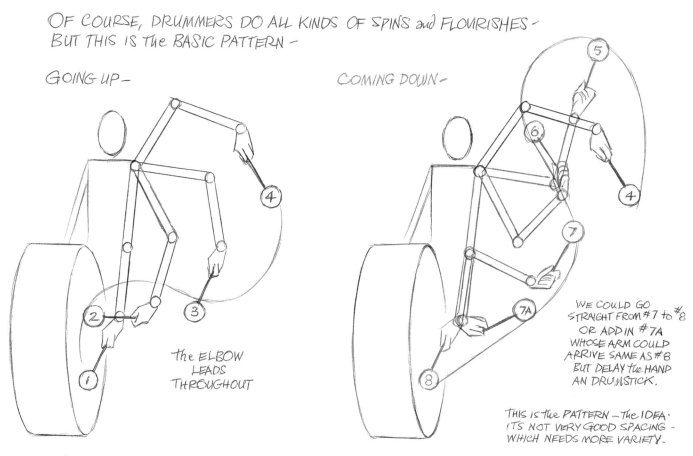

The ELBOW
LEADS
THROUGHOUT

WE COULD GO
STRAIGHT FROM #7 to #8
OR ADD IN #7A
WHOSE ARM COULD
ARRIVE SAME AS #8
BUT DELAY the HAND
AN DRUMSTICK.

THIS IS the PATTERN - the IDEA.
ITS NOT VERY GOOD SPACING -
WHICH NEEDS MORE VARIETY.

RESULT: CURVACEOUS, UNFOLDING MOVEMENT - MADE WITH A RULER.

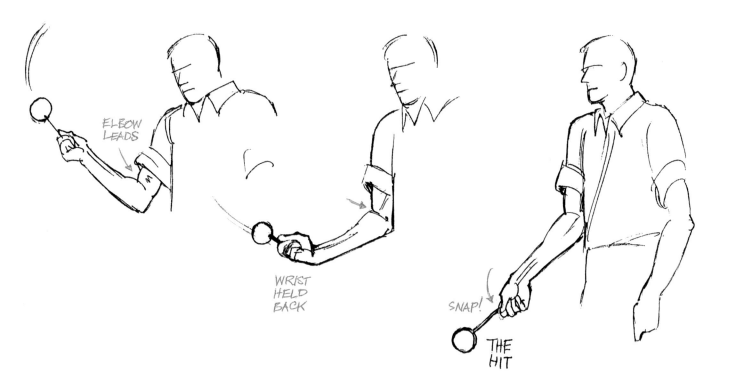

ELBOW
LEADS

WRIST
HELD
BACK

SNAP!

THE
HIT

AN ORCHESTRA CONDUCTOR BREAKS JOINTS IN SUCCESSION LIKE CRAZY.

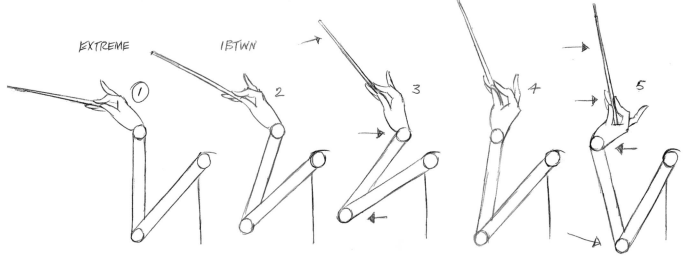

EXTREME IBTWN

ELBOW GOES FORWARD AS HAND and BATON GO BACK.

WRIST BREAKS FORWARD AS ELBOW, FINGERS, BATON GO BACK.

LET'S TAKE the VERY BROAD ACTION OF A MAN SLAPPING OUT A MUSICAL BEAT.

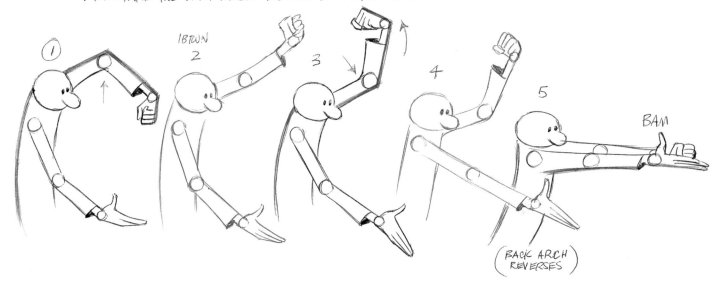

IBTWN

BAM

(BACK ARCH REVERSES)

IT'S HAPPENING WITH A DOG'S FOOT.

AND THIS IS A REDUCED ACTION FOR A CONDUCTOR...

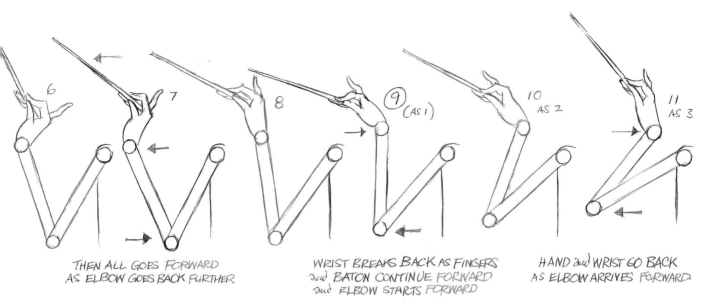

THEN ALL GOES FORWARD
AS ELBOW GOES BACK FURTHER

WRIST BREAKS BACK AS FINGERS
and BATON CONTINUE FORWARD
and ELBOW STARTS FORWARD

HAND and WRIST GO BACK
AS ELBOW ARRIVES FORWARD

IT LOOKS COMPLICATED, BUT WHEN YOU START TO THINK THIS WAY, IT AIN'T.

IT'S BASICALLY THE SAME ACTION AS HITTING
THE TABLE OR BEATING THE BASS DRUM —

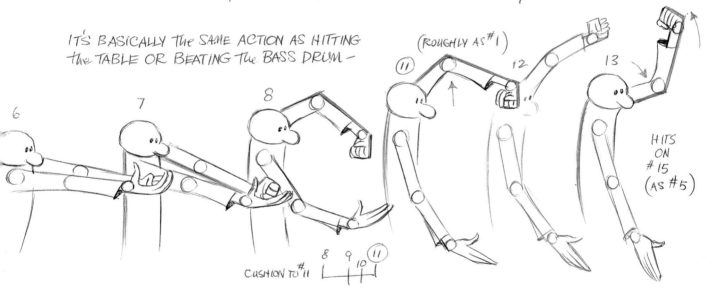

CUSHION TO #11

HITS
ON
#15
(AS #5)

OR A FIST BROADLY KNOCKING ON A DOOR —

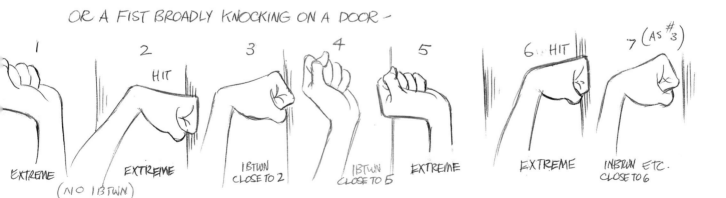

THERE ARE LOTS OF SIMPLE LITTLE ACTIONS WHICH CAN BE ENHANCED
WITH JUST A TINY BIT OF FLEXIBILITY.

SAY, A HAND CLAPPING –

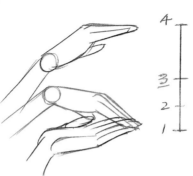
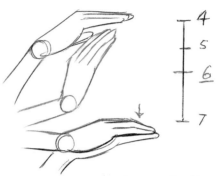

WRIST LEADS – TIP DRAGS GOING UP WRIST LEADS – TIP DRAGS GOING DOWN

ALSO, IT HELPS TO DISPLACE
The PALM SLIGHTLY ON the HIT.
$\left(\dfrac{\text{ON the CONTACT}}{\text{NOT AFTER the HIT}} \right)$,
– DISPLACE The HAND THAT'S
BEING HIT SLIGHTLY.

IF the HAND STAYS IN
The SAME PLACE IT WILL
LACK VITALITY.
WHAT WE FEEL IS The
DISPLACEMENT OF the HIT.

AGAIN, WE COULD DO THIS:

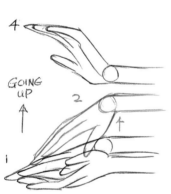

GOING
UP

BREAKDOWN AS PREVIOUS

The WRIST BREAKS AS
the FINGERS KEEP RISING

MAYBE HAVE NO
IN BETWEEN GOING DOWN

OR COULD HAVE ONE
IN BETWEEN GOING DOWN.

(OR)

WITH ONE IN BETWEEN
The WRIST COULD ARRIVE FIRST

AND THEN DISPLACE
the PALM ON The HIT.

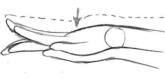

242

OF COURSE, APPLAUSE MAY BE LIKE THIS—
SO WE'D DRAW IT THIS WAY, OBVIOUSLY—

SPANISH FLAMENCO PERSON CLAPS
DIFFERENTLY. TIPS OF FINGERS HIT PALM

AND OBVIOUSLY A WRESTLER CLAPS DIFFERENTLY
FROM A DRUNK OR A DIPLOMAT'S WIFE—OR A BABY.
BUT THE PRINCIPLE IS STILL THIS — A NUMBER OF JOINTS BREAKING, ONE AFTER ANOTHER.

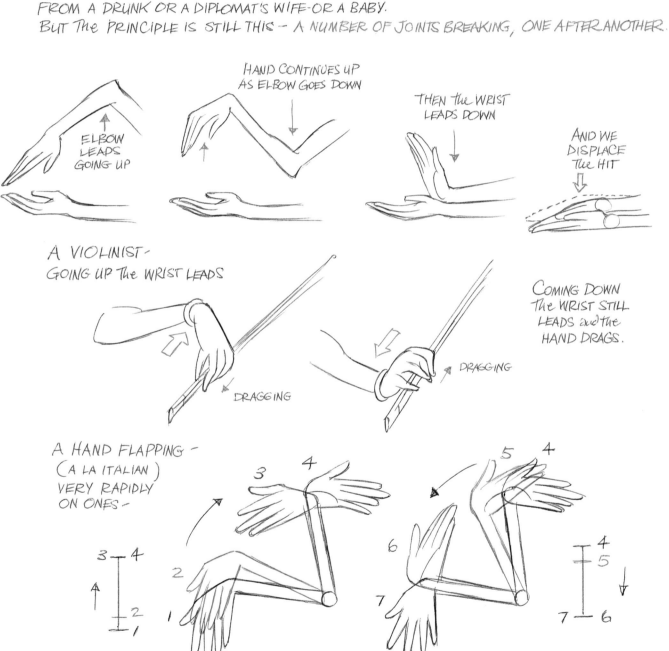

ELBOW LEADS GOING UP

HAND CONTINUES UP AS ELBOW GOES DOWN

THEN THE WRIST LEADS DOWN

AND WE DISPLACE THE HIT

A VIOLINIST—
GOING UP THE WRIST LEADS

DRAGGING

COMING DOWN THE WRIST STILL LEADS and the HAND DRAGS.

DRAGGING

A HAND FLAPPING —
(A LA ITALIAN)
VERY RAPIDLY
ON ONES—

243

EVEN IN A LITTLE THING LIKE THIS WE CAN GET FLEXIBILITY —

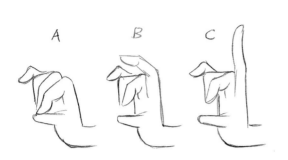

TO OPEN THESE FINGERS A STRAIGHT INBETWEEN GOING UP WOULD BE OK.

BUT ON THE WAY DOWN DRAG THE INBETWEEN

IF WE HAD A BETTER FEELING OF CONTACT AND PRESSURE TO BEGIN WITH —

= BETTER GOING UP WHEN THIS PRESSURE IS RELEASED.

SAY WE'RE HAMMERING A NAIL —

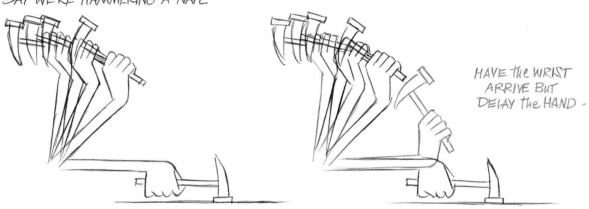

HAVE THE WRIST ARRIVE BUT DELAY THE HAND —

AGAIN, WE CAN TAKE ALL THIS TOO FAR.
BUT THE THING IS TO KNOW IT SO WE CAN USE IT WHEN WE WANT (WHICH WILL BE A LOT.)

TAKE SOMEONE'S HANDS KNOCKING TOGETHER GOING 'GOODY, GOODY'

MAYBE WE JUST WANT TO INBETWEEN IT FAVOURING THE ANTICIPATE —

AND IT WOULD BE FINE —

244

IT MIGHT NOT BE NECESSARY TO 'OVERANIMATE' IT WITH BROKEN JOINTS –
BUT MAYBE IT'S GOOD. LET'S TRY IT.

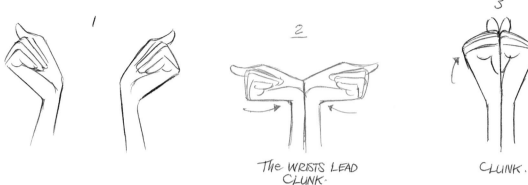

The WRISTS LEAD
CLUNK.

CLUNK.

NOW HOW ABOUT THIS FOR PULLING IT APART?

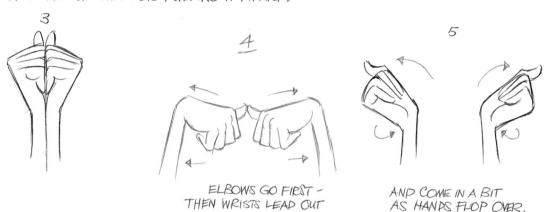

ELBOWS GO FIRST –
THEN WRISTS LEAD OUT

AND COME IN A BIT
AS HANDS FLOP OVER.

(OR) IT MIGHT BE NICE TO HAVE JUST ONE BREAK –

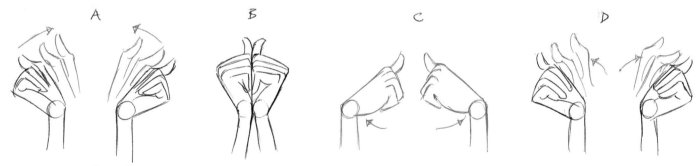

SO IT'S ALL A MATTER OF DEGREE –

WE'RE SHOWING THESE DEVICES and PRINCIPLES IN THE RAW –
IN THE CRUDEST POSSIBLE STATE TO MAKE IT CLEAR –
TO LIMBER THINGS UP – TO STOP THINGS BEING STIFF OR STILTED.

WE CAN USE THEM INCREDIBLY SUBTLY OR OVERUSE THEM
SO THINGS GO RUBBERY OR MUSHY.

BUT IT'S SURPRISING HOW FAR WE CAN GO WITH BREAKING JOINTS
and HAVE IT WORK BEAUTIFULLY.

FLEXIBILITY IN The FACE

THERE'S A TENDENCY TO FORGET HOW MOBILE OUR FACES REALLY ARE IN ACTION - AND IT'S ALWAYS SHOCKING TO SEE HOW MUCH DISTORTION THERE IS WHEN WE LOOK AT LIVE ACTION OF ACTORS' CLOSE-UPS FRAME BY FRAME.

NOT TO MENTION WHAT A FACIAL CONTORTIONIST CAN DO (IN SPITE OF the JAWS and TEETH NOT BEING RUBBER.)

THE SKULL OBVIOUSLY REMAINS THE SAME BUT THERE'S <u>LOTS</u> OF ACTION HAPPENING BELOW THE CHEEKBONES. OUR UPPER TEETH DON'T CHANGE POSITION AS THEY'RE LOCKED ONTO OUR SKULL. THE HINGED LOWER JAW ACTION IS PRIMARILY UP and DOWN WITH A SLIGHT LATERAL MOTION.

SOLID BONE — HINGE

the TENDENCY IS TO FORGET JUST HOW BIG OUR MOUTH CAVITY IS...

OUR DENTIST KNOWS HOW BIG IT IS.

AND HOW SMALL IT CAN APPEAR.

the LOWER JAW IS HINGED IN FRONT OF the EAR.

ART BABBITT OFTEN TOLD OF HOW, AFTER ANIMATING the BEAUTIFUL EVIL QUEEN 'MAGIC MIRROR ON the WALL' SCENE IN "SNOW WHITE and the SEVEN DWARFS" (A DEGREE OF REALISM THAT NO ONE HAD EVER ATTEMPTED BEFORE, LET ALONE SUCCEED IN ACHIEVING,) HE BECAME INHIBITED WHEN ANIMATING CLOSE-UPS ON the 7 DWARFS. HE GOT HELP FROM the OTHER TOP MEN IN DARING TO COMPRESS and DISTEND the FACES. HE ALWAYS SAID," BE BRAVE. DON'T BE AFRAID TO STRETCH the FACE."

THERE'S A TENDENCY TO HAVE A SIMPLE MOUTH SQUIRMING AROUND - FLOATING ON The FACE

STRETCH IT TO MAKE IT AN INTEGRAL PART OF the FACE.

and COMPRESS IT.

THERE'S A TREMENDOUS AMOUNT OF ELASTICITY IN OUR FACE MUSCLES.

A MAN SMOKING A PIPE - (LEAVING OUT The PIPE)

SUCKING IN

PUFFING OUT

247

TAKE CHEWING, FOR EXAMPLE:

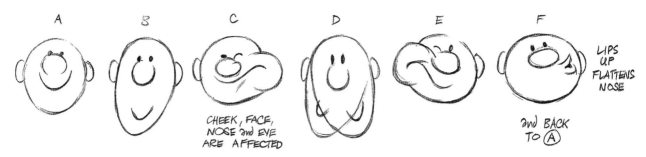

A B C D E F

LIPS
UP
FLATTENS
NOSE

CHEEK, FACE,
NOSE and EYE
ARE AFFECTED

and BACK
TO (A)

WE COULD GO FROM ANY OF THESE POSITIONS TO ANY OTHER IN ANY SEQUENCE, VARYING IT.

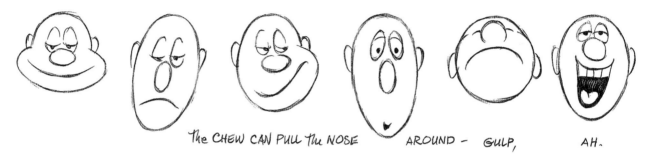

The CHEW CAN PULL the NOSE AROUND - GULP, AH.

AGAIN, WITH SQUASH and STRETCH, WE TRY TO KEEP the SAME AMOUNT OF MEAT.
IF YOU TOOK IT OUT and WEIGHED IT - IT WOULD WEIGH The SAME.

AN UNCOUTH FELLOW -

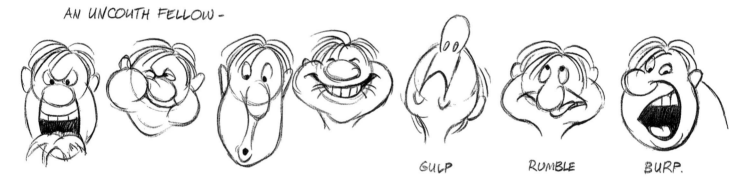

GULP RUMBLE BURP.

SO, AGAIN, IT'S <u>WHO</u> IS CHEWING? FAT, SMALL, OLD, CRAZY, INHIBITED?
A SOPHISTICATED PERSON CHEWING VERSUS A TRAMP WHO HASN'T EATEN FOR 3 WEEKS?

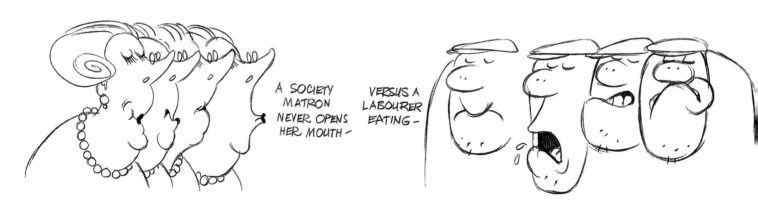

A SOCIETY
MATRON
NEVER OPENS
HER MOUTH -

VERSUS A
LABOURER
EATING -

248

OVERLAPPING ACTION IN The FACE

HERE'S A THING YOU OFTEN SEE GOOD ACTORS DOING:
SAY SOMEONE GETS FRIGHTENED –

IT'S CRUDE
JUST TO GO

FROM ONE
TO The OTHER.

IT CAN GO IN SECTIONS –

ONE
THING
AT A
TIME –

The OVERLAPPING
ACTION WORKS
IT'S WAY
DOWN
The FACE
(CAN BE
VERY FAST)

FIRST The EYE – THEN The NOSE – THEN The MOUTH – THEN The HAIR

(OR) VICE VERSA – WORKS IT'S WAY <u>UP</u> THE FACE –

FIRST The MOUTH – THEN The NOSE – THEN The EYE – THEN The HAIR .

START FROM SQUINT –

EYE OPENS FIRST – NOSE STRAIGHTENS – JAW FALLS 2nd OPENS

START WITH THE EYES — THEN KEEP GOING
AS THE MOUTH OVERLAPS and STRETCHES

 The CHANGE COULD TRAVEL ACROSS THE FACE.

SAY SOMEONE'S DISAPPOINTED —

START
FROM
ITS
OPPOSITE —
(THIS MIGHT
HAPPEN MORE
SLOWLY)

 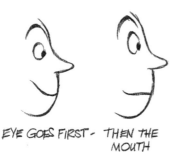

EYE GOES FIRST — THEN THE
MOUTH DROPS — The EYEBROW and BROW
 REVERSES FURROWS
 and CHIN GOES IN.

WE ALL KNOW
the TWO FACE —
the
DOUBLE FACE
WHERE
THERE'S
CONTRADICTION:

 PLUS EQUALS =

PUTTING
A BRAVE
FACE ON IT —

ONE SIDE OF THE FACE IS TELLING US ONE THING and the OTHER SIDE IS TELLING US ANOTHER —

I'D LIKE TO ANIMATE ONE SIDE SEPARATELY and THEN ANIMATE The OTHER.

250

INSTANT READ - PROFILES FOR READABILITY

THIS HAS TO GO IN the BOOK SOMEWHERE and IT MIGHT AS WELL BE HERE...

WHAT'S THIS?

OR THIS?

BUT IT'S PRETTY CLEAR WHAT THIS → IS.

IF WE WANT OUR AUDIENCE TO READ AN ACTION FAST - SHOW IT IN PROFILE.

NOT → BUT →

AND NOT → BUT ←

AND NOT → BUT →

WE CERTAINLY DON'T HAVE ANY TROUBLE SEEING WHAT'S HAPPENING HERE -

Ⓐ Ⓑ Ⓒ Ⓓ Ⓔ Ⓕ Ⓖ

AND FROM the POINT OF VIEW OF FLEXIBILITY - LOOK HOW JUST A SIMPLE REVERSAL OF HER BACK ARCH GIVES TERRIFIC SUPPLENESS. DRAWING Ⓓ'S BACK IS ABOUT AS CONCAVE AS YOU CAN GET - STAYS THAT WAY ON Ⓔ and THEN REVERSES TO CONVEX ON Ⓕ and Ⓖ. The HAIR IS DELAYED and ONLY DROPS ON Ⓕ. NICE.

IT'S ALWAYS A GOOD IDEA TO TRY TO GET A CLEAR OPPOSITE FROM WHAT WE'RE GOING TO CHANGE TO - WHETHER IT'S A FACIAL EXPRESSION OR A CHANGE OF SHAPE LIKE THIS.

TO FINISH OFF THIS SECTION and AS A KIND OF REVIEW —

HERE'S AN EXAM IN FLEXIBILITY —

AN ASSIGNMENT ART BABBITT GAVE US TO PRACTICE SUCCESSIVE BREAKING JOINTS —

1. TAKE THE FRONT VIEW OF A FEMALE SWAYING SIDE TO SIDE.
2. HAVE THE HIPS WORK IN A FIGURE 8.
3. HAVE THE HEAD COUNTER THE BODY.
4. HAVE THE HANDS WORK INDEPENDENTLY and BREAK THE JOINTS.

HERE'S THE SCRIBBLE I MADE AS ART SET OUT THE PROBLEM:

HIPS
WORK
IN FIGURE 8

KIND OF A SCARY PROBLEM and AS I WANTED TO DO IT SORT OF REALISTICALLY — EVEN SCARIER.
OK, WHAT DO WE DO FIRST? (THINKS) DUHHH… HEY, OF COURSE — THE (KEY) = DRAWING #①
THE ONE THAT TELLS THE STORY.

① →

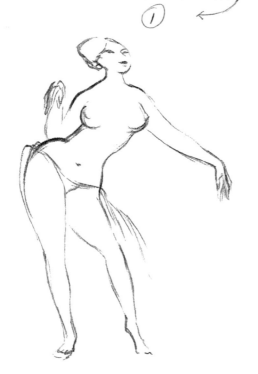

WHAT'S NEXT?
(THINKS)
…OBVIOUSLY…
THE NEXT EXTREME
WHERE SHE'LL SWAY
TO THE OTHER SIDE →

— CALL THIS #13
BECAUSE WHEN
I ACT IT OUT
I TAKE ABOUT
½ A SECOND TO SWING
TO ONE SIDE and
½ SEC TO SWING BACK
= 1 SECOND OVERALL.

13

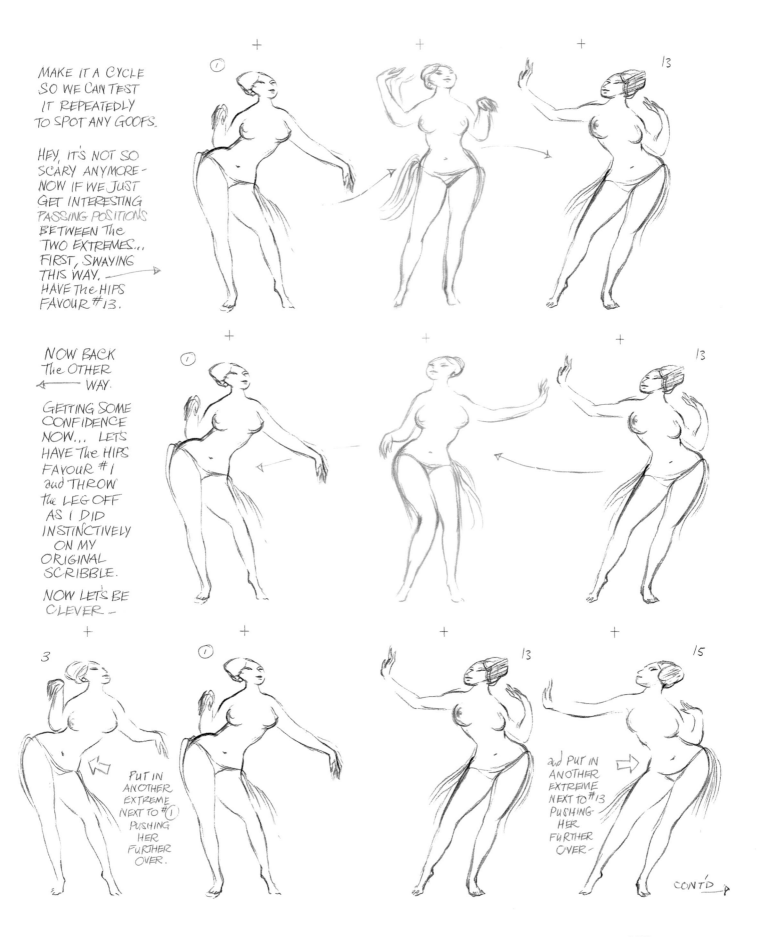

MAKE IT A CYCLE
SO WE CAN TEST
IT REPEATEDLY
TO SPOT ANY GOOFS.

HEY, IT'S NOT SO
SCARY ANYMORE-
NOW IF WE JUST
GET INTERESTING
PASSING POSITIONS
BETWEEN THE
TWO EXTREMES...
FIRST, SWAYING
THIS WAY.
HAVE THE HIPS
FAVOUR #13.

NOW BACK
THE OTHER
WAY.

GETTING SOME
CONFIDENCE
NOW... LETS
HAVE THE HIPS
FAVOUR #1
and 'THROW'
THE LEG OFF
AS I DID
INSTINCTIVELY
ON MY
ORIGINAL
SCRIBBLE.

NOW LET'S BE
CLEVER -

PUT IN
ANOTHER
EXTREME
NEXT TO #①
PUSHING
HER
FURTHER
OVER.

and PUT IN
ANOTHER
EXTREME
NEXT TO #13
PUSHING
HER
FURTHER
OVER -

CONT'D ▷

253

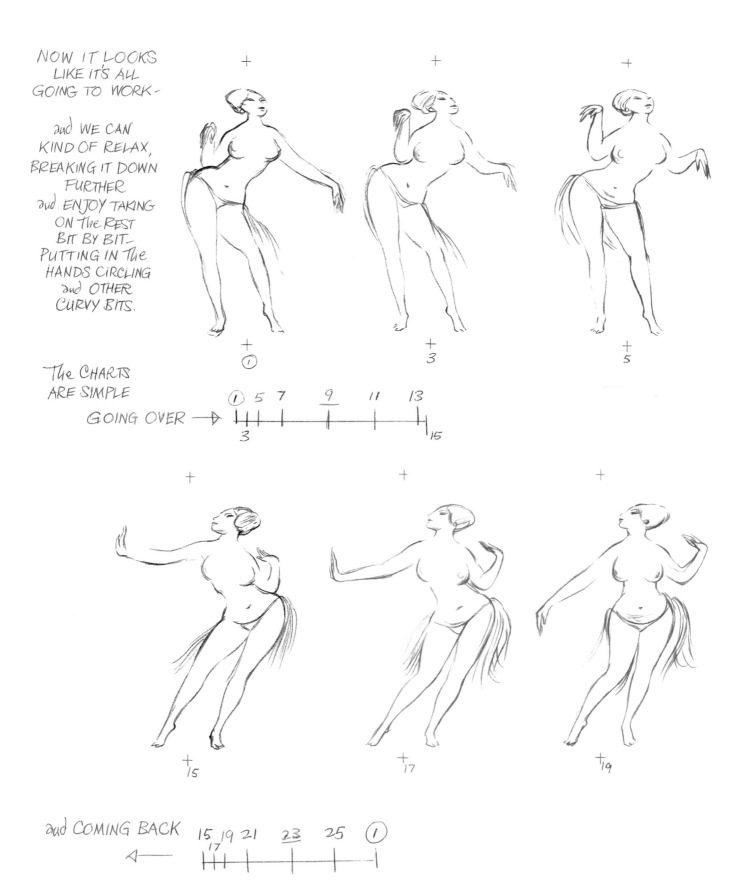

NOW IT LOOKS LIKE IT'S ALL GOING TO WORK—

and WE CAN KIND OF RELAX, BREAKING IT DOWN FURTHER and ENJOY TAKING ON The REST BIT BY BIT— PUTTING IN The HANDS CIRCLING and OTHER CURVY BITS.

The CHARTS ARE SIMPLE

GOING OVER →

and COMING BACK

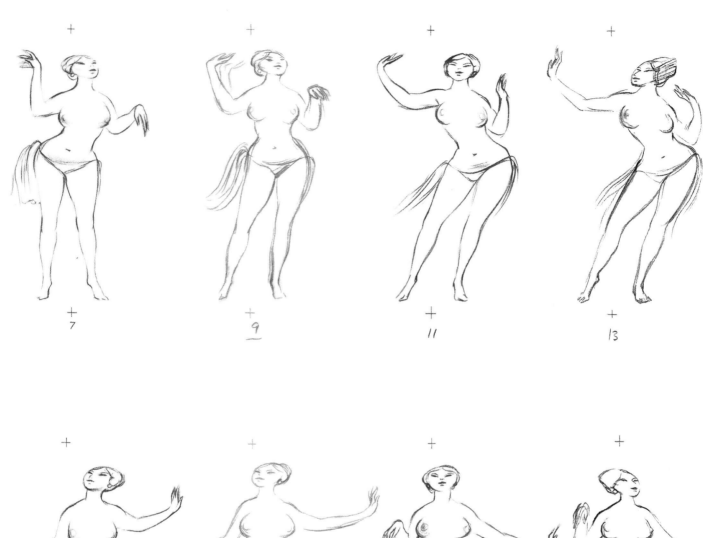

7 9 11 13

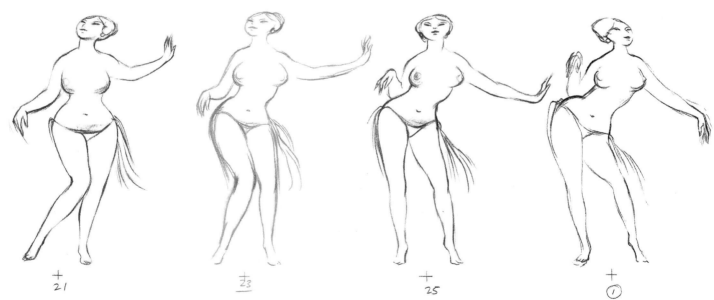

21 23 25 ①

THEN ADD IN ONES THROUGHOUT — BUT THEY'RE JUST
BRAINLESS INBETWEENS TO SMOOTH THINGS OUT FURTHER.
(THIS CAME OUT JUST FINE, DIDN'T NEED ANY CORRECTIONS.)

255

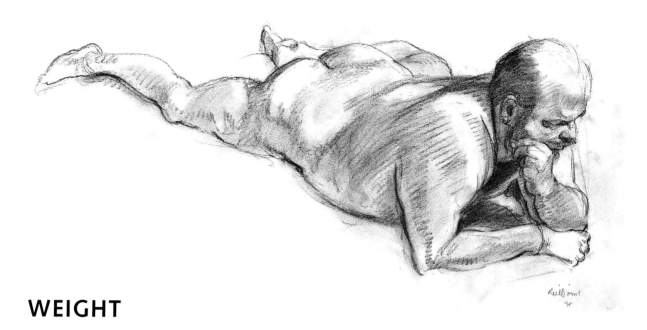

WEIGHT

THE FIRST QUESTION I EVER ASKED MILT KAHL WAS: `HOW DID YOU EVER GET THAT JUNGLE BOOK TIGER TO WEIGH SO MUCH?'

HE ANSWERED, `WELL, I KNOW WHERE The WEIGHT IS ON EVERY DRAWING. I KNOW WHERE The WEIGHT IS AT ANY GIVEN MOMENT ON The CHARACTER. I KNOW WHERE The WEIGHT IS, and WHERE IT'S COMING FROM and WHERE IT'S JUST TRAVELLING OVER- and WHERE The WEIGHT IS TRANSFERRING TO.'

WE'VE ALREADY SEEN THAT IN A WALK WE FEEL The WEIGHT ON The DOWN POSITION WHERE The LEG BENDS AS IT TAKES The WEIGHT, ABSORBING The FORCE OF The MOVE. BUT HOW ABOUT OTHER KINDS OF WEIGHT? OBJECTS -LIGHT? HEAVY? HOW DO WE SHOW THAT?

ONE WAY WE CAN SHOW HOW HEAVY AN OBJECT IS —
-IS BY The WAY WE PREPARE TO PICK IT UP.
TO PICK UP WEIGHT WE HAVE TO PREPARE FOR IT - TO ANTICIPATE The WEIGHT. OBVIOUSLY PICKING UP A PIECE OF CHALK, A PEN OR A FEATHER DOESN'T REQUIRE ANY PREPARATION -

BUT A HEAVY STONE...

WE CAN SUGGEST WEIGHT BY JUST HAVING HIM WALK AROUND IT - SIZING IT UP.

BAD. NO FEELING OF WEIGHT. IT MUST BE A POLYSTYRENE ROCK.

HOW'S HE GOING TO DO THIS? HE'S CONSIDERING WHAT HE'S GOING TO PICK UP. HOW HEAVY IS IT? HE'S ANTICIPATING WHAT IT'S GOING TO WEIGH...

256

MAYBE WE DON'T HAVE THE SCREEN TIME TO HAVE HIM WALK AROUND, BUT ONE WAY OR ANOTHER, HE'S GOING TO ANTICIPATE THE WEIGHT.

LOOK WHAT THE SPINE IS DOING...

HE'D CERTAINLY SPREAD HIS FEET FIRST AND BEND HIS KNEES.

AND GET AS CLOSE TO THE WEIGHT AS POSSIBLE.

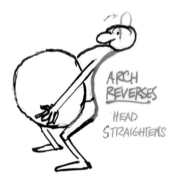

ARCH REVERSES
HEAD STRAIGHTENS

HE ADJUSTS HIMSELF SO AS TO NOT DAMAGE HIMSELF, HE DOESN'T WANT A HERNIA.

BODY GOES BACK AS HE LIFTS

TRIES TO GET UNDERNEATH THE WEIGHT - MIGHT ADJUST FEET IN LITTLE BITS - ERRATICALLY

BACK ARCH REVERSES AS HE TRIES TO GET A PURCHASE -

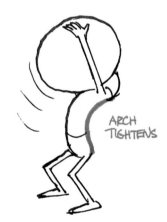

ARCH TIGHTENS

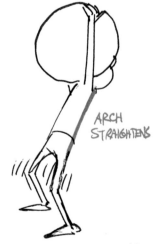

ARCH STRAIGHTENS

BIG LIFT

STRAIGHTENS - KNEES SHAKE

FALLS BACK OR WHATEVER.

257

A MAN CARRYING A SACK OF POTATOES ON HIS BACK BENDS DOWN TO COUNTERBALANCE THE WEIGHT. THE WEIGHT FORCES HIS BODY CLOSER TO THE GROUND, KEEPING THE KNEES BENT and MAKING THE FEET SHUFFLE ALONG. THE FEET ALSO SPLAY OUT TO FORM A SORT OF TRIPOD TO SPREAD THE WEIGHT OVER A LARGER AREA.

FEET APART-
KNEES
ALWAYS BENT

FEET DONT
COME OFF
THE GROUND
VERY MUCH.

A LOT OF DIFFERENCE IN THESE WALKS OR RUNS IS DETERMINED BY THE WEIGHT THE PERSON MIGHT BE CARRYING. IF A PERSON IS CARRYING A HEAVY ROCK-
THE WEIGHT WOULD LOWER THE SHOULDERS and STRETCH THE ARMS. THE HEAD and NECK COULD COME DOWN.

(PULLED SLIGHTLY APART) 17 9 1

HE'LL MOVE
MORE SLOWLY
and THE BODY
WILL RAISE
ONLY SLIGHTLY
ON THE
PASSING POSITION

BUT THE ROCK
WILL NOT RAISE
AT ALL.

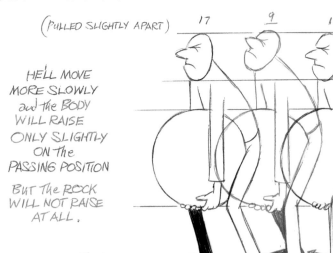

AGAIN, THE
PASSING FOOT
WILL HARDLY
LEAVE THE GROUND
and
THE KNEES WILL
REMAIN BENT
ALL THE TIME
FROM THE WEIGHT.

THE TIMING OF THE FEET
COULD BE ERRATIC -

ie. STEP, PAUSE, STEP, STEP, PAUSE, STEP, PAUSE, STEP, STEP, STEP, PAUSE, etc.
OR HE COULD GLIDE RAPIDLY and THEN DROP IT.

258

A HAND PICKING UP A SILK
HANDKERCHIEF LYING ON
The GROUND ENCOUNTERS
NO RESISTANCE -

BUT A HAND PICKING UP A BRICK-
LET'S CONSIDER WHAT HAPPENS TO The WHOLE BODY -

The WEIGHT
OF The BRICK
STRAIGHTENS
The ARM
and PULLS
The SHOULDER
DOWN.

ANGLE OF HEAD
COULD OPPOSE
SHOULDERS.

The ARM IS
HELPING TO
BALANCE
The BRICK
IN The RIGHT
HAND.

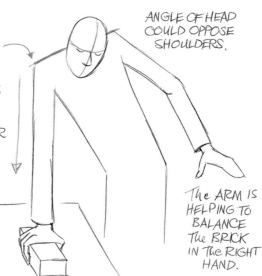

PICKING UP A FEATHER
IS'NT GOING TO HAVE ANY EFFECT ON The BODY.

REVERSING The FEATHER SHAPE ⌒ TO ⌣ IN The MOVE MAKES The FEATHER EVEN
LIGHTER.

OF COURSE, ONE WAY TO GET WEIGHT IS TO BE CONSCIOUS OF IT.

The GREAT ANIMATOR, BILL TYTLA SAYS -

"The POINT IS THAT YOU ARE NOT MERELY SWISHING A PENCIL ABOUT, BUT YOU HAVE
WEIGHT IN YOUR FORMS and YOU DO WHATEVER YOU POSSIBLY CAN WITH THAT WEIGHT
TO CONVEY SENSATION. IT IS A STRUGGLE FOR ME and I AM CONSCIOUS OF IT ALL The TIME".

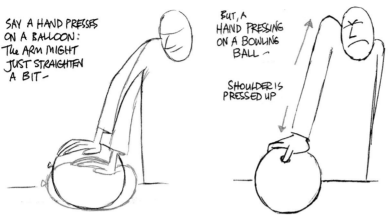

SAY A HAND PRESSES ON A BALLOON: THE ARM MIGHT JUST STRAIGHTEN A BIT —

BUT, A HAND PRESSING ON A BOWLING BALL —

SHOULDER IS PRESSED UP

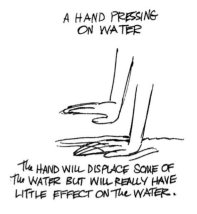

A HAND PRESSING ON WATER

THE HAND WILL DISPLACE SOME OF THE WATER BUT WILL REALLY HAVE LITTLE EFFECT ON THE WATER.

LET'S DROP A FEW THINGS WHICH FALL AT DIFFERENT SPEEDS BECAUSE OF THEIR WEIGHT and WHAT THEY'RE MADE OF.

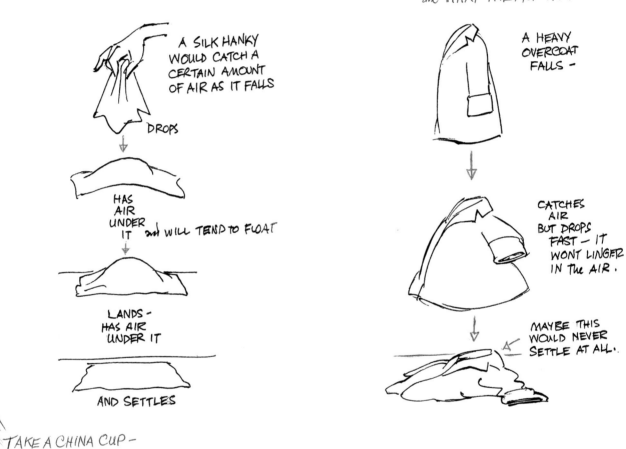

A SILK HANKY WOULD CATCH A CERTAIN AMOUNT OF AIR AS IT FALLS

DROPS

HAS AIR UNDER IT and WILL TEND TO FLOAT

LANDS — HAS AIR UNDER IT

AND SETTLES

A HEAVY OVERCOAT FALLS —

CATCHES AIR BUT DROPS FAST — IT WONT LINGER IN THE AIR.

MAYBE THIS WOULD NEVER SETTLE AT ALL.

TAKE A CHINA CUP —

IN REALITY THE CUP WOULD PROBABLY SHATTER ON IMPACT BUT WE CAN HAVE IT BOUNCE AROUND A BIT. TAKE LIBERTIES WITH REALITY BUT MAKE IT APPEAR BELIEVABLE.

BOUNCE BOUNCE BOUNCE BOUNCE SETTLES PAUSE THEN IT SHATTERS

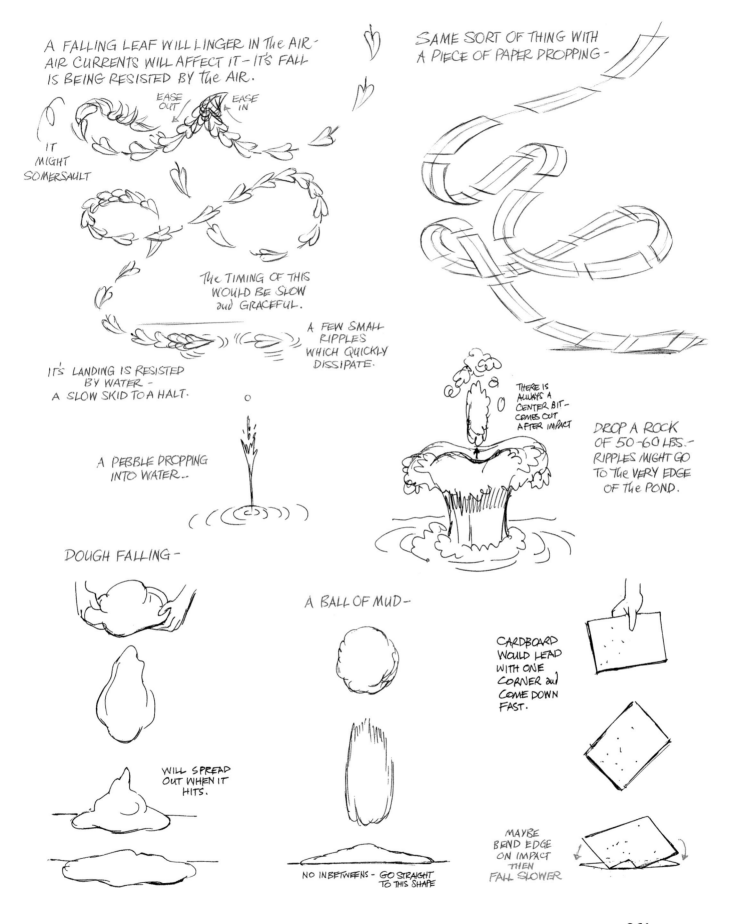

A FALLING LEAF WILL LINGER IN THE AIR-
AIR CURRENTS WILL AFFECT IT - IT'S FALL
IS BEING RESISTED BY THE AIR.

EASE OUT EASE IN

IT MIGHT SOMERSAULT

The TIMING OF THIS WOULD BE SLOW and GRACEFUL.

A FEW SMALL RIPPLES WHICH QUICKLY DISSIPATE.

IT'S LANDING IS RESISTED BY WATER -
A SLOW SKID TO A HALT.

SAME SORT OF THING WITH
A PIECE OF PAPER DROPPING-

A PEBBLE DROPPING INTO WATER.-

THERE IS ALWAYS A CENTER BIT- COMES OUT AFTER IMPACT

DROP A ROCK OF 50-60 LBS.- RIPPLES MIGHT GO TO THE VERY EDGE OF THE POND.

DOUGH FALLING-

A BALL OF MUD-

CARDBOARD WOULD LEAD WITH ONE CORNER and COME DOWN FAST.

WILL SPREAD OUT WHEN IT HITS.

NO INBETWEENS - GO STRAIGHT TO THIS SHAPE

MAYBE BEND EDGE ON IMPACT THEN FALL SLOWER

261

PRESSURE and WEIGHT —

TOUCHING

PRESSING

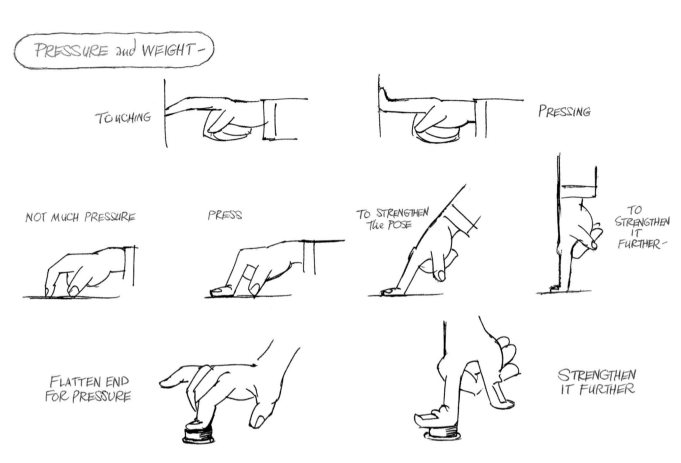

NOT MUCH PRESSURE

PRESS

TO STRENGTHEN the POSE

TO STRENGTHEN IT FURTHER —

FLATTEN END FOR PRESSURE

STRENGTHEN IT FURTHER

SUPPOSE the SURFACE IS SOFT — CLOTH OR RUBBER — IT WOULD GIVE.

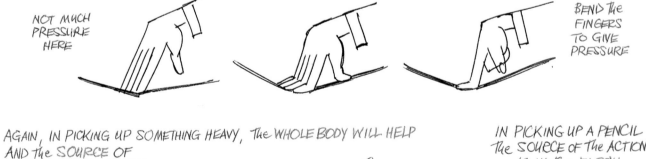

NOT MUCH PRESSURE HERE

BEND the FINGERS TO GIVE PRESSURE

AGAIN, IN PICKING UP SOMETHING HEAVY, The WHOLE BODY WILL HELP AND the SOURCE OF The ACTION IS IN the HIPS —

IN PICKING UP A PENCIL the SOURCE OF The ACTION IS IN the ELBOW,

— OBVIOUSLY NOT FROM the HIPS

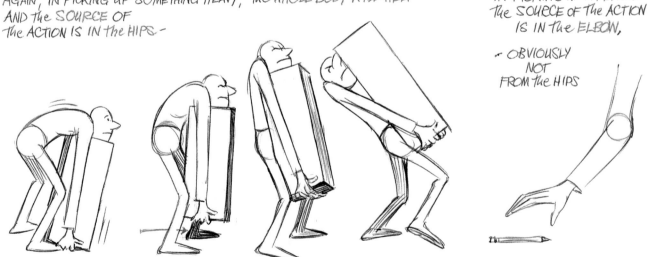

262

A VERY HEAVY BOX FALLING — A HARD GOLF BALL FALLING— A STEEL BALL OR BOWLING BALL FALLS—

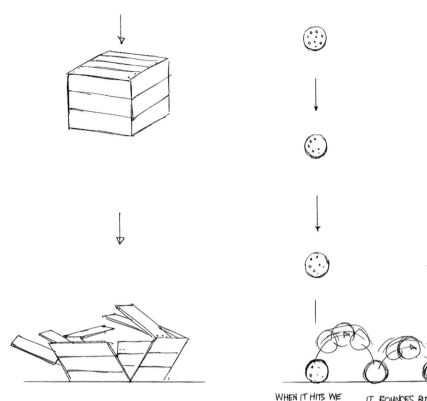

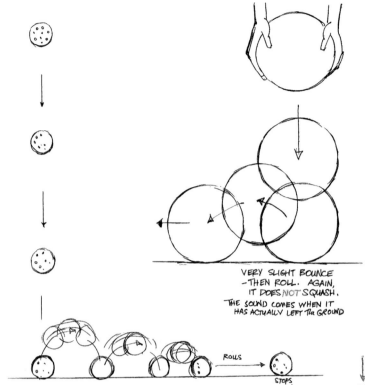

VERY SLIGHT BOUNCE
—THEN ROLL. AGAIN,
IT DOES NOT SQUASH.
THE SOUND COMES WHEN IT
HAS ACTUALLY LEFT THE GROUND

ROLLS

STOPS

WHEN IT HITS WE
SHOW THE CONTACT
BUT IT DOES NOT SQUASH
AND IMMEDIATELY RISES.

IT BOUNCES BUT IMMEDIATELY ROLLS TO A STOP.

A TENNIS BALL WILL SQUASH ON IMPACT

THEN
REGAIN ITS
ORIGINAL
SHAPE

TO FEEL THE IMPACT THE BOX IS PARTIALLY OPEN
AT THE MOMENT OF IMPACT.

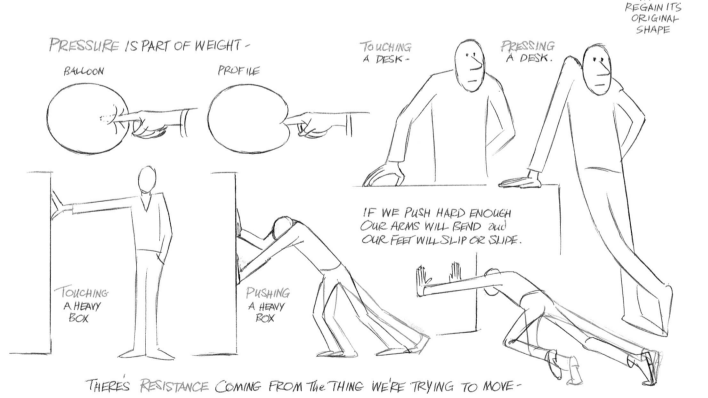

PRESSURE IS PART OF WEIGHT —

BALLOON PROFILE

TOUCHING
A DESK —

PRESSING
A DESK.

IF WE PUSH HARD ENOUGH
OUR ARMS WILL BEND and
OUR FEET WILL SLIP OR SLIDE.

TOUCHING
A HEAVY
BOX

PUSHING
A HEAVY
BOX

THERE'S RESISTANCE COMING FROM THE THING WE'RE TRYING TO MOVE—

263

HOW MUCH EFFORT DO WE HAVE TO EXPEND
① TO MOVE SOMETHING?
② TO CHANGE ITS DIRECTION?
③ OR TO STOP IT?
WILL INDICATE HOW MUCH IT WEIGHS.

COMING TO A STOP IS PART OF WEIGHT:

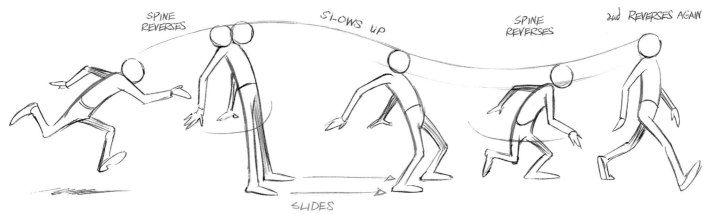

SPINE REVERSES

SLOWS UP

SPINE REVERSES

2nd REVERSES AGAIN

SLIDES

COMING TO the END OF A SLIDE, WE'RE THROWN OFF BALANCE

THEN WE GO INTO OUR NEXT ACTION - LIKE COMING OFF AN ESCALATOR.

FRANK THOMAS SAYS-
"WE'VE GOT TO DO SOMETHING TO STOP the FORWARD PROGRESSION OF BELIEVABLE WEIGHT."

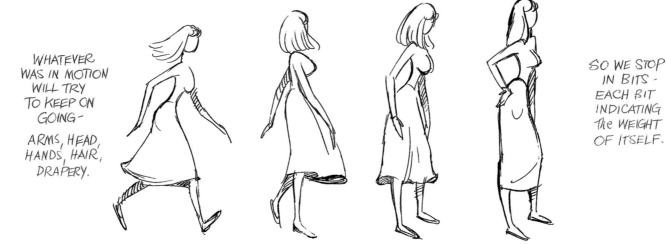

WHATEVER WAS IN MOTION WILL TRY TO KEEP ON GOING -

ARMS, HEAD, HANDS, HAIR, DRAPERY.

SO WE STOP IN BITS - EACH BIT INDICATING the WEIGHT OF ITSELF.

HERE'S MILT KAHL ON IT -
"STOPPING THINGS CONVINCINGLY IS ONE OF the DIFFICULT THINGS TO DO IN ANIMATION. WHEN YOU COME TO A STOP, PICK A GOOD PLACE TO STOP. HOW YOU CHOOSE TO STOP- WHAT KIND OF A STOP - WHETHER IT'S AN ALERT STOP OR A LAZY ONE, CHOOSING WHERE TO DO IT IS AN IMPORTANT CHOICE. I HATE TO SEE A FOOT COME THROUGH and LAND and THEN NOTHING HAPPENS TO IT. I THINK WHEN IT LANDS WE OUGHT TO GO AHEAD and PUT the WEIGHT ON IT - OR ROCK FORWARD - OR RAISE the OTHER FOOT."

264

SO, HOW MUCH EFFORT IT TAKES TO STOP SOMETHING SHOWS HOW MUCH IT WEIGHS.

ALSO, THE SPEED OF AN ACTION WILL DETERMINE HOW VIOLENT THE DRAPERY IS -

IF A MAN IS RUNNING WITH A COAT MADE OF THIN, LIGHT MATERIAL and HE COMES
TO A SUDDEN STOP, THE MATERIAL WILL CONTINUE TO FLOW, TO KEEP ON GOING -
TO GO AHEAD OF HIM INDEPENDENTLY and THEN FLOP BACK and SETTLE. ('FOLLOWS
THROUGH')

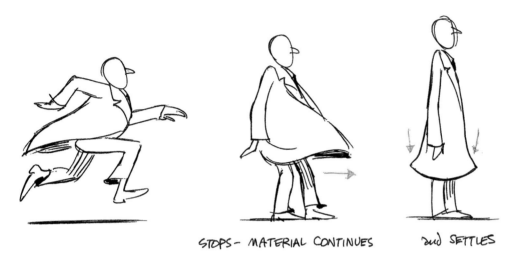

STOPS - MATERIAL CONTINUES and SETTLES

A WOMAN IN A SILK NIGHTIE... THE MATERIAL WILL BLOSSOM and FLAP VIOLENTLY.

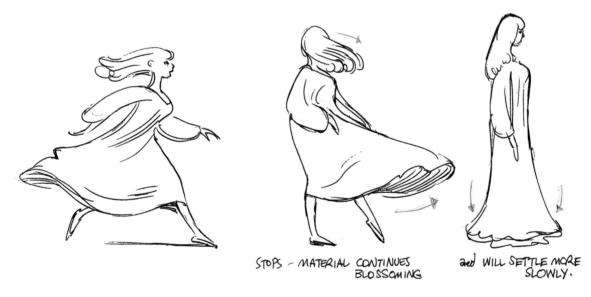

STOPS - MATERIAL CONTINUES and WILL SETTLE MORE
BLOSSOMING SLOWLY.

SO WHEN SHE STOPS, HER CLOTHES and HAIR FOLLOW THROUGH ARRIVING LATER THAN THE MAIN ACTION.
AND OF COURSE, HER MAIN ACTION ALSO STOPS IN PARTS, FINISHING UP AT DIFFERENT TIMES.
HAS THERE EVER BEEN AN ACTION WHERE ALL THE PARTS OF A BODY MOVED UNIFORMLY?
(EXCEPT IN ROBOTS, and PROBABLY NOT EVEN IN THEM.)
AGAIN, 'FOLLOW THROUGH' IS THE RESULT OF and IS GENERATED BY THE MAIN ACTION.

BUT THE ONLY WAY WE CAN REALLY SHOW WEIGHT IS WITH THE ACTION.
SAY WE'RE PICKING UP A HEAVY BATCH OF HAY WITH A PITCHFORK—

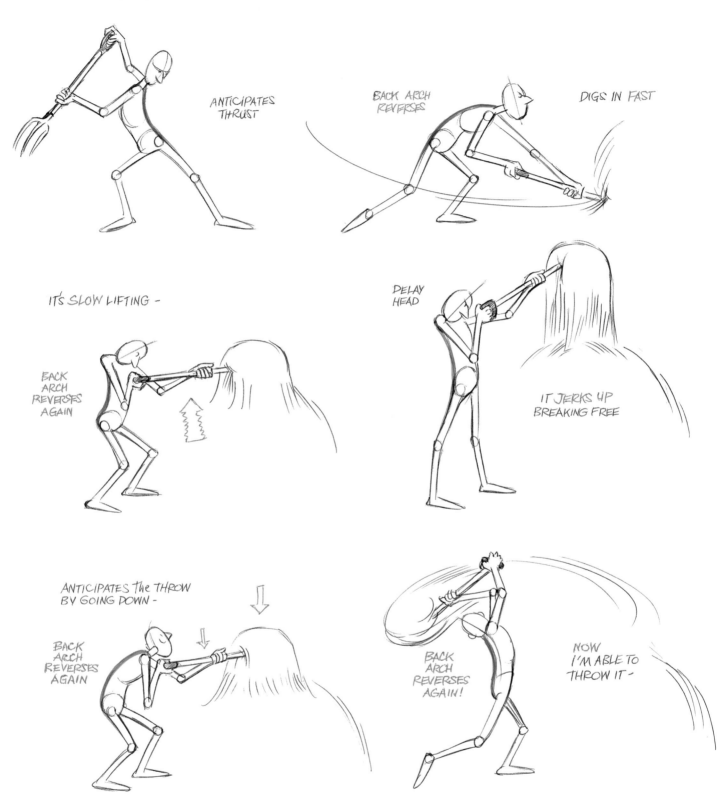

ANTICIPATES
THRUST

BACK ARCH
REVERSES

DIGS IN FAST

IT'S SLOW LIFTING —

BACK
ARCH
REVERSES
AGAIN

DELAY
HEAD

IT JERKS UP
BREAKING FREE

ANTICIPATES THE THROW
BY GOING DOWN —

BACK
ARCH
REVERSES
AGAIN

BACK
ARCH
REVERSES
AGAIN!

NOW
I'M ABLE TO
THROW IT —

266

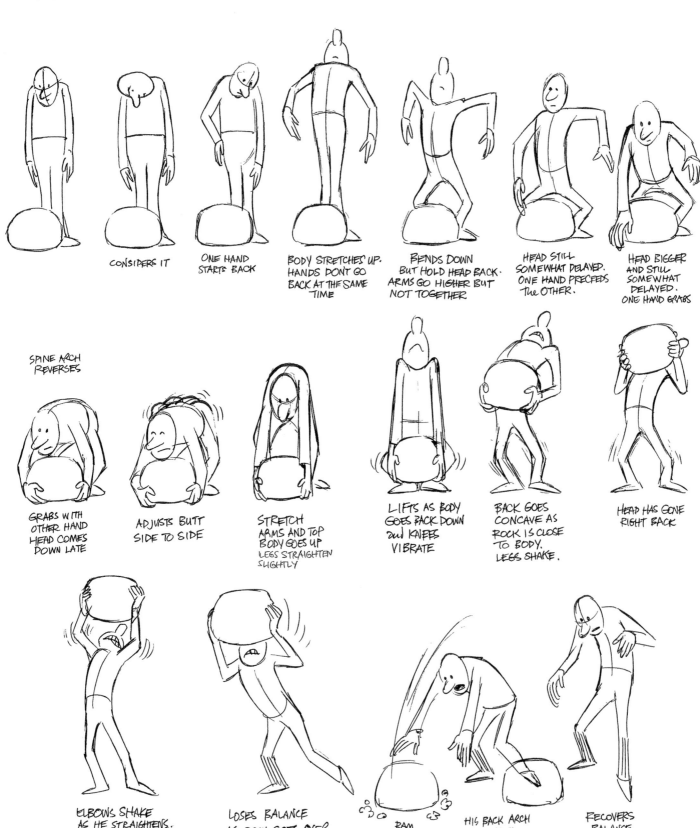

CONSIDERS IT

ONE HAND STARTS BACK

BODY STRETCHES UP. HANDS DON'T GO BACK AT THE SAME TIME

BENDS DOWN BUT HOLD HEAD BACK. ARMS GO HIGHER BUT NOT TOGETHER

HEAD STILL SOMEWHAT DELAYED. ONE HAND PRECEDS THE OTHER.

HEAD BIGGER AND STILL SOMEWHAT DELAYED. ONE HAND GRABS

SPINE ARCH REVERSES

GRABS WITH OTHER HAND HEAD COMES DOWN LATE

ADJUSTS BUTT SIDE TO SIDE

STRETCH ARMS AND TOP BODY GOES UP LEGS STRAIGHTEN SLIGHTLY

LIFTS AS BODY GOES BACK DOWN and KNEES VIBRATE

BACK GOES CONCAVE AS ROCK IS CLOSE TO BODY. LEGS SHAKE.

HEAD HAS GONE RIGHT BACK

ELBOWS SHAKE AS HE STRAIGHTENS. HE'S GOING TO THROW IT.

LOSES BALANCE AS ROCK GOES OVER

BAM

HIS BACK ARCH REVERSES

RECOVERS BALANCE

A MAN WITH A HEAVY MALLET IS GOING TO THROW IT ON AN ANVIL —

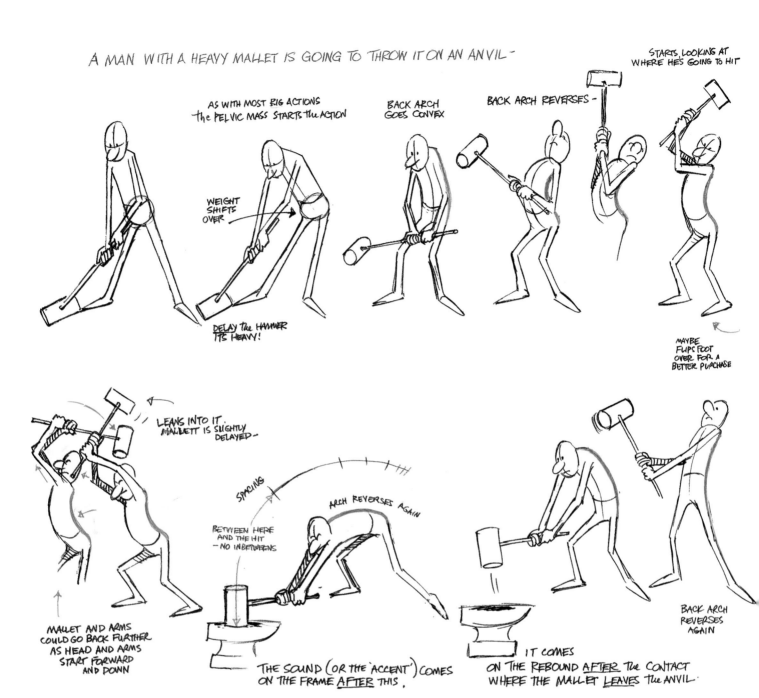

STARTS LOOKING AT
WHERE HE'S GOING TO HIT

AS WITH MOST BIG ACTIONS
the PELVIC MASS STARTS the ACTION

BACK ARCH
GOES CONVEX

BACK ARCH REVERSES —

WEIGHT
SHIFTS
OVER

DELAY the HAMMER
ITS HEAVY!

MAYBE
FLIPS FOOT
OVER FOR A
BETTER PURCHASE

LEANS INTO IT.
MALLETT IS SLIGHTLY
DELAYED —

SPACING

ARCH REVERSES AGAIN

BETWEEN HERE
AND THE HIT
— NO INBETWEENS

MALLET AND ARMS
COULD GO BACK FURTHER
AS HEAD AND ARMS
START FORWARD
AND DOWN

THE SOUND (OR THE 'ACCENT') COMES
ON THE FRAME AFTER THIS.

IT COMES
ON THE REBOUND AFTER the CONTACT
WHERE THE MALLET LEAVES the ANVIL

BACK ARCH
REVERSES
AGAIN

SO WE TRY TO FIND ALL the VARIOUS POSSIBILITIES TO CONVEY WEIGHT VISUALLY —

CAN WE DELAY PARTS?
GO FAST AND SLOW?
USE UP AND DOWN?
BREAK the JOINTS?
REVERSE the BODY ARCH?
SHIFT the WEIGHT?

— AND SELECT WHAT WE NEED TO PUT OVER WHAT WE WANT.
AND WHEN WE HAVE ALL THIS STUFF IN OUR BLOODSTREAM — CONCENTRATE ON PERSONALITY.
WHO IS DOING IT and IN WHAT SITUATION?

268

RUNNING and TRYING TO CHANGE DIRECTION SHOWS the WEIGHT.

IN TURNING A CORNER CHARLIE CHAPLIN DID A FAMOUS SKIDDING OR HOPPING TURN.
HE SKIDS ROUND the CORNER IN A CURVE and RUNS OUT the OTHER WAY.

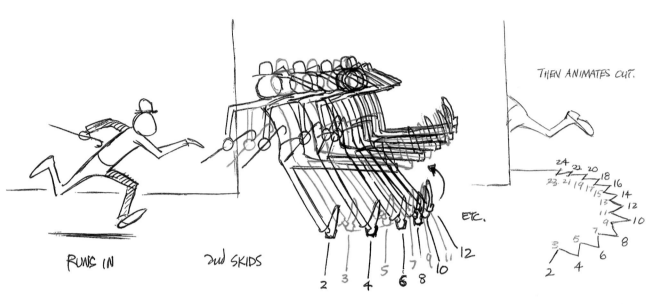

THEN ANIMATES OUT.

RUNS IN and SKIDS ETC.

2 3 4 5 6 8 10 12

LIKE A MOTORBIKE HE LEANS INTO the CURVE OF the TURN. THE FEET ARE OFFSET ON the
 IN BETWEENS TO MAKE the SKID.
IN ANIMATION - IF HE SKIDS FOR ABOUT A SECOND -
A WAY TO DO THIS IS TO MAKE A SERIES OF DRAWINGS FROM 2 TO 24 (EVEN NUMBERS)
THEN MAKE ANOTHER SERIES, OFFSET SLIGHTLY, FROM 3 to 23 (ODD NUMBERS)
THEN WE INTERLEAVE THEM. (FOR MORE ON THIS SEE 'VIBRATIONS')

DANCING

TO FINISH OFF THIS SECTION ON WEIGHT WE SHOULD INCLUDE DANCING.
The REASON IS THAT the ESSENTIAL PART OF DANCING IS NOT WHAT'S HAPPENING TO the FEET
BUT WHAT'S HAPPENING TO the BODY - the WEIGHT - the UP and DOWN OF the BODY.

KEN HARRIS and ART BABBITT WERE BOTH SPECIALISTS IN DANCE ANIMATION and THEY
BOTH SAID EXACTLY the SAME THING: IT'S the UP AND DOWN ON the BODY and HANDS
THAT IS the MOST IMPORTANT THING IN A DANCE. IT'S WHAT'S HAPPENING TO the BODY
 WITH the WEIGHT MOVING UP and DOWN IN RHYTHM.

IN A TAP DANCE - (PULLED APART)

IF WE BLOCK OUT the FEET and JUST GET the UP and DOWN OF the BODY RIGHT-
 THEN WE CAN PUT the FEET ON ANYWHERE.

LET'S ADD FEET TO A SIMILAR UP and DOWN BODY PLAN. THE BEAT IS ON 12's (THIS WORKS WELL ON TWOS)

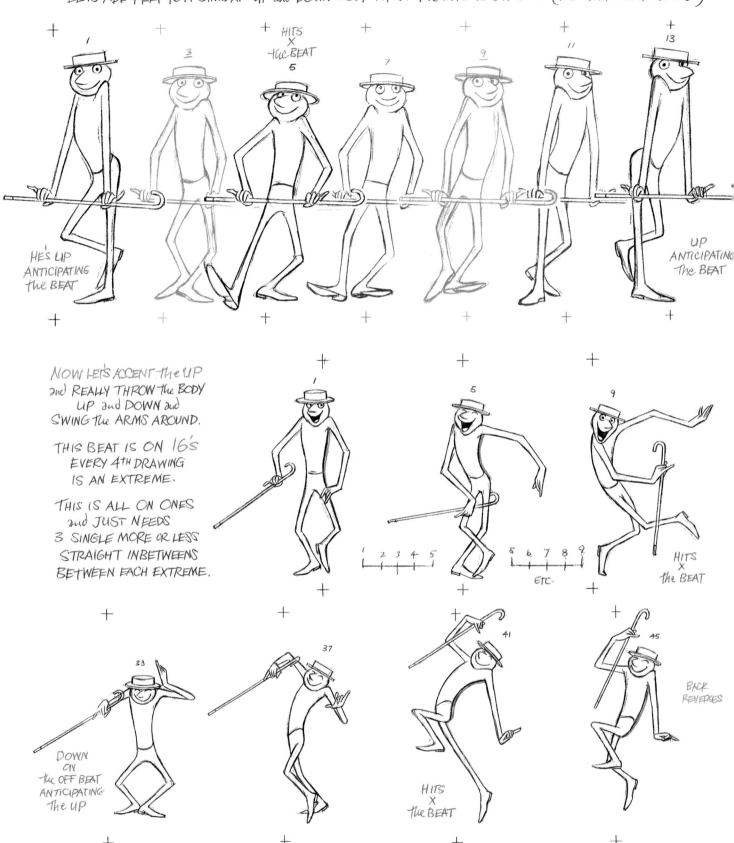

1

3

HITS
X
The BEAT
5

7

9

11

13

HE'S UP
ANTICIPATING
The BEAT

UP
ANTICIPATING
The BEAT

NOW LET'S ACCENT the UP
and REALLY THROW the BODY
UP and DOWN and
SWING the ARMS AROUND.

THIS BEAT IS ON 16's
EVERY 4TH DRAWING
IS AN EXTREME.

THIS IS ALL ON ONES
and JUST NEEDS
3 SINGLE MORE OR LESS
STRAIGHT INBETWEENS
BETWEEN EACH EXTREME.

1

5

9

1 2 3 4 5 5 6 7 8 9
 ETC.

HITS
X
the BEAT

33

37

41

45

DOWN
ON
the OFF BEAT
ANTICIPATING
The UP

HITS
X
the BEAT

BACK
REVERSES

270

ON A DANCE - USUALLY HIT the BEAT ON the DOWN. WE FEEL the WEIGHT AS the BODY COMES DOWN.

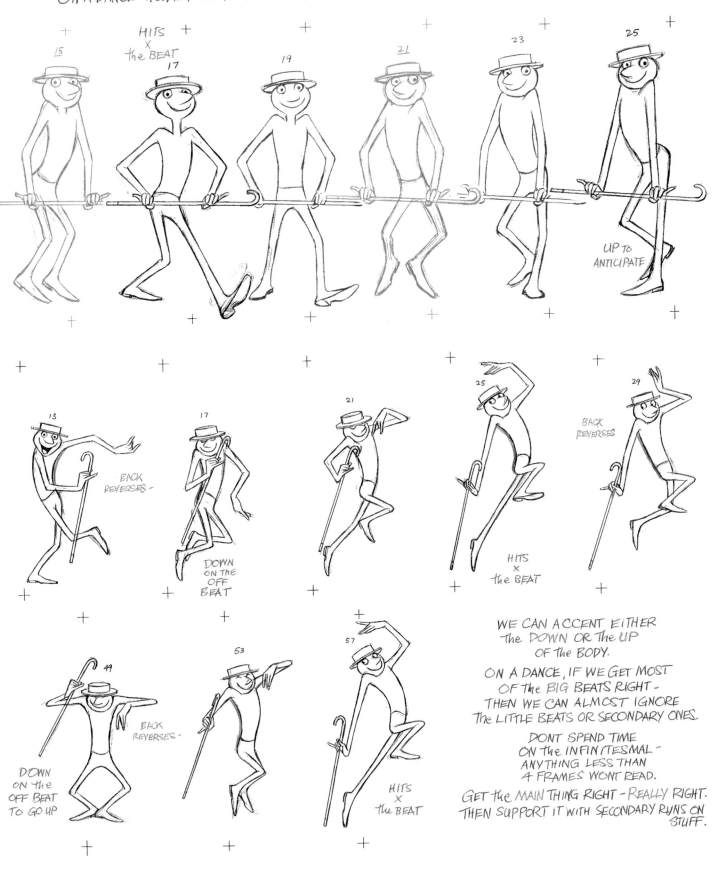

WE CAN ACCENT EITHER the DOWN OR The UP OF the BODY.

ON A DANCE, IF WE GET MOST OF the BIG BEATS RIGHT - THEN WE CAN ALMOST IGNORE the LITTLE BEATS OR SECONDARY ONES.

DONT SPEND TIME ON the INFINITESMAL - ANYTHING LESS THAN 4 FRAMES WONT READ.

GET the MAIN THING RIGHT - REALLY RIGHT. THEN SUPPORT IT WITH SECONDARY RUNS ON STUFF.

271

WITH DANCERS - NOTICE THE *TWIST IN THE SHOULDERS*
AS THEY OPPOSE THE *TWIST IN THE HIPS.*

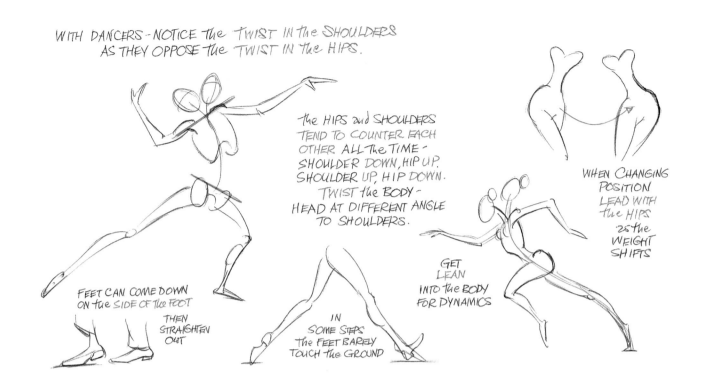

THE HIPS and SHOULDERS
TEND TO COUNTER EACH
OTHER ALL THE TIME -
SHOULDER DOWN, HIP UP.
SHOULDER UP, HIP DOWN.
TWIST THE BODY -
HEAD AT DIFFERENT ANGLE
TO SHOULDERS.

WHEN CHANGING
POSITION
LEAD WITH
THE HIPS
as the
WEIGHT
SHIFTS

FEET CAN COME DOWN
ON THE SIDE OF THE FOOT
THEN
STRAIGHTEN
OUT

IN
SOME STEPS
THE FEET BARELY
TOUCH THE GROUND

GET
LEAN
INTO THE BODY
FOR DYNAMICS

ON SYNCHRONISING THE ACTION TO A MUSICAL BEAT, THERE ARE 2 *RULES OF THUMB:*

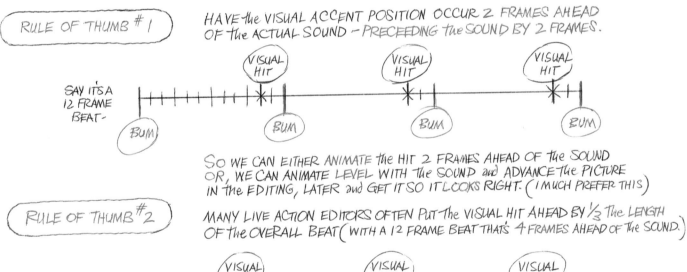

RULE OF THUMB #1

HAVE THE VISUAL ACCENT POSITION OCCUR 2 FRAMES AHEAD
OF THE ACTUAL SOUND - PRECEEDING THE SOUND BY 2 FRAMES.

SAY IT'S A
12 FRAME
BEAT -

VISUAL HIT VISUAL HIT VISUAL HIT

BUM BUM BUM BUM

SO WE CAN EITHER ANIMATE THE HIT 2 FRAMES AHEAD OF THE SOUND
OR, WE CAN ANIMATE LEVEL WITH THE SOUND and ADVANCE THE PICTURE
IN THE EDITING, LATER and GET IT SO IT LOOKS RIGHT. (I MUCH PREFER THIS)

RULE OF THUMB #2

MANY LIVE ACTION EDITORS OFTEN PUT THE VISUAL HIT AHEAD BY 1/3 THE LENGTH
OF THE OVERALL BEAT (WITH A 12 FRAME BEAT THAT'S 4 FRAMES AHEAD OF THE SOUND.)

12 FRAME
BEAT

VISUAL HIT VISUAL HIT VISUAL HIT

BUM BUM BUM BUM

AS WITH DIALOGUE, I THINK THE BEST WAY IS TO ANIMATE LEVEL WITH THE SOUND - THEN FIDDLE
WITH IT IN THE EDITING TILL IT LOOKS JUST RIGHT. ALSO WE LEARN THINGS THIS WAY, AS RULES
OF THUMB ARE ONLY WHAT THEY ARE - RULES OF THUMB. TRY IT and SEE WHAT WORKS BEST.
MAYBE IT'S BETTER ONE FRAME ADVANCED, MAYBE TWO, MAYBE 3 OR 4. MAYBE ITS BEST LEVEL.
(IT'S NEVER BETTER LATE.)

ANTICIPATION

IS THERE ANYBODY WHO DOESN'T KNOW WHAT THIS GUY'S GOING TO DO?

The GREAT ANIMATOR, BILL TYTLA SAID,

"THERE ARE ONLY 3 THINGS IN ANIMATION -

1	ANTICIPATION
2	ACTION
3	REACTION

AND THESE IMPLY the REST.
LEARN TO DO THESE THINGS WELL
and YOU CAN ANIMATE WELL."

CHARLIE CHAPLIN SAID,

1	TELL 'EM WHAT YOU'RE GOING TO DO.
2	DO IT.
3	TELL 'EM THAT YOU'VE DONE IT.

THE GREAT FRENCH MIME, MARCEL MARCEAU SAYS,

"USE BIG ANTICIPATION."

WHY? BECAUSE IT COMMUNICATES WHAT IS GOING TO HAPPEN.
THE AUDIENCE SEES WHAT IS GOING TO HAPPEN - THEY SEE THE ANTICIPATION
AND SO THEY ANTICIPATE IT WITH US. THEY GO WITH US.

WHY? BECAUSE FOR ALMOST EVERY ACTION WE MAKE THERE IS AN ANTICIPATION.
WE THINK OF THINGS FIRST - THEN DO THEM.

UNLESS IT'S A PRE-PROGRAMMED RESPONSE LIKE SHIFTING GEARS ON A CAR
OR GETTING DRESSED, WE KNOW THAT WE THINK OF SOMETHING FIRST - THEN DO IT.
AS WITH SPEECH, WE KNOW THAT OUR BRAIN FIXES UPON THE SENSE OF WHAT
IT WANTS TO SAY - THEN GOES INTO A VERY COMPLEX SERIES OF MUSCLE
SELECTIONS TO SAY IT.

SO, ANTICIPATION IS THE PREPARATION FOR AN ACTION. (WHICH WE ALL RECOGNISE WHEN WE SEE IT.)
ANTICIPATION TAKES PLACE IN ALMOST EVERY ACTION -
AND CERTAINLY IN EVERY BIG ACTION.

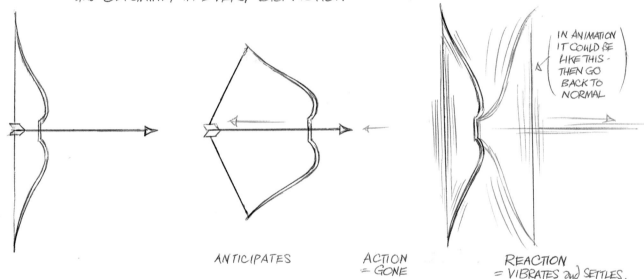

ANTICIPATES

ACTION = GONE

IN ANIMATION IT COULD BE LIKE THIS - THEN GO BACK TO NORMAL

REACTION = VIBRATES AND SETTLES.

THE ANTICIPATION IS ALWAYS IN THE OPPOSITE DIRECTION TO WHERE THE MAIN ACTION IS GOING TO GO.

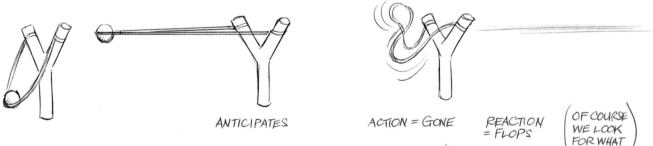

ANTICIPATES

ACTION = GONE

REACTION = FLOPS

(OF COURSE WE LOOK FOR WHAT IS HIT)

ANY ACTION IS STRENGTHENED BY BEING PRECEEDED BY IT'S OPPOSITE.

IF ACTION IS IN the WHOLE BODY
THEN WE HAVE ANTICIPATION OF
TREMENDOUS LATENT FORCE.

USUALLY the ANTICIPATION IS SLOWER - LESS VIOLENT THAN The ACTION
SLOW ANTICIPATION ZIP! = FAST ACTION

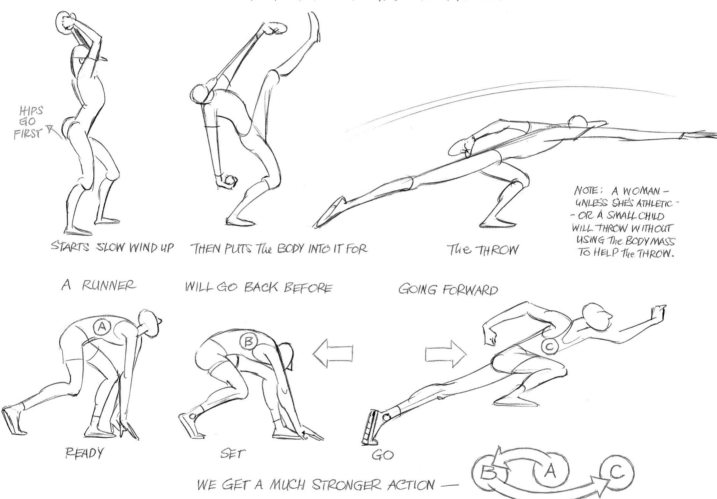

HIPS
GO
FIRST

STARTS SLOW WIND UP THEN PUTS The BODY INTO IT FOR The THROW

NOTE: A WOMAN -
UNLESS SHE'S ATHLETIC -
- OR A SMALL CHILD
WILL THROW WITHOUT
USING The BODY MASS
TO HELP the THROW.

A RUNNER WILL GO BACK BEFORE GOING FORWARD

READY SET GO

WE GET A MUCH STRONGER ACTION —

ANY ACTION CAN BE ENHANCED IF THERE IS AN ANTICIPATION BEFORE the ACTION.

SO WE GO BACK BEFORE WE GO FORWARD.
WE GO FORWARD BEFORE WE GO BACK.
WE GO DOWN BEFORE WE GO UP.
WE GO UP BEFORE WE GO DOWN.

The RULE IS: 'BEFORE WE GO ONE WAY — FIRST GO the OTHER WAY.'

275

OF COURSE, WITH A `CARTOON` CARTOON -

FEATHERS LINGER

SEES SOMETHING

ANTICIPATES HIS EXIT

NO DRAWINGS GOING OUT — HE'S JUST GONE.

ANTICIPATION HAPPENS WITH SMALLER 2nd UNDERSTATED MOVEMENTS.

GETTING UP FROM A CHAIR, WE GO BACK BEFORE WE GO FORWARD 2nd DOWN BEFORE WE GO UP.

ANTICIPATES BACK TO GO FORWARD

GOES FORWARD 2nd DOWN TO GO

UP

SOMEONE MAKING A POINT -

WEAK ANTICIPATE 2nd WEAK POINT

NOW, MAKING THE ACTION STRONGER -

PREPARING BODY BACK SLIGHTLY BODY FORWARD

GOING BACK FIRST IN the OPPOSITE DIRECTION MAGNIFIES the RESULT.

TAKE A SIMPLE THING LIKE STARTING A WALK -

IT'S UNNATURAL TO START A WALK WITH the FARTHEST FOOT FROM the DIRECTION WE'RE GOING.

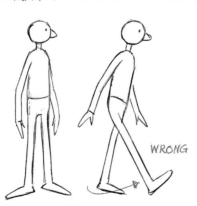

WRONG

The OBVIOUS WAY TO GO TO HIS LEFT IS TO START WITH HIS LEFT FOOT.

START the WALK WITH the FOOT NEAREST TO WHERE HE'S GOING -

OK.

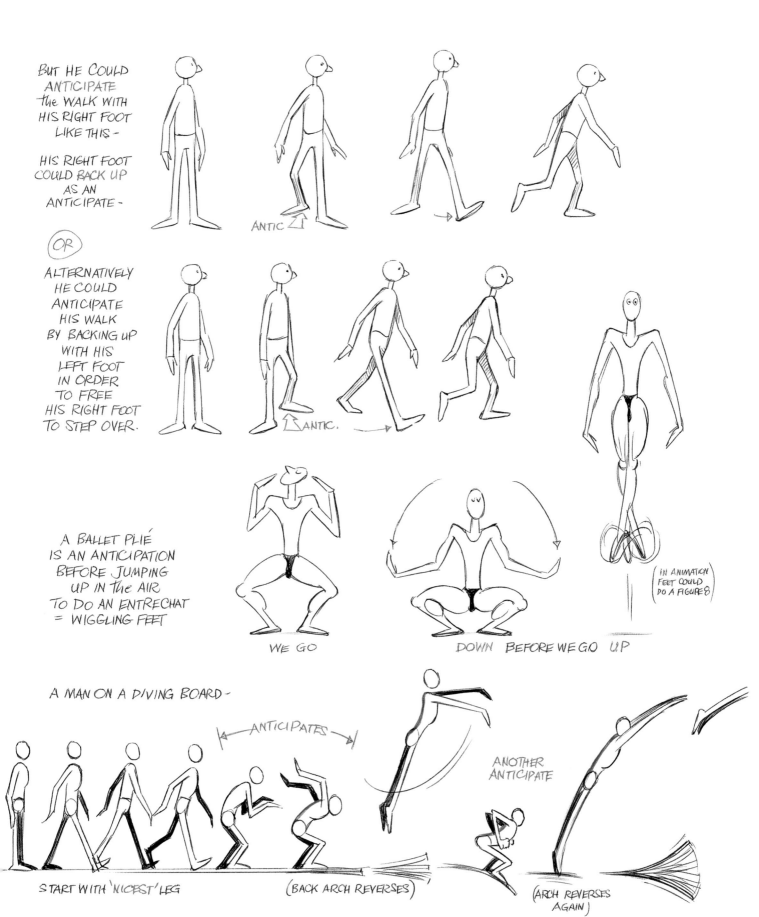

BUT HE COULD ANTICIPATE the WALK WITH HIS RIGHT FOOT LIKE THIS -

HIS RIGHT FOOT COULD BACK UP AS AN ANTICIPATE -

ANTIC

(OR)

ALTERNATIVELY HE COULD ANTICIPATE HIS WALK BY BACKING UP WITH HIS LEFT FOOT IN ORDER TO FREE HIS RIGHT FOOT TO STEP OVER.

ANTIC.

(IN ANIMATION FEET COULD DO A FIGURE 8)

A BALLET PLIÉ IS AN ANTICIPATION BEFORE JUMPING UP IN THE AIR TO DO AN ENTRECHAT = WIGGLING FEET

WE GO DOWN BEFORE WE GO UP

A MAN ON A DIVING BOARD -

ANTICIPATES

ANOTHER ANTICIPATE

START WITH 'NICEST' LEG (BACK ARCH REVERSES) (ARCH REVERSES AGAIN)

277

WITH SMALLER ACTIONS — TAKE A HAND WRITING —

IT'S PERFECTLY CLEAR
WHAT'S HAPPENING —

BUT JUST BY PUTTING IN A SMALL ANTICIPATE UP BEFORE HE WRITES — WE FEEL the PERSON THINKING.

OR WE CAN USE FLAMBOYANT THEATRICAL GESTURES AS ANTICIPATION.
SAY A SHOWBIZ WOMAN IS GOING TO PUT HER HAND ON HER HIP — (IT'S A FIGURE 8)

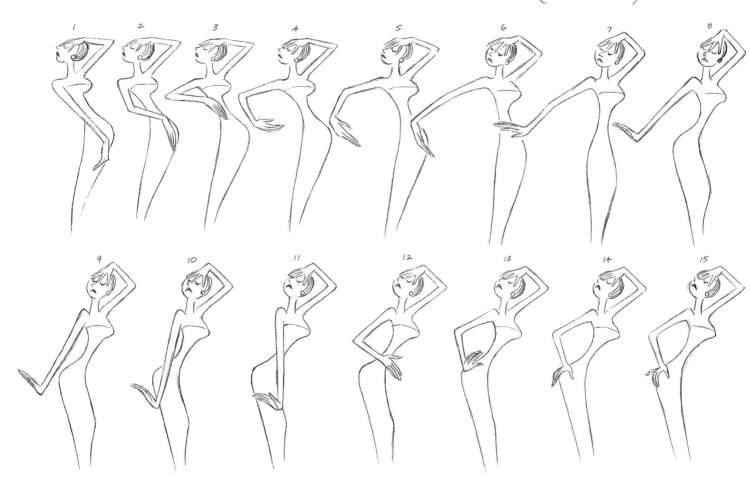

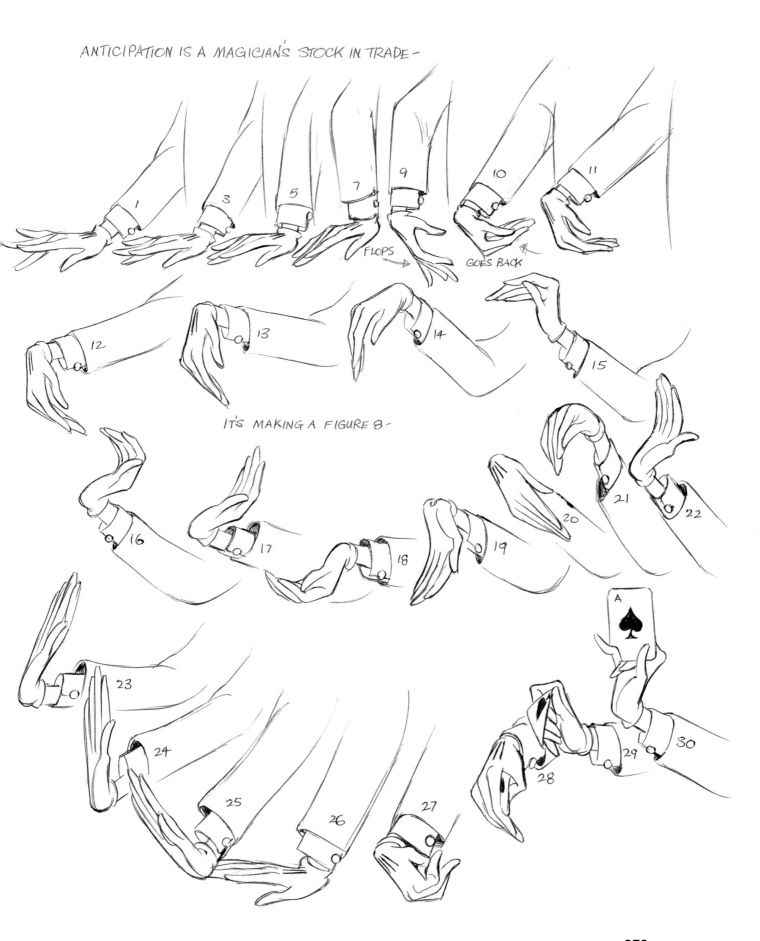

ANTICIPATION IS A MAGICIAN'S STOCK IN TRADE—

FLOPS

GOES BACK

IT'S MAKING A FIGURE 8—

279

IF SOMEONE'S GOING TO HIT SOMEONE HE WOULD ANTICIPATE BACK BEFORE SWINGING FORWARD.

The ANTICIPATION TELLS US EXACTLY WHAT'S GOING TO HAPPEN.

IN the EARLY DAYS OF ANIMATION the CONTACT WAS LIKE HITTING A PUDDING —

THE 'HIT' WAS USUALLY HELD FOR 4 FRAMES.

GRIM NATWICK SAID,
"AT DISNEY'S I LEARNED HOW TO DELIVER A PUNCH FROM ART BABBITT. ART SAID, 'DON'T EVER SHOW the HAND HITTING the CHIN. SHOW the HAND AFTER IT'S PAST the CHIN and the CHIN HAS MOVED OUT OF PLACE!'"

TODAY WE JUST SHOW the RESULT.

THERE IS NO POINT OF CONTACT.

WE LEAVE OUT the CONTACT and SHOW the HAND PAST the HITTING POINT

= 10 TIMES the IMPACT.

KEN HARRIS TOLD ME THIS IS WHAT THEY DID IN OLD WESTERN FILMS. THEY WOULD EDIT OUT the 'POINT OF CONTACT' FRAMES TO JUST SHOW the RESULT OF the HIT and PUT A BIG BANG ON IT.

SO, WE PUT the SOUND HIT WHEN the FIST IS PAST the FACE — WHEN the CHARACTER IS DISLODGED and the ARM SWINGS THROUGH. WE GET the IMPACT, the STRENGTH FROM the DISPLACEMENT.

AGAIN,
The ANTICIPATION IS — WE PREPARE FOR the ACTION. WE BROADCAST WHAT WE'RE GOING TO DO.

The ONLY TROUBLE WITH ANTICIPATIONS IS THAT THEY CAN BE CORNY.
The AUDIENCE GOES, "AW SURE, I KNOW, I SEE, NOW YOU'RE GOING TO DO THIS... BORING..."

SO THEN the GREAT THING IS TO DO SOMETHING DIFFERENT — A SURPRISE — WHICH CAN BE VERY FUNNY (OR SHOCKING.) JUST DON'T DO WHAT'S EXPECTED.

WE COULD SAY THAT AN ANTICIPATION IS AN EXPECTATION OF WHAT WILL OCCUR.
THE AUDIENCE EXPECTS SOMETHING TO HAPPEN BEFORE IT ACTUALLY HAPPENS.

A SURPRISE GAG WORKS WHEN THE AUDIENCE READS THE EXPECTATION and EXPECTS
A CERTAIN THING TO HAPPEN and THEN SOMETHING QUITE DIFFERENT HAPPENS —

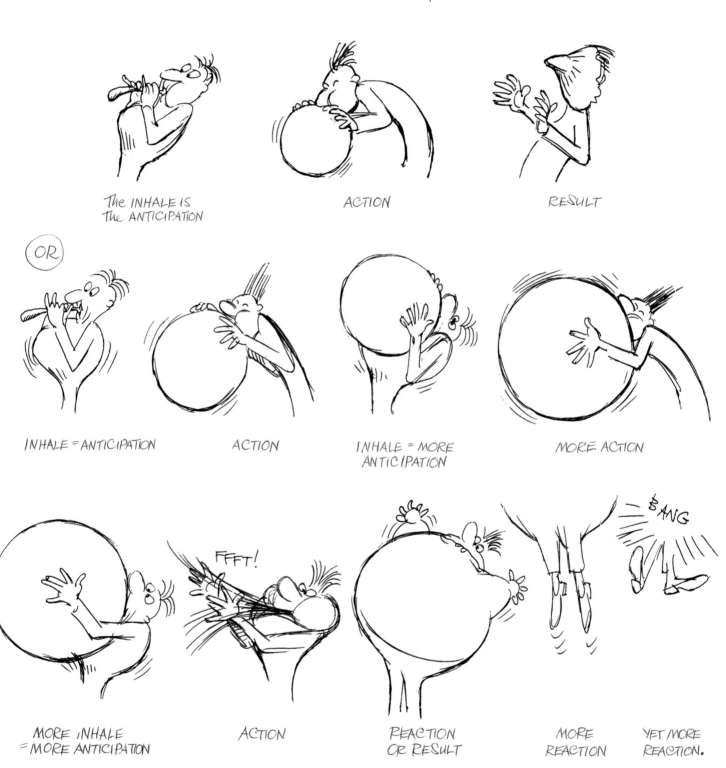

The INHALE IS The ANTICIPATION ACTION RESULT

INHALE = ANTICIPATION ACTION INHALE = MORE ANTICIPATION MORE ACTION

MORE INHALE = MORE ANTICIPATION ACTION REACTION OR RESULT MORE REACTION YET MORE REACTION.

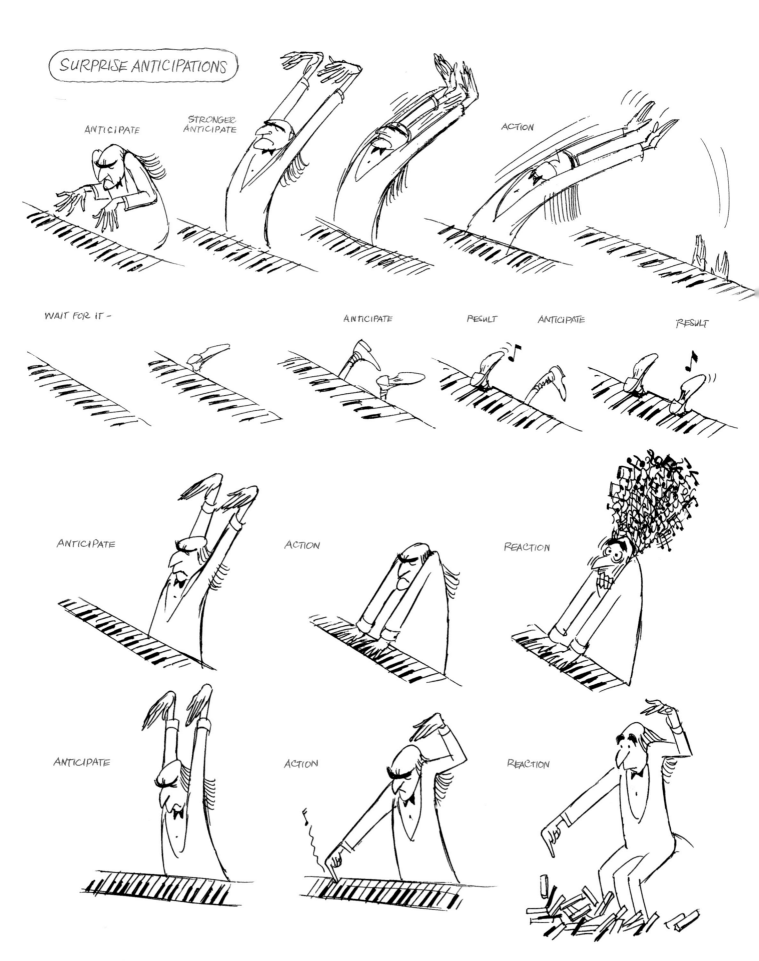

SURPRISE ANTICIPATIONS

ANTICIPATE STRONGER ANTICIPATE ACTION

WAIT FOR IT - ANTICIPATE RESULT ANTICIPATE RESULT

ANTICIPATE ACTION REACTION

ANTICIPATE ACTION REACTION

282

A WAY TO GET 'SNAP' WHICH ANIMATORS ARE ALWAYS TALKING ABOUT IS THIS:

SAY A CHARACTER SEES SOMETHING MILDLY SURPRISING and LOOKS UP SLIGHTLY –

I FRAME I FRAME

WE PUT IN A VERY FAST ANTICIPATION – A DRAWING OR TWO IN the OPPOSITE DIRECTION FROM WHERE WE WANT TO GO. IT'S TOO FAST FOR the EYE TO SEE IT – IT'S JUST FOR ONE OR TWO FRAMES – IT'S INVISIBLE TO the EYE BUT WE FEEL IT. THIS GIVES IT the SNAP.

SAY A SOCCER GOALIE IS GOING TO STOP A BALL WITH A CIRCULAR FOOT FLOURISH –

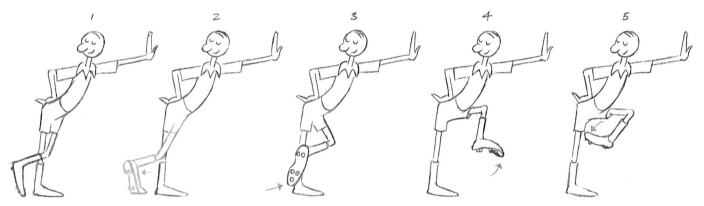

JUST A ONE FRAME
ANTICIPATION WILL DO The TRICK! THEN → MOVES IN OPPOSITE DIRECTION

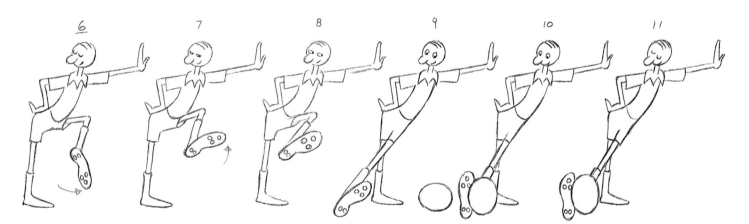

OF COURSE, The FOOT FLOURISH IS ITSELF AN ANTICIPATION OF CATCHING The BALL.

THIS DEVICE GIVES AN EXTRA PUNCH TO AN ACTION BY INVISIBLY ANTICIPATING ANY ACTION. IT'S THE SAME THING AS A 'NATURAL' ANTICIPATION — JUST GO THE OPPOSITE WAY FIRST — BUT ONLY FOR ONE, TWO OR THREE FRAMES.

A BASEBALL PLAYER HAVING CAUGHT A BALL COULD ANTICIPATE THE ANTICIPATION OF HIS THROW FOR JUST 2 FRAMES -

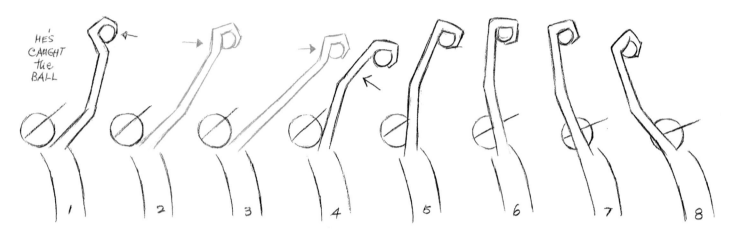

ANTIC. FORWARD FOR 2 FRAMES - NOW GO BACK INTO THE 'NORMAL' ANTICIPATION -

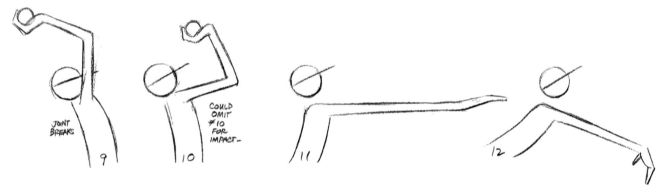

CONCLUSION:

WHENEVER POSSIBLE WE TRY TO FIND AN ANTICIPATION (OR ANTICIPATIONS) BEFORE THE ACTION.

BILL TYTLA SAID, " BE SIMPLE.
 BE DIRECT.
 BE CLEAR. "

AND " BE VERY SIMPLE.
 MAKE A STATEMENT -
 and FINISH IT - SIMPLY. "

SO, ┌─────────────────────────────────┐
 │ 1 WE ANTICIPATE the ACTION │
 │ 2 DO IT │
 │ 3 and SHOW WE'VE DONE IT. │
 └─────────────────────────────────┘

ANTICIPATION LEADS ON NATURALLY RIGHT INTO 'TAKES' and 'ACCENTS'

TAKES AND ACCENTS

A 'TAKE' IS AN ANTICIPATION OF AN ACCENT WHICH THEN SETTLES.

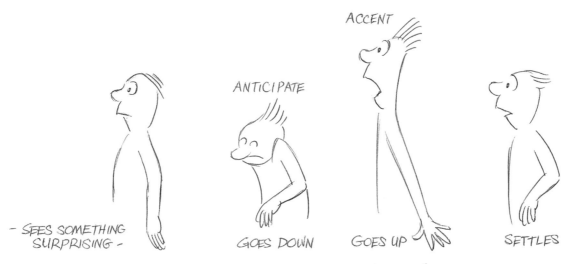

ACCENT

ANTICIPATE

- SEES SOMETHING
SURPRISING -

GOES DOWN GOES UP SETTLES

THIS IS THE BASIC PATTERN OF A CARTOON 'TAKE.'

HERE FOLLOWS A BUNCH OF FORMULAS and VARIATIONS ON HOLLYWOOD TAKES
WORKED OUT IN THE 1930'S and 40'S.....

285

BUT WHILE WE'RE AT IT, WE COULD STRENGTHEN OUR BASIC TAKE BY ADDING IN A SLIGHT UP ANTICIPATION OF THE DOWN ANTICIPATION AS HE TAKES A CLOSER LOOK—

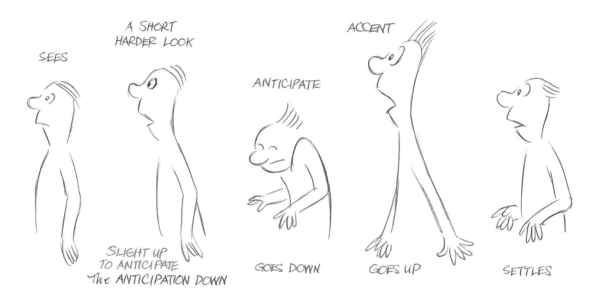

SEES

A SHORT HARDER LOOK

SLIGHT UP TO ANTICIPATE THE ANTICIPATION DOWN

ANTICIPATE

GOES DOWN

ACCENT

GOES UP

SETTLES

HERE'S A FORMULA FOR AN ORDINARY STRAIGHT UP and DOWN TAKE (LASTS 1 FOOT = ⅔ SEC.) (THIS IS DISNEY-TYPE TIMING)

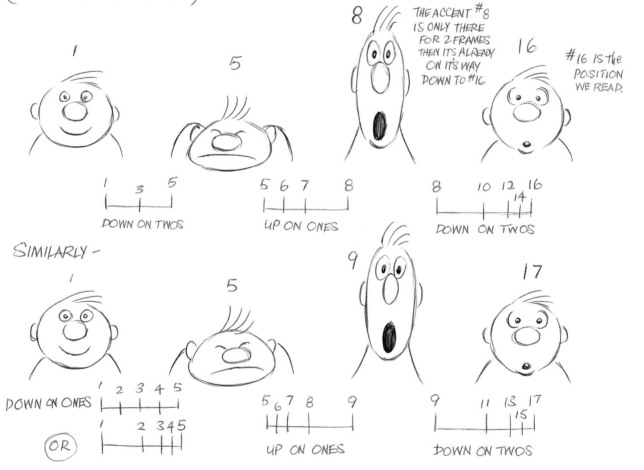

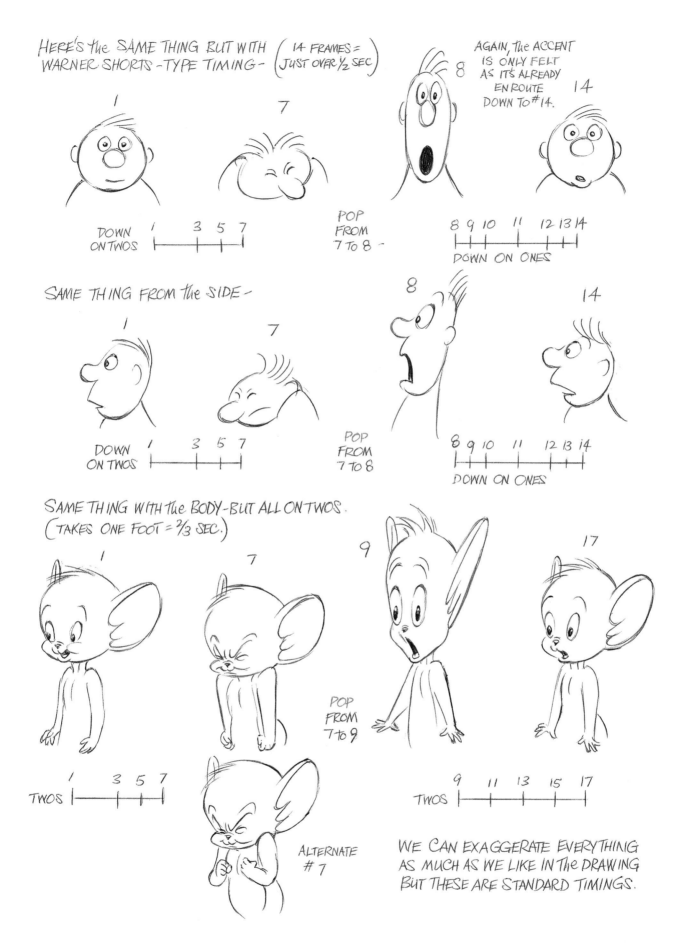

HERE'S THE SAME THING BUT WITH WARNER SHORTS -TYPE TIMING - (14 FRAMES = JUST OVER ½ SEC)

1 7

DOWN ON TWOS 1 3 5 7

POP FROM 7 to 8 -

AGAIN, THE ACCENT IS ONLY *FELT* AS IT'S ALREADY EN ROUTE DOWN TO #14.

8 14

8 9 10 11 12 13 14
DOWN ON ONES

SAME THING FROM THE SIDE -

1 7

DOWN ON TWOS 1 3 5 7

POP FROM 7 TO 8

8 14

8 9 10 11 12 13 14
DOWN ON ONES

SAME THING WITH THE BODY - BUT ALL ON TWOS. (TAKES ONE FOOT = ⅔ SEC.)

1 7 9 17

TWOS 1 3 5 7

POP FROM 7 to 9

ALTERNATE #7

TWOS 9 11 13 15 17

WE CAN EXAGGERATE EVERYTHING AS MUCH AS WE LIKE IN THE DRAWING BUT THESE ARE STANDARD TIMINGS.

287

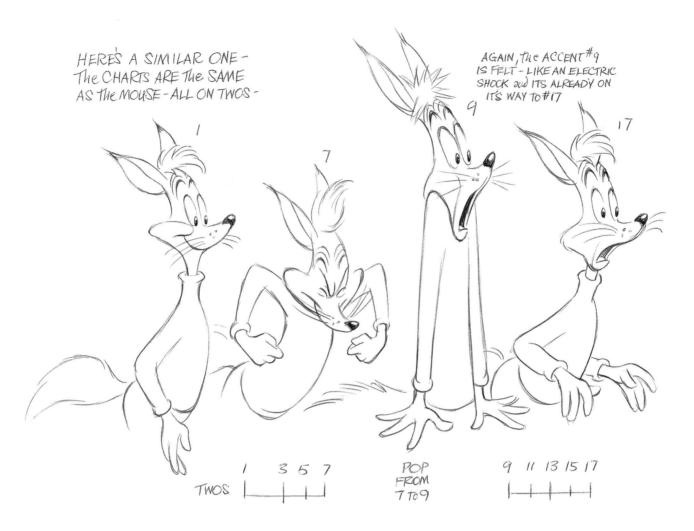

HERE'S A SIMILAR ONE - THE CHARTS ARE THE SAME AS THE MOUSE - ALL ON TWOS -

AGAIN, THE ACCENT #9 IS FELT - LIKE AN ELECTRIC SHOCK and IT'S ALREADY ON IT'S WAY TO #17

1

7

9

17

TWOS 1 3 5 7

POP FROM 7 TO 9

9 11 13 15 17

THESE ARE SOLID WORKING FORMULAS - BUT WE CAN START BEING MORE INVENTIVE -

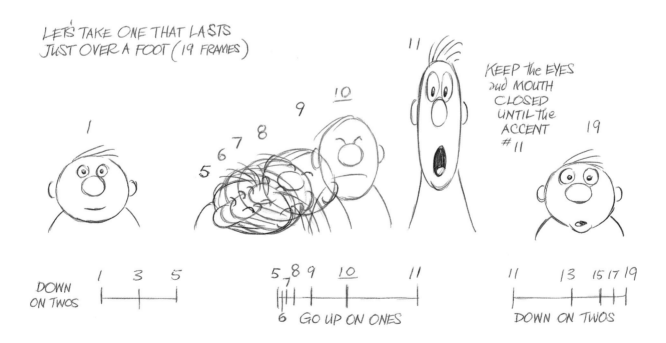

LET'S TAKE ONE THAT LASTS JUST OVER A FOOT (19 FRAMES)

KEEP THE EYES and MOUTH CLOSED UNTIL THE ACCENT #11

1

5 6 7 8 9 10

11

19

DOWN ON TWOS 1 3 5

5 7 8 9 10 11
6 GO UP ON ONES

11 13 15 17 19
DOWN ON TWOS

288

NOW LET'S MAKE IT KIND OF A DOUBLE TAKE.
WE'LL KEEP the SAME CHARTS BUT DRAG the HEAD
FROM SIDE TO SIDE and KEEP IT 'SQUASHED'
ON ITS WAY UP TO #11.

POP the HEAD
SHAPE, EYES
and MOUTH
ON #11

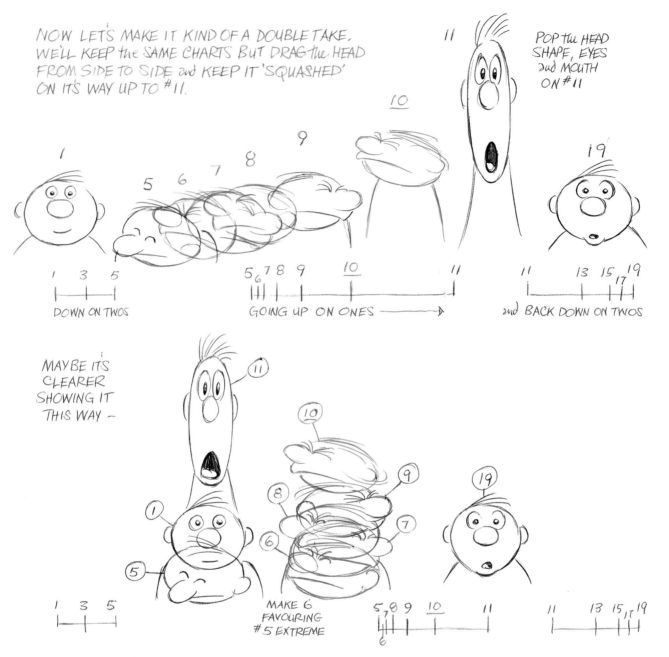

DOWN ON TWOS

GOING UP ON ONES ——————▷

and BACK DOWN ON TWOS

MAYBE ITS
CLEARER
SHOWING IT
THIS WAY –

MAKE 6
FAVOURING
#5 EXTREME

WE SHOULDN'T WORRY ABOUT DISTORTED DRAWINGS OR IMAGES.
LIVE ACTION HAS TERRIBLY DISTORTED FRAMES.

BUT WE SHOULD REMEMBER WHAT the ORIGINAL VOLUME OF A CHARACTER IS -
AND NOT STRETCH and COMPRESS FORGETTING THIS VOLUME - SO THAT the CHARACTER
CHANGES OVERALL SIZE.

MILT KAHL SAID, "I KEEP the SAME AMOUNT OF MEAT IN A TAKE."

BUT WE CAN
PUSH IT AROUND
LIKE MAD –

WE SHOULDN'T BE AFRAID OF DISTORTION IN the INTERIOR OF AN ACTION.
OUR DRAWINGS OR IMAGES MAY LOOK STRANGE, BUT WE REALLY ONLY SEE the START and END POSITIONS.
WE FEEL the DISTORTION WITHIN and THATS WHAT COUNTS.
THERE IS WILD DISTORTION and LEAN IN LIVE ACTION and WE CAN GO FURTHER —

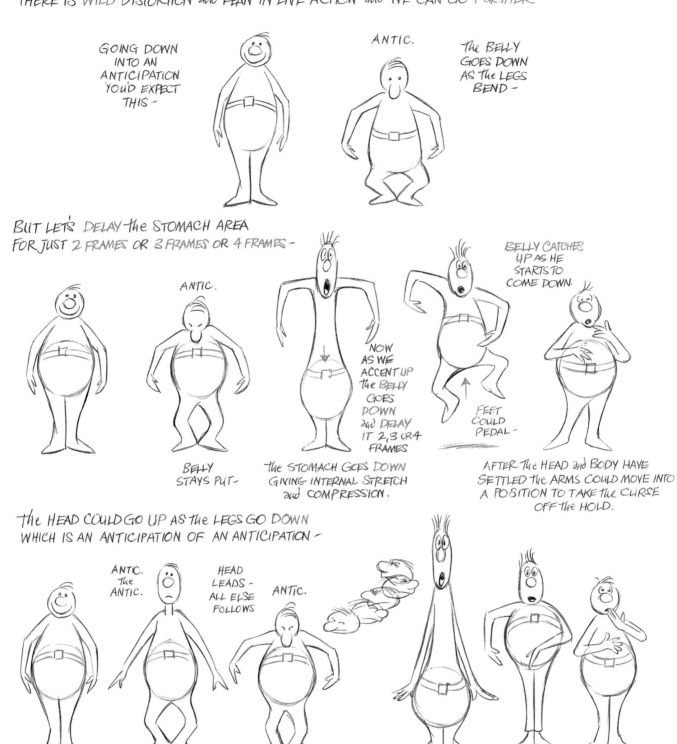

GOING DOWN
INTO AN
ANTICIPATION
YOU'D EXPECT
THIS —

ANTIC.

The BELLY
GOES DOWN
AS The LEGS
BEND —

BUT LET'S DELAY the STOMACH AREA
FOR JUST 2 FRAMES OR 3 FRAMES OR 4 FRAMES —

ANTIC.

NOW
AS WE
ACCENT UP
the BELLY
GOES
DOWN
and DELAY
IT 2,3 OR 4
FRAMES

BELLY CATCHES
UP AS HE
STARTS TO
COME DOWN.

FEET
COULD
PEDAL —

BELLY
STAYS PUT —

The STOMACH GOES DOWN
GIVING INTERNAL STRETCH
and COMPRESSION.

AFTER The HEAD and BODY HAVE
SETTLED THE ARMS COULD MOVE INTO
A POSITION TO TAKE the CURSE
OFF the HOLD.

The HEAD COULD GO UP AS the LEGS GO DOWN
WHICH IS AN ANTICIPATION OF AN ANTICIPATION —

ANTIC.
The
ANTIC.

HEAD
LEADS —
ALL ELSE
FOLLOWS

ANTIC.

THIS IS HOW TEX AVERY DID HIS WILD, CRAZY TAKES — EXTENDING ON A SERIES OF COMPOUND ACTIONS—
DELAYING BITS, OFTEN JUST 2 FRAMES APART — A SERIES OF ACTIONS = A CUMULATIVE RESULT.

ART BABBITT HAD A GREAT EMBELLISHING DEVICE FOR THE HANDS AT THE END OF A TAKE -
WHICH LOTS OF ANIMATORS UTILISED -

AFTER THE TAKE, WHERE HE'S COMING BACK TO NORMAL (IF WE HAVE THE TIME FOR IT)
HAVE THE ARMS MAKE AN ELABORATE FLURRY -ON ONES. - VERY FAST.

THE ARMS EACH
SWING AROUND
IN A CIRCLE
COUNTERING
EACH OTHER.

THEY CAN MAKE
A FIGURE 8
AS LONG AS THEY
COUNTER
EACH OTHER.

THE LEFT ARM DOES THE SAME AS THE RIGHT - BUT STARTS LATER and COUNTERS IT.

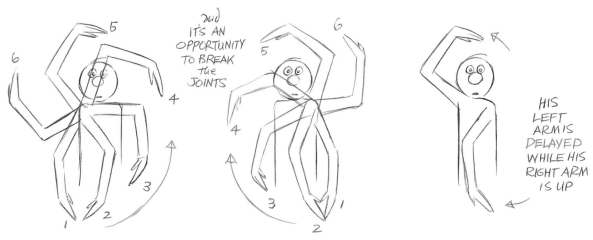

and
IT'S AN
OPPORTUNITY
TO BREAK
THE
JOINTS

HIS
LEFT
ARM IS
DELAYED
WHILE HIS
RIGHT ARM
IS UP

ANOTHER LITTLE REFINEMENT - THE ARM COULD KEEP KNOCKING HIS HAT OFF and ON AGAIN -

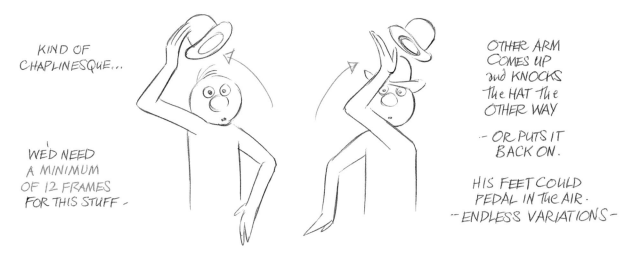

KIND OF
CHAPLINESQUE...

WE'D NEED
A MINIMUM
OF 12 FRAMES
FOR THIS STUFF -

OTHER ARM
COMES UP
and KNOCKS
THE HAT THE
OTHER WAY

- OR PUTS IT
BACK ON.

HIS FEET COULD
PEDAL IN THE AIR.
- ENDLESS VARIATIONS -

IT'S A GOOD IDEA TO LOOK FOR AN EXTRA 'BREAKDOWN'-
LET'S SAY A MAN SEES SOMETHING OUTRAGEOUS and YELLS "WHAAAAAAT?!!"

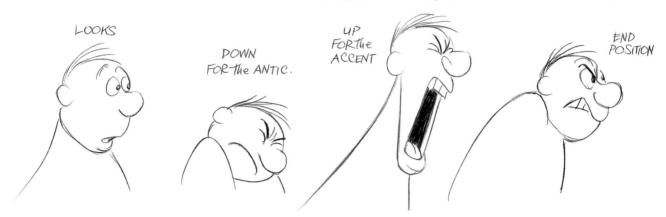

THIS WILL DO THE JOB OK - BUT LET'S LOOK FOR ANOTHER BREAKDOWN - ANOTHER
POSITION THAT WILL STRENGTHEN IT and GIVE US MORE 'CHANGE'-MORE VITALITY.

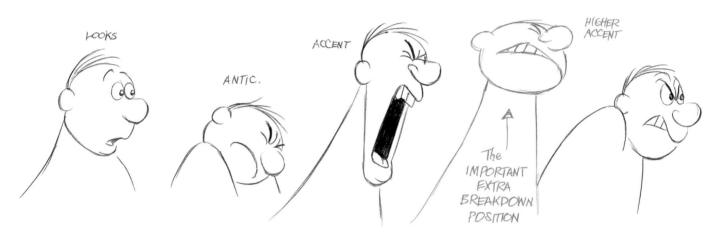

SO WE LOOK FOR WHATEVER CAN GIVE US MORE CHANGE OF SHAPE WITHIN THE ACTION.
LET'S PUT IN ANOTHER ONE. HAVE HIM LOOK UP BEFORE THE DOWN ANTICIPATION.
AGAIN, WE ANTICIPATE THE ANTICIPATION—

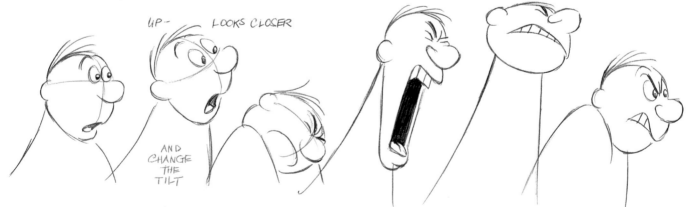

MAYBE WE'RE IN DANGER OF OVERANIMATING — OF GILDING THE LILY HERE - BUT ITS
ALWAYS WORTH SEEING IF THERE'S ANOTHER MOMENTARY POSITION POSSIBLE TO
CREATE MORE CONTRAST - MORE CHANGE WITHIN. (AGAIN, THERE'S NOTHING LIKE TRYING IT.)

HAVING TOO MUCH ANTICIPATION CAN BE CORNY SOMETIMES and CRAZY TAKES UNNECESSARY.
JUST TO CONTRADICT ALL THIS WILD, UP, DOWN and AROUND ACTION, ONE OF the STRONGEST
TAKES I'VE EVER SEEN WAS IN A FILM WITH BASIL RATHBONE AS the VILLAIN.
HE'S SMACK IN the MIDDLE OF the CINEMASCOPE SCREEN and HE'S BEING GIVEN INFORMATION
BY AN AIDE WHICH SHOCKS HIM.

THERE'S LOTS OF ACTION BEHIND HIM and AROUND HIM WHICH COULD DEFLECT OUR ATTENTION,
YET HIS TAKE JUMPS RIGHT OUT AT YOU. HE HARDLY MOVES ANY DISTANCE AT ALL, YET
YOU REALLY SEE IT! THERE'S NO ANTICIPATION DOWN and NO STRETCHED ACCENT. PART
OF THE REASON WE SEE IT IS BECAUSE HIS HEAD IS FROZEN IN THE MIDDLE OF the SCREEN-
(The 'SACRED' CENTRAL OVAL.) HIS HEAD MAKES A SHORT, SHARP MOVE UP, THEN CUSHIONS BACK A BIT.

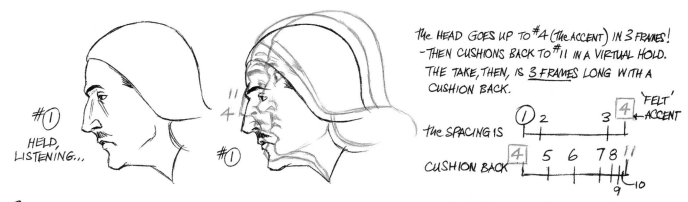

#① HELD, LISTENING...

the HEAD GOES UP TO #4 (the ACCENT) IN 3 FRAMES!
-THEN CUSHIONS BACK TO #11 IN A VIRTUAL HOLD.
THE TAKE, THEN, IS 3 FRAMES LONG WITH A
CUSHION BACK.

the SPACING IS ① 2 ... 3 | 4 'FELT' ← ACCENT

CUSHION BACK 4 5 6 7 8 11 / 9 10

SO, IF WE DEFINE A TAKE AS A STRONG MOVEMENT TO SHOW SURPRISE OR REACTION,
HE'S SUCCEEDED WITHOUT ALL OUR ANIMATION DEVICES. HOWEVER USEFUL THEY ARE TO US,
LIFE DOESN'T FOLLOW OUR CONVENIENT ANIMATION FORMULAS. (JUST STUDY ANY LIVE ACTION.)

GETTING ACCENTS RIGHT WAS the THING THAT GAVE ME the MOST TROUBLE IN ANIMATING.
I REALLY HAD TO WORK AT IT — IF IT WAS A SOFT ACCENT WITH A HEAD OR A BODY-OR
A SHARP, HARD
ACCENT OF A HAND
OR FINGER.
-PLUS HOW LONG
TO HOLD A
HAND OUT THERE
TO READ?

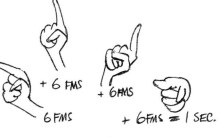

+ 6 FMS
+ 6 FMS
6 FMS
+ 6 FMS = 1 SEC.

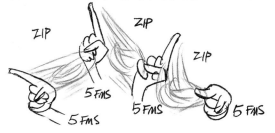

ZIP ZIP ZIP
5 FMS 5 FMS 5 FMS 5 FMS

TRY TO POINT 4 TIMES IN A SECOND = 4 ACCENTS.
IT'S PRETTY HARD TO DO. 4 STATIC HOLDS OF
6 FRAMES EACH - AND HOW DO YOU GET FROM
ONE TO The OTHER? ANYWAY, I'VE FOUND THAT
YOU NEED AT LEAST 6 FRAMES TO READ ANY ACCENT.

TEX AVERY SAYS IT'S 5 FRAMES. YOU
NEED A MINIMUM OF 5 FRAMES TO READ
A HOLD. TEX'S STUFF WENT SO FAST
THAT I GUESS IT WORKS AS ENOUGH OF
A PAUSE IN the CONTEXT OF ALL THAT SPEED.

FINALLY I CAUGHT ON - AS USUAL, The SECRET IS KIND OF SIMPLE! IT'S JUST GETTING The DIFFERENCE BETWEEN A HARD ACCENT and A SOFT ACCENT.

A HARD ACCENT RECOILS - IT BOUNCES BACK -

SPEEDING IN A B ← A

TRY and POINT REALLY HARD and YOUR FINGER HAS TO BOUNCE BACK, OR GO UP OR DOWN OR SHAKE A BIT. IT WON'T STAY STATIC.

and A SOFT ACCENT KEEPS ON GOING.

SPEEDIING IN A A → B

IF WE POINT MORE GENTLY The HAND WILL CUSHION AS IT SLOWS TO A STOP.

WITH A HARD ACCENT -
IF WE HIT AN ANVIL WITH A STEEL HAMMER, The ANVIL IS OBVIOUSLY NOT AFFECTED BY The HAMMER and WHEN The HAMMER COMES DOWN IT BOUNCES BACK.

THIS BOUNCE BACK IS The ACCENT. The SOUND IS HERE. 1 FRAME <u>AFTER</u> The HIT IS WHERE WE GET The SOUND.

CONTACT FOR 1 FRAME and IT IMMEDIATELY BOUNCES BACK (and SLOWS INTO A HOLD)

SAME WITH A HAMMER
HITTING A NAIL - The ACCENT IS NOT WHEN The HAMMER CONTACTS The NAIL.

AGAIN, The SOUND IS ON The BOUNCE BACK - ONE FRAME AFTER The CONTACT.

NO. NOT EVEN THIS ONE. IT'S THIS ONE.

A SOFT ACCENT WILL KEEP ON GOING -
THINK OF AN ORCHESTRA CONDUCTOR CONDUCTING WALTZ TEMPO -

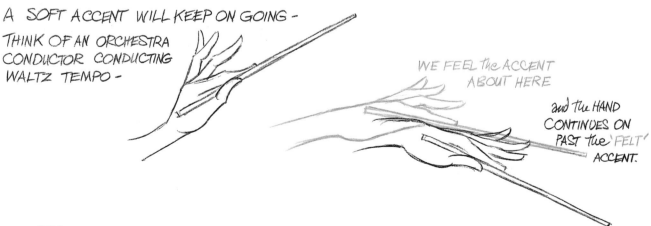

WE FEEL The ACCENT ABOUT HERE

and The HAND CONTINUES ON PAST The 'FELT' ACCENT.

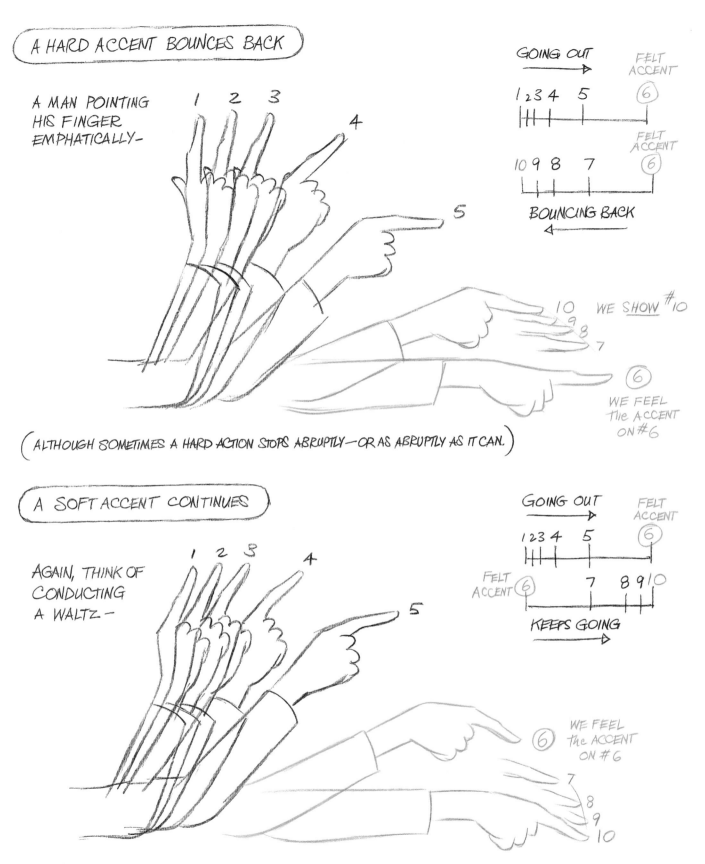

A HARD ACCENT BOUNCES BACK

A MAN POINTING HIS FINGER EMPHATICALLY—

1 2 3 4 5

GOING OUT →

1 2 3 4 5 FELT ACCENT ⑥

10 9 8 7 FELT ACCENT ⑥

BOUNCING BACK ◁

WE SHOW #10
10
9
8
7

⑥ WE FEEL THE ACCENT ON #6

(ALTHOUGH SOMETIMES A HARD ACTION STOPS ABRUPTLY—OR AS ABRUPTLY AS IT CAN.)

A SOFT ACCENT CONTINUES

AGAIN, THINK OF CONDUCTING A WALTZ—

1 2 3 4 5

GOING OUT →

1 2 3 4 5 FELT ACCENT ⑥

FELT ACCENT ⑥ 7 8 9 10

KEEPS GOING →

⑥ WE FEEL THE ACCENT ON #6
7
8
9
10

WE STILL SPEED INTO OUR ACCENT BUT THE MOVEMENT CONTINUES.

A KARATE FOOT, AFTER SNAPPING OUT, WILL BOUNCE BACK IN A HARD ACCENT.

AFTER SPEEDING OUT INTO the 'FELT' ACCENT #1

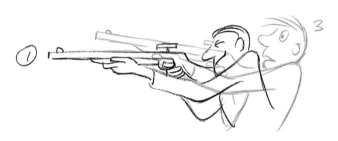

THEN BOUNCES BACK

and WE 'READ' #9

TAKE SOMEONE SHOOTING - DISPLACE the GUN FOR IMPACT

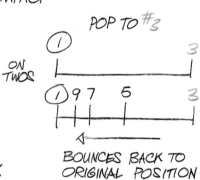

POP TO #3

ON TWOS

BOUNCES BACK TO ORIGINAL POSITION

WE GET the SOUND OF the SHOT AS the GUY POPS BACK WITHOUT ANY INBETWEENS and THEN SLOWS BACK TO NORMAL.

IMPACT BACK

A SOFT ACCENT

"I'D BE HAPPY TO-"

A HARD ACCENT

"WHY CERTAINLY"

COULD BE SOFT OR HARD...

"HI THERE CUTIE-"

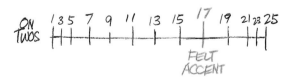

FELT ACCENT

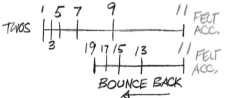

BOUNCE BACK

(BUT USUALLY HEAD ACCENTS ARE UP SEE 'DIALOGUE'!)

296

TIMING, STAGGERS, WAVE AND WHIP

WE HAVE the ART THAT CAN PLAY MOST FREELY WITH TIME.

WE DON'T HAVE TO USE NORMAL TIME. WE CAN EITHER GO TOO FAST-TO GET SPASTIC HUMOUR and FRANTIC ACTIVITY – OR GO TOO SLOW and GET BEAUTY and DIGNITY.

YEARS AGO A SCIENTIST FRIEND OF MINE SHOWED ME FILM HE MADE AROUND The WORLD OF MEN and ANIMALS – NONE OF IT SHOT AT NORMAL SPEED. IT WAS ALL INTENTIONALLY FILMED TOO FAST OR TOO SLOW. HE HAD ELEPHANTS RUNNING LIKE MICE and VICE VERSA, PEOPLE IN RELIGIOUS RITUALS RACING AROUND AS IF PLAYING TAG, PEOPLE KISSING IN SLOW MOTION, ETC. AFTER AN HOUR OF THIS YOUR MIND TURNED INSIDE OUT – GIVING A KIND OF GOD'S EYE VIEW OF LIFE and ACTION.

THERE WAS A SHOT OF A TRAMP ON A PARK BENCH PUTTING A MATCHSTICK IN HIS EAR. IT WAS FILMED SLIGHTLY IN SLOW MOTION, 30 OR 32 FRAMES A SECOND. AS HE FIDDLED WITH The MATCHSTICK YOU SAW LITTLE RIPPLING MUSCLES OF PLEASURE SPREAD ACROSS HIS FACE WHICH YOU WOULD NEVER SEE AT NORMAL SPEED. STRANGE, BUT COMPULSIVE VIEWING.

SINCE THEN I'VE ALWAYS TRIED TO AVOID NORMAL TIMING. I ALWAYS TRY TO GO JUST A LITTLE TOO FAST and THEN SWITCH TO GOING JUST A LITTLE TOO SLOW — COMBINE IT. GO FOR the CHANGE, the CONTRAST. The SLOW AGAINST the FAST. KEEP SWITCHING BACK and FORTH. IT'S HARD TO DETECT BUT MAKES COMPULSIVE VIEWING.

STAGGER TIMINGS

THERE ARE SEVERAL WAYS TO STAGGER DRAWINGS BACK and FORTH TO CAUSE THINGS TO SHAKE OR VIBRATE, TO MAKE HANDS TREMBLE OR HELP WITH LAUGHING OR CRYING.

WE MAKE A SERIES OF DRAWINGS OF NORMAL ACTION and INTERLEAVE THEM BACK and FORTH IN DIFFERENT WAYS TO MAKE THEM SHUDDER and SHAKE.

THE SIMPLEST FORM OF STAGGER VIBRATION IS THIS —

SAY WE WANT
A LEAF ON A TREE
TO FLUTTER
IN THE WIND...

#1 and #9 ARE the 2 EXTREMES and WE JUST MAKE 7 EQUAL IN BETWEENS

1 2 3 4 5 6 7 8 9

THEN WHEN WE EXPOSE IT ON OUR X-SHEETS INSTEAD OF the USUAL—

1
2
3
4
5
6
7
8
9

— WE SKIP ONE and GO FORWARD and THEN COME BACK etc. —

1
3
2
4
3
5
4
6
5
7
6
8
7
9

OR SKIP AROUND FOR A MORE VIOLENT EFFECT

1
5
4
2
7
4
3
9
1
5
4
9

AND WE'RE NOT LIMITED TO JUST THAT. FOR VARIETY HOLD SOME FOR 2 OR 3 FRAMES and OTHERS FOR ONE. IT'S AN ERRATIC EXPOSURE — IT DEPENDS HOW VIOLENT WE WANT IT TO BE.

1
3
2
5
4
6
9
7
8

VIBRATIONS ALSO WORK WELL ON TWOS:

1
3
2
4
3
5
4

ANY COMBINATION CAN WORK. THIS IS the PRINCIPLE OF STAGGERED EXPOSURE

ANOTHER WAY—
TAKE A DIVING BOARD VIBRATING AFTER the DIVER'S LEFT IT —

WE MAKE #1, 9, and 17

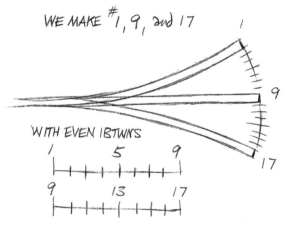

WITH EVEN 1BTWN'S

1 5 9
|—+—+—+—+—+—+—+—|

9 13 17
|—+—+—+—+—+—+—+—|

IT'S SURPRISING HOW MUCH YOU CAN REPEAT EACH END, #1 TO #17 ETC. AND WHEN IT SLOWS TO A STOP.

1
17
2
16
3
15
4
14
5
13
6
12
7
11
8
10
9
etc.

OF COURSE WE CAN MAKE MORE FLEXIBLE PASSING POSITIONS WITHIN THE EXTREMES

BUT IT WILL WORK WELL EITHER WAY.

E
B
A
D
C

THESE ARE the VIBRATIONS MOST ANIMATORS USE — FOR LACK OF A NAME I CALL IT the 'UP and DOWN' OR 'BACK and FORTH' VIBRATION.

298

THIS CAN BE USED FOR LAUGHTER OR CRYING:

1 17

SHOULDERS UP SHOULDERS DOWN

SHOULDERS UP SHOULDERS DOWN

OR SHIVERING WITH COLD:

SIMPLY BECAUSE the HEAD EXTREMES ARE CLOSE TOGETHER and the KNEES FAR APART WE GET A VARIETY OF SPACING IN the ACTION.

THE ONLY PROBLEM WITH THIS METHOD IS THAT IT TENDS TO BE A BIT MECHANICAL — WE COULD BREAK IT UP BY DOING MORE INTERESTING PASSING POSITIONS WITH IN IT.

BUT the REALLY GREAT METHOD IS the ONE DEVELOPED BY NORMAN FERGUSON AT DISNEY'S. KEN HARRIS SHOWED IT TO ME and KEN GOT IT FROM SHAMUS CULHANE WHO GOT IT FROM FERGUSON. FOR LACK OF A NAME, I'M CALLING IT

The SIDE TO SIDE VIBRATION FORMULA

SAY WE WANTED TO HAVE A HEAD WOBBLE FROM SIDE TO SIDE —

WE MAKE A SERIES OF DRAWINGS FROM 1 to SAY, 33 —

33

17

1

33 33A

17 17A

1 1A

THEN WE MAKE A CAREFUL TRACING OF #1 and #33 JUST SLIGHTLY OFFSET —

and WE MAKE A NEW SERIES OF DRAWINGS #1A TO 33A GOING UP the OTHER SIDE.

INTERLEAVING TWO SERIES OF DRAWINGS GIVES US ALL KINDS OF POSSIBILITIES FOR VIBRATING ACTION.

THEN WE INTERLEAVE THEM

1
1A
2
2A
3
3A
4
4A
5
5A
6
6A
7
7A
8
8A
etc.

AND WE GET A SIDE TO SIDE WOBBLE BY HAVING 2 STRIPS OF ACTION. 2 PATTERNS OF ACTION INTERLEAVED —

299

HANDS WITH
The PALSY -

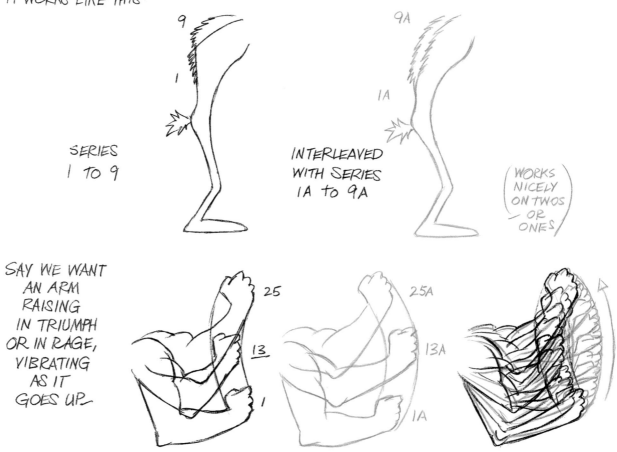

KEN HARRIS ANIMATED A SCENE WHERE The CHARACTER HAD AN "EARTHQUAKE" VIBRATION
GOING UP HIS BODY FROM HIS TOES, TO HIS LEGS, and HIS BACK. USING THIS SYSTEM
IT WORKS LIKE THIS -

SERIES
1 TO 9

INTERLEAVED
WITH SERIES
1A TO 9A

(WORKS
NICELY
ON TWOS
OR
ONES)

SAY WE WANT
AN ARM
RAISING
IN TRIUMPH
OR IN RAGE,
VIBRATING
AS IT
GOES UP-

(AND OF COURSE WE CAN BE MORE INVENTIVE WITH OUR PASSING POSITIONS and BREAKDOWNS WITHIN the ACTION)

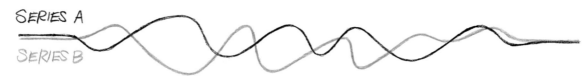

SERIES A

SERIES B

SO, BASICALLY IT'S JUST TWO SERIES OF DRAWINGS DONE SEPARATELY and INTERLEAVED WITH
EACH OTHER — GIVING ENDLESS POSSIBILITIES OF WOBBLES, JUDDERS, QUIVERS and SHAKES.

300

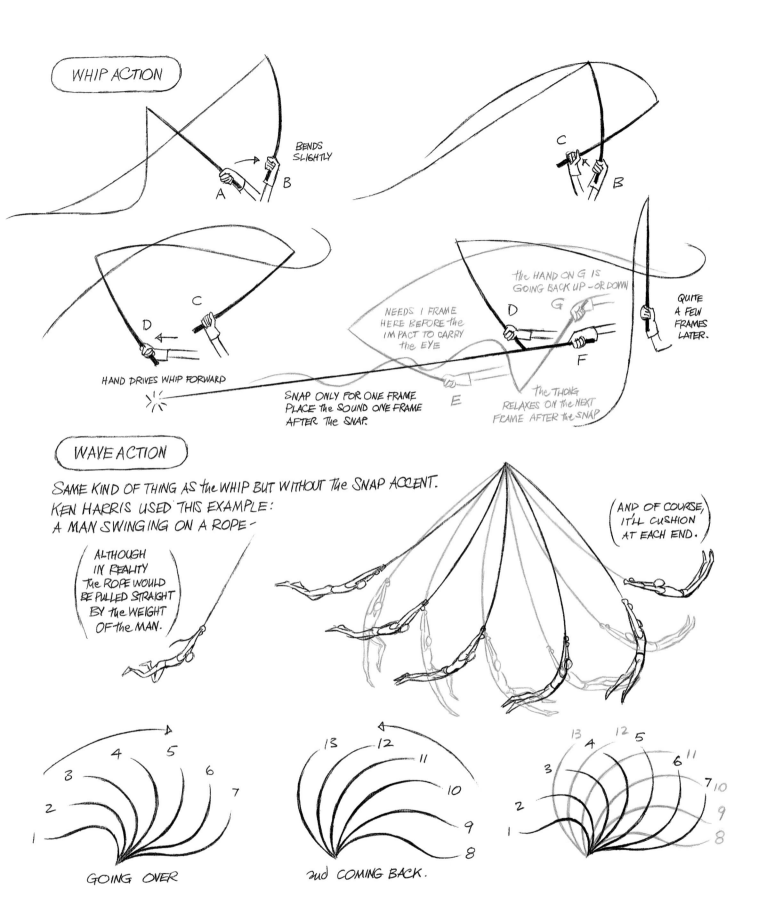

WHIP ACTION

BENDS
SLIGHTLY

A
B
C

HAND DRIVES WHIP FORWARD

D
C

SNAP ONLY FOR ONE FRAME
PLACE The SOUND ONE FRAME
AFTER The SNAP.

NEEDS I FRAME
HERE BEFORE the
IMPACT TO CARRY
the EYE

the HAND ON G IS
GOING BACK UP — OR DOWN

D G
F
E

the THONG
RELAXES ON The NEXT
FRAME AFTER the SNAP

QUITE
A FEW
FRAMES
LATER.

WAVE ACTION

SAME KIND OF THING AS the WHIP BUT WITHOUT The SNAP ACCENT.
KEN HARRIS USED THIS EXAMPLE:
A MAN SWINGING ON A ROPE —

ALTHOUGH
IN REALITY
The ROPE WOULD
BE PULLED STRAIGHT
BY The WEIGHT
OF The MAN.

(AND OF COURSE,
IT'LL CUSHION
AT EACH END.)

1 2 3 4 5 6 7

GOING OVER

8 9 10 11 12 13

2nd COMING BACK.

1 2 3 4 5 6 7 8 9 10 11 12 13

301

HERE'S THE WHIP ACTION APPLIED TO A WOMAN BATTING HER EYES - (EXAGGERATED)

HELPING US OUT ON THE LAST 2 MONTHS OF 'A CHRISTMAS CAROL', ABE LEVITOW ANIMATED A WONDERFUL LITTLE LAUGH ON TINY TIM. AT DINNER ABE and I WERE DEMOLISHING THE WINE and I RATTLED ON ABOUT HIS WORK and THE GREAT LAUGH HE'D JUST DONE. ABE SAID, "WELL, I'M AWFULLY GLAD THAT YEARS AGO KEN HARRIS SHOWED ME THAT WHIP PRINCIPLE AS A PATTERN FOR A LAUGH." "WHAT? SHOW ME, SHOW ME!" WE STUMBLED BACK TO THE STUDIO and ABE SCRIBBLED SOMETHING LIKE THIS:

"WHAT?" I BURBLED, "I DON'T GET IT..."
"COME ON, DICK, IT'S A WHIP PATTERN.
- LOOK, LIKE THIS..."

"THAT'S WHAT YOU DID ON TINY TIM?"
"YEAH, YOU KNOW, THE WHIP ACTION - LIKE THIS..."

ABE'S LAUGH IS ON THE NEXT PAGE and I'M INCLUDING IT TO SHOW JUST HOW SUBTLY THESE BASIC THINGS CAN BE USED. THE SHOULDERS GO UP and DOWN WITHIN THE LAUGH and YOU CAN JUST ABOUT SEE THE WHIP PATTERN UNDERLYING THE ACTION.

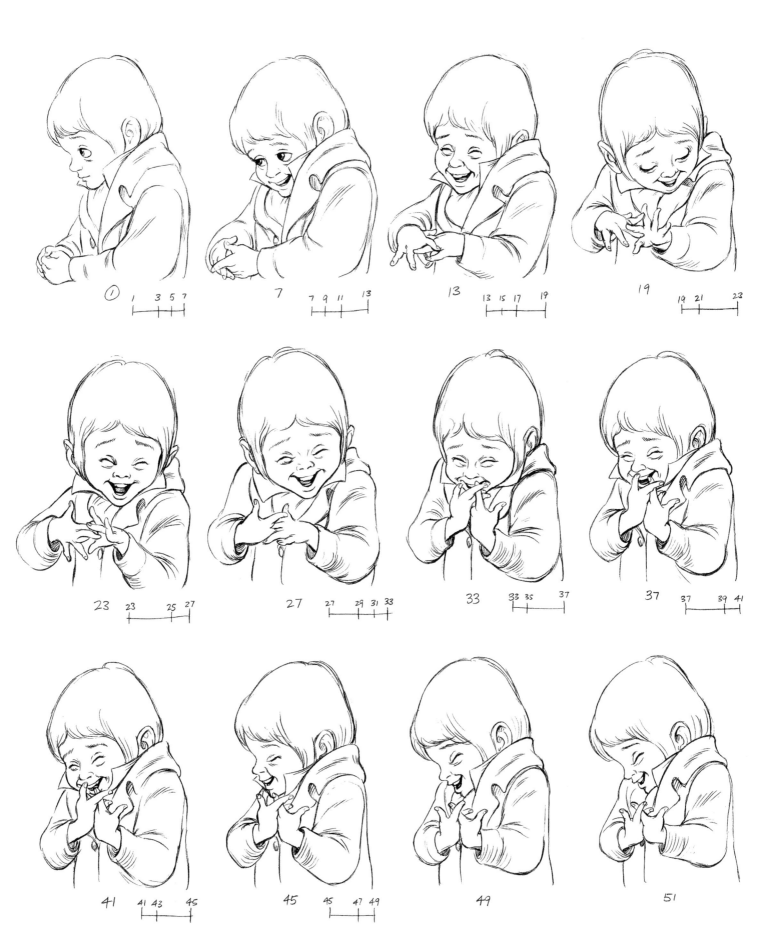

303

DIALOGUE

IMAGINE A HANDSOME MAN TALKING TO A BEAUTIFUL WOMAN and THIS IS WHAT HE SAYS:

IT LOOKS LIKE HE'S SAYING, "I LOVE YOU," DOESN'T IT?
HE'S NOT. HE'S SAYING, "ELEPHANT JUICE."
(MY 11 YEAR OLD DAUGHTER BROUGHT THIS HOME FROM SCHOOL.)

TRY IT. IT ILLUSTRATES the POINT THAT WE DON'T HAVE STANDARDISED MOUTH SHAPES FOR EVERY CONSONANT and VOWEL. WE'RE ALL DIFFERENT. OUR MOUTHS ARE ALL DIFFERENT and WE USE THEM DIFFERENTLY. THERE'S NO SET WAY TO FORM INDIVIDUAL LETTERS and VOWELS. The ACTOR, JIM CARREY, MOVES HIS MOUTH DIFFERENTLY THAN The ENGLISH QUEEN.

OF COURSE ALL OUR MOUTHS OPEN FOR the VOWELS A, E, I, O, U. (AY, EE, EYE, OH, YOO.) AND THEY CLOSE FOR The CONSONANTS B, M, P, F, T, V. (BEE, EM, PEE, EFF, TEE and VEE.) AND The TONGUE IS UP BEHIND The TEETH FOR N, D, L, TH and T (THOUGH WE DON'T ALWAYS SEE IT.) BUT A LOT OF the POSITIONS IN REAL LIFE ARE AMBIVALENT and INDIVIDUAL.

HOW NOT TO DO LIP SYNC:

I HAD AN ENTHUSIASTIC 6th GRADE TEACHER WITH A WIDE MOUTH
FULL OF VERY LARGE TEETH SET OFF BY BRIGHT RED LIPSTICK.

EVERY MORNING SHE HAD US ALL STAND UP and VERY SLOWLY
EE - NUNN - SEE - AYTEH :

"MOO VAH BULL LIPSSSSSS,
MOO VAH BULL LIPSSSSSS,
ARR THUH VEHREE BEHSSST LIPSSS
TOO TAWK ANNND SSSING WITHTHTH."

FOLLOWED BY -

"GOOOD MOHRRNNING TOO YOOO,
GOOOD MOHRRNNING TOO YOOO -
WEER OLL INN OWRR PLAYYSEZZ
WITH SSUNNSHEYENEE FAYSSEZZ.
OHHH, THISSS IZZ THUH WAYEE
TOO STAHRRT AHH NEEYOO DAYEE."

SOMETIMES SHE'D HAVE US SIT and SAY "P" (PUH) FOR A MINUTE
and I KIND OF ENJOYED HEARING the LITTLE EXPLOSIONS OF AIR.

PEOPLE DON'T TALK LIKE THIS!
WE SMUDGE FROM ONE WORD SHAPE TO the OTHER.
The ANIMATORS CALLED IT

PHRASING.

LIKE IN MUSIC - YOU SMUDGE OVER A FAST COMPLEX PASSAGE HITTING JUST the MAIN
THINGS - YOU DON'T HAVE TO MACHINE GUN EVERY NOTE EQUALLY - YOU BLUR OVER IT.

WHEN WE SPEAK WE DON'T ARR TICK YOO LATEH EVERY LITTLE SIL AH BULL
and LETTER and POP. SOME PEOPLE HARDLY MOVE THEIR LIPS WHEN THEY TALK.

The THING IS TO THINK OF the WORDS, WORD SHAPES and PHRASES - NOT OF LETTERS.

OUR MOUTHS ARE ALL DIFFERENT.

MOST PEOPLE HAVE EITHER the TOP The BOTTOM TEETH ARE
TEETH VISIBLE MOST OF The TIME - FEATURED MOST OF the TIME.

THE MOST FUN I'VE HAD WITH LIP SYNC SO FAR WAS WITH VINCENT PRICE'S VOICE —
BECAUSE HE HAD SUCH A MOBILE FACE, MOUTH, JAWS and THROAT.
FROM THE SIDE HE LOOKED AS YOU'D EXPECT, BUT WHEN HE TURNED TO THE FRONT HE LOOKED LIKE A FIS

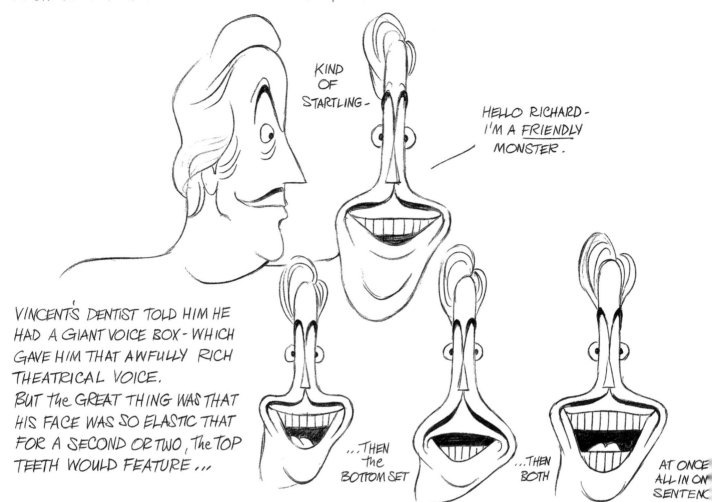

KIND OF STARTLING —

HELLO RICHARD —
I'M A <u>FRIENDLY</u>
MONSTER.

VINCENT'S DENTIST TOLD HIM HE
HAD A GIANT VOICE BOX — WHICH
GAVE HIM THAT AWFULLY RICH
THEATRICAL VOICE.
BUT THE GREAT THING WAS THAT
HIS FACE WAS SO ELASTIC THAT
FOR A SECOND OR TWO, THE TOP
TEETH WOULD FEATURE ...

...THEN THE
BOTTOM SET

...THEN
BOTH

AT ONCE
ALL IN ON
SENTENC

AND BECAUSE HE SPREAD OUT HIS DIALOGUE
YOU HAD THE TIME TO ARTICULATE ALL THE POPS, CRACKLES, SLOW VOWELS and CONSONANTS.
(LIKE BEING BACK IN GRADE SIX.) YOU COULD OVERANIMATE IT and IT STILL LOOKED NATURAL
MOSTLY WE HAVE TO HOLD DOWN OUR MOUTH ACTION, UNLESS WE'RE SHOUTING OR SINGING.

THE IMPORTANT CONSONANTS ARE THE <u>CLOSED</u> MOUTH ONES —

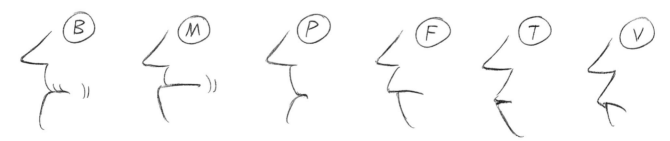

IN ORDER TO READ THESE POSITIONS WE NEED AT LEAST TWO FRAMES. ONE ISN'T ENOUGH.
(IF WE DON'T MAKE THESE POSITIONS THE VOWEL THAT FOLLOWS WILL BE VITIATED.)

FOR GOOD CRISP DIALOGUE WE SHOULD <u>POP</u> INTO OUR VOWELS - (NO INBETWEENS)
DON'T CUSHION INTO IT. CUSHION BACK <u>AFTER</u> the ACCENT. HIT IT BIG, THEN SOFTEN IT.
HIT the DIALOGUE ACCENT- i.e. "B <u>A</u>NG!"

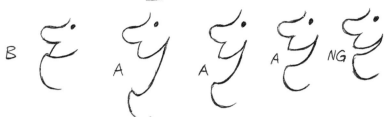

(OR) WE <u>COULD</u> CUSHION A BIT AT the BOTTOM OF the POP- and HAVE A SMALL POP TO the "NG"

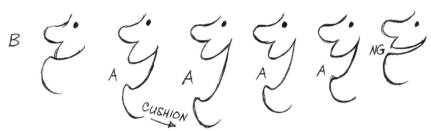

TAKE the WORD "B<u>AY</u>S B<u>O</u>LL" WITH TWO VOWELS - HIT the FIRST VOWEL HARDER THAN the 2<u>nd</u>.

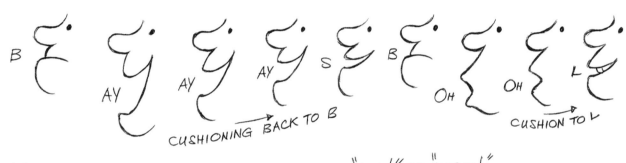

AGAIN, IF SOMEONE SAYS A BROAD VOWEL LIKE "H<u>E</u>Y!" OR "W<u>O</u>W!" -
DON'T <u>EASE</u> INTO the VOWEL FROM the "W" WITH SEVERAL DRAWINGS.

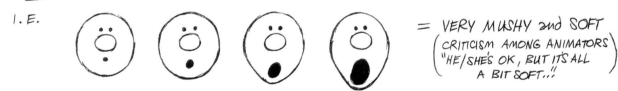

I.E. = VERY MUSHY and SOFT
(CRITICISM AMONG ANIMATORS
"HE/SHE'S OK, BUT IT'S ALL
A BIT SOFT...")

LOSE the MIDDLE POSITIONS. SMACK RIGHT INTO IT and GET MUCH MORE VITALITY.

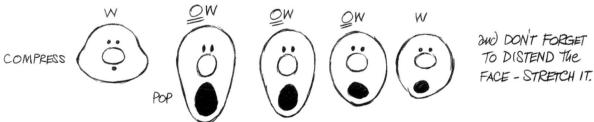

and) DON'T FORGET
TO DISTEND the
FACE - STRETCH IT.

A PREVALENT FAULT IN DIALOGUE IS THAT the BOTTOM OF the FACE DOESN'T STRETCH and COMPRESS ENOUGH,
WHICH MAKES OUR ANIMATION STIFF and STILTED.

307

The (KEY) TO LIP SYNC IS GETTING THE FEELING OF THE WORD and NOT THE INDIVIDUAL LETTERS

THE IDEA IS NOT TO BE TOO ACTIVE - GET THE SHAPE OF THE WORD and MAKE SURE WE SEE IT. SELECT WHAT'S IMPORTANT and AVOID FLAPPING THE MOUTH AROUND ANIMATING EVERY LITTLE THING.

ACTORS FITTING DIALOGUE OVER FOREIGN FILMS HIT ONLY THE ACCENTS and GLOSS OVER THE MIDDLE STUFF. THEY MATCH THE FIRST VOWEL AT THE START OF THE SENTENCE and THE LAST ACCENT OF THE SENTENCE - and WHAT'S IN BETWEEN WILL WORK (OR TEND TO WORK.)

THINK OF IT THIS WAY:

TAKE THE WORD "FORTUNE" -

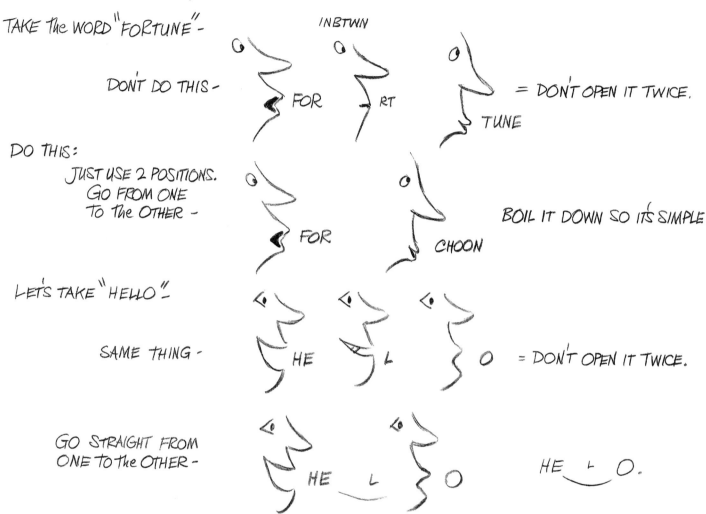

DON'T DO THIS - INBTWN FOR RT TUNE = DON'T OPEN IT TWICE.

DO THIS:
JUST USE 2 POSITIONS.
GO FROM ONE
TO THE OTHER - FOR CHOON BOIL IT DOWN SO IT'S SIMPLE

LET'S TAKE "HELLO"

SAME THING - HE L O = DON'T OPEN IT TWICE.

GO STRAIGHT FROM
ONE TO THE OTHER - HE L O HE L O.

WE CAN'T BE LITERAL IN READING OUR SOUND TRACK.
"MEMORY" IS NOT 2 OPENS - IT'S ONE

IT'S NOT:
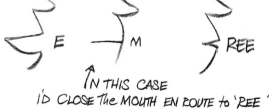
OPEN OPEN
M EM OH REE
UNLESS THEY'RE SINGING
♪ MEM - OH - REES ♪
IT'S "MEM-REE"
 ↑
 OPEN

M E M REE WE DON'T ANIMATE EVERY SINGLE VOWEL.

 ↑ IN THIS CASE
 I'D CLOSE THE MOUTH EN ROUTE TO 'REE'

308

REMEMBER THE UPPER TEETH ARE ANCHORED TO THE SKULL and DO NOT ANIMATE and THE LOWER JAW'S ACTION IS MOSTLY UP and DOWN — WITH THE LIPS and TONGUE FORMING THE SOUNDS.

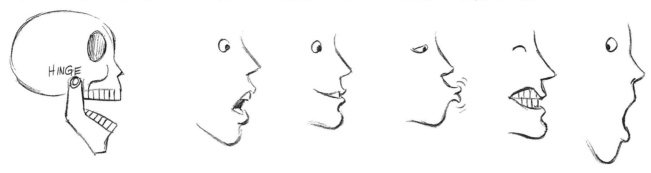

A RULE: NEVER INBETWEEN THE TONGUE IN SPEECH. OUR TONGUES WORK SO FAST, THAT IT'S JUST UP OR JUST DOWN — NEVER SEEN EN ROUTE (OF COURSE IT PAUSES.)

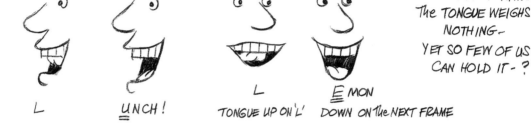

L UNCH ! L E MON

TONGUE UP ON 'L' DOWN ON THE NEXT FRAME

ISN'T THERE A SAYING — THE TONGUE WEIGHS NOTHING — YET SO FEW OF US CAN HOLD IT - ?

THE TONGUE IS HOOKED ON THE BACK OF THE LOWER JAW and IS NOT FLOATING AROUND IN LIMBO OR STUCK IN THE THROAT. ALSO THE JAWS and TEETH AREN'T RUBBER. BE CONSISTENT ABOUT TEETH.

HOWEVER, THERE'S SOME AWFULLY FUNNY STUFF BEING DONE THESE DAYS WHERE THEY JUST SAY, "HELL, IT'S A CARTOON - LET'S HAVE IT BE A CARTOON." AND THEY TREAT THE TEETH AS RUBBER and POP FROM THIS

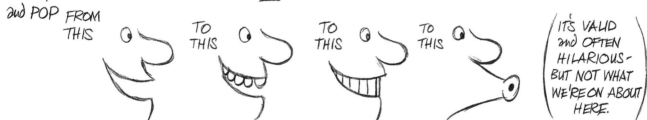

TO THIS TO THIS TO THIS

IT'S VALID and OFTEN HILARIOUS — BUT NOT WHAT WE'RE ON ABOUT HERE.

ANOTHER RULE: WE SAID WE NEED AT LEAST 2 FRAMES TO READ IMPORTANT CONSONANTS — LIKE M, B, P, F, V OR T (OR 'TH') IF WE DON'T, THE VIEWER WON'T SEE IT.

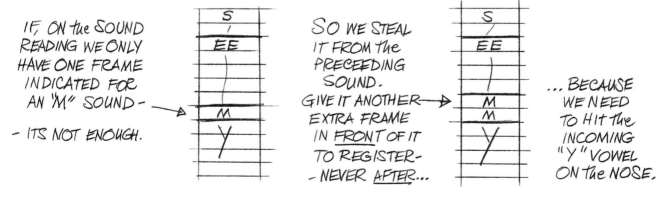

IF, ON THE SOUND READING WE ONLY HAVE ONE FRAME INDICATED FOR AN "M" SOUND —

— ITS NOT ENOUGH.

SO WE STEAL IT FROM THE PRECEEDING SOUND. GIVE IT ANOTHER EXTRA FRAME IN FRONT OF IT TO REGISTER — NEVER AFTER...

... BECAUSE WE NEED TO HIT THE INCOMING "Y" VOWEL ON THE NOSE.

309

PICTURE and SOUND SYNC

THIS BRINGS US TO the THORNY PROBLEM OF: DO WE ANIMATE LEVEL SYNC OR ANIMATE the PICTURE ONE FRAME AHEAD OF the SOUND MODULATION OR TWO FRAMES AHEAD OF the SOUND, OR WHAT?

ANSWER: WORK LEVEL.

S	1
	2
EE	3
	4
	5
M	6 ← PUT OUR 'M' DRAWINGS #6 and 7
	7 ← RIGHT ON the 'M' SOUND.
Y	8
	9
	10

OR) IF WE'RE ON TWOS —
and IT WORKS OUT THAT WAY —
WORK ONE FRAME AHEAD.

S	1
EE	3
	5 ← PUT OUR 'M' DRAWING #5 ONE FRAME AHEAD OF the 'M' SOUND
M	7 ← (and #7 'Y' DRAWING 1 FRAME AHEAD OF the 'Y' SOUND etc.)
Y	9

THERE IS A CRUDE RULE OF THUMB THAT IT LOOKS BETTER WITH the PICTURE LEADING the SOUND BY 2 FRAMES. BECAUSE OF THIS, A DISEASE SPRANG UP WHERE SOME EDITORS SET UP the TYRANNY THAT ANIMATORS MUST ANIMATE EVERYTHING 2 FRAMES AHEAD OF the SOUND SO THEY COULD JUST PLOP IN the RESULT and GO HOME.

WRONG. THERE ISN'T JUST ONE RULE. SOMETIMES LEVEL SYNC WORKS BEST — SOMETIMES IT'S BETTER WITH the PICTURE ONE FRAME ADVANCED, OFTEN IT IS BETTER 2 FRAMES AHEAD (HENCE the DISEASE) and SOMETIMES IT'S BETTER WITH the PICTURE EVEN 3 FRAMES AHEAD OF the SOUND.

IF YOU ALWAYS ANSWER,
"IT'S 2 FRAMES AHEAD"
YOU GET A CRAZY SITUATION
WHERE YOU'RE THINKING SIDEWAYS —

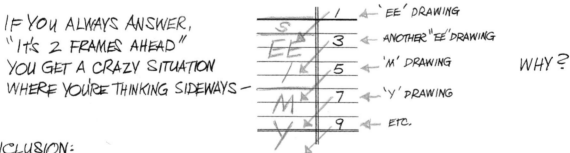

S	1 ← 'EE' DRAWING
EE	3 ← ANOTHER "EE" DRAWING
	5 ← 'M' DRAWING
M	7 ← 'Y' DRAWING
Y	9 ← ETC.

WHY?

CONCLUSION:

THERE IS ONE REAL SYNC and THAT IS LEVEL. RIGHT ON the MODULATION IS 100% PERFECT, LOGICALLY. IT JUST DEPENDS WHAT <u>LOOKS</u> BEST WHEN WE PLAY WITH IT. SO WE EXPOSE RIGHT ON the NOSE OR ONE FRAME AHEAD — IF IT'S CONVENIENT — <u>NEVER LATE</u>.

THEN WE CAN RUN OUR TESTS AT LEVEL SYNC, THEN ADVANCE the PICTURE ONE OR TWO OR THREE FRAMES — DEPENDING ON WHAT LOOKS RIGHT TO US. WE LEARN THINGS THIS WAY.
IT ALL DEPENDS ON the CHARACTER and TYPE OF VOICE and HOW WE'VE DONE the JOB.

310

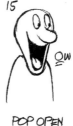

ACCENTS

The OLD MASTERS PUT SHARP PHYSICAL ACTIONS and HEAD MOVES 3 OR 4 FRAMES AHEAD OF The MODULATION — THEN PUT The MOUTH ACTION ON The NOSE - (IN A MANNER OF SPEAKING.)

IF ON
ONES -

			1
			2
			3
HEAD ACCENT X			4
3 FRAMES AHEAD		N	5
			6
SOUND ACCENT X			7
			8
		O	9
		W	10
			11

IF ON
TWOS -

			1
HEAD ACCENT X			3
4 FRAMES AHEAD		N	5
SOUND ACCENT X			7
		O	9
		W	11

THEY GET UP THERE (OR DOWN THERE) FOR the ACCENT 3 OR 4 FRAMES EARLY - THEN the MOUTH OPENS ON the SOUND.

PUT SIMPLY - 1 5 7 9 11 15

THIS DEVICE GIVES
A BEAUTIFUL
RESULT.
MUCH BETTER
THAN HITTING IT
ALL AT ONCE.

1 3 5 7 7 8 9 11

ACCENT
X

POP OPEN
ON MODULATION
X

MOST OF the TIME the HEAD ACCENT IS UP.
1. ANTICIPATE DOWN
2. THEN HEAD ACCENTS UP
3. THEN LIPS ON The VOWEL (IT'S USUALLY A VOWEL THAT WE'RE HITTING.)

WE CAN DO IT IN REVERSE, BUT MOSTLY ITS STRONGER GOING UP. (BUT DOWN IS FINE, TOO.)

ANYWAY, THERE IS <u>ALWAYS</u> AN ACCENT — UNLESS IT'S AN UTTERLY BORING PERSON SPEAKING.

TAKE: "WELL, AT LAST YOU'RE HOME!" = 3 ACCENTS
↑ ↑ ↑
VOWEL VOWEL VOWEL

HIT ONLY the VOWELS WHICH ARE IMPORTANT. GLOSS OVER The OTHERS.
WE HIT CERTAIN ACCENTS WHEN SPEAKING and WE SLUR OVER The REST.

OR "WELL, AT LAST YOU'RE HOME!"
↑
BIG ACCENT

OR "WELL, AT LAST YOU'RE HOME!"
↑ ↑
SMALL BIG
ACCENT ACCENT

JUST HIT the MAIN ACCENTS. SELECT WHAT'S IMPORTANT - WHETHER IT'S A SOFT OR HARD ACCENT.

HARD ACCENT: "NO!" GO DOWN (OR UP) and YOU BOUNCE BACK.
SOFT ACCENT: "NOOooo"... GO DOWN (OR UP) and CONTINUE.

HERE'S AN EXAMPLE OF BODY ACTION PREDOMINATING.
SHE'S SAYING, "I'LL SLIP INTO SOMETHING COOLER."
<u>ACCENT</u>

SHE DOES IT WITH HER SHOULDER.
IT'S UP AS SHE TURNS TOWARD US, ANTICIPATES DOWN
and GOES UP FAST FOR the MAIN ACCENT ON COOLER.
ALSO AT the SAME TIME HER HEAD ACCENT GOES <u>DOWN</u>
ON the "OO". THE ONLY MOUTH ACCENT ALSO ON the "OO".
SHOULDER UP, HEAD DOWN, MOUTH EXAGGERATED —
ALL TO HIT the ONLY ACCENT IN the SENTENCE.

HERE ARE the MAIN EXTREMES: KEYS #①, �37 and ㊽ TELL the STORY.

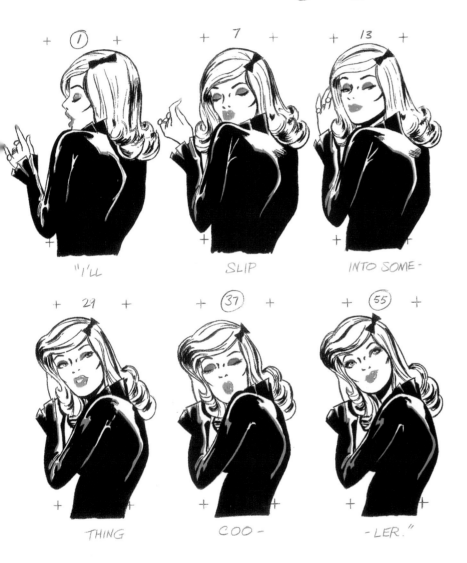

"I'LL SLIP INTO SOME-

THING COO- - LER."

THIS WORKS FINE, BUT WOULD HAVE BEEN EVEN BETTER IF the HEAD and
SHOULDER ACCENT HAD COME 3 or 4 FRAMES AHEAD of the "OO" MODULATION.

312

ACTION	DIAL	
O TURNS	I	1
	LL	3
		5
HEAD ANTIC. DOWN X	S	7
	L	9
	E	11
HEAD UP X	P	13
	E	15
1	T	17
	EH	19
SHOULDER GOES DOWN TO ANTIC. ACCENT	S	21
		23
BLINK X	U	25
	M	27
	TH	29
	ING	31
2 HEAD GOING DOWN		33
SHOULDER GOES UP	C	35
ACCENT X	O	37
	O	39
		41
HEAD GOING UP SHOULDER DOWN	L	43
	EH	45
		47
3	R	49
X		51
		53
		55
	CUT	

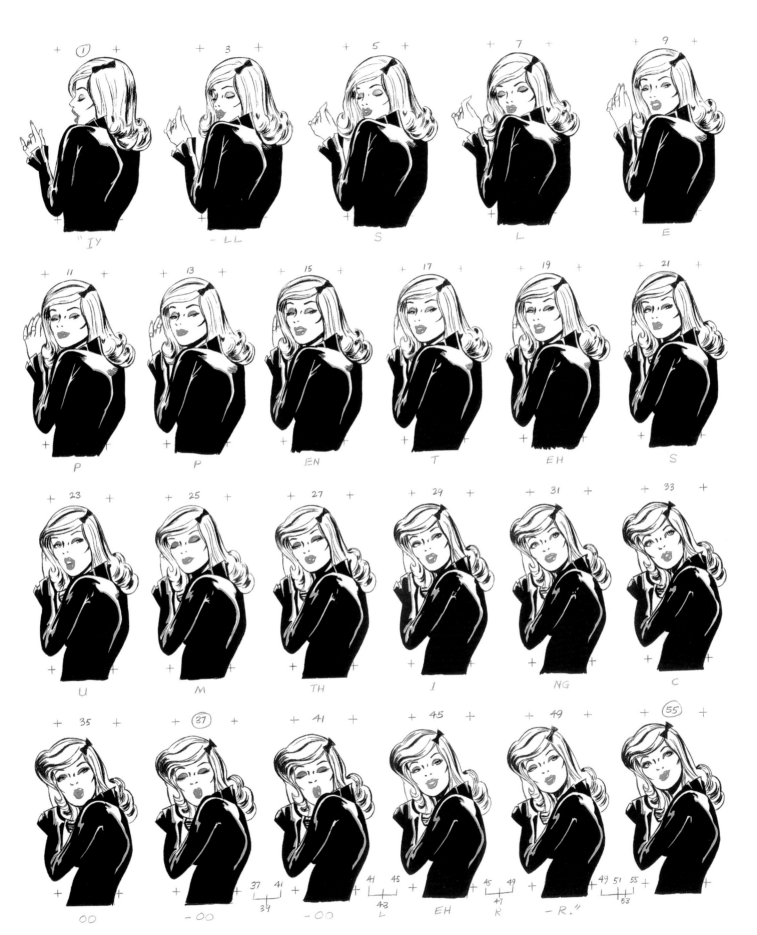

313

ATTITUDE

MAKE THE POINT OF THE SHOT CLEAR WITH BODY ACTION FIRST. THE BODY ATTITUDE SHOULD ECHO THE FACIAL ATTITUDE. IT'S ALL ONE. THE EXPRESSION OF THE BODY AND FACE IS MORE IMPORTANT THAN THE MOVEMENT.

IF WE GET THE BODY AND HEAD IN THE RIGHT ATTITUDE WE CAN ALMOST GO WITHOUT THE MOUTHS. THE MOUTH ACTION CAN GO ON LAST — THEY CAN BE THE LAST THING TO WORK ON.

KEN HARRIS SAID HE LEARNED THE MOST ABOUT LIP SYNC WHEN HE HAD TO ANIMATE A MARTIAN CHARACTER WHO HAD NO MOUTH. THIS MEANT HE HAD TO GET THE HEAD ACCENTS RIGHT TO MAKE IT CONVINCING.

IN PLANNING WE SHOULD MAKE SURE WE DON'T HAVE TOO MUCH GOING ON. HOW MANY POSES FOR THIS SENTENCE - FOR THIS THOUGHT? ACT IT OUT AND BOIL IT DOWN SO ITS SIMPLE AND KEEP IT SIMPLE.

WE CAN ONLY PUT OVER ONE THING AT A TIME. JUST AS WE CAN ONLY SAY ONE WORD AT A TIME, WE CAN ONLY PROJECT ONE GESTURE AT A TIME. THE WHOLE POSE SHOULD WORK TOWARD THAT ONE THING.

The SECRET

ONE EVENING IN THE EARLY 70'S I WAS TALKING TO MILT KAHL ABOUT THE SUPERB MOUTH SHAPES HE ALWAYS GOT IN HIS ANIMATION. HE SAID, "WATCH SINGERS FOR MOUTH SHAPES."

I ASKED, "IS THERE ANY REAL SECRET TO LIP SYNC?"

HE LIT UP. "YOU WANT THE SECRET? I'LL TELL YOU THE SECRET! YOU KNOW THAT JIM HENSON WITH HIS FROG MUPPET? WELL, HE'S A GENIUS! HE UNDERSTANDS SOMETHING THAT PUPPETEERS NEVER DID BEFORE. HERE HE'S JUST GOT A SOCK OVER HIS HAND AND THOUGH HE CAN NEVER MATCH THE SOUND EXACTLY, HE DOES A FAR BETTER JOB THAN MOST OF US ANIMATORS WITH ALL OUR TECHNICAL RESOURCES. YOU WATCH WHAT HE'S DOING! HE'S PROGRESSING THE ACTION. HE'S GOING SOMEWHERE WITH THAT FROG WHEN HE'S TALKING.

"I LEARNED THIS BACK ON 'SONG OF THE SOUTH' WHEN I HAD THE FOX SAYING TO THE RABBIT, 'I'M GOING TA ROAST YUH, ETC, ETC'. I HARDLY MOVED THE MOUTH AT ALL. HE WAS SPEAKING THROUGH HIS TEETH WHEN HE PUSHED FORWARD TOWARDS THE RABBIT. HE PROGRESSED TOWARDS THE RABBIT! I PROGRESSED IT AS HE SPOKE AND THAT'S THE SECRET. GO SOMEWHERE, ANYWHERE, AS YOU SPEAK."

WHEN I GOT BACK TO ENGLAND I RUSHED IN TO KEN HARRIS AND JUMPED UP AND DOWN, "I'VE GOT THE SECRET! THE SECRET OF LIP SYNC! MILT KAHL TOLD ME THE SECRET!"

KEN LOOKED UP QUIZZICALLY.

"THE SECRET!" I BURBLED, "THE SECRET IS TO PROGRESS THE ACTION AS YOU SPEAK!"

KEN'S EYES ROLLED HEAVENWARD. "WHAT DO YOU THINK I'VE BEEN TRYING TO TELL YA?"

WELL, THE PENNY DROPPED (FINALLY) AND I NEVER LOOKED BACK. THAT'S IT.

ACTING

IN the 1930's SOMEBODY ASKED LOUIS ARMSTRONG, "WHAT IS SWING?" LOUIS ANSWERED, "MAN, IF YOU HAVE TO ASK, YOU'LL NEVER KNOW."

BUT WE ALL KNOW ABOUT ACTING! WE DO IT ALL DAY. WE'RE ACTING DIFFERENT PARTS ALL THE TIME. THERE ARE SEVERAL OF US IN HERE.

DO YOU ACT THE SAME WAY WITH YOUR WIFE/HUSBAND/LOVER AS WHEN A TRAFFIC COP PULLS YOU OVER? OR WITH THE BANK MANAGER? OR WITH YOUR CHILDREN? WITH YOUR BOSS? WITH CO-WORKERS? FRIEND? WITH YOUR SUBORDINATES? YOUR ENEMIES?

WE'RE ACTING ROLES ALL THE TIME, DEPENDANT ON THE SITUATION WE'RE IN and WE KNOW IT. WE TROT OUT THE PERSONALITY APPROPRIATE TO WHAT'S REQUIRED IN OUR SITUATION.

> THERE'S: THE AUTHORITARIAN
> THE CHILD
> THE STUDENT
> THE RESPONSIBLE ADULT
> THE LOVER
> THE FRIEND
> THE CLOWN
> THE EMPATHETIC, KINDLY PERSON
> THE HUNTER
> THE POWER-CRAZY MANIAC etc.

THE THING IS TO BE AWARE OF IT and USE IT TO EXPRESS THINGS—TO DEVELOP THE ABILITY TO PROJECT IT THROUGH OUR DRAWINGS OR INVENTED IMAGES BY GETTING INTO THE CHARACTER WE'RE DEPICTING, IN THE SITUATION THEY'RE IN, KNOWING WHAT IT IS THEY WANT — and WHY THEY WANT IT — THAT'S ACTING.

315

WE WANT TO PUT SOMETHING OVER CLEARLY THROUGH A PARTICULAR CHARACTER—
CLEAR DEPICTIONS OF WHAT'S GOING ON WITH the CHARACTER.

DO ONE THING AT A TIME and BE CRYSTAL CLEAR.

IF WE START WITH THAT, THEN WE CAN DEEPEN OUR PERFORMANCE AS MUCH
AS WE ARE CAPABLE OF.

WE CERTAINLY ALL KNOW the BASIC EMOTIONS.

AND WE ALL KNOW ABOUT FEAR
 GREED
 HUNGER
 COLD
 LUST
 VANITY
 LOVE
 and the NEED TO SLEEP.

KNOWING THESE, IT'S JUST ABOUT HOW DIFFERENT PEOPLE HANDLE THEM.

SO IT'S JUST A QUESTION OF WIDENING OUR RANGE TO ACCOMMODATE MORE
ROLES — WHICH WE DO NATURALLY BY OBSERVATION and EXPERIENCE —

(AND) HAVING and DEVELOPING the ABILITY TO PROJECT IT INTO the CHARACTER
 WE'RE WORKING ON.

MILT KAHL ALWAYS SAID, "I THINK YOU JUST DO IT. IF YOU HAVE A PROBLEM
YOU HAVE TO PUT IT OVER. GOT TO HAVE A THOROUGH UNDERSTANDING OF WHAT
YOU'RE AFTER. AND IF YOU KNOW WHAT YOU'RE AFTER — YOU JUST KEEP AFTER
IT TILL YOU GET IT."

AND, "GIVE IT A LOT OF THOUGHT HOW YOU'RE GOING TO DO the BEST JOB OF
PUTTING the PERFORMANCE ON the SCREEN — PUTTING OVER WHAT YOU HAVE
TO PUT OVER."

GOT TO GET INSIDE the CHARACTER. WHAT DOES HE/SHE/IT WANT?
AND EVEN MORE INTERESTING — WHY DOES the CHARACTER WANT?

WHAT AM I DOING and WHY AM I DOING IT?

The PEOPLE WHO REALLY KNOW HOW TO ACT ALL SAY, "YOU DON'T ACT,
YOU BECOME."

The MOVIE STAR, GENE HACKMAN SAID SOMETHING LIKE, "I WORK LIKE MAD
AT NEVER BEING CAUGHT ACTING."

The GOOD ACTORS DO A LOT OF RESEARCH SO the REALITY THEY'RE DEPICTING
BECOMES THEIR REALITY.

316

THE FINE CHARACTER ACTOR, NED BEATTY SAID, "SOME ACTORS HYPNOTISE THEMSELVES INTO BECOMING the PART — BUT A VERY SMALL GROUP OF ACTORS ACTUALLY HYPNOTISE the AUDIENCE.

SO the IDEA IS TO HYPNOTISE the AUDIENCE.

FRANK THOMAS USES the WORD 'CAPTIVATE.' "YOU'RE TRYING TO GRAB the AUDIENCE'S ATTENTION and HOLD IT — HOLD IT WITH SOMETHING REAL THAT THEY CAN IDENTIFY WITH."

CONCLUSION:

WE TRY TO MAKE IT SO REAL, SUPER-REAL, THAT IT'S COMPULSIVE VIEWING. WE EXPERIENCE the EMOTION and MAGNIFY the RESULT.

I'VE ALWAYS BEEN EMBARRASSED BY ANIMATORS HANGING AROUND the WATER COOLER TALKING ABOUT "THE ACTING."

IT'S WELL KNOWN THAT A LOT OF ARTISTS CAN TALK A TERRIFIC FIGHT, BUT WHEN YOU SEE THEIR DRAWINGS, IT'S A DEAD GIVEAWAY OF WHAT THEY'RE REALLY LIKE. AND HOW MUCH MORE SO WHEN THEIR DRAWINGS ARE ACTUALLY MOVING AROUND. YOU CAN SEE A PERSON'S STRENGTHS and WEAKNESSES RIGHT AWAY.

IF WE'RE A COLD FISH, SUPERFICIAL PERSON OR EMOTIONAL WRECK, THERE IT IS FOR ALL TO SEE. SO WE CAN ONLY EXPRESS OURSELVES AS BEST WE CAN WITH WHAT WE HAVE TO OFFER EMOTIONALLY and TECHNICALLY.

(BUT) A REALLY GOOD PROFESSIONAL SHOULD BE ABLE TO HANDLE A WIDE RANGE OF ACTING MATERIAL, WHATEVER HIS/HER EMOTIONAL STATE OF MIND.

THERE'S THIS STORY ABOUT A SERIOUSLY DEPRESSED MAN IN GERMANY WHO WENT TO SEE A PSYCHIATRIST:

The PSYCHIATRIST SAYS, "YOU'VE LOST YOUR SENSE OF HUMOUR IN LIFE YOU NEED TO HAVE A REALLY GOOD LAUGH. GO TO the CIRCUS — THERE'S THIS GREAT CLOWN, GROCK, The FUNNIEST MAN YOU'VE EVER SEEN."

The ANSWER COMES BACK, "I AM GROCK."

FRANK THOMAS, A MASTER OF ANIMATING EMPATHY and PATHOS, ALWAYS CRITICISED ME (CONSTRUCTIVELY) FOR SPENDING TOO MUCH TIME ON SPECTACULAR SURROUNDING ANIMATION and NOT ENOUGH OF GOING STRAIGHT FOR the EMOTIONAL CENTRE.

PART OF the REASON WAS THAT I FELT WE WEREN'T YET GOOD ENOUGH AT IT, SO WE'D WORK ON the "WORLD" OF the PIECE and LEAVE the "HAMLET" STUFF TILL LAST — BUT FRANK'S CRITICISM IS VALID.

ANIMATION WAS KIND OF IN THE DOLDRUMS WHEN WE STARTED MAKING 'WHO FRAMED ROGER RABBIT' AND FRANK WROTE ME A WONDERFULLY ENCOURAGING LETTER INCLUDING, "IF YOU BRING THIS OFF, YOU'LL BE A HERO."

I CARRIED FRANK'S LETTER IN MY CHEST POCKET THROUGHOUT THE 2½ YEARS OF PRODUCTION PRESSURE AND WOULD REREAD IT EVERY TIME THINGS GOT ROUGH.

WHEN THE PICTURE CAME OUT AND WAS A HIT, NOTHING FROM FRANK.
2 MONTHS LATER IT'S THE BIGGEST PICTURE OF THE YEAR, NOTHING FROM FRANK.
3 MONTHS LATER I RANG HIM UP.

"HI, FRANK, IT'S DICK."

"....YEAH..."

"HI, FRANK, WELL, WE MADE IT! IT'S A HIT, FRANK! IT'S A HIT!"

"....YEAH..."

"I MEAN, WELL, WE DID THE BEST WE COULD AND IT'S A HUGE SUCCESS! ENORMOUS!"

".....YEAH."

"WELL, I KNOW, FRANK, IT COULD HAVE BEEN BETTER, BUT WE REALLY WORKED HARD AND EVERYBODY LOVES IT!"

"...YEAH."

"WELL, ER, UM, I GUESS THAT YOU COULD SAY THAT WE RAISED A GIMMICK TO THE LEVEL OF A NOVELTY, BUT IT'S A HIT!"

"....YEAH."

"AW, COME ON FRANK, I KNOW YOU ALWAYS CRITICISE ME FOR NOT GRABBING THE AUDIENCE EMOTIONALLY – BUT YOU'VE GOT TO GIVE IT TO ME, WHEN THE VILLAIN'S GOING TO KILL THE RABBIT BY DIPPING HIM IN THE VAT OF ACETONE, ALL THE KIDS IN THE AUDIENCE YELL, "DON'T DO IT! DON'T DO IT!"

(LONG PAUSE)...'.I WISH THEY HAD."

WELL, I KNOW WHAT FRANK MEANS. IN MY DEFENSE, I HAD TO PUSH VERY STRONGLY FOR SOME ANIMATION I DID AT THE FRONT OF THE OPENING CARTOON WHERE WE COULD AT LEAST SEE WHAT THE RABBIT LOOKED LIKE BEFORE HE STARTED SHOOTING AROUND LIKE A CROSS BETWEEN CHEWING GUM AND A FIREWORK.

BUT THERE WAS A REAL OPPORTUNITY FOR PATHOS THAT WE MISSED.

THERE WAS A SHOT OF ROGER SITTING ON A GARBAGE CAN IN A BACK ALLEY CRYING ABOUT WHAT HE THOUGHT WAS HIS WIFE'S INFIDELITY.

LIKE GROCK, I WANTED TO SHOW A COMPLETELY DIFFERENT SIDE OF the RABBIT'S PERSONALITY BEHIND HIS PROFESSIONAL MASK. I WANTED TO ANIMATE IT MYSELF, BUT I HAD TOO MUCH ELSE TO DO. WE HAD A FINE LEAD ANIMATOR WHO WAS AT the TIME VERY LONELY and I KNEW HE WAS the MAN FOR the JOB.

A TOP EXECUTIVE COMES IN and SAYS, "BY the WAY, DICK, SO and SO REALLY WANTS TO DO THAT SCENE. I SAID, "OH NO, HE'S A SUPERB BROAD ANIMATOR and INVENTIVELY FUNNY, EXCELLENT, BUT I THINK HE'S WRONG FOR THIS SCENE. HE'S GOT A GREAT GIRLFRIEND, HE'S VERY UP and NOT the PERSON FOR THIS JOB." "BUT HE REALLY WANTS TO DO IT, DICK, HE'S BEEN PHONING ME UP ABOUT IT." "BUT HE'S WRONG - IT'LL BE OK - BUT IT WON'T HAVE THIS OTHER SIDE TO IT. The OTHER GUY SHOULD DO IT." "BUT HE'S DYING TO DO IT..".

I LOSE the ARGUMENT. OUTVOTED. IT'S WRONG, BUT the PICTURE FEELS LIKE A HIT and ANYWAY I CAN'T AFFORD TO BE FIRED. OF COURSE the RESULT WAS JUST LIKE ALL the OTHER MANIC SCENES - and WE MISSED HAVING ANOTHER DIMENSION TO the CHARACTER WHICH WOULD HAVE GIVEN A MUCH STRONGER EMOTIONAL PULL WITH the AUDIENCE.
WIN SOME, LOSE SOME.

IN AN INTERVIEW IN 1972 AT the ZAGREB FILM FESTIVAL, FRANK THOMAS TALKED ABOUT A MAN "WHO NEVER HAD TALENT FOR ENTERTAINMENT. HE WAS ONE OF the BEST ASSISTANTS WE EVER HAD. HE KNEW EVERYTHING YOU COULD TEACH ABOUT MOVEMENT, MOVING the CHARACTER and WEIGHT and DEPTH and BALANCE and ALL THESE THINGS. HE COULD DRAW THEM LIKE ANYTHING, BUT HE HAD A VERY WEAK SENSE OF ENTERTAINMENT and HE HAD A VERY POOR CHOICE OF WHAT TO DO IN ANIMATION — SO HIS ANIMATION WAS ALWAYS FLAT. IT ALWAYS MOVED NICELY, BUT NOBODY WANTED TO LOOK AT IT."

MILT KAHL ALWAYS SAID, "IT'S A MATTER OF PICKING the RIGHT THING TO DO and MAKING UP YOUR MIND ABOUT THAT. AND THEN NOT LETTING ANY OTHER IDEAS INTERFERE WITH IT. DON'T LET YOUR MAIN IDEA GET BURIED OR INTERFERED WITH BY SOMETHING ELSE."

CONCLUSION:
WE THINK ABOUT IT IN the OVERALL, JUST AS IF WE WERE AN ACTOR DOING IT. HOW DO WE DO IT the BEST WAY TO PUT The BUSINESS OVER the BEST? BEFORE WE ANIMATE WE FIGURE OUT IN ADVANCE EXACTLY WHAT WE'RE GOING TO DO.

KNOW WHERE WE'RE GOING. IN PLANNING LOCK DOWN the IMPORTANT POSES.

ART BABBITT SAID THAT THE GREAT BILL TYTLA (RENOWNED FOR THE EMOTIONAL POWER AND HEARTFELT PASSION IN HIS WORK) SPENT <u>DAYS</u> WORKING ON TINY THUMBNAILS. HE HAD EVERYTHING ALL WORKED OUT IN MINIATURE BEFORE ANIMATING. (AND THE END RESULT STILL CAME OUT JUST AS QUICKLY AS OTHER ANIMATORS.) GRIM NATWICK ALSO TOLD ME, "TYTLA WAS A VERY, <u>VERY</u> CAREFUL PLANNER."

CHANGE OF EXPRESSION

I WAS VERY TAKEN WITH WHAT DISNEY MASTER ANIMATOR/TEACHER ERIC LARSON HAS TO SAY IN FRANK THOMAS AND OLLIE JOHNSTON'S "THE ILLUSION OF LIFE." HE SAID IN THE EARLY MICKEY MOUSE SHORTS THEY DISCOVERED THIS PRINCIPLE: IF YOU WERE LOOKING AT A PORTRAIT AND –

"THE SUBJECT GRADUALLY LOWERED HIS BROWS INTO A FROWN –
PAUSED – AND THEN LIFTED ONE BROW AND GLANCED TO THE SIDE,
YOU IMMEDIATELY WOULD SENSE A CHANGE FROM ONE THOUGHT
TO ANOTHER. SOMETHING VERY IMPORTANT HAPPENED!
THROUGH A CHANGE OF EXPRESSION THE THOUGHT PROCESS WAS SHOWN."

I THOUGHT, OK, LET'S JUST SKETCH THIS OUT IN ITS SIMPLEST FORM AND SEE WHAT IT LOOKS LIKE –

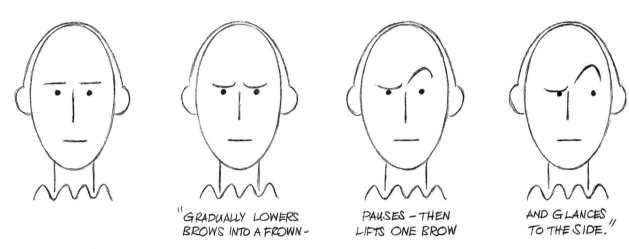

"GRADUALLY LOWERS BROWS INTO A FROWN –

PAUSES – THEN LIFTS ONE BROW

AND GLANCES TO THE SIDE."

GREAT. HE'S THINKING! THEN I WONDERED – IS THERE ANY WAY TO STRENGTHEN THIS FURTHER?

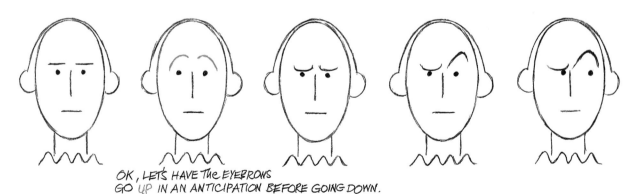

OK, LET'S HAVE THE EYEBROWS GO <u>UP</u> IN AN ANTICIPATION BEFORE GOING DOWN.

320

THAT WORKS. CAN WE STRENGTHEN IT FURTHER STILL?
WHY DON'T WE ANTICIPATE the RAISED EYEBROW BY *LOWERING* IT FURTHER?

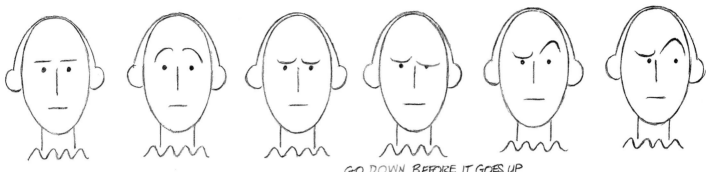

GO *DOWN* BEFORE IT GOES UP

THAT WORKS TOO. ANYTHING ELSE WE CAN DO?

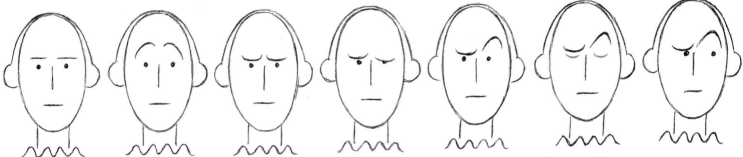

A *SLOW BLINK* ENROUTE
MIGHT HELP IT —

MAYBE WE'VE OVERANIMATED IT BY NOW and MAYBE IT'S A BIT CORNY - BUT IT SHOWS
WHAT WE CAN DO BY LOOKING FOR EXTRA POSITIONS - MORE *CHANGE* - MORE BANG
FOR the BUCK.

(LOOK FOR the CONTRAST)

MILT KAHL ALWAYS SAID DON'T CHANGE The EXPRESSION *DURING A BROAD MOVE.*
HE'D USE THIS EXAMPLE:
SAY WE HAVE A PERSON READING A BOOK —

HE HEARS A NOISE
WHICH STARTLES HIM —
— FRIGHTENS HIM —
and HE
SWINGS ROUND.

FOR A START WE'D NEED SOMETHING TO CHANGE <u>FROM</u> - SOMETHING OPPOSITE - SOMETHING THAT'S A LOT DIFFERENT FROM WHAT WE'RE GOING TO CHANGE TO.

LET'S LIFT the BOOK UP and PUSH HIM DOWN DEEPER INTO IT.
- GIVE HIM A COMPLACENT OR AMUSED EXPRESSION — THEN WE'VE GOT A BIGGER CHANGE - A STRONGER CHANGE.

BUT WE DON'T WANT TO CHANGE HIS EXPRESSION <u>DURING</u> the MOVE WHERE WE CAN'T SEE IT. SO WE INSERT A POSITION WHERE WE SEE the CHANGE <u>BEFORE</u> the MOVE.

the EXPRESSION CHANGES AS HE'S <u>STARTING</u> TO TURN and WE KNOW HE'S SCARED.

THEN MOVE→

(OR) HAVE HIM MOVE and CHANGE the EXPRESSION AT the <u>END</u> OF HIS MOVE WHERE WE CAN SEE IT.

EITHER WAY IS MUCH MORE EFFECTIVE.

The IDEA IS TO PUT the CHANGE WHERE YOU CAN SEE IT - NOT DURING the BROAD MOVE - UNLESS the MOVE IS QUITE SLOW - THEN WE COULD READ IT.
AGAIN, the MIND IS the PILOT. WE THINK OF THINGS BEFORE the BODY DOES THEM.
THERE'S ALWAYS A SPLIT SECOND OF "THINKING TIME" BEFORE the CHARACTER DOES the ACTION.

322

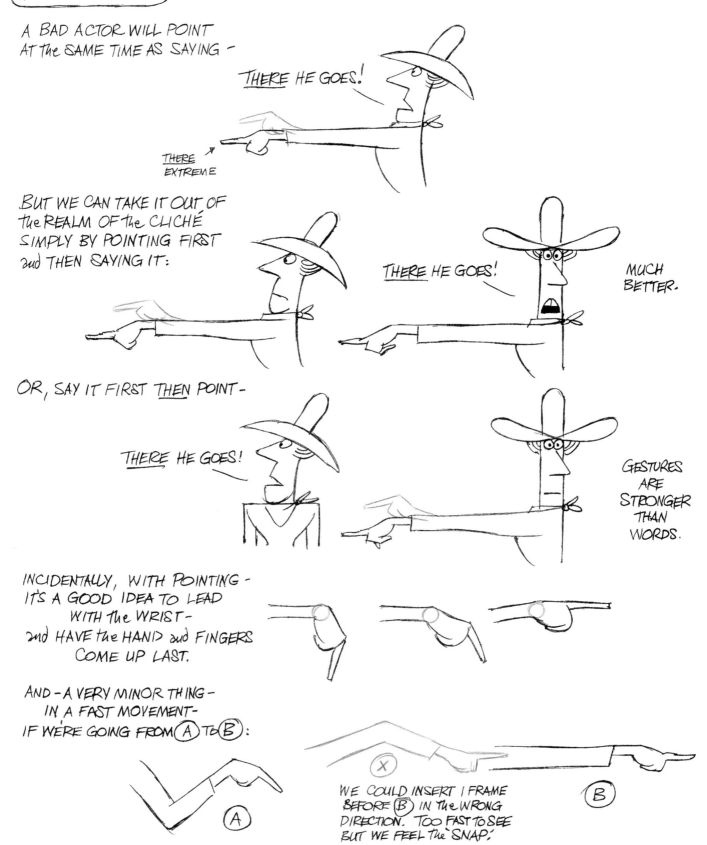

AN ACTING POINT

A BAD ACTOR WILL POINT
AT THE SAME TIME AS SAYING —

THERE HE GOES!

THERE
EXTREME

BUT WE CAN TAKE IT OUT OF
THE REALM OF THE CLICHÉ
SIMPLY BY POINTING FIRST
and THEN SAYING IT:

THERE HE GOES!

MUCH
BETTER.

OR, SAY IT FIRST THEN POINT—

THERE HE GOES!

GESTURES
ARE
STRONGER
THAN
WORDS.

INCIDENTALLY, WITH POINTING—
IT'S A GOOD IDEA TO LEAD
WITH THE WRIST—
and HAVE THE HAND and FINGERS
COME UP LAST.

AND — A VERY MINOR THING —
IN A FAST MOVEMENT—
IF WE'RE GOING FROM (A) To (B):

(A)

(X)

WE COULD INSERT 1 FRAME
BEFORE (B) IN THE WRONG
DIRECTION. TOO FAST TO SEE
BUT WE FEEL THE SNAP.

(B)

323

The BRILLIANT DISNEY ART DIRECTOR/DESIGNER, KEN ANDERSON SAID,

"PANTOMIME IS THE BASIC ART OF ANIMATION.
BODY LANGUAGE IS THE ROOT and FORTUNATELY IT IS UNIVERSAL."

I WAS WITH KEN IN TEHRAN JUST BEFORE THE REVOLUTION and I HAD A NASTY SHOCK and A BIG LESSON WHEN THEY RAN MY ½ HOUR OSCAR-WINNING 'A CHRISTMAS CAROL' FOR AN IRANIAN AUDIENCE.

WE HAD TRIED TO HAVE AS MUCH BODY LANGUAGE IN THE FILM AS WE COULD BUT WE STILL WERE LEFT WITH DICKENS' LITERATE STORY. OF COURSE THE AUDIENCE DIDN'T UNDERSTAND A WORD. A CHUCK JONES CARTOON CAME ON AFTER and BLEW US OUT OF THE WATER.

SO FOR US, WE SHOULD KEEP WORDS TO A BARE MINIMUM and MAKE EVERYTHING AS CLEAR AS WE CAN THROUGH PANTOMIME. WE SHOULD FEEL WE HAVE ONLY THE BODY TO TELL THE STORY.

IT'S A GREAT IDEA TO STUDY SILENT MOVIES. ALTHOUGH MUCH OF THE ACTING IS LAUGHABLY HAMMY and CORNY— IT'S ALL VERY CLEAR. ALMOST A LOST ART.

AN ACTOR HAS TO BE SPONTANEOUS TO A DEGREE - BUT IT'S NOT SPONTANEOUS FOR US- IT'S ANYTHING BUT. WE CAN SIT DOWN and GIVE IT A LOT OF THOUGHT. WE CAN TRY THINGS, TEST THEM and MAKE CHANGES. WE'VE GOT THE BODY CONTROL and WE'RE NOT LIMITED BY PHYSICAL DEXTERITY, OR GRAVITY, OR AGE, OR RACE, OR SEX. AGAIN, WE CAN INVENT WHAT DOESN'T EXIST IN REALITY and STILL MAKE IT APPEAR BELIEVABLE.

SYMMETRY OR 'TWINNING'

I FEEL THAT SYMMETRY HAS GOTTEN A BAD PRESS BECAUSE OF BAD ANIMATION ACTING. PEOPLE SAY 'AVOID TWINNING' — WHERE BOTH ARMS and HANDS ARE DOING THE SAME THING.

BUT JUST WATCH ANY POLITICIAN, PREACHER OR LEADER OF WHATEVER, OR EXPERT ON TELEVISION, WHEN THEY'RE LAYING DOWN THE LAW THEIR ARMS and HANDS WILL TWIN SYMMETRICALLY.

HERE'S THE BROAD PATTERN —

(THEN THEY BREAK IT UP)

"WE NEED BALANCE, HARMONY, ABUNDANCE,

— HAPPINESS FOR ALL.

AND IT'S UP TO YOU TO VOTE FOR ME OR TO SEND MONEY

SO THAT I CAN DELIVER GLORIOUS

SUCCESS ENLIGHTENMENT HARMONY PROSPERITY ABUNDANCE BALANCED LIVING etc.

THEY MAY DO IT IN A REDUCED VERSION –

"I'M OPEN, HONEST, IT COMES FROM MY – AND I'LL NEVER IN ORDER – FUTURE
 HEART... LIE TO YOU – TO BRING A FOR US ALL."
 GLORIOUS,
 INCLUSIVE –

AND WATCH YOURSELF WHEN YOU'RE LAYING DOWN the LAW ABOUT SOMETHING. WE JUST DO IT NATURALLY.
I THINK SYMMETRY IS AN EXPRESSION OF HARMONY, BEAUTY, BALANCE, ORDER and AUTHORITY and PEOPLE
USE IT ALL The TIME (BREAKING IT UP TO POINT OR WHATEVER) and THEN RETURN TO IT TO EXPRESS
the WHOLENESS THEY'RE TRYING TO CONVEY.
SO, A JUDICIOUS USE OF TWINNING IS EFFECTIVE BECAUSE IT'S EVERYWHERE. IT'S ALL TO DO
WITH HOW WE USE IT.

A WAY TO TAKE the CURSE OFF TWINNING IS JUST TO DELAY ONE OF the HANDS OR ARMS BY 4 OR 6 FRAMES

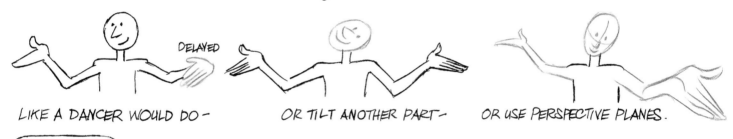

LIKE A DANCER WOULD DO – OR TILT ANOTHER PART – OR USE PERSPECTIVE PLANES.

STEAL IT!

IN A MARVELLOUS TV MASTERCLASS ON ACTING, MICHAEL CAINE SHOCKED EVERYONE BY SAYING,
 "IF YOU SEE SOME ACTOR DOING A PIECE OF BUSINESS THAT YOU ADMIRE – STEAL IT."
 (PAUSE FOR EFFECT) "STEAL IT!" (AUDIENCE SHOCK, HORROR) "BECAUSE ... THEY DID."

EYES

SOUND ADVICE CAME FROM the DISNEY STUDIO EARLY ON:
 IF YOU'RE SHORT OF TIME, SPEND IT ON the EYES. THE EYES ARE WHAT PEOPLE WATCH.
OF COURSE THIS IS TRUE. The EYES ARE the VISIBLE PART OF the BRAIN – DIRECTLY CONNECTED TO IT.

I THINK THAT'S WHY WE SEE the 'SOUL' OR PERSON REVEALED IN The EYES. IT'S SCARY. WE'RE
LOOKING INSIDE EACH OTHER.

OUR EYES ARE SUPREMELY EXPRESSIVE and WE EASILY COMMUNICATE WITH the EYES ALONE. WE CAN OFTEN TELL the STORY JUST WITH the EYES,

AND HOW MUCH MORE DRAMATIC IT IS TO JUST TURN the EYES INSTEAD OF the WHOLE BODY!

HERE'S SOMETHING WE SEE ALL DAY EVERY DAY — and I'D NOT SEEN IT ANIMATED UNTIL I STARTED RANTING ABOUT IT TO ANIMATORS 5 YEARS AGO:

WHEN LISTENING ON the PHONE the EYES FLICKER AROUND IN A STACCATO FASHION REFLECTING The LISTENER'S SHIFTING THOUGHTS IN REACTION. OUR EYES ARE RARELY STILL.

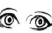

IT'S GOOD TO DISTEND the PUPIL TO SHOW FORM — FEEL PART OF the EYE.

MOVE PUPIL DOWN WITH LID AS IF IT'S HEAVY - FORCING IT DOWN.

THERE'S AN INFINITE VARIETY OF BLINKS, BUT HERE'S A SIMPLE FORMULA.

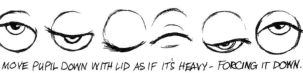

THIS IS CRUDE, BUT EFFECTIVE — WORKS WELL ON ONES OR TWOS.

WE CAN GO ON FOREVER ABOUT ACTING (and WE DO) BUT OUR JOB IS-

① PUT OVER the POINT OF the SCENE CLEARLY.

② GET INSIDE the CHARACTER OR CHARACTERS. (and EVERYBODY'S REALLY DIFFERENT.)

③ SHOW CLEARLY WHAT THEY'RE THINKING.

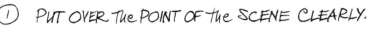

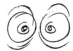

ANIMAL ACTION

FOUR LEGGED ANIMALS WALK LIKE TWO OF US JOINED TOGETHER — ONE SLIGHTLY AHEAD OF THE OTHER — TWO SETS OF LEGS SLIGHTLY OUT OF PHASE.

WE LOOK FOR ALL THE SAME THINGS AS WE DO WITH A HUMAN. START WITH THE CONTACT POSITIONS (PROBABLY STARTING ON THE FRONT FOOT.) WHERE ARE THE UPS and DOWNS? WHERE IS THE WEIGHT? WHAT'S THE SPEED? CHARACTER? DIFFERENCES IN BUILD?

A FOUR LEGGED WALK
HAS TWO MAIN
EXTREMES —
(EXAGGERATED)

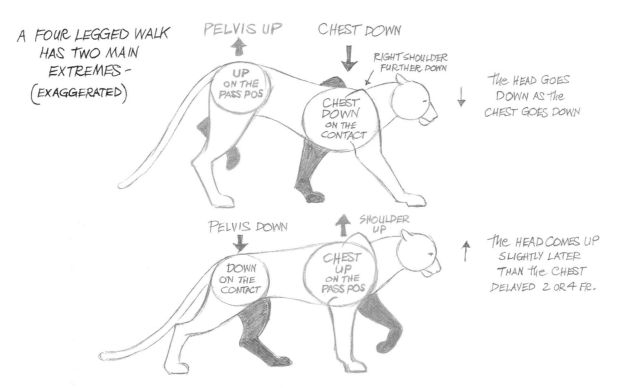

BUT WITH TWO SETS OF LEGS WORKING, THERE'S A LOT OF WEIGHT TRANSFERENCE GOING ON — WHERE THE WEIGHT IS COMING FROM, WHERE IT IS and WHERE ITS GOING TO.

327

IF WE'RE GOING TO BE "REALISTIC" IN OUR ACTION WE'RE GOING TO HAVE TO DO THE RESEARCH: HOW the ANIMAL IS BUILT, IT'S SIZE and TYPE — WATCHING and WATCHING UNTIL WE KNOW IT.

LIVE ACTION REFERENCE

STUDY FILM and VIDEO and The EXTRAORDINARY MUYBRIDGE PHOTOS of ANIMALS WHERE The HIGHS and LOWS and CHANGING MUSCLE SHAPES ARE CLEARLY DISPLAYED AGAINST BACKGROUND GRIDS.

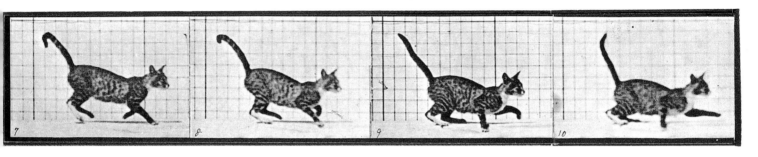

A MAESTRO OF ANIMAL ACTION, MILT KAHL SAID HE DID THOROUGH RESEARCH ON ANIMALS and ALWAYS DID. HE SAID HE SPENT HUNDREDS OF HOURS STUDYING ACTIONS OF VARIOUS ANIMALS and WALKS and RUNS — WHAT'S HAPPENING — WHERE The WEIGHT IS and HOW YOU DRAW THEM. HE SAID HE DIDN'T THINK THERE WAS AN EASY WAY OF ARRIVING AT THESE THINGS: WE JUST HAVE TO GO THROUGH IT.

MILT SWORE BY The MUYBRIDGE BOOKS — FOUND THEM EVEN BETTER THAN FILM, BECAUSE OF the GRIDS.

KEN HARRIS ALSO SWORE BY MUYBRIDGE. HE BOILED DOWN A SIMPLE FORMULA — SOMETHING LIKE THIS —

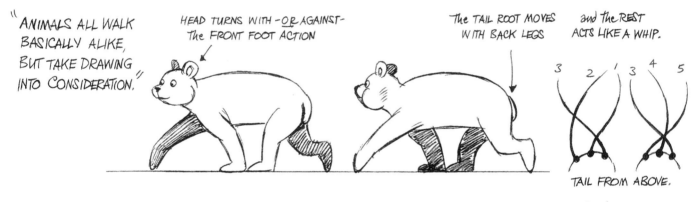

"ANIMALS ALL WALK BASICALLY ALIKE, BUT TAKE DRAWING INTO CONSIDERATION."

HEAD TURNS WITH — OR AGAINST — The FRONT FOOT ACTION

The TAIL ROOT MOVES WITH BACK LEGS

and The REST ACTS LIKE A WHIP.

TAIL FROM ABOVE.

SINCE MOST ANIMAL WALKS ARE PRETTY SIMILAR, IF WE UNDERSTAND The WALK OF A MEDIUM BUILT ANIMAL LIKE A HORSE, DOG OR LARGE CAT WE CAN APPLY the SAME KNOWLEDGE TO OTHER ANIMALS DEPENDING ON THEIR SIZE, WEIGHT, DESIGN and THEIR TIMING — The INTERVALS OF THEIR FEET LANDING.

IF WE GET DOWN ON ALL FOURS WE CAN FEEL HOW THEY WALK.

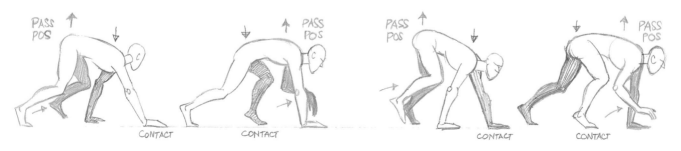

ABE LEVITOW ASKED
AN INTERESTING QUESTION —

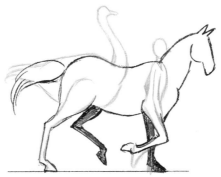

DOES A HORSE WALK LIKE AN OSTRICH AND A MAN?

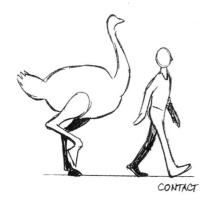

CONTACT

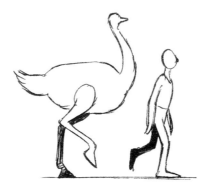

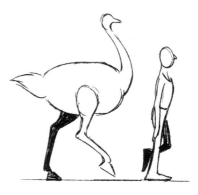

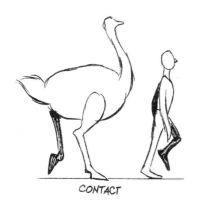

CONTACT

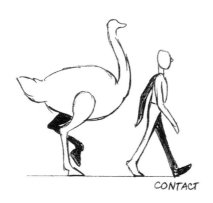

CONTACT

ETC.

OR

DOES AN OSTRICH AND A MAN WALK LIKE A HORSE?

BASIC ANIMAL WALK PATTERN

APPLYING TO MOST ANIMALS - USING A MEDIUM SIZE DOG.
THERE'S SO MUCH GOING ON THAT COLOURS HELP -

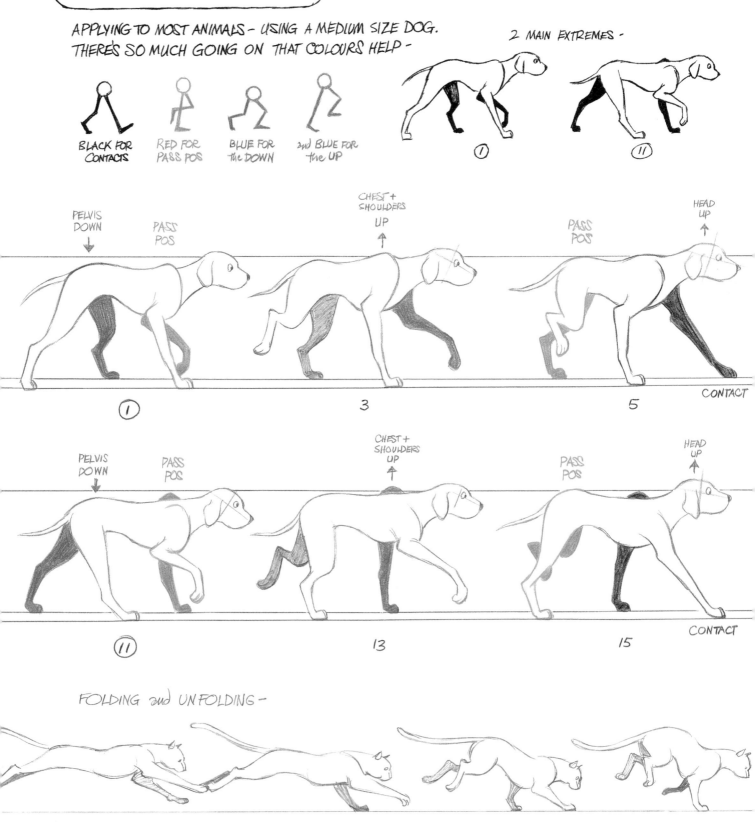

BLACK FOR
CONTACTS

RED FOR
PASS POS

BLUE FOR
the DOWN

2nd BLUE FOR
the UP

2 MAIN EXTREMES -

①

⑪

PELVIS
DOWN

PASS
POS

CHEST +
SHOULDERS
UP

PASS
POS

HEAD
UP

① 3 5 CONTACT

PELVIS
DOWN

PASS
POS

CHEST +
SHOULDERS
UP

PASS
POS

HEAD
UP

⑪ 13 15 CONTACT

FOLDING and UNFOLDING -

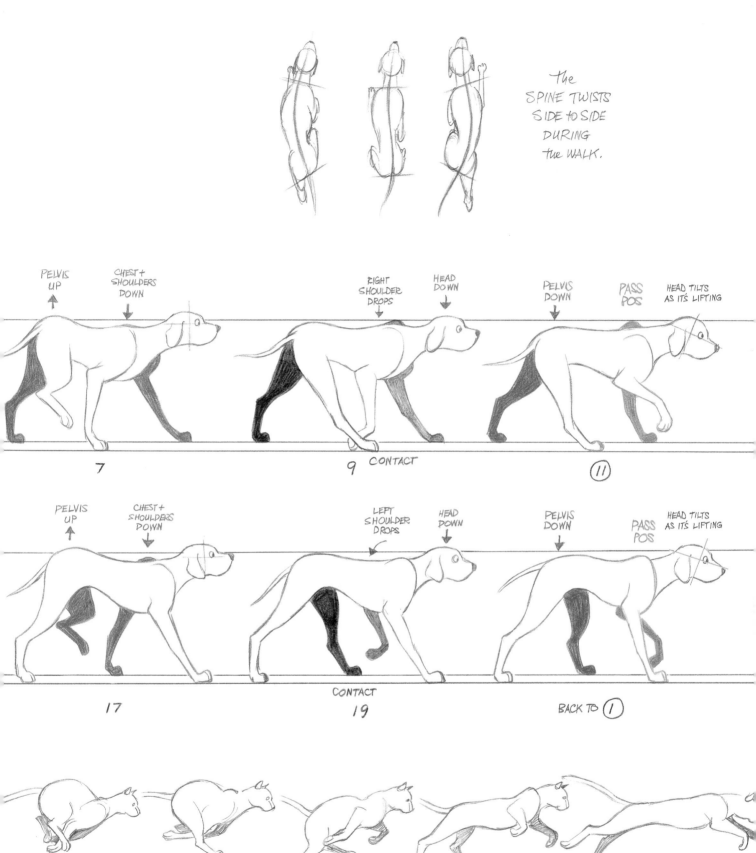

The
SPINE TWISTS
SIDE to SIDE
DURING
the WALK.

PELVIS UP CHEST + SHOULDERS DOWN

RIGHT SHOULDER DROPS HEAD DOWN

PELVIS DOWN PASS POS HEAD TILTS AS IT'S LIFTING

7 9 CONTACT ⑪

PELVIS UP CHEST + SHOULDERS DOWN

LEFT SHOULDER DROPS HEAD DOWN

PELVIS DOWN PASS POS HEAD TILTS AS IT'S LIFTING

17 CONTACT 19 BACK TO ①

331

HERE'S A FUNNY 'INVENTED' WALK ON A DONKEY - ON TWOS - WALKING ON 16's. IT'S PLANNED WITH THE FRONT LEG and
the OPPOSING BACK LEG 'TWINNING' - TAKING the STEP TOGETHER. The EXTREMES #1 and #17 ARE LEVEL and the PASSING POSITION #9
BODY and HEAD ARE RAISED SLIGHTLY. The DOWN IS ON #5 and the UP IS ON #13. SIMPLE, BELIEVABLE, BUT NO ANIMAL WALKS LIKE THIS.

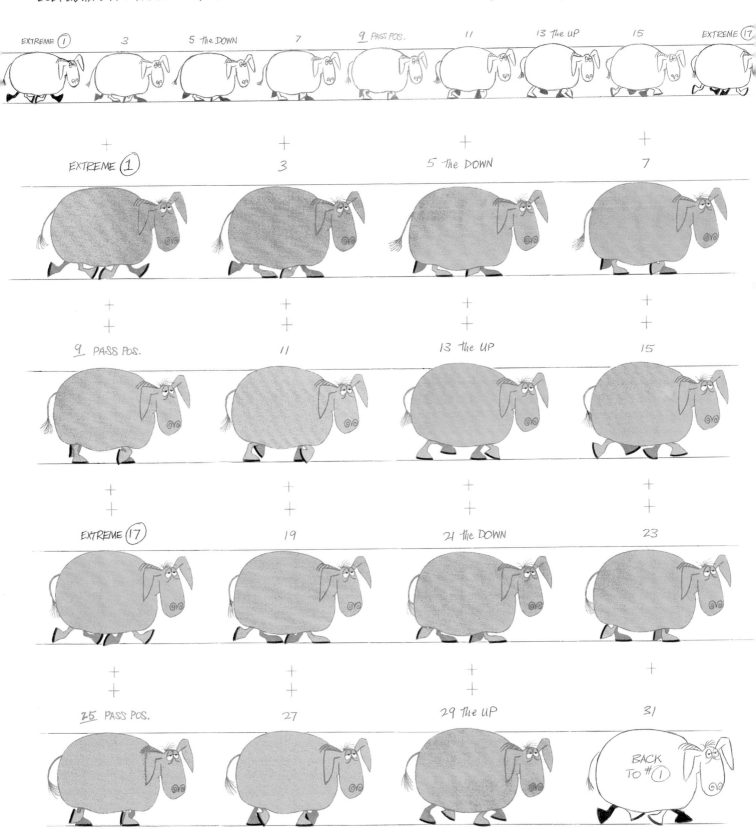

332

DIRECTING

I THINK THERE ARE ONLY A FEW IMPORTANT THINGS TO KNOW ABOUT DIRECTING – BUT WE'VE GOT TO KNOW THOSE.

The DIRECTOR'S JOB IS TO MAKE IT ALL WORK. I HAVE THREE RULES:

1. BE SIMPLE.
2. BE CLEAR.
3. PUT EVERYTHING WHERE YOU CAN SEE IT.

The DIRECTOR IS A 2 FACED CREATURE WITH A FOOT IN 2 CAMPS. The SITUATION DEMANDS IT.

IT'S GOING TO BE GREAT WE HOPE

DO GOOD WORK and DRAW FASTER

SCHEDULE

the FRONT ROOM

The BACK ROOM

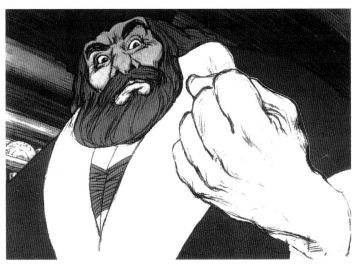

"IT'S A *BUSINESS*, GOD DAMN IT! "
(ANON. EXECUTIVE)

"IT'S NOT A BUSINESS IT'S AN *EXPRESSION* ! "
EMERY HAWKINS (ANIMATOR)

OF COURSE IT'S BOTH - BUT DO YOU KNOW THE GOLDEN RULE?

WHOEVER HAS THE GOLD MAKES THE RULES.

WE'RE BEING HIRED TO DO A JOB and WE SHOULD DO WHAT WE'RE BEING HIRED TO DO. WE SHOULD FOLLOW THE RULES. IF WE WANT ARTISTIC FREEDOM THEN WE PROVIDE OUR OWN GOLD.

(The 'BRIEF') IS SO IMPORTANT! I ALWAYS WRITE ON ONE SHEET OF PAPER WHAT THE GOALS ARE — WHAT WE'RE SUPPOSED TO DO. FOR EXAMPLE, THE "WHO FRAMED ROGER RABBIT" FILM:
FIRST, MAKE THE MARRIAGE OF LIVE ACTION and CARTOON REALMS BLEND TOGETHER CONVINCINGLY.
SECOND, USE (A) DISNEY ARTICULATION
(B) WARNER TYPE CHARACTERS
(C) TEX AVERY HUMOUR (BUT NOT SO BRUTAL.)
OUR JOB IS TO ALLAY THE FEARS OF THE EXECUTIVES and INCITE GREED BY OUR TALENT DISPLAY-
SOLVING THE PROBLEMS UP FRONT. DESIGN THE STUFF OR SELECT WHAT'S GOOD and SHOW IT WORKS.

(The LEICA REEL) OR ANIMATIC, OR FILMED COLOUR STORYBOARD WILL SHOW WHAT'S WORKING - (AND WHAT ISN'T) IT'S SOMETHING FOR EVERYONE TO HANG THEIR HAT ON and CALM DOWN.
THEN WE MAKE THE CHANGES TO THAT LEICA REEL - NOT TO THE ANIMATION. THIS WAY THE ANIMATORS CAN GET ON WITH THEIR WORK IN SOME KIND OF PEACE.

(SEPARATE THE CHARACTERS) SHOW THE DIFFERENCE BETWEEN THEM. IT'S ALL TO DO WITH CONTRAST:
SIZES, SHAPES, COLOURS, VOICES. PUT OPPOSITES TOGETHER: BIG and
LITTLE, FAT and THIN, TALL and SHORT, ROUND and SQUARE, OLD and YOUNG, RICH and POOR etc.

THIS IS SO VERY IMPORTANT! A SUCCESSFUL EXAMPLE IS DISNEY'S 'LION KING' WHERE ALL The CREATURES SOUND, LOOK and BEHAVE QUITE DIFFERENTLY FROM EACH OTHER.

(BEST FOOT FORWARD) PUT The BEST ANIMATORS ON The OPENING, ENDING and AS PILLARS SPOTTED THROUGH The MIDDLE — LIKE ACTORS WHO KNOW The IMPORTANCE OF STAGE ENTRANCES and EXITS. PUT The BEST PEOPLE ON CLOSE UPS and LONG SCENES, LESS EXPERIENCED PEOPLE ON 3 FOOT LONG-SHOTS and MIDDLE PEOPLE IN The MIDDLE.

(CASTING ANIMATORS) EVERYBODY HAS THEIR 'THING' THEY DO WELL. IT'S OUR JOB TO CAST THEM FOR WHAT THEY <u>CAN</u> DO and NOT WHAT THEY CAN'T DO.

(MAKING CHANGES) UNLESS THEY'RE ASKING FOR HELP, ALLOW The ANIMATOR TO GIVE BIRTH UNIMPEDED. ONCE THEY'RE PREGNANT WITH A NEW SCENE THEY WON'T MIND MAKING CHANGES TO A PREVIOUS ONE. WE'RE ALL The SAME.

("SAY! SAY!") KEEP The DOOR OPEN FOR CONTRIBUTIONS FROM EVERYONE ON the TEAM. IF YOU CATCH THEM MUTTERING, ASK THEM TO "SAY! SAY!" THEY MIGHT BE RIGHT ABOUT SOMETHING.

(VOICE RECORDING) IF YOU CAST The RIGHT ACTOR FOR The JOB IT'S The EASIEST THING IN The WORLD. THEY'LL USUALLY GIVE IT TO YOU ON TAKE ONE. THEN JUST GET ANOTHER TAKE FOR INSURANCE. ACTUALLY THEY'LL USUALLY GIVE IT TO YOU ON The REHEARSAL — SO TELL The RECORDIST TO RECORD EVERYTHING. IT'S ONLY IF YOU HAVEN'T MADE CLEAR WHAT'S REQUIRED THAT YOU CAN END UP WITH FIFTY TAKES.

(HOOK-UPS) IT'S OUR RESPONSIBILITY TO ENSURE THAT ONE ANIMATOR'S SHOT HOOKS UP PERFECTLY TO The NEXT PERSON'S SHOT. THERE'S NO EXCUSE FOR AN ANIMATION DIRECTOR TO GET THIS WRONG AS WE CAN DRAW PERFECT MATCH-UPS.

(RESEARCH) VERY, VERY, VERY IMPORTANT. RESEARCH EVERYTHING TILL YOU KNOW The SUBJECT INSIDE OUT. DON'T WING IT.

(EDITING) WE SHOULD KNOW EDITING TECHNIQUES. I STUDY AKIRA KUROSAWA The JAPANESE DIRECTOR, WHO I THINK IS The WORLD'S GREATEST EDITOR AS WELL AS DIRECTOR.

(BELIEVE IN YOUR MATERIAL) ANOTHER GREAT THING ABOUT KUROSAWA IS THAT HE BELIEVES IN HIS MATERIAL. HE TRUSTS The AUDIENCE and TRUSTS HIMSELF TO TELL HIS STORY and ALLOWS The AUDIENCE TO COME TO The FILM. SO AS A DIRECTOR YOU HAVE TO BELIEVE IN YOUR MATERIAL.

IT'S AMAZING WHAT YOU CAN GET AWAY WITH.

AN INTERESTING THING HAPPENED ON "WHO FRAMED ROGER RABBIT."

THE ACTOR, BOB HOSKINS HAD A GREAT ABILITY TO CONCENTRATE ON A NON-EXISTANT RABBIT WHO WAS 3 FEET HIGH. UNLIKE MOST ACTORS WHO LOOK THROUGH OR PAST THE INVISIBLE CHARACTER, BOB COULD STOP HIS EYES RIGHT AT THE 3 FOOT LINE WHERE THE RABBIT'S EYES WOULD BE.

ONE DAY ANIMATOR SIMON WELLS (NOW A TOP DIRECTOR) CAME IN TO ME AND SAID, `WE'VE GOT A PROBLEM — HOSKINS IS LOOKING AT A 6 FOOT HIGH RABBIT — WHAT DO WE DO?´ HE WAS RIGHT. HOSKINS HAD TEMPORARILY LAPSED AND WAS LOOKING and TALKING TO A WALL ABOUT 6 FEET OFF THE GROUND.

THE RABBIT'S SUPPOSED TO BE DOWN HERE.

I THOUGHT, `WELL, THE RABBIT'S GOT THESE HUGE FEET — LET'S JUST STRETCH HIM UP ON HIS TOES AGAINST THE WALL´. `FOR NO <u>REASON</u>?´ `WHAT ELSE ARE WE GOING TO DO? THE RABBIT'S NEUROTIC — IT SHOULD WORK.´

THEY EVEN USED THE SHOT IN THE PROMOTIONAL TRAILERS AND NO ONE EVER QUESTIONED IT.

I ALWAYS SKETCH EVERYTHING OUT SMALL FIRST. The LITTLE DRAWINGS, BECAUSE THEY'RE 'THINKING' DRAWINGS, ALWAYS SEEM TO SHOW IF THE IDEA IS WORKING CLEARLY OR NOT:

$$\boxed{\text{The PROCEDURE}}$$

TO MAKE The SOUP:

PLANNING STRUCTURE

STORYBOARD (DESIGNED ALREADY? OR ROUGH)

LEADS TO ↓

TEST The 'LEICA' REEL OR 'ANIMATIC' OR FILMED STORYBOARD

LEADS TO ↓

CAN EVEN TEST THESE PLANNING DRAWINGS (USUALLY SMALL THUMBNAILS)

CLEAR UNDERSTANDING OF SHOT

THEN

MAN BITES DOG

TEST (KEY) POSITIONS
The BIG DRAWINGS OR POSITIONS THAT <u>HAVE</u> TO BE THERE.

TEST EXTREMES = ANY OTHER POSITIONS THAT <u>HAVE</u> TO BE THERE.
— USUALLY 'CONTACTS'

TEST PASSING POSITIONS (PERHAPS JUST IN ROUGH)

SPONTANEOUS FLOW

DO SEVERAL STRAIGHT AHEAD RUNS —

The PRIMARY THING

The SECONDARY THING

The THIRD THING

The FOURTH THING

ANY OTHER BITS - LIKE DRAPERY

HAIR

FAT

TAILS etc.

and WE CAN KEEP ON TESTING.

AND TO DO THIS WE'RE USING:

GOOD KEYS FOR CLARITY

WEIGHT = 'CHANGE' and ANTICIPATION.

TO GET FLEXIBILITY:

WE'RE USING OVERLAPPING ACTION (DELAYING THINGS and MOVING THINGS IN PARTS)

and WE'RE USING SUCCESSIVE BREAKING OF JOINTS

ACCENTS — HEAD, BODY, HANDS, FEET (GET THERE EARLY)

STAGGER VIBRATIONS

COMPRESSION and DISTENTION (SQUASH and STRETCH)

DIFFERENT WALKS and RUNS = WE'RE STRESSING the DIFFERENCE BETWEEN THINGS and PEOPLE.

'INVENTED' MOVES THAT CAN'T HAPPEN IN The REAL WORLD BUT WE MAKE LOOK BELIEVABLE.

FOR DIALOGUE WE'RE PROGRESSING IT SOMEWHERE.

WE'RE USING ALL THESE THINGS BROADLY OR VERY SUBTLY.

ALL THIS IS the ANATOMY TO ENABLE US TO GIVE The PERFORMANCE, SUSTAIN IT and MAKE IT COMPULSIVE VIEWING.

AND ONCE IT'S ALL ABSORBED INTO the BLOODSTREAM — TO FREE US TO EXPRESS!

'THE PLAY'S THE THING.'

Start with the things that you know and the things that are unknown will be revealed to you.

Rembrandt, 1606–1669

ACKNOWLEDGEMENTS

Now I know why authors profusely thank their editors! So thanks to Walter Donohue at Faber and Faber for daring to think there might be a useful book here and for his enthusiasm and patience as I struggled endlessly to complete.

And thanks to the production team: Nigel Marsh, Kate Ward and Ron Costley for coping with my unorthodox format and crazy demands. Linda Rosenberg of Farrar, Straus and Giroux has been an energetic enthusiast and supporter of the book all the way along.

I'm also very grateful to Roy E. Disney who has helped me in many different ways.

The Disney Studio has been very generous and co-operative as they always have been during my life-long one-foot-in and one-foot-out relationship with them. Special thanks to Howard Green for his consistent help and encouragement.

I think the book already shows how much I owe to my teachers and friends: Ken Harris, Art Babbitt, Milt Kahl, Emery Hawkins and Grim Natwick. But I want to especially thank Frank Thomas and Ollie Johnston for their kindness and advice over the years. It's been a privilege to have these men as allies and friends.

Thanks to author/animator John Canemaker for his advice and long term support. My 25 year collaborator Roy Naisbitt saved the old artwork I would have thrown out and that's why we have the illustrations. Thanks Roy. Animator/director Neil Boyle started out as my protege and ended up giving me sound advice over the three and a half years it's taken. Catharine and Andy Evans at Dimond Press went far beyond the call of duty as we pushed their laser copier to its limits. Thanks to Chris Hill for his help with the computer images on the cover.

I want to thank my son, animator Alex Williams for constantly telling me the book will be useful. My old school friend, animator Carl Bell has been helping me with stuff for years. Also my friend, author Ralph Pred, has been extremely stimulating and encouraging.

My photographer friend Frank Herrmann took the early photographs. Thanks Frank. The 'old man' photos are by Jacob Sutton. Thanks, Jake. Thanks to builder Dennis Nash for building me an inventive place to work on the book.

And thanks go to the following who all helped in different ways – Chris Wedge, Tom Sito, Morten Thorning, Miguel Fuertes, Jane Miller, Nicola Solomon, Sue Perotto, Dean Kalman Lennert, Di McCrindle, Lyn Naisbitt, Julie Kahl, Heavenly and Scott Wilson, Phil and Heather Sutton, John Ferguson, Ted and Jill Hickford, Marilyn and David Dexter, Ellen Garvie, Mallory Pred, Saskia and Rebekah Sutton.

The cover on page x appears by kind permission of *Animation Magazine*. Roger Rabbit © Touchstone Pictures and Amblin Entertainment, Inc. used by kind permission of Touchstone Pictures and Amblin Entertainment, Inc. The photograph is by Jacob Sutton; The photographs on pages 2, 6, 8 and 45 are by Frank Herrmann; The stills on page 4 and page 10 from *The Charge of the Light Brigade* © *The Charge of the Light Brigade*, courtesy of MGM; The photograph on page 7 is used by kind permission of Disney Enterprises, Inc.; The stills on pages 18 and 19 from *Steamboat Willie*, *The Skeleton Dance*, *Flowers and Trees*, *Three Little Pigs* and *Snow White and the Seven Dwarfs* are used by kind permission of Disney Enterprises, Inc.; The poster on page 21 is used by kind permission of the British Film Institute; 'Epitaph of an Unfortunate Artist' is from the *Complete Works of Robert Graves*, courtesy of Carcanet Press Limited, 1999; The photograph on page 26 appears by kind permission of Disney Enterprises, Inc.; The photograph on page 39 'Golf Ball Bounce' © Harold Edgerton, courtesy of the Science Photo Library; The Bugs Bunny sketch by Ken Harris on page 46 appears by kind permission of Warner Bros.; The photographs on page 328 are by Eadweard Muybridge, courtesy of the Kingston Museum and Heritage Service; The sketches on page 336 and page 337 appear by kind permission of Touchstone Pictures and Amblin Entertainment, Inc.